William Blake

Robin Hamlyn and
Michael Phillips

*Introductory essays
by Peter Ackroyd and
Marilyn Butler*

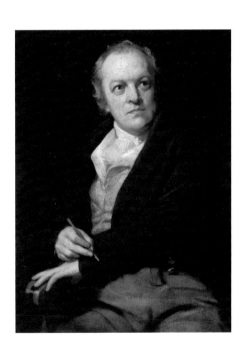

William Blake

Tate Publishing

Supported by
GlaxoWellcome

In New York the exhibition is made possible by
The Isaacson-Draper Foundation

Cover: *The Good and Evil Angels*
1795/?c.1805 (no. 252)

Frontispiece: Thomas Phillips,
William Blake 1807 (no. 1)

Published by order of the Tate Trustees 2000
on the occasion of the exhibition at Tate Britain,
London, 9 November 2000 – 11 February 2001,
and the Metropolitan Museum of Art, New
York, 27 March – 24 June 2001

ISBN 1 85437 314 5

A catalogue record for this publication
is available from the British Library

Published by Tate Gallery Publishing Limited,
Millbank, London SW1P 4RG

Catalogue design by
Esterson Lackersteen

Printed and bound in Great Britain
by Balding + Mansell, Norwich

Contents

Sponsor's Foreword

Glaxo Wellcome is delighted to be associated with this celebration of the life and works of one of Britain's most intriguing artists. William Blake was an innovator and a radical, his works still exerting a popular fascination today. This exhibition, which features pieces drawn from collections worldwide, takes a bold, original and ambitious look at this very individual artist.

Themes of revelation, innovation and education shape Glaxo Wellcome's programme of support for the arts. Glaxo Wellcome has a long association with the visual arts founded on a series of successful partnerships with Britain's galleries and museums, built on a shared commitment to excellence, innovation and access. As well as supporting important and unusual exhibitions, Glaxo Wellcome is committed to encouraging young people to take part in, and learn about, performance and visual art. Our support for projects involving young people aims to encourage new audiences and learning and participation in the arts at an early age. Through our associations, we hope to give them – and you – the opportunity to take a fresh look at the arts.

Glaxo Wellcome is pleased to be working in partnership with Tate, following two successful sponsorships at Tate Britain. Our congratulations must go to Tate for bringing together this fascinating collection, which documents Blake's work more precisely and extensively than has been done previously.

We hope that this outstanding exhibition will introduce the work of William Blake to as wide an audience as possible, and further enlighten those who know his work well. Please enjoy the exhibition.

Foreword

The reputation of William Blake (1757 – 1827) as an artist and writer of astonishing power and originality stands today perhaps higher than ever. He continues to inspire painters and poets, musicians and mystics, men, women, and children. And despite his famously radical politics and vehement rejection of much of the social establishment about him, he has been affectionately adopted by a wide British public as a kind of patron saint. It may be that the heady combination of forceful individualism and soaring creativity is a trait we would like to think was distinctively British. Yet Blake is known and admired by an ever-expanding international network. Not only have many exhibitions of his work been mounted in America and Europe (most recently earlier this year in a British Council/British Museum show in Helsinki and Prague) but a developing profusion of Internet traffic around his work is extending his profile, globally, day by day.

Blake's progress from ostracised outsider at the time of his death to today's acclaimed genius has been steady, and marked by discernible milestones. Followers like Samuel Palmer, John Linnell and Dante Gabriel Rossetti helped to keep Blake's immediate memory alive, and Alexander Gilchrist's *Life of William Blake*, published in 1863 (with later editions in 1880, 1907, 1942 and 1945) consolidated this with a reliable and engaging survey of his life, beginning a gradual process of canonization. In the twentieth century, artists like Stanley Spencer and Graham Sutherland, amongst many, were to acknowledge Blake's influence on their work, and two significant art-historical surveys in 1959 and 1977, by Anthony Blunt and David Bindman respectively, followed by Martin Butlin's 1981 catalogue raisonné of the paintings and drawings, formed the intellectual bedrock for much subsequent research and led a field of scholarship that was ultimately to place Blake as prominently as Constable and Turner in the history of British art.

Though the original terms of Sir Henry Tate's National Gallery of British Art founded at Millbank in 1897 excluded Blake (as an artist born before 1790), the Tate Gallery's expanding remit and progressive acquisition of a rich and broad collection of his work from all phases in his career was to make it during the course of the twentieth century a central resource for all Blake scholars and admirers. The process began with transfers from the National Gallery in 1909, 1931 and 1934, consolidated by major acquisitions from the Linnell sale in 1918 and in the W. Graham Robertson gift in 1939. The Tate Gallery also spearheaded major exhibitions of Blake's work. In October to December 1913 it staged the first ever exhibition of his work in a public gallery, and in 1947 a show organised with the British Council toured to several European capitals. From March to May 1978 Millbank saw the largest and most comprehensive display of Blake's work to date, curated by Martin Butlin, then Keeper of the Tate Gallery's Historic British Collection.

Martin Butlin's project remains a key reference point for all Blake studies and vividly brought his powers as a visual artist to broad public notice. The present Tate Britain exhibition, though even larger in scale, does not seek to supersede the great 1978 undertaking but to complement it – by showing Blake in his full range to a new generation, by exploring the central themes of his work in new historic, literary and artistic contexts, and by trying to uncover more of that complex and exhilarating relationship between his persona, his milieu, and his output as an artist and writer. We are particularly grateful to Peter Ackroyd and to Marilyn Butler in this respect for their searching introductory contributions to the catalogue. The project as a whole was conceived and inspired by Robin Hamlyn, Senior Curator, Tate Collections, who has worked tirelessly on the project for the past two years, channelling his passion and knowledge of his subject into a strong selection and original interpretative commentary. He has worked closely from the outset with Michael Phillips, Reader at the University of York, whose detailed knowledge of Blake in Lambeth has been invaluable. Though acknowledgements to the project's many other participants are recorded elsewhere, I would like to underline the notable achievements of Christine Riding, who, with Lizzie Carey-Thomas and Martin Myrone, shouldered the principal curatorial as well as administrative burdens most deftly and were central to making and shaping the show.

As ever, our debt to the many lenders of works to this exhibition is profound: more than 500 individual works have come from 45 sources internationally. The willingness of owners to participate in such an ambitious undertaking has been very gratifying. I must note particular thanks to Antony Griffiths and his colleagues in the Department of Prints and Drawings at the British Museum for arranging the largest loan of works ever made from their department to another institution's exhibition; to Ladislav Kesner at the Prague Castle; to Duncan Robinson, David Scrase and their colleagues from the Fitzwilliam Museum; to Stephen Keynes; and to Patrick McCaughey and Scott Wilcox of the Yale Center for British Art, who generously accommodated our many requests, above all agreeing to lend all 100 plates of *Jerusalem* from their collection. We are also indebted to the National Trust for lending *A Vision of the Last Judgment* from Petworth House, despite a prior commitment to lend it to the British Museum earlier this year, having recognised that its absence would have seriously impoverished the opening section of the exhibition. And thanks are due to Polly Smith, Rosemary Watt and colleagues at the Glasgow City Art Gallery for heroically agreeing to lend *Sir Jeffery Chaucer and the Nine and Twenty Pilgrims on their Journey to Canterbury* from Pollok House.

I am pleased to pay tribute too to the exhibition sponsors Glaxo Wellcome, who made the project possible in the first place and who have become close allies and supporters of Tate Britain. Two previous Tate sponsorships prepared the way for this new partnership, and we have much enjoyed working again with their team to bring Blake and his art to a wide public in this country. After its London showing, the exhibition moves in a slightly modified form to the Metropolitan Museum of Art, New York. For their determination to see Blake on a Manhattan stage, we should salute Director Philippe de Montebello, Associate Director of Exhibitions Mahrukh Tarapor, and Elizabeth Barker, Assistant Curator of Drawings and Prints, who has also contributed to the catalogue. The Metropolitan Museum is grateful for The Isaacson-Draper Foundation's generous support of the exhibition in New York. All this marks an auspicious start to this millennium's engagement with William Blake, visionary, worldwide.

Stephen Deuchar
Director, Tate Britain

Acknowledgements

Many people have been involved in the realisation of this project. In addition to the comments made in the Director's Foreword, we would like to acknowledge the contributions of a number of institutions and individuals.

Any William Blake exhibition is, of course, greatly dependent on the research and writings of distinguished scholars, in particular the late Sir Geoffrey Keynes, G. E. Bentley Jr, Martin Butlin, David Bindman, David V. Erdman, Robert N. Essick and Joseph Viscomi. Along with many other scholars in the fields of literature and art they have informed this exhibition and its texts: a huge debt is owed to them all.

We would like to thank Michael Phillips for his specialised knowledge of Blake in Lambeth that brings this exhibition a unique dimension. We are also grateful for the advice and support of Stephen Deuchar, Director of Tate Britain, Sheena Wagstaff, Head of Exhibitions and Displays, and Richard Humphreys, Head of Interpretation and Education. The exhibition as a visual spectacle has been greatly enhanced by the involvement of the designer, Charles Marsden-Smedley, and the graphic designer, Philip Miles, who has approached his task with characteristic enthusiasm. Jon Hill and Maria Spann of Esterson Lackersteen are acknowledged here for creating catalogue layouts that combine the spirit of Blake with a strong sense of modernity.

A number of our colleagues deserve individual recognition: Lizzie Carey-Thomas has tackled the logistics of this highly complex project with consummate professionalism, intelligence and humour; Martin Myrone has notably shared in guiding the intellectual thrust of the exhibition, as well as contributing significantly in an editorial capacity to the catalogue; Sionaigh Durrant, as exhibition registrar, has brought her extensive knowledge and practical skills to bear on one of the largest loan exhibitions the Tate has ever staged; and from the inception of the project Rosie Bass of Tate Collections has scrupulously and cheerfully provided administrative support. In Tate Publishing Nicola Bion and Tim Holton have approached the challenges of editing and producing the catalogue with great care and attention, and Katherine Rose co-ordinated the complex picture research. We would also like to thank our fellow contributors David Blayney Brown, Lizzie Carey-Thomas, Noa Cahaner McManus, Martin Myrone, Martin Postle, Ian Warrell, and Elizabeth Barker from the Metropolitan Museum of Art, New York; the project's conservators, Rica Jones, Jehannine Mauduech, Brian McKenzie, Joyce Townsend and Piers Townshend; the art handlers, led by Terry Warren and assisted by Geoff Hoskins and Dan Pyett, who were responsible for hanging the works for the exhibition; and Sarah Greenberg, Tate Britain's interpretation editor.

Michael Phillips's preparation of the Lambeth section of the exhibition benefited from the research support provided by awards of a British Academy Research Readership in the Humanities and fellowships of the National Endowment for the Humanities, British Library Centre for the Book, Yale Center for British Art and the Folger Shakespeare Library.

In addition we would like to thank the staff of the following institutions: Bodleian Library; Rare Books and Manuscripts Departments and the Reading Rooms of the British Library; Prints and Drawings Department, British Museum; City of Westminster Archive Centre; Glasgow Art Gallery and Museum; Huntington Library and Art Collections; Lambeth Archives Department, Minet Library; London Library; London Metropolitan Archives; National Trust; Public Record Office; Prints and Drawings and Sculpture Departments, Victoria and Albert Museum; and the following individuals; Vivian Aldus, David Alexander, Brian Allen, Anne Anninger, Richard Aspin, Iain Bain, Shelley Bennett, Heather Birchall, Delphine Bishop, Nicolas Booth, Christopher Brown, Katherine Brown, Margaret Brown, Sally Brown, Martin Butlin, Greg Buzwell, Jane Carr, Antonia Charlton, Richard Childs, Ruth Cloudman, Charles Collinson, Lucy Cullen, David Dance, Henry Darst, Roger Davey, Christian Dettlaff, Mark G Dimunation, Meg Duff, Jacqueline Dugas, Anthony Dyson, Elizabeth Easton, Andrew Edmunds, Mark Edwards, Edwina Ehrman, Lucy Eldridge, Jane Farrington, Helen Forde, Gillian Forrester; Andrew Gilmour, Melissa Gold, Timothy Goodhue, Dan Goyder, Antony Griffiths, John Griffiths, Judith Guston, Jeanette Hall, Anne d'Harnoncourt, Tim Harris, Colin Harrison, Annette Hauswald, Clive Hirst, Maryl Hosking, Bridget Howlett, Ralph Hyde, Juliet Ireland, John Ittmann, Deborah Jenkins, Chloe Johnson, Dana Josephson, Ladislav Kesner, Katheryn Kiely, Carole Lapointe, Mary Lister, Stephen Lloyd, Loveday Manners Price, Denis Marnon, Charles E. Mather III, Sally Mason, Sheila McGregor, Liz Miller, Christine Nelson, Jon Newman, Heather Norville-Day, Bernard Nurse, Ed Nygren, Lois Oliver, Mark O'Neill, Bronwen Ormsby, Peter Otto, Robert Parks, Kim Pashko, Ann Percy, Charles E Pierce Jr, Pam Porter, David Powell, Sue Reed, Anne Rose, John Sargent, David Scrase, Daniel de Simone, Janet Skidmore, Elizabeth Smallwood, Alastair Smith, Kathleen Soriano, Lindsay Stainton, Paul Stanley, Karen Stewart, Emma Strouts, Virginia Tandy, Pierre Théberge, Alicia Thomas, Margaret Timmers, Tony Trowles, Stephen Urice, Sarah Vallance, Henry Wemyss, David Weston, Catherine Whistler, Timothy Wilson, Liz Woods, Henry Woudhuysens, Nancy Wulbrecht, David Wykes, Suzanne Wynne, Irena Zdanowitz, and David S. Zeidberg. Finally, Robin Hamlyn would also like to single out his family in gratitude for their great patience.

Robin Hamlyn and Christine Riding

Preface

The purpose of this exhibition and its accompanying catalogue is to explain and bring to life the achievements of William Blake, one of our greatest and most intriguing artists, poets and writers. In displaying the full range of Blake's work together with contextual materials, this exhibition focuses on his vision, his rich and complex mythology, his political interests, and his highly original working techniques.

The exhibition has been conceived in four thematic sections. 'One of the Gothic Artists' concentrates on Blake's life-long interest in the Gothic, both as a source of his own distinctive style and technique and as an ideal of spiritual and artistic integrity. Beginning with his apprenticeship years drawing the royal tombs of Westminster Abbey, this section reveals Blake's unique response to biblical texts as well as British and foreign poetry and history, and concludes with his extraordinary series of watercolours illustrating Dante's Divine Comedy. 'The Furnace of Lambeth's Vale' focuses on Blake's life in Lambeth during the 1790s, when his radical political views and innovative printmaking techniques came together in a new visionary art. Blake's work, with contemporary documents and images gathered around a representation of the studio where he and his wife Catherine worked, gives some sense of Blake's working methods and way of life during the years of the French Revolution and the Terror. 'Chambers of the Imagination' explores Blake's visionary universe, analysing the materials out of which he forged his ideas, his language and his images, and illuminating some of the key characters of his imaginative world – such as his mythological figures Albion and Urizen, as well as the poet John Milton, who was such a powerful source of inspiration. Showing how for Blake word and image were inextricably linked, the final section, 'Many Formidable Works', displays his major illuminated books, including *Songs of Innocence and of Experience* and *Jerusalem*. These not only affirm the artist's original vision but represent those works for which Blake himself wished and expected to be remembered.

Robin Hamlyn and Christine Riding

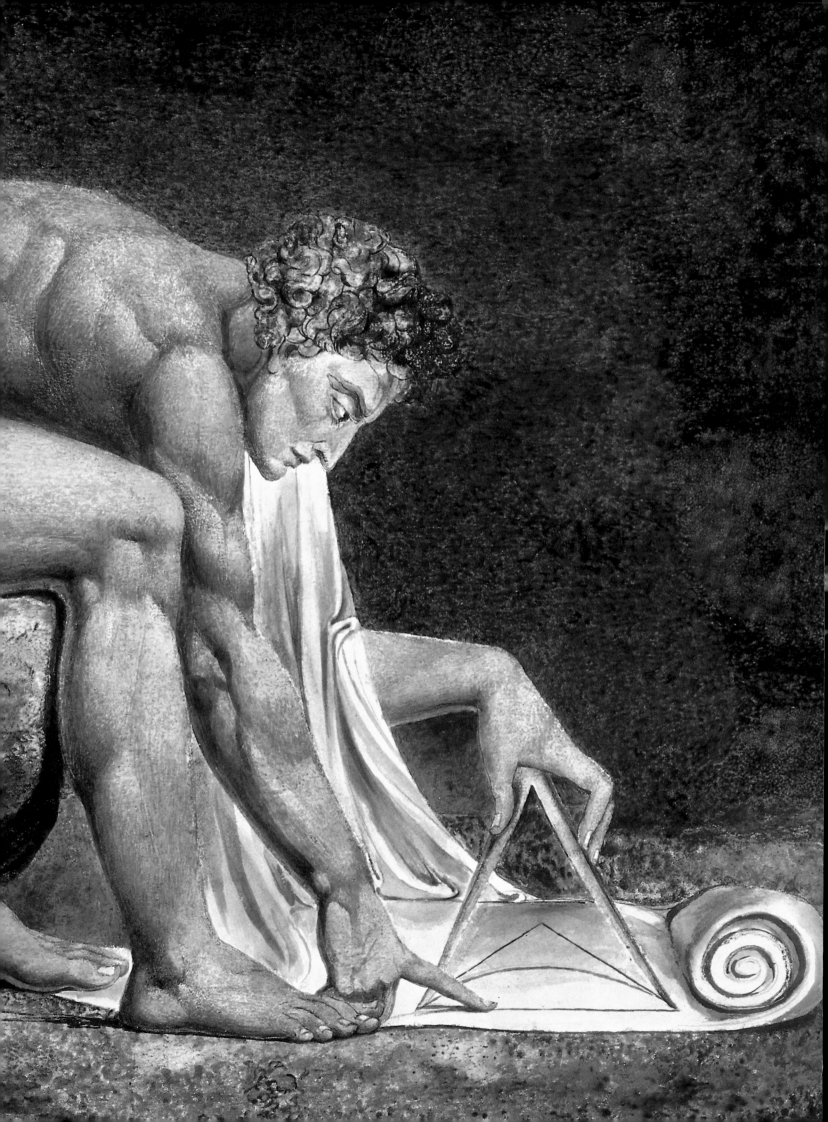

William Blake: The Man
Peter Ackroyd

In later life William Blake invoked, or perhaps recalled seeing, 'the Angel at my Birth', but she led him into a life of the deepest obscurity and of occasional suffering. From the beginning he seems to have considered that he could not expect the smallest help from anyone or anything else on earth; it was as if he had been self-created and owned no other kin. He was largely indifferent to his immediate family, to whom he made few references, and seems instinctively to have withdrawn into himself because he could not deal with those closest to him; it might be considered that in such a living context can be found the origins of those furious individual and didactic myths that he created in subsequent life, but the relationship between art and natural existence is not an easy one to define. Certainly he found within himself that which was richer and more splendid than any external reality, and from earliest childhood he was imbued with a religious sensibility and capacity for spiritual vision. His glimpse of angels in Peckham Rye (still an enchanted place) was only the most visible presentiment of the biblical figures whom he saw everywhere.

Yet in many respects he would have seemed a not altogether unfamiliar child: he dressed like the son of a tradesman, which he was; he was short, vigorous and powerfully built. His mature height was 5ft 5in, so we may imagine him as a somewhat short child. His pugnacity and vigour were in turn accompanied by sensitivity to any presumed slight or threat. He could also be single-minded and obstinate as well as pugnacious. It is to the credit of his parents that they realised something of their son's unique temperament – their liberality or latitude may have sprung in part from their own London radicalism and dissent – and never, for example, sent him to school, where the usual dictates of learning by rote accompanied by strict punishment would certainly have aroused his violent distaste. In fact there is a sense in which he always remained a child, susceptible to sudden hurts and prone to outbursts of fury; on a less immediate level, too, his earliest impressions lingered with him and he preserved the visionary faculties of his infancy. He remained anxious and impetuous, and in later life often succumbed to what he called 'Nervous Fear' when the world of authority and imposed order threatened to overwhelm him.[1]

Even though he was not despatched to school, he was sent to train as an apprentice. He was educated as a commercial engraver and, although he could not possibly have known or expected it at the time, it was the trade to which he would be unwillingly attached for the rest of his life. There was never any rest for him from the workaday or workshop world, and the man later known for his 'visionary enthusiasms' had to subdue himself to an employment that needed endless patience, care and attention to detail. It is not within the scope of this essay to elaborate upon all the minutiae and subtleties of the engraver's art, but it may be noted that all of Blake's great mythic creations and visionary designs spring directly from an immersion in what was a time-consuming, dirty and often frustrating business. Even by this early stage, however, he once wrote that he had a 'great ambition to know everything';[2] as a very young man he sensed the capacities of enlightenment and understanding that dwelled within him. As an apprentice despatched to draw medieval monuments, for example, he was inspired by the tombs of the great men in Westminster Abbey among which he worked. But he was ambitious for his art rather than for himself, since he was preoccupied with images of mortality and history as a way of lending substance to his own more fugitive visions.

At the same time as he trained as an apprentice, in fact, he set out to study for the Royal Academy schools where he would be further instructed in Greek and Roman originals. He was not alone in this period, however, and he became the companion of other young artists; they were also Londoners who shared his tastes and preoccupations, but he was never an easy friend. Throughout his life there are stories of rebuffs and reproofs that he directed against anyone who crossed him, and with even those closest to him he could often be nervous and excitable; in these young days, too, he suffered abdominal pain from excessive anxiety. He rarely forgot criticism, and in one of his accounts of himself he noticed 'how I did secretly Rage'[3] at a less than constructive remark made by a teacher at the Royal Academy. He could also hold grudges for a very long period, and never really forgave or forgot what he considered the mistaken precepts of Sir Joshua Reynolds.

Yet the reverse side of his sensitivity and anger, as it were, was his obstinate and extravagant self-confidence; it is one of the most remarkable and yet generally unremarked features of his life that he always extolled himself in the highest terms as the equal of Raphael or of Dürer. Only that stubborn sense of uniqueness and self-certainty, of course, permitted him to create an entire mythological system of his own; but, as if in flight from the recognition of his apparent failure in this world, he was often concerned to exert or exalt his status in the 'spiritual world', which he considered to be the true aim of his endeavours.

It is important to recognise here the role of his wife, Catherine, in supporting and nurturing that sense of himself. Theirs is one of the most perfect and yet somehow most poignant unions in literary history. Despite his often professed theories of sexual promiscuity and unregeneracy, of which there are many images in his published works, it seems that he expected and received

Opposite:
'Newton' 1795/*c*.1805
(no. 249, detail)

1 Keynes 1980, p.20.
2 Ackroyd 1995, p.56.
3 E.565.

entire loyalty and affection from his wife; she was the constant companion of his endeavours, working with him on his engravings, stitching his clothes, preparing his food – and, perhaps most importantly, instinctively agreeing with and believing his account of his visions. Theirs was in many respects a quiet and introverted union; they remained childless throughout their long marriage and, as in many such partnerships, they retained and reinforced their own child-likeness.

Before their marriage he asked her if she pitied him and, on answering in the affirmative, he announced his love for her. Yet there were other reasons for pity, and even from their early years he was already known as 'poor Blake' or 'poor Will', as if his destiny upon the earth had already been vouchsafed. He often offended other people by his manner and conversation. 'Always be ready to speak your mind' was his good advice but it brought him a great deal of trouble throughout his life. He could be deliberately wild and contrary, even on occasions sarcastic. There are records of some of his ringing conversational denunciations: 'It is a false ... That is a lie'.[4] Despite growing obscurity in the world he continued obstinately to believe in himself – which shows, at the very least, the right sense of priorities – and indeed the more marginalised he became, the more grandiloquent he grew.

But this did not apply to his visions of the spirits, or angels, who surrounded him night and day, and about whom he was always most plain and straightforward. He spoke of them vividly enough but without any undue emphasis or design; for him they were the ordinary conditions of the world. In one sense these epiphanies marked the continuing presence of a childhood vision or childhood imagination, as has been suggested, yet on the other hand they afforded him a sense of security or of being effectively 'singled out'. They were also an aspect of his sturdy obstinacy and refusal to be bullied into submission by the theories or perceptions of other men.

Of course the taint of madness followed him but he was an object of sympathy and pity rather than of horror – 'poor Blake' was, as always, the redolent phrase. There were several reasons for this attenuated response. For one, he was not alone: in an age of revolution and radical dissent there were many from his own background who decried Newtonian physics as an aspect of societal control and who as a result propounded visions of spirits and angels. One of the great prophets of the period, Emmanuel Swedenborg, was also vouchsafed visions. There is no doubt, too, that in one sense Blake believed himself to be a prophet. There is the famous story of Catherine and him sitting naked in their garden in Lambeth (to which they removed in 1791), with the remark that 'it's only Adam and Eve, you know'.[5] But this emphasis on nudity,

as an emblem of the unfallen world, was also not unknown to Blake's more radical contemporaries.

Unlike his contemporaries, however, he was also a great artist; as a result his relations to prophecy and angelic knowledge were striated by all the keen imaginative divisions of his nature. Thus his work is at once imperious and ironic, denunciatory and satirical, lyrical and ambiguous. He said inconsistent things, sometimes to be only vexatious or playful; he could be wilful and assertive when his pronouncements were doubted, and there were occasions when his freedom became a form of self-imposed solitude. He could also repeat himself, so that some people found him tiresome. He could be self-enclosed, withdrawn, secretive, distant and detached. But he could also be humorous, animated and high-spirited. He was the strangest mixture of discipline and disorder but, in that sense, there is no real or necessary contrast between the art and the life.

It could be argued, for example, that he needed the stimulus or goad of another's false imagination in order adequately to convey or understand his own. Certainly he was often spurred into matching creativity by the writing or painting of someone else. But that in turn resembles his own life in the world. A number of anecdotes emphasise his powerful responses: on one occasion, for example, he encountered a man knocking about a woman somewhere near St Giles – Blake fell upon him 'with such counter violence of reckless and raging rebuke' that the offender 'recoiled and collapsed'.[6] The husband, or lover, later confessed that he thought 'the very devil himself had flown upon him in defence of the woman'. But with Blake you cannot have one aspect of his character without the others: his beneficence and his rage, his labour and his dilatoriness, his arrogance and his anxieties are all of a piece. He was a tradesman as well as a visionary.

His visions were in fact unhelpful in only one sense, when they prevented him from getting on with his work; as an engraver, for example, he already had a reputation for being dilatory, tardy and unreliable. He once wrote that 'my Abstract folly hurries me often away while I am at work, carrying me over Mountains & Valleys, which are not Real, in a land of Abstraction where Spectres of the Dead wander'.[7] This is often taken as an aesthetic credo but, given his general inability to finish commissions on time, it is more likely to mean that he followed his inner visions with fascinated attention, to the detriment of the customary labours at hand; it was day-dreaming to the point of genius. In company, too, he was often diverted and abstracted; in the middle of conversation he might look away, seeming lost for a moment. That is perhaps another reason why he seemed so ill suited to, and incapable of coping with, the world. There were times

4 BR.315.
5 BR.53-4.
6 Mona Wilson, *The Life of William Blake*, London 1932, p.215.
7 Keynes 1980, p.34.

when he was excessively over-optimistic, and there were times when he was cast down to the point of self-abasement; he possessed no settled or negotiable way of handling 'ordinary' reality.

As a result he was making very little money, and on occasions Catherine would present him with the tools of his craft to remind him that even those who range over lands of abstraction must work for their bread. He knew well enough that he was being left behind in the race of life, however, but, as he once said, 'I laugh at Fortune, & Go on'.[8] On one occasion when Catherine remarked, 'The money is going, Mr Blake', he replied, 'Oh, damn the money!'[9] Yet there were also times when he egregiously overcharged customers and peremptorily demanded payment; it is one of the many complexities of an already complex temperament.

Other elements of that temperament come more vividly into prominence on the one occasion when he and his wife left London; for three years they resided in Felpham, near Bognor Regis, as the guests and employees of a local poet and patron, Sir William Hayley. Here Blake resigned himself to almost complete neglect, and once more his visions became a source of comfort as much as of inspiration. He subdued his own personality and demands to those of Hayley, who treated Blake with a mixture of admiration and condescension, but as a consequence he fell into a slough of melancholy; in his isolation and frustration he began to suffer from general anxiety and nervous fear. His arraignment for alleged seditious remarks after pushing a soldier out of his cottage garden reduced him to a state of trembling paranoia, in which he feared that Hayley himself was a paid spy used to suborn his testimony. After his acquittal, however, Blake reverted to the terms of utmost servility to his erstwhile patron.

His physiognomy is of some interest in this context. It has been described as one of 'quivering intensity', complemented or negated by a 'stubborn English chin'.[10] Brow and forehead preponderate which lent him 'an eager steadiness of passionate expression … the look of one who can do all things but hesitate'. His eyes were 'large and lambent', while students of the exotic might care to note that 'the bump of ideality' was very pronounced upon his cerebellum.[11]

On his return to London, and particularly on his removal to Fountain Court in the Strand, he became a familiar figure in the streets of the city. Now he resembled a quiet undemonstrative tradesman, dressed in a somewhat old-fashioned manner. He would carry his pint of porter from the local tavern, and was already well known for his eccentricity. There are anecdotes in this later period of his being pointed out as the man 'who sees spirits and talks to angels'.[12]

Yet his own spirits were raised by the fact that, for the first time in his life, he found young 'disciples' who listened to his discourses and reverenced his art. A group of young artists who called themselves 'The Ancients' considered Blake to be an inspired prophet and indeed, in their presence, he did become inspired; after years of neglect and derision he had found good company. In this period, therefore, there emerges a more human or at least more humane Blake. In earlier years he was alternately inspired and introverted, his work and personality filled with energy, terror and exaltation rather than with any more amiable or intimate feelings; at the end of his life he played with the children of his friends, showed them his childhood albums, talked about pets (he always preferred cats to dogs) and sang in the evenings those simple folk airs to which he was so profoundly attached.

Yet his marriage was still the central aspect of his life. 'I have very little of Mr Blake's company,' Catherine confided to one young friend, 'he is always in Paradise'.[13] She was now humbly clad, and sat with him 'motionless and silent' when he 'needed her presence to comfort him'.[14] One observer remarked that they were 'still poor, still Dirty',[15] by which he meant that they continued to labour over their engraving inks. Yet now they took it all with great quietness, resignation and fortitude. One contemporary, meeting him for the first time, observed that 'he looks care-worn and subdued; but his countenance radiated as he spoke of his favourite pursuit'.[16]

On the day of his death, while working upon some illustrations of Dante, he stopped work and turned to his wife, who was in tears. 'Stay, Kate,' he said, 'keep just as you are – I will draw your portrait – for you have ever been an angel to me.' When he had finished this last drawing, he put it down beside him and began singing verses and hymns. 'My beloved, they are not mine,' he said, 'no – they are not mine.'[17] He had already compared death to 'a removing from one room to another',[18] and at the very end of his own life he told his wife that they would never be parted, that he would be with her always. At six on that Sunday evening, in August 1827, he expired 'like the sighing of a gentle breeze'.[19]

There will be some who discern enough pathos and sorrow in William Blake's life to justify calling it a tragedy. But that was not how it seemed to him at all, but rather one of vision embodied and art made alive. It is perhaps not inappropriate, therefore, to end this account of Blake the man with one of his finest unpublished descriptions – 'What it will be Questiond When the Sun rises do you not see a round Disk of fire somewhat like a Guinea O no no I see an Innumerable company of the Heavenly host crying Holy Holy Holy is the Lord God Almighty'.[20]

8 Keynes 1980, p.11.
9 BR.276.
10 David Bindman, *William Blake: Catalogue of the Collection in the Fitzwilliam Museum, Cambridge,* Cambridge 1970, p.59.
11 BR.242.
12 Sophie de Morgan, *Three Score Years and Ten,* London 1895, p.68.
13 BR.221.
14 Gilchrist 1863, p.359.
15 BR.232.
16 BR.249.
17 BR.502.
18 BR.337.
19 Ibid.
20 E.565–6.

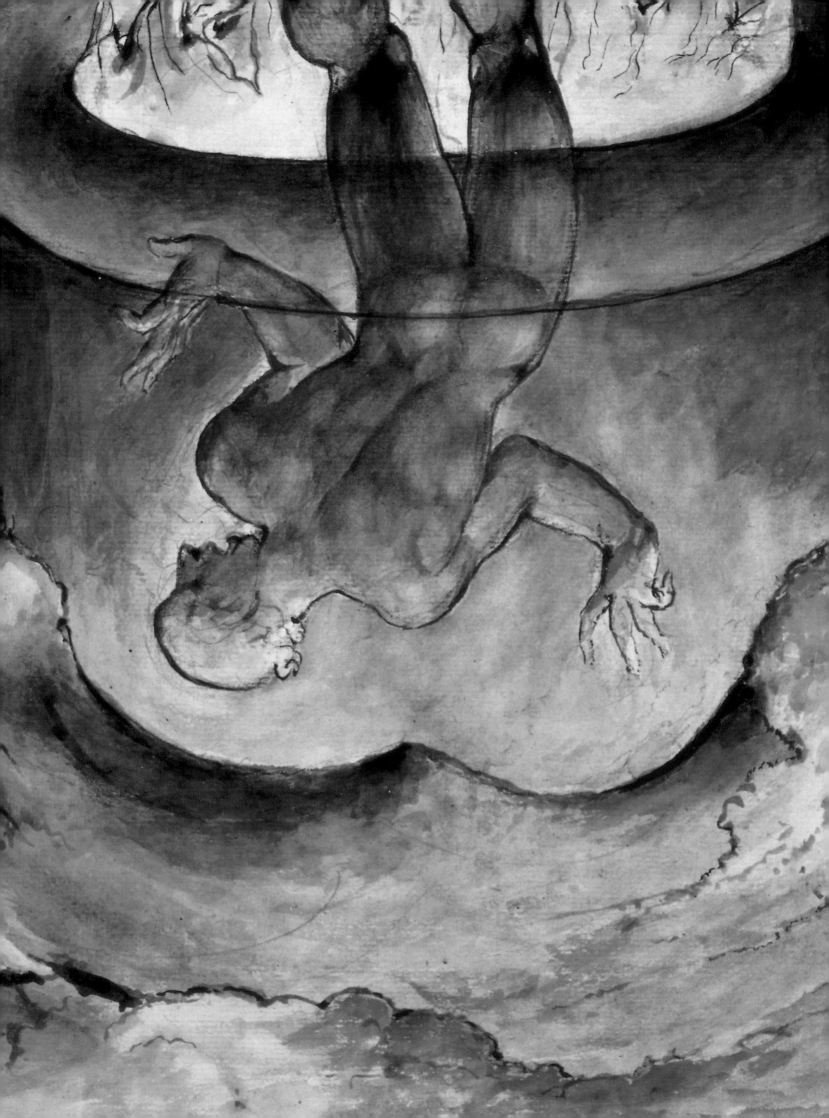

Blake in his Time
Marilyn Butler

William Blake (1757–1827) worked until just before his death at seventy, and published his first volume of poems (*Songs of Innocence*, 1789) unusually late, when he was thirty-two.

His dates have put him into the Romantic period, as if he were the contemporary of Wordsworth and Coleridge, authors of the *Lyrical Ballads* (1798), or of Byron, Shelley and Keats, the younger generation that Blake outlived. In practice Blake paid little or no attention to the famous poets, novelists and essayists publishing at the same time. The notion of the Romantic Blake has done him a disservice by making him too eccentric and too private, as though dwelling in a world of his own imagining. He has too easily been made a naive artist, perhaps a depressive. There is an alternative Blake: the purposeful craftsman-artist, whose themes could be better summarised as contending speculative ideas in an age of mental fight. In this guise he is the author of a virtual library matching the range of print culture in his day, with books in the highest, most sublime category – Bibles, prophesies, epics, allegories – at one end of the shelf, and children's songs, hymns and games at the other.

Blake's career began to take shape when in 1772, at fifteen, his father, a London hosier, apprenticed him to James Basire, an engraver specialising in fine-art antiquities. At about the same time Blake began writing poetry. Later he showed his poems to friends, the painter John Flaxman and the Revd A. S. Mathew, who paid to have them printed but not published in 1783 as *Poetical Sketches*. These poems belong quite naturally in the Elizabethan revival of the second and third quarters of the eighteenth century. The dramas copy Shakespeare's History plays, popular on stage from the 1730s for their content – wars against France. The poems echo Collins's imitations in the 1740s of the songs of Spenser and Shakespeare, Thomas Percy's ballad collection, *Reliques of English Poetry* (1765), and Thomas Chatterton's bravura construction, c.1768–70, of a 'lost' corpus of fifteenth-century songs and dramas, attributed to a priest named Thomas Rowley, and allegedly discovered in a chest in the church of St Mary Redcliffe, Bristol.

As part of Blake's training Basire sent him out to draw medieval monuments from Westminster Abbey and other old London churches, while in the workshop he learnt the techniques of engraving. This vocational education would normally have made him a skilled artisan. But he immersed himself voluntarily in early or very early art forms and in his writing, as in his drawing and engraving, tried out forms and styles appropriate to historical subjects. His earliest engraving, *Joseph of Arimathea* (1773), from a drawing or print after

Michelangelo, belongs to the grand primitive style or the sublime. Another commission of the same year, to engrave Stothard's illustrations for Joseph Ritson's *A Select Collection of English Songs*, uses thick lines for shading that give village scenes the look of woodcut. Blake's effects of simplicity or ancientness were achieved by attentive study of other artists or craftsmen, not taken from life. Sometimes his models were genuinely old, sometimes they were modern, and in the latter case some were eventually considered fakes.

For example, the long, regular, unrhyming lines Blake uses in many of his longer works recall the Old Testament, especially the Psalms and Isaiah, in the English King James version. His generation had a new understanding of the poetry of the Bible after Bishop Robert Lowth's Oxford lectures on the topic, delivered in Latin from 1754 and translated into English in 1787. Blake is more likely to have worked from the model of James Macpherson's free translations of primitive Gaelic poetry, such as the epic *Fingal* (1761), supposedly first delivered orally in the third century by the bard Ossian; stylistically Macpherson followed the Old Testament, as interpreted by Lowth. Blake admired Macpherson and other modern poets writing as primitives. Like them he preferred to create an imagined ancient world rather than pedantically copy or translate texts: 'I will not Reason & Compare: my business is to Create'.[1]

The dominant fashions of his day in literature and art were historical, as the word Romanticism implies. There is consistency as well as variety in Blake's work, its concern with what human beings have done and suffered in real time, Aristotle's definition of history. Among France's neighbours a romantic revival coincided with a gothic revival: broadly it looked back nostalgically to the Middle Ages, a period predating the seventeenth-century cultural ascendancy of France. But Blake's settings soon reached further, into yet remoter and darker ages – outer space, or eternity. For these a just-plausible architecture was becoming available by the late eighteenth century, the archaic buildings, pyramids and cave-temples of Hindu India, ancient Egypt and Mexico.

The few first-hand impressions we have of Blake the man do indeed bring out his eccentricity, sometimes termed madness. After 1800, as an artist and a thinker, he was increasingly often taken for a naive or an 'enthusiast', that is a religious crank.[2] In the 1820s he was admired by a religious group of painters; after his death, thanks to them, his name was cited, if at all, as that of a minor visionary. More ambitious claims on his behalf, by Yeats around 1900, again recruited him into a coterie, this time the revivers of arcane neoplatonic wisdom. Some scholars throughout the twentieth century

Opposite:
'The Simoniac Pope' 1824–7
(no. 82, detail)

1 *Jerusalem* (1820), pl.10, line 20; for Macpherson see BR.546.
2 Robert Hunt's review of Blake's *Exhibition of Paintings in Fresco, Poetical and Historical Inventions* (1809) in the Examiner described him as an 'unfortunate lunatic'; on visiting Blake in 1811, Robert Southey reported he had been shown 'a perfectly mad poem called Jerusalem'. Crabb Robinson, *Diary, 24 July 1811*; BR.229.

remained of the opinion that Blake must be approached as an essentially religious writer, on his own terms and using his language. On the other hand, when in the 1940s and 1950s Blake first received the treatment accorded a major artist, it was a historical scholar, David V. Erdman, whose *Prophet Against Empire* (1954) did most to make him accessible, by recognising the extent to which he was profoundly a man of his own time.[3]

Blake's so-called visions may sometimes be another artist's images, allegories or flights of the imagination. Stories of his odd behaviour read very differently, if, like other artists of the day, he deliberately cultivated a reputation for eccentricity. He must in his youth have conveyed the idea of a self-taught genius, or Mathew and Flaxman would not have paid to have his poems printed. To succeed, a writer from the lower orders had to present himself as ruggedly independent in character, preferably rough in style, certainly more visionary than he actually was. Robert Burns in his *Poems* (1786) wrote as a rustic, successfully prompting Henry Mackenzie to hail him as a 'heaven-taught plowman', though his smallholder father had provided him with a good education; in the next generation James Hogg adopted the identity of the 'Ettrick Shepherd'. Blake already knew at least one artist, James Barry, who fashioned himself as an angry man of genius. Even the ballad-collector Joseph Ritson, whose important *Collection of Historical Song and Ballad* Blake worked on as an engraver in 1783, attracted notice by becoming personally offensive about his gentlemanly predecessors and rivals.

To seem truly independent as an engraver or book-illustrator was near impossible. The publisher-bookseller was a demanding employer, and even established painters were often at the mercy of patrons. Writers had some advantages: they dealt with a large buoyant publishing industry and the market for books was expanding. Blake had analysed the situation and publicised what he was doing as craggy resistance to the dependent role of employee in an age when new technology could make craftsmen redundant, or reduce them to repetitive tasks or machine-minding. Already with *There is No Natural Religion* and *Songs of Innocence* he had experimentally performed all the tasks necessary to produce a book – writing, designing, illustrating, etching, printing, advertising and (when he could) selling. Blake's first *Prospectus* in October 1793 conveys fierce pleasure at declaring his independence. Previous artists, even Milton and Shakespeare, suffered, he says, because they neglected the means of getting the productions of their labours and genius to the public. He announces ten books ready for sale from his home in Lambeth.

But Blake also announced that this was a project to bring high art into the homes of ordinary people 'in a style more ornamental, uniform and grand than any before discovered'. He promised moreover to sell his books at a quarter of the cost of a conventional book of printed materials plus engravings. The price range, from 3s. for *Thel* to 10s. 6d., or 53p, for the big folio *America*, was extraordinarily cheap compared with the book prices of the day, then about 6s. a volume, but rising to 10s. in Scott's heyday after 1814, which could raise the price of a novel to 30s. or £2. In the event Blake had no adequate means of advertising, distributing and selling his works; he undersold his talents, labour and time. In or soon after 1795 he gave up printing his illuminated books until *Milton* (1810/11).[4]

Though the books soon failed commercially, so that for twenty-five years Blake could barely earn a living, they played a crucial role in enabling him to become and to remain productive. In the long run his illuminated books would be very valuable, commercially as well as intrinsically. The enterprise of 1793, hopeful, risky, pragmatic, followed on from his laborious but focused apprenticeship. This was not the behaviour of an enthusiast, for whom the message overrides the medium, still less of a madman out of touch with reality or other people. Picking out some of the illuminated books, I shall show how consistent he remains in his craftsmanlike selectiveness and attention to detail, and how current in his topics. He intended to be understood as well as grand, and he provided his public with many reference points of understanding, visual, printed, oral and local.

Blake appeals to different readers in different ways, and in some of his illuminated books he appeals cogently to Londoners. *Songs of Innocence* is a children's book of a most subtle kind: a nostalgic recollection of an urban childhood, of walking out to fields at the edges of London, of remembering the child-centred world of play and the images and metre of Isaac Watts's hymns. *Songs of Experience* (1794), a fully adult politicised sequel, reflects the intense intellectual activity of the contentious revolution years. Together the two books read best as opposites, neither a pair nor a simple succession, with the world of the child celebrated and preferred.

The sixth title listed in the *Prospectus* and priced at 7s. 6d., *The Marriage of Heaven and Hell* maintains the London theme and is perhaps the best introduction to Blake's illuminated books taken together, since in it Blake acts out his real-life role as a self-employed engraver and writer. He presents himself comfortably at home in 13 Hercules Buildings, Lambeth, rooms on an approach road to Westminster Bridge that also served

3 Milestones in building Blake's reputation as a poet, painter and thinker include Alexander Gilchrist, *Life of Blake*, 2 vols (London, 1863); W. B. Yeats, *Ideas of Good and Evil* (1903); S. Foster Damon, *Blake: His Philosophy and Symbols* (Boston and New York 1924) and *Blake Dictionary* (1965); G. L. Keynes, *Bibliography* (1921), expanded in Japanese by B. Jugaku (Tokyo, 1929), and Keynes's many editions and articles; N. Frye, *Fearful Symmetry: A Study of Blake* (1947); David V. Erdman, *Prophet Against Empire* (Princeton, 1954) and *Concordance* (1967), etc; G. E. Bentley Jr, *Blake Bibliography* (1964), etc.

4 For a short informative account of Blake's career see Jon Mee, 'Blake', in *An Oxford Companion to the Romantic Age*, ed. Iain McCalman (Oxford, 1999).

Blake and his wife and business partner Catherine as their workplace and shop. He first describes an intriguingly broad aim – 'the notion that man has a body distinct from his soul, is to be expunged' – and then the means, 'printing in the infernal method, by corrosives, which in Hell are salutary and medicinal, melting apparent surfaces away, and displaying the infinite which was hid'. It is, by common standards, a laborious dirty job, but not to Blake, who continues, 'If the doors of perception were cleansed every thing would appear to man as it is: infinite.'[5]

At this time Blake also felt at home in the busy printing house of the publisher Joseph Johnson, a gathering place for freethinkers from different backgrounds. Fellow print-workers often shared Blake's identification with the popular tradition of Dissent, with its political legacy from the 'Leveller' wing of seventeenth-century Puritanism, and its lasting millenarian tendencies, now fed by the French Revolution and an apocalyptic sense of *fin-de-siècle*. But Johnson was currently publishing many of the leading figures in middle-class 'rational Dissent'. Most of his writers openly sympathised with the French Revolution of 1789; after England went to war with France in February 1793, such attitudes became increasingly unpopular and, for notables such as Tom Paine, dangerous. By 1790 Johnson was Blake's regular employer, who hired him as an illustrator or more often an engraver for books such as Mary Wollstonecraft's *Original Stories from Real Life* (1791), Erasmus Darwin's *Botanic Garden* (1791) and John Stedman's *Narrative, of a Five Years' Expedition, against the Revolted Negroes of Surinam* (1796).[6]

In a mode of fellowship Blake in *The Marriage of Heaven and Hell* casts himself and his fellow-workers as the ink-blackened figures humorously known as printer's devils. By taking the term literally, he transforms Johnson's shop in St Paul's Churchyard into Hell, but has the so-called devils trade places with strict Christians or self-appointed Angels. The devils' thinking turns conventional hierarchies, such as Heaven above Hell, Soul above Body, upside down. Blake urges his readers to think 'by contraries' – antithetically – to value Hell as a productive, energising Chaos, and to try out the delights of disobedience.

Blake, acting himself, finds contemporary London a world full of mental activity, exhilarating to be in: 'I was walking among the fires of hell, delighted with the enjoyments of genius; which to Angels look like torment and insanity.' 'Infernal' mental activity finds expression as seventy aphorisms, the 'Proverbs of Hell', which largely replace the original Biblical Book of Proverbs

with concepts from the new natural sciences as practised in Paris – and introduced to English readers in the *Botanic Garden* by the early evolutionist and man of science, Erasmus Darwin. These Proverbs valorize power, excess, even the emerging idea of an evolutionary struggle, through their imagery of tigers, horses and overflowing fountains. We should not be bound by those laws of our fathers Edmund Burke invoked in his *Reflections on the Revolution in France* (1790). 'Drive your cart and your plow over the bones of the dead', says one new Proverb, and another: 'Sooner murder an infant in its cradle than nurse unacted desires.'[7]

The language, humour and religious cross-references of *The Marriage of Heaven and Hell*, for instance the use of Proverbs and 'Memorable Fancies', draw unabashedly on the London of popular religious enthusiasm. There is a running joke against a relatively new sect, the Swedenborgians, who on their arrival in mid-century London became notable for appearing to promote free love, but in 1790–1 revised their organisation and precepts so that in Blake's eyes they were now a conventional, respectable Church. Without these exuberant elements, and the eclectic mixture of style and forms, *The Marriage of Heaven and Hell* would not exist, but it is also more quietly an informal philosophical dialogue capturing the discussions of leading controversialists of the day.

The first of these is Constantin Volney (1757–1820), French count, member of the French National Assembly and author of *The Ruins, or a Survey of the Revolutions of Empire* (Paris, 1791; trans. J. Marshall, pub. J. Johnson, London, 1792), which was with Paine's *Age of Reason* the most popular and influential freethinking book in early nineteenth-century Britain. Volney argues that religion is a deception on the peoples of the world, giving power to the few; he denounces Moses as the original cunning usurper. Immediately Johnson's leading illustrator, Blake's friend Henry Fuseli, picked up the notion of the Egypt of the Book of Exodus as the scene for the expulsion of old gods. It is strikingly illustrated in Fuseli's plate for Darwin's *Botanic Garden*, 'The Fertilization of Egypt', which Blake engraved in 1791 (fig.1). Fuseli was a crucial mentor for Blake at this time, since he was a theorist who favoured ancient epic, the sublime, and allegory ('the sensible presentation of what cannot be seen with the naked eye'), placed the 'dramatic invention' even of a Shakespeare below epic, and considered copying from nature lower still. Fuseli had however elevated some scenes from Shakespeare (especially one from *Macbeth*) to epic status in his illustrations for Boydell's *Shakespeare Gallery*, and was now working for Johnson on a big illustrated edition of

5 *The Marriage of Heaven and Hell*, pl.14, lines 75–81.

6 Stedman's narrative contributed to the campaign to abolish the slave trade, assisted by Blake's engraving after Stedman, 'A Negro hung alive by the Ribs to a Gallows', dated 1792.

7 *The Marriage of Heaven and Hell*, pl.7, line 2; pl.10, line 7.

Milton, including of course *Paradise Lost*, the work that caused Blake to observe that Milton was 'of the Devil's party without knowing it'.[8] The third controversialist present in *The Marriage of Heaven and Hell* and other contemporary work by Blake was Tom Paine, not for his celebrated *Rights of Man* (1791–2) but for his attack on the morality and authenticity of the Old Testament in *The Age of Reason* (1794–5).

On plate 11 of *The Marriage of Heaven and Hell* Blake sets out what was by 1791 a fashionable radical position emanating in Revolutionary France, though the wording is Blake's own:

> The ancient Poets animated all sensible objects with Gods ... adorning them with the properties of woods, rivers, mountains ...
> Till a system was formed, which some took advantage of & enslav'd the vulgar by attempting to ... abstract the mental deities from their objects: thus began Priesthood ...
> And at length they pronounced that the Gods had orderd such things.
> Thus men forgot that All deities reside in the human breast.

Blake follows this with a scene making it easier for us to listen in to actual conversations. Of all the Old Testament prophets, he along with other radicals preferred Isaiah and Ezekiel. He introduces them as guests with himself at a London supper. Isaiah responds to questions like an urbane sceptic of the day. No, he has not really heard the voice of God; but 'the voice of honest indignation is the voice of God'. Ezekiel complains that the Jews' code has been imposed on other nations – 'and what greater subjection can be?'[9] If Old Testament prophets are covertly 'poets' of the popular school, a poet of that school now may in a suitably modified manner act as a prophet. A poet of any age may be, like Homer and Michelangelo, an Ur-Poet, if he has the imagination and invention.

Another scene gives something of Blake as a thinker in his own right. He casts his fictional persona as the Devil's spokesman in a debate with the Angel of orthodoxy, who instead of appearing as an Anglican is mischievously made a Swedenborgian. The rules seem to be that each contestant is to imagine a world based on the ideology of the other. First the conservative Angel projects Blake's revolutionary optimism as a hideous parody of real-world turmoil, a scene in space where spiders crawl on fiery tracks, and from an abyss a monstrous serpent erupts, with a head like Leviathan, though the forehead has a tiger's stripes. The Angel's

devourer may have been suggested by the bloodthirsty language of the French Revolution from 1789, and by a famous remark in the Convention of 1793 that, like Saturn, the Revolution had begun to devour its own children.[10] Or, since the Leviathan is tiger-headed and comes from the East, he could evoke the defiant Indian prince Tipu, Sultan of Mysore, whose emblem was the tiger and whose wars with the East India Company came to an uneasy peace in 1791.[11]

When it is Blake's turn to travesty his opponent's world-view, he imagines a universe of monkeys, chained, yet inclined as they grow more numerous to gobble one another up. Blake takes literally the terminology of physiocrats and political economists such as A. R. J. Turgot and Adam Smith. He envisages a society divided into two classes, the Prolific and the Devouring, synonyms for the productive classes (mainly labouring) and the consuming classes (mainly the rich), those who labour and those who profit from labour. These caricatures of revolutionary democracy and market-force economics assume the pictorial qualities of current cartoonists such as James Gillray in order to convey ideological issues sharply to the people.

The notions Blake heard debated in Johnson's shop during the French-Revolutionary years become leading themes of his prolific Prophecies of 1793–5. Two undoubted epics, *America* (1793) and *Europe* (1794), introduce a hero, Orc, the youthful Apollo-like activist in Blake's imaginative retellings of the two recent

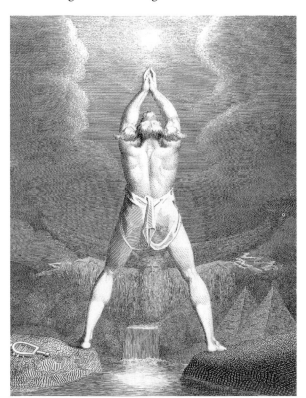

8 *The Marriage of Heaven and Hell*, pl.6, line 13.
9 *The Marriage of Heaven and Hell*, pls.12–13.
10 Mob violence during and after the Fall of the Bastille in 1789 was already described in the Paris press as 'monstrous'; cf. the prophecy of Pierre Vergniaud in the Convention, 13 March 1793, that 'the Revolution, like Saturn, successively devouring its children, will engender only despotism'.
11 Tipu Sahib (1753–99), sultan of Mysore, fought a succession of wars against the British from 1775 until his death during the storming of his fortress, Seringapatam, in 1799.

Fig. 1: William Blake after Henry Fuseli 'The Fertilization of Egypt' Engraving 19.4×15.2 (7⅝×6) from Erasmus Darwin, The Botanic Garden vol. 1 (1791)

revolutions. A sequel, *The Song of Los* (1795), describes revolutions still to come in its two parts, named 'Africa' and 'Asia'. Another trilogy consisting of *The First Book of Urizen* (1794), *The Book of Ahania* (1795) and *The Book of Los* (1795) seems more preoccupied with what Blake later, in the short poem or hymn known as 'Jerusalem', called 'mental fight' – with the Bible, its use to control minds and its relations with other Middle Eastern religious traditions. *The Song of Los* is strongly linked to this second trilogy, for it introduces Los, Blake's favourite protagonist and alter ego, who resembles both a sun-god (as the name Sol suggests) and the strong, tireless artificer Blake. The first plate of *The Song of Los* shows a worshipper kneeling in front of an image of the sun, representing natural religion, which is largely obscured by the dark clouds of mystifying Mosaic religion; on the eighth and last plate the sun returns cleared of its dark encumbrances by Los's son, Orc.

Of the cluster of 'Prophecies' Blake executed between 1793 and 1795, *The First Book of Urizen* is the most focused and impressive. As the title indicates, it is a sceptical reworking of the Pentateuch, the five early books of the Bible attributed traditionally to Moses. The opening plates show a very old man, more hunched and feeble than most of Blake's unpleasant father figures, writing his book or gouging out a tablet of stone. The opening lines parody the invocation of Milton's *Paradise Lost*: Blake's topic is not the story of man's disobedience but that of 'the primeval priest's assumed power'. Moses-like, Urizen tells how the world was made from Chaos, emphasising fixity rather than flux, the limiting, enslavement and rule of the self as well as of others. His name incorporates the word 'Reason', often for Blake a narrow system of mental self-restraint. War against Urizen's assumption of power breaks out in a Heaven peopled with 'Eternals', shadowy figures who appoint Los as their champion in a mighty conflict with Urizen – the war in heaven of Genesis and the central books of *Paradise Lost*.

Leaving the Old Testament, the plates of the middle part of the book vividly introduce other religions' myths of the primal scene, including Plato's account of man as originally a hermaphrodite, now forever seeking reunion with his female Other. Los and Urizen form such a union, but break apart again. In a 'Fall' alternative to that of Genesis and *Paradise Lost* a bound god wreathed with serpents and two companions is hurled head-down from Heaven, with the god's arms flung out to resemble the iconography of the Crucifixion (fig.2). This plate (no.6(7)), based on an ancient-world representation of Orpheus, musician and god, boldly associates a pagan sacrificial deity with Jesus, who was crucified with two

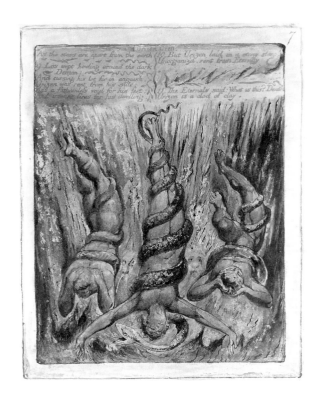

Fig. 2: 'The First Book of Urizen' 1794 Plate 6 (7), Copy G Relief etching colour printed and finished with pen, ink and watercolour The Lessing J. Rosenwald Collection, Library of Congress

thieves. It hints at further resemblances in the two traditions' myths of resurrection and rebirth. Blake shows more than a passing interest in fashionable syncretism, linking religions together; he has a knowledge of iconography and of current antiquarian books.

Blake's paganism can be violent and its outcomes unjust. Los endures parturition and gives birth to a daughter, Enitharmon. Later he rapes her, with the result that Orc is born and a new cycle of violence begins between father and son. Mythology richly reports family strife, by its tales of child abuse among the gods or of conflict between man and wife, father and son. Blake seizes the opportunity such stories give to depict with new intensity the bloody tortured bodies of his suffering protagonists, especially the violence and pain of birth, in a manner reminiscent of anatomical drawings of his day. The association gives his figures enhanced power and frightfulness in keeping with Fuseli's values. But it also suggests a further source, back in print in the 1790s, that helps sustain much of Blake's later work: the doctor David Hartley's *Observations on Man*, a highly influential study of the inter-connectedness of the body (physiology) with the mind (psychology), though to Blake equally interesting for its final section on the individual's relations with others and with God.[12]

Meanwhile, in *The First Book of Urizen* the cries of the chained Orc eventually wake Urizen, Los's enemy; his return ensures that human history, in its fallen and tragic biblical version, can begin. For all their range of reference

12 David Hartley (1705–57) was the author of *Observations on Man, his Frame, his Duties and his Expectations* (London, 1749), a work incorporating psychology, physiology and a mystical inward strand of Christianity. For the next generations' liberals and radicals, well into the nineteenth century, Hartley classically established the interactiveness of mind and body, thanks largely to Joseph Priestley's selective abridgement as *Hartley's Theory of the Human Mind, on the principle of the association of ideas* (1774–5). Blake, unusually, knew the more spiritual original version: he engraved the portrait of Hartley for a new edition of the complete *Observations* issued by the author's son (1791). For a persuasive examination of Blake's closeness to the original Hartley, see Richard C. Allen, *Hartley on Human Nature* (Albany, 1999) pp.23–4, 324–5 and especially 355.

and visual impact, reinforced by a new technique of putting oil-paint directly on to the plate, Blake's 'Bibles of Hell' with their deconstructive message have seemed at best strange and at worst repellant. The harsh tone and the violence were characteristic of revolutionary rhetoric and of popular radical religion. The Anglican clergyman George Stanley Faber still thought it necessary in his Bampton Lectures of 1801 to defend the Books of Moses against the assaults of the 1790s:

> The Books of Moses constitute a part of divine Revelation, against which Infidelity has of late years directed her principal attack. They have been studiously represented as little better, than a collection of popular traditions built upon … the legendary tales of classical antiquity … The language of profane ridicule [is] sedulously adopted … and while the bowels of the earth are ransacked, to convince the literary world of the erroneousness of the Mosaical chronology, history and travels, satire and tragedy, nay even romances and novels, are employed to disseminate the poison among other classes of readers.[13]

Faber may not have known of Blake, but his sketch of 1790s travesties of the Old Testament and of their intended readership applies equally well to *The Marriage of Heaven and Hell*, the Urizen group of Prophetic Books, and the large coloured prints of 1795 on archetypal despots – 'God Judging Adam', 'Nebuchadnezzar' and, more marginally, the genius of eighteenth-century reason, 'Newton'.

After 1800 Blake turned, as did many contemporaries, to the topic of Britishness, its continuities, imagined identity and historical divisions. The protagonist of a new large work, 'Vala', begun in 1799 but never completed, was the giant Urthona, who represented mankind as a whole. Borrowing that comprehensive notion in about 1803 for a new nationalist long poem, *Jerusalem*, Blake chose to call his British giant and hero Albion, the Roman name for Celtic Britain. In what over twenty years grew into Blake's largest work Albion personifies the entire people, history and topography of the British Isles, from the mountains of the Celtic west to London's Kentish Town, including minute plant and insect life in and under the soil. This was an imaginative realisation of sophisticated seventeenth- and eighteenth-century scholarship, much of it Continental, that understood scripture as a composite work, the product of many hands, hospitable to many forms – prophecy, war, literary squabbles, bloodthirsty murders, grand invocations, ballad-like hymns, gazetteer-like lists of towns and mountains. It

encompassed previous imaginative histories of Britain, Macpherson's, Chatterton's and Gray's: a descriptive and narrative feat, a panorama of the nation, its metropolis and the 'vegetative world'.

The period of gestation of *Jerusalem* and a second British poem, *Milton*, which soon separated from it, coincided with the appearance in stages of a new work of British history, in the form of a three-volume scholarly collection. The *Archaiology of Wales* (London, 1801–7) anthologised Welsh poetry and prose written before 1200. The terminal date is a reminder that the Anglo-Norman Edward I completed the destruction of the last Welsh princely court in 1282. From 1789 the new collection's editors, William Owen Pughe and Edward Williams, had worked together on the early Welsh-language cultural legacy, and in two poetic publications, the *Heroic Elegies of Llywarc Hen* (1792) and Edward Williams's *Poems, Lyric and Pastoral*, 2 vols. (1794), they set out to give the Welsh, specifically, a national consciousness. Cultural nationalism strengthened at the same time in Scotland and Ireland, in the latter case accompanied in 1798 by violent rebellion and followed in 1800–1801 by a forced-through parliamentary Union of Ireland with the rest of Britain.

In *Jerusalem* Albion has two allegorical female 'emanations', one named Jerusalem, the other Erin. Blake had long since learnt from Macpherson, on the authority of Lowth, that the Bible's mourning women speak for a defeated people, such as the Jews after the fall of Jerusalem to Nebuchednezzar's Assyrians. Blake declares openly in *Jerusalem* that he is merging the Hebrew Bible, the historical chronicle of the Jews, with the equally ancient story of the British. Through the figure of Erin he less directly indicates that his narrative concerns itself with the defeats, by Anglo-Saxons from the sixth century and Anglo-Normans from the twelfth century, of two of the Celtic native peoples of Britain, the Welsh and Irish. Their ancient culture and their dispossession were the founding themes of the bardic system of the Welsh nationalist historians, and thanks to the publications funded and written by the London Welsh they became for Blake a classic example of human cruelty and the love of domination.

The key Celticist for Blake was probably Edward Williams (1746–1826), poet, unitarian and stonemason, better known by his bardic name of Iolo Morganwg. He first assisted Owen Pughe with an edition of the fifteenth-century poet Dafydd ap Gwilym (1789); some of Dafydd's poems in this volume were found in the twentieth century to have been written by Iolo himself. Bardism too in its 1790s form seems to have been largely his creation. Its leading features according to Iolo

13 G. S. Faber, 'Preface', *Horae Mosaicae*, Bampton Lectures (1801), pp. vii–viii.

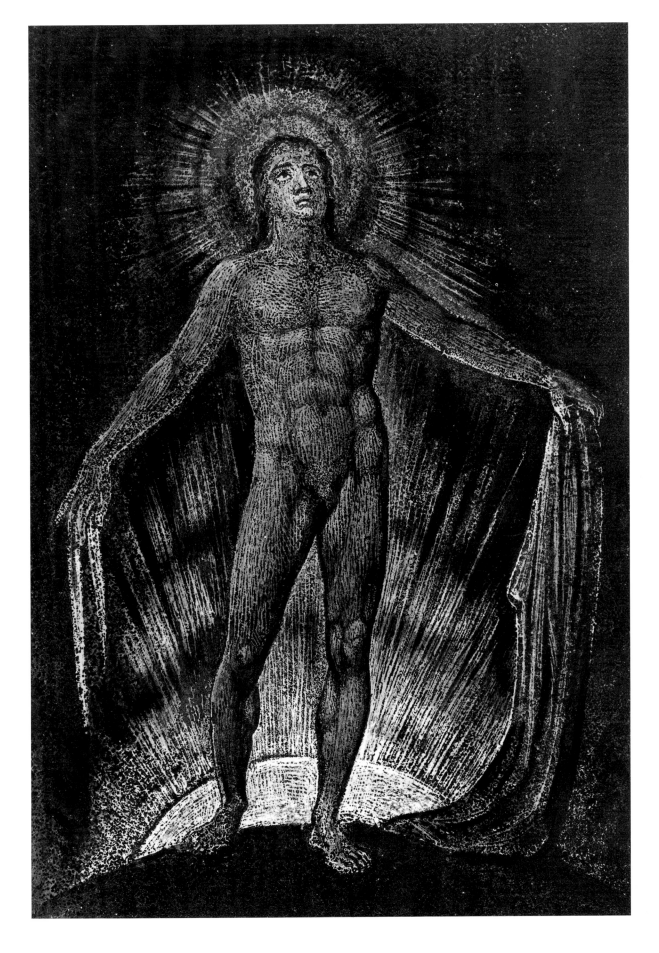

include pacificism, with roots going back to the age of the Hebrew Patriarchs; a strong oral culture, committed to popular memory; a natural religion, its rites conducted in the open air; and an ancient tradition of transubstantiation, also known as metempsychosis, or the migration of souls.[14]

Blake knew something of Druidism in the mid-1780s. By the early 1800s he knew the *Archaiology of Wales*; in time, it is not clear when, he became personally acquainted with Owen Pughe and Iolo. One of the Triads or aphorisms collected in the *Archaiology* was the source of Blake's painting, 'The Ancient Britons', commissioned by Owen Pughe himself and exhibited at Blake's exhibition in 1809. The minor writer Crabb Robinson recorded that Blake told him, 'I have conversed with the – Spiritual Sun – I saw him on Primrose-hill'.[15] Blake appears to have been alluding here to a public meeting at the autumn equinox, 22 September 1792, when Iolo as self-appointed Chief Bard officiated at a Gorsedd, or meeting, on London's Primrose Hill, as he had done at the previous summer solstice, thus reviving Druidic ceremonies in honour of the sun.[16]

Blake may indeed have been present at one of three Gorsedds in 1792–3, but a written source was also available: Iolo published in full his unwieldy Address on the occasion, and the formal Ode that he gave at all three meetings, as an Appendix to his own English *Poems, Lyric and Pastoral* (1794), a book distributed by Joseph Johnson.[17]

The Address and the Ode, taken together, constitute Iolo's fullest direct account of ancient Bardism, and also give away his relatively matter-of-fact attitude to it. Ambitiously made up of fourteen Petrarchan sonnets, the Ode prosily imitates one of the most famous of supposedly ancient Welsh poems: the 'Hanes Taliesin', or 'Life of Taliesin', in which a sixth-century poet (whose existence and oeuvre have been doubted) mystically recounts his many previous lives from the beginning of the world.[18] Iolo is after a fashion identifying himself with this strangest and darkest of predecessors, yet he also refers to previous lives as, among other things, a tyrant, a Druid and a sheep. His narration rattles through 2,000 years and a variety of experiences, playing down mysticism or enthusiasm, summarising a popular history based on the wrongs done by the rich and powerful – most recently the French monarchy and English slave traders. The modern angle of vision is in keeping with his treatment elsewhere of the apparently sensational matter of the return of the undead, for example in the Preface to his and Owen Pughe's *Llywarc Hen* (1792). Instead of eliciting terror, as in contemporary Gothic ballads, tales and novels, Iolo demystifies these

spectres into 'Friends of Humanity', a term contemporary liberals used of themselves, benign souls who return to life as 'a blessing to the world'.

Blake knew other Celtic scholarship and writing – by the Anglican clerics Jacob Bryant and Edmund Davies, who disapproved of the nationalists, and by Thomas Gray, author of *The Bard*, a poem about Edward I's massacre of the last Welsh court poets. He mentions all these but not the nationalist Iolo by name. Even so, Blake's debt to the British revival is fundamental, for *Milton* and *Jerusalem* owe their unique atmosphere and strange plot lines to the presence in them of the dead, especially Iolo's model Taliesin, Britain's Dark Age Ur-Poet.

Of Blake's two late poems, *Milton* (written 1803–4, published 1810–11) is the more lyrical and accessible, because here the poet again casts himself and tells a personal story. In the garden of a cottage the poet William Hayley rented for him at Felpham in Sussex Blake had what he described to friends as 'visions', which became the inspiration for *Milton*, the shorter poem on a British theme (fig.3). The story tells how in the garden Blake himself encounters his poetic alter ego, Los, 'a terrible flaming Sun', who, Christ-like, does up his sandals and kisses him, 'And I became One Man with him arising in my strength' (plate 20). For 'Blake' in the poem it is a religious experience, and Los takes on divine attributes, through iconography that is both pagan and Christian. Then also on plate 20(22) Los speaks in the idiom of Taliesin when he describes his past lives in the mysterious poem given pride of place in the *Archaiology* in 1801:

> 'I am that Shadowy Prophet who Six Thousand Years ago
> Fell from my station in the Eternal bosom. Six Thousand Years
> Are finishd. I return! both Time & Space obey my will.
> I in Six Thousand Years walk up and down: for not one Moment
> Of Time is lost, nor one Event of Space unpermanent,
> But all remain … tho' on the Earth where Satan Fell, and was cut off all things vanish & are seen no more
> They vanish not from me & mine, we guard them first & last'[19]

Blake's language and his metre is grander than Taliesin's; and in an age of discovery for astronomy, geology and palaeontology his 'not one Moment is lost' hints at a new

14 For the first Celticist discussion of the migrating soul, see 'Preface', W. Owen Pughe [and E. Williams] (eds.), *Llywarc Hen: Heroic Elegies* (London, 1792), pp.xxix–xxxi; for Bardism as an enlightened religion and system for spreading 'liberty, peace and happiness', see p.xxiv; for the ancient link with the Hebrew Patriarchs, pp.xxv, xxviii; for meetings 'in the eye of the light and the face of the sun', p.xxvii.

15 Crabb Robinson, *Diary*, 10 Dec. 1825; BR.313–14.

16 Four bards officiated, including William Owen 'of the oration and primitive orders' and Edward Williams 'of the primitive and Druidic orders'. The Gorsedd (or meeting) was reported in the *Gentleman's Magazine* 62 (Oct. 1792), p.956, and the *Monthly Register* 3 (Jan. 1793), pp.16–19. See Dena Taylor, 'A Note on Blake and the Druids of Primrose Hill', *Blake: An Illustrated Quarterly* (Winter, 1983–4), pp.104–5.

17 The Appendix or 'Advertisement' includes thirty 'Aphorisms of Druidic Theology', beginning with metempsychosis: Edward Williams, *Poems, Lyric and Pastoral*, 1794, II, pp.193–217.

perspective into deep time.

In the second half of the poem (plates 40(39)–44(45)) the narrator 'Blake' meets John Milton, England's national poet. Milton must present a problem under Iolo's bardic rules because of the evil he did when, in his seventeenth-century life, he was a politician and warmonger. Blake seems to refer to Iolo's account of the circumstances in which a soul returns, but specifically corrects Iolo's use of one word, annihilation. Iolo refers to God 'annihilating' Evil (*Poems*, 11.197) but to the 'absolute annihilation' or death of an individual as abhorrent to God (11.198). 'Blake' however makes voluntary self-annihilation the condition of Milton's return to life, won only after a hard struggle with Satan: 'Know thou, I come to self-annihilation. / Such are the Laws of Eternity that each shall mutually / Annihilate himself for others good'.[20] A gentle, regenerate Milton appears walking down a garden path now of 'solid fire, as bright / As the clear Sun'. Los, Milton and Blake's brother Robert, who worked with William on Druid subjects shortly before his death in 1787, all return to life in the garden in order to merge their identity with William Blake's. In *Milton*, then, Blake borrows the doctrine of transubstantiation, as found in Iolo's writings of 1792–4 and made topical from 1801, accepts in principle its mildness and imaginatively embodies it in scenes flooded with sunlight, the naked figures austere and calm. They owe their nobility to the presence in Blake's universe, but not Iolo's, of deep suffering, wrongdoing and cruelty, without which Milton would not return movingly and in a state of grace.

A perceptive contemporary able to compare Blake's use of metamorphosis with Iolo's would have seen not just the poetic added value in Blake but cogent meaning, detached from some of Iolo's purposes but sympathetic to others. In Blake, too, a mixed Welsh/English poetic tradition has continuing life, and in any age it might renew itself in the creative imagination of an individual poet. But the powerful theme of the merging of one identity with another is only broached in *Milton*; in *Jerusalem* it is developed into an allegory still more sublime and spiritual.

Throughout his work Blake states that the body cannot be separated from the mind or soul, or the human from the divine; but *Jerusalem* is the fullest exploration of this holistic position – for which, as usual, Blake gives intelligible points of reference. Blake's reading and acquaintances were liberal and current: in the 1790s he took in the rapidly developing natural sciences, by then holistic: body and mind were described as an 'organisation', meaning what is now called an organism or a system. Plants, animals and humans depended on

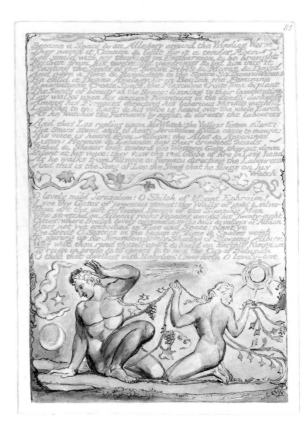

Fig. 4: 'Jerusalem. The Emanation of the Giant Albion' 1804–27 Plate 85, Copy E Relief etching finished with additions in watercolour, pen and ink and gold and silver approx. 22 × 16 (8⅝ × 6 ¼) The Paul Mellon Collection, Yale Center for British Art

their natural environment; the nervous system's responses to stimuli prompted the largely involuntary 'choices' of a mind (or brain). One of the best-argued general overviews of the holistic human being occurred in the first volume of David Hartley's *Observations on Man, his Frame, his Duties, his Expectations* (1749). Perhaps because of its length and coverage it did not reach a wide public until Priestley's abridged version of vol. I, largely concerned with physiology and neurology, in 1774–5. Priestley claimed in his Preface that he did not disapprove of vol. II, which went on to reflect on the developmental psychology of individuals, the extent to which they actually enjoyed freewill, and above all the conflict between self-gratification and ambition on the one hand, and social and religious duties on the other. He considered, however, that the religious section did not belong in a ground-breaking work on natural physiology, neuroscience and psychology.

Blake as a young man knew something of physiology: the nervous system and the veins, for example, and their representation. In his brief period of study at the Royal Academy he attended the classes on the human body of the distinguished anatomist William Hunter, and his drawing of the body is visibly indebted throughout to eighteenth-century anatomical drawing, by Cowper and Whytt as well as Hunter. This convention is not realistic in terms of what the eye sees: usually it indicates the

18 Thomas Love Peacock, another keen student of Welsh, ironically summarised this poem on 'the Druidical doctrine of transmigration ... Taliesin had been with the cherubim at the fall of Lucifer, in Paradise at the fall of man ... in the ark with Noah and in the Milky Way with Tetragrammaton' (Misfortunes of Elphin, 1828, ch. vi). The full text appeared in Welsh first among Taliesin's poems in the Archaiology of Wales, I (1801), p.19; cf. Pughe and Williams, Llywarc Hen, p.xxxin.

19 *Milton*, pl.20(22), lines 15–23.

20 Milton, pl.39(38), lines 34–6. In discussing the Soul and its advancement (Llywarc Hen, pp.xxix–xxxi), Iolo uses the relatively unusual words annihilation, Eternity, and turpitude, all repeated by Blake in Milton's speech of self-denial before his return to life as Blake (II, 29–49). Cf. Williams, *Poems* (1794), Aphorisms 1, 3, 5, 8, 10, 12, 14, 23 (II, 195–201), and Pughe and Williams, *Llywarc Hen*, p.xxx.

veins and nerves under the skin. Even in his youth Blake often mimicked this style, but the body's interior becomes greatly accentuated in *Jerusalem*, where blood pulses through Albion's veins, and fibres representing the nerve-system not only come to view but merge with the tendrils of plants to suggest the oneness of life (fig.4). This way of representing the body is 'literalised' in the passage in which Los travels through the passages of the sleeping Albion.[21] The sick or pain-racked body of Albion conflicts with the healthy colour and decoration of the naked primal Celts, painted with representations of their objects of worship such as the sun and stars.

Blake is responding with a new intricacy and self-consciousness to Hartley on the body, but the version of Hartley that Blake knew was the complete one he worked on as an engraver in 1791, which went on to consider human development beyond selfhood, in search of ethical, social and religious goals. Like all great Blakean protagonists, including Urizen, the earlier Los and Urthona, Albion and the British people he represents are hopelessly torn and incomplete. Albion's 'divisions' include the male Luvah and the females Jerusalem, Erin, Enitharmon and Vala. This is an allegorical presentation of inward conflict and destructive personal relationships, on the private and domestic as well as the national scene. In Hartley's more simply stated view individuals pursued goals, such as ambition and the pleasures of the senses, that were unlikely to make them happy. In their maturity they needed to become more disinterested: sympathy for others, in the form of family love, fraternity, a civic sense, directs us to the most exalted motive, an underlying idealism he terms the 'love of God'. In the words of Hartley's Proposition 71: 'The love of God regulates, improves and perfects the other Parts of our Nature … it is therefore our primary Pursuit, and ultimate End.' Hartley's term for this 'End', identifiable as Hartleyan by any of his readers, is 'Self-annihilation'.[22]

In *Jerusalem* Blake handles more abstractly the central metaphor of *Milton*, metempsychosis, so that it stands for love of the two kinds Hartley urges, human or social fellow-feeling and the love of God. Los epitomises the first of these, for he brings together in harmony the misceginated peoples of the islands: 'What do I see? The Briton Saxon Roman Norman amalgamating / In my Furnaces into One Nation, the English.'[23] His friendship with Albion echoes friendships in the Bible – 'Los was the friend of Albion who most lov'd him,'[24] but reaches a new level of self-sacrifice when he tries to help the sick Albion by undergoing a strange subterranean journey, 'walking among / Albions rocks & precipices!: caves of solitude & dark despair'.[25] This entry into a suffering friend's body,

mind and experience is an act of sympathy and fellow-feeling if Albion's humanness is emphasised, but it seems more like self-annihilation as Albion gradually comes to stand for Christ.[26] Whereas in *Milton* he was the Eternal Bard, in *Jerusalem* Los has a more complex identity as Bard, Builder, Eternal Prophet and Saviour.

Hartley's strain of mysticism must have been suspect to the Dissenter Priestley, for Richard C. Allen shows how it links Hartley to groupings of enlightened Catholics – Archbishop Fénelon (1651–1715) and his mentor the mystic Mme Guyon (1648–1717) in France, and a likeminded quietist group with Jacobite sympathies, including William Law, Isaac Watts, the poet John Byrom and the surgeon George Cheyne in England. The emotion in Hartley's section on the love of God was likely to remind rationalist readers of 'enthusiasm', or popular religion. Blake's reputation as a madman derives largely from his espousal in *Jerusalem* of this fervent strand, as in the British-Hebraist opening to the second chapter (plate 27), entitled 'To the Jews'. 'Was Britain the primitive seat of the patriarchal religion? It is true, and cannot be controverted. Ye are united, O ye inhabitants of earth, in one religion, the religion of Jesus – the most ancient, the eternal, and the everlasting gospel.' But, as a Biblical miscellany, *Jerusalem* does not stay long in one vein. Blake at once turns into a different register, the more impersonal metre and medium of ballad, and at the same time remembers the pleasures of his own childhood:

> The fields from Islington to Marybone,
> To Primrose Hill and St Johns Wood
> Were builded over with pillars of gold,
> And there Jerusalems pillars stood.

As the ballad continues, the experience on which it draws is mature but also generalised, the cycle of human history as the Bible tells it, at its nadir in Babylon and homeliest 'in mournful ever-weeping Paddington':

> Where Albion slept beneath the Fatal Tree
> And the Druid's golden knife
> Rioted in human gore,
> In Offerings of Human Life.

Like Iolo in his *Ode After Taliesin* and like Albion, Blake in his own person endures or inflicts the sufferings of Britain, Israel, Europe and Asia. Adopting the first person, he acknowledges that he, as part of mankind, has been cruel: 'I have reclaimd thee as my own, / My selfhood, Satan, armed in gold.' But he also identifies himself with 'the human form divine', and with Jesus who took that form:

21 *Jerusalem*, pl.45, lines 5–6.
22 Hartley, *Observations* (1791), II, 309.
23 *Jerusalem*, pl.92, lines 1–2.
24 *Jerusalem*, pl.35, line 12.
25 *Jerusalem*, pl.45, lines 5–6.
26 At the centre of the poem, Luvah, one of the divisions of Albion, undergoes the Crucifixion in Britain as Jesus did in Canaan: 'They cast lots into the helmet: they give the oath of blood in Lambeth / They vote the death of Luvah & they naild him to Albions Tree in Bath' (plate 65, lines 7–8).

And thine the Human Face & thine
The Human Hands & Feet & Breath,
Entering thro' the Gates of Birth,
And passing thro' the Gates of Death.

This gem-like poem familiarly echoes the epic narrative in which it is placed, the life of the individual writer participating in the story of the British and of humanity.

It is Los who says, 'I must Create a System, or be enslav'd by another Mans.'[27] Blake in *Jerusalem* frankly borrowed systems from others as he had done all along. Iolo presented Bardism as true history if not official history, and Blake either accepted this or wrote as if he did. He subtitles his 1809 exhibition, 'Poetical and Historical Inventions', and spells out aims for 'The Ancient Britons' that could hold for *Milton* and *Jerusalem*: 'Believing with Milton the ancient British History, Mr B[lake] has done as all the ancients did … given the historical fact in its poetical vigour so as it always happens, and not in that dull way that some Historians pretend.'[28] Equally, he chose a 'Theory of Mind', or account of psychological development, found in Hartley, tactically modified by Priestley but current again in the early 1800s, for its 'indissoluble union between physiology, metaphysics and Christianity'.[29] In essence Blake was again writing the truth, in a known if not definitive version, and by poetic invention and intensity making it live. His artistry as well as his craft emerges triumphant in two poems which have related but not identical themes about human beings and their transforming powers of perception.

Blake acquired new admirers during 1820, including a group of middle-class painters known as 'the Ancients'. He was introduced into a Hampstead circle, largely of artists gathered together by a Mr and Mrs Charles Aders, where his own contributions were described as quiet and polite, even when he was being plagued by scalp-hunters hoping to hear mad utterances or by patronising men of the art world. The painter Collins taunted him by saying 'very rude things such as people of the world … will indulge in towards "enthusiasts"'.[30] Meanwhile, the vogue for memorable sayings created a market in Blakisms, most of them probably spurious, or at best an obliging performance on Blake's part. The literary men who had known Blake for some time, Crabb Robinson and Southey, had by now fixed opinions of his eccentricity, fuelled by *Jerusalem*, as in Robinson's diary entry of 17 December 1825: 'I fear I shall not make any progress in ascertaining his opinions or feelings … their [*sic*] being really no system or connection in his mind at all, his future conversation will be but varieties of wildness and incongruity.'[31] But this conflicts with the middle-aged Samuel Palmer's recollection of an evening he spent in Blake's house, where the old man showed him his Italian sixteenth-century prints. 'In conversation he was anything but sectarian or exclusive, finding sources of delight throughout the whole range of art; while, as a critic, he was judicious and discriminating.'[32]

His most useful friend in the last decade, the painter John Linnell, was an admirer of the style of Dürer and Michelangelo, and thus far a man after Blake's heart. Linnell found Blake the commissions for his grand *Illustrations of the Book of Job* and of Dante's *Divine Comedy*, and the rustic woodcuts to Virgil's *Eclogues*. Blake in his lifetime was best known for his illustrations or designs for new editions of other poets or individual poems, such as Edward Young's *Night Thoughts* (1797) and Robert Blair's *The Grave* (1806). The act of illustrating another artist, sharing with him the representation of lives first imagined in other times, was appropriately social, co-operative and human-centred. At the same time, by drawing on his audience's religious feelings and cultural memories through allegory or allusion, Blake achieves the larger aim of his later years, the sensible presentation of what cannot be seen by the naked eye.

27 Ibid, pl.10, 20.
28 Blake, *Descriptive Catalogue*, no. V, *Blake's Complete Writings*, ed. Geoffrey Keynes (London 1966), p 578.
29 Benjamin Rush to Thomas Jefferson, 2 January 1811, cited Richard C. Allen, *David Hartley on Human Nature* (New York 1999), p.1.
30 Quoted by Gilchrist, the original source probably Samuel Palmer, BR.306–7.
31 BR.315.32.
32 S. Palmer to A. Gilchrist, 23 August 1855; *The Letters of William Blake*, ed. G. Keynes, 3rd ed, 1980, p.175.

Chronology

1757
- Born on 28 November, the second son of James and Catherine Blake, at 28 Broad Street, Golden Square, Soho, London. James was a 'moderately prosperous hosier' (Gilchrist 1863, I, p.5). Baptised in St James's Church, Piccadilly, 11 December.

1762
- 25 April: Catherine Butcher (Boucher), later William's wife, born.

1767
- 4 August: probable birth date of Blake's favourite brother, Robert.

1767–8
- According to Benjamin Heath Malkin, entered Henry Pars's drawing school, 101 Strand, at the age of ten. Perhaps around the late 1760s he had his first vision, while walking across Peckham Rye near London, when he saw 'a tree filled with angels, bright angelic wings bespangling every bough like stars' (Gilchrist 1863, I, p.7).

1769–70
- At the age of twelve began writing the poems included in *Poetical Sketches* (printed 1783) (no.17).

1772
- Apprenticed on 4 August to the engraver, James Basire (1730–1802) of Great Queen Street, Lincoln's Inn Fields, for a period of seven years.

1774
- Sent out by Basire to make drawings from old buildings and monuments, in particular Westminster Abbey (nos.5–15).

1775
- Dated drawings of monuments in Westminster Abbey attributed to Blake.
- The American War of Independence begins.

1779
- On completion of his apprenticeship Blake was admitted on 8 October to the Royal Academy Schools at Somerset House as an engraver.
- Meets the sculptor John Flaxman, a fellow student. It seems likely that he attended the Schools irregularly.

1780
- In May, exhibits at the Royal Academy for the first time. The work is a watercolour, *The Death of Earl Goodwin*. Exhibits subsequently in 1784, 1785, 1799, 1800 and 1809.
- On 6 June, according to his first biographer, Alexander Gilchrist, Blake is borne along by the mob who liberated Newgate Prison in the Gordon Riots.
- Begins commercial engraving for the radical publisher, Joseph Johnson.

1782
- 2 April: Robert Blake, William's youngest and favourite brother, admitted to the Royal Academy Schools as an engraver.
- On 18 August at St Mary's Battersea, Blake marries Catherine Butcher (or Boucher), daughter of a market gardener. They move to 23 Green Street, Leicester Fields, not far from where Sir Joshua Reynolds, President of the Royal Academy, lives.

1783
- John Flaxman and the Revd A.S. Mathew finance the printing of Blake's *Poetical Sketches*, though the book was never published.

1784
- Blake meets J.T. Smith for the first time at Harriet Mathew's house (wife of Revd Mathew).
- On 26 April Flaxman writes to William Hayley stating that he is sending him a copy of Blake's *Poetical Sketches*.
- Blake's father buried on 4 July.
- In the autumn Blake sets up a print shop in partnership with James Parker who was a fellow apprentice at Basire's. Only two prints by Blake are published before the partnership finishes in 1785.

1785
- Four works shown at the Royal Academy in May, three illustrations to the biblical story of Joseph and *The Bard, from Gray* (untraced, see no.221). The critic in the *Daily Universal Register* thought that in the latter the bard 'appears like some lunatic'.

1787
- Death of Robert Blake from consumption; buried 11 February at Bunhill Fields, London. Blake looked after him continuously 'without sleep' for the last two weeks of his life. Blake claimed that the appearance of Robert to him in one of his 'visionary imaginations' led to the idea of relief etching in copper for printing his poetry (Gilchrist 1863, I, pp. 59, 69).

1788
- Produces his first works using his method of relief-etched illuminated printing: *There is No Natural Religion* and *All Religions are One* (nos.107, 109), though these were not printed until 1794–5.

1789
- 13 April: William and Catherine were among those signing a declaration that they believed in the doctrines of Emanuel Swedenborg at the first session of the New Jerusalem Church. Unlike Flaxman, Blake never actually joined the Church, and he later attacked Swedenborg in *The Marriage of Heaven and Hell* (1790–3) (no.127).
- In June the French Revolution begins.
- *Tiriel*, consisting of a manuscript poem and a series of twelve illustrations, is usually dated to this year (see nos.19–22).
- Publishes his first major independent works, *Songs of Innocence* and *The Book of Thel* (see nos.111e, 126, 128).

1790
- In the autumn William and Catherine move to 13 Hercules Buildings, Lambeth. He begins *The Marriage of Heaven and Hell*.

1791
- The first book of Blake's unfinished poem in seven books, *The French Revolution*, is printed for Joseph Johnson but in view of the political situation is abandoned. Only one set of page proofs survives.
- Six engravings after Blake's designs appeared in a new edition of Mary Wollstonecraft's book *Original Stories from Real Life*.

1792
- Blake's mother, Catherine, dies and is buried in Bunhill Fields.

1793

● Publishes *The Marriage of Heaven and Hell* (begun 1790) (no.127), *Visions of the Daughters of Albion* (no.125), *America* (no.115, 124), *For Children: The Gates of Paradise* (no.130).

● In January Louis XVI, King of France, executed and in February Britain, led by Prime Minister William Pitt, goes to war with France.

● Blake's *Prospectus* of works for sale is dated 10 October and lists engravings and illuminated books for sale or in hand (nos.122–130).

1794

● Date on the title pages of *Songs of Experience* (no.117d), *Europe* (no.299), *The First Book of Urizen* (no.296).

1795

● Date on the title pages of *The Song of Los* (no.301), *The Book of Ahania*, *The Book of Los* (no.302).

● Designs and produces the large colour prints. Some of these can be firmly dated to 1795, though others, despite having a date 1795 on them, were printed in the early 1800s (see nos.241–253).

● Commissioned by Richard Edwards to illustrate Edward Young's *Night Thoughts* (see nos.29–36).

1796

● Publication of George Cumberland's *Thoughts on Outline* with eight plates engraved by Blake.

● Probably began work on the manuscript *Vala* or *The Four Zoas*, which he continues to work on until *c*.1807 (no.300).

1797

● Commissioned by Flaxman to illustrate Thomas Gray's *Poems* for his wife Ann (called Nancy) (see nos.37–40).

1799

● First documented work for Thomas Butts (*c*.1757–1845), Blake's most important patron. Butts's patronage of Blake, which included commissions for many Bible illustrations, was crucial to his survival as an artist for the next twenty years (see nos.41–56).

1800

● Blake makes annotations to Boyd's 1785 translation of Dante's *Inferno* at about this time.

● On 18 September William and Catherine Blake left Lambeth for a cottage near William Hayley's house at Felpham, near Chichester, Sussex (no.272, pl.36). During a three-year stay Blake painted a series of eighteen 'Heads of Poets' for Hayley's library (nos.64, 254).

1801

● 31 July: Flaxman passes on to Blake the Revd J. Thomas's commission for illustrations to Milton's 'Comus' and the works of Shakespeare (see no.228).

1802

● First series of Ballads by Hayley with fourteen illustrations designed and engraved by Blake.

1803

● 12 August: Blake ejects a soldier, John Scholfield, from his garden and, reported (wrongly) to have cursed King George III, is charged with sedition.

● Determined 'to be no longer Pesterd with [Hayley's] Genteel Ignorance & Polite Approbation' William decides to leave Felpham.

● By 26 October the Blakes had settled back in London at 17 South Molton Street, near Oxford Street. The house still survives.

1804

● In January tried for sedition in Chichester on a charge brought against him by John Scholfield, and acquitted.

● Date on title-pages of *Milton* (completed 1808 or later; 272) and *Jerusalem* (completed 1820; 303).

1805

● Commissioned by Robert Cromek to illustrate to Robert Blair's poem *The Grave* (no.16).

1806

● Benjamin Heath Malkin's *A Father's Memoirs of His Child* with a biographical account of Blake in the introductory letter.

1807

● Portrait by Thomas Phillips exhibited at the Royal Academy in May (no.1).

1808

● *Jacob's Dream* and *Christ in the Sepulchre, Guarded by Angels* (no.55) exhibited at the Royal Academy in May.

● Illustrations to Robert Blair's *The Grave* published by Cromek, with Blake's designs engraved by Luigi Schiavonetti and a frontispiece after Phillips's portrait.

● Produces the set of twelve illustrations to Milton's *Paradise Lost* for Thomas Butts (see nos.258–68).

● Annotates Reynolds's *Discourses* around this time (no.233).

● Produces *A Vision of the Last Judgment* (no.59) commissioned by the Countess of Egremont in 1807.

1809

● Opening in May of Blake's exhibition of his own work, accompanied by his *Descriptive Catalogue*, at 28 Broad Street, the house of his brother James. The exhibition included *Sir Jeffery Chaucer and the Nine and Twenty Pilgrims on their Journey to Canterbury* (no.62) and *The Bard from Gray* (no.221). In September the critic Robert Hunt, having seen the show, described Blake in the periodical *The Examiner* as 'an unfortunate lunatic, whose personal inoffensiveness secures him from confinement.' Although scheduled to close on 29 September, the exhibition was still open in June 1810.

1810

● Blake's engraving after his painting *Sir Jeffery Chaucer and the Nine and Twenty Pilgrims* (no.62) published in October. Stothard's rival painting caused a breach in their friendship (no.63).

1811

● Henry Crabb Robinson's essay entitled 'William Blake, Künstler, Dichter, und Religiöser Schwärmer' (Artist, Poet and Religious Mystic) published in the first issue of *Vaterländisches Museum*, Hamburg.

1812

● Blake exhibited four works (three tempera and one watercolour) as a member of the Associated Painters in Water Colour: *Sir Jeffery Chaucer* (no.62), *The Spiritual Form of Pitt*, (no.213) *The Spiritual Form of Nelson* and *Detached Specimens of an original illuminated Poem, entitled Jerusalem, The Emanation of the Giant Albion* (no.303).

1815

● June 1815 is the probable date of Blake's visit to the Royal Academy to copy the cast of the Laocoön for Abraham Rees's *Cyclopedia* (no.3).

1816

● Blake is included in *A Biographical Dictionary of the Living Authors of Great Britain and Ireland*.

1817

● The critic William Paulet Carey (writing about the President of the Royal Academy Benjamin West) praised Blake's illustrations to *The Grave* and regretted Blake's lack of success, 'one of those highly gifted men, who owe the vantage ground of their fame, solely to their own powers'. He reported that there had been some doubt as to whether Blake was alive.

1818

● In June John Linnell (1792–1837) is introduced to Blake by George Cumberland's son, George. Linnell becomes an important patron and supporter of Blake. On 12 September (or earlier) Linnell introduces the watercolourist and astrologer John Varley (1778–1842) and the artist John Constable (1776–1837) to Blake. Blake also meets through Linnell the artists Samuel Palmer, George Richmond and Edward Calvert, who later form 'The Ancients'.

● A revised version of *For Children: The Gates of Paradise* (1793) is produced probably at this time, entitled *For the Sexes: The Gates of Paradise*.

1819

● 14 October: first dated examples of the 'visionary heads', drawn by Blake for Varley.

1820

● First copies of *Jerusalem* dating from this period (no.303).

1821

● Blake moves to 3 Fountain Court, the Strand. Dr Thornton's *Pastorals of Virgil* are published, containing Blake's wood-engravings (no.217).

1823

● On 1 August Blake has his life-mask taken by James Deville (no.219).

● Linnell commissions Blake to engrave his illustrations to the *Book of Job*.

1824

● Linnell commissions Blake to produce illustrations to Dante's *Divine Comedy* and also engravings after them (nos.68–96). Between 1824 and 1827 he produces 102 designs and 7 engravings (at various stages of completion) and a number of associated drawings.

1825

● Henry Fuseli dies on 17 April.

1826

● In March engravings of *Illustrations of The Book of Job* are published.

● John Flaxman dies on 7 December.

1827

● Blake dies in London on 12 August at 3 Fountain Court. The young artist George Richmond wrote that 'Just before he died his countenance became fair, his eyes brightened, and he burst out into singing of the things he saw in heaven' (Gilchrist 1863, I, p.362).

● The artist John Constable was 'much concerned at the death of poor Mr Blake' and hoped that the Artists' General Benevolent Institution would help Catherine. On 11 September Catherine Blake becomes Linnell's housekeeper (in 1828 she moves again to 20 Lisson Grove as Frederick Tatham's housekeeper).

1828

● In his book, *Nollekens and his Times*, J.T. Smith includes a long description of Blake.

1831

● Catherine Blake dies on 18 October.

Catalogue

Note

All works are by William Blake unless otherwise stated.

Dimensions of works are given in centimetres, height before width, followed by inches in brackets. In the case of prints the image size and the size of the support is usually given.

Illuminated books are referred to by letter (e.g. 'Copy A') according to the census of Blake Books in G. E. Bentley Jr, *Blake Books*, Oxford 1972. Plate numbers for the illuminated books are also taken from Bentley 1972 unless otherwise stated. In the case of illuminated books that have Blake's own plate numbers, for example *Europe* Copy B (no.299), references are to Bentley's number first followed by Blake's, thus: pl.4(1).

All quotations from Blake's writings are from *The Complete Poetry and Prose of William Blake*, edited by David V. Erdman, Commentary by Harold Bloom, Berkeley and Los Angeles 1982 (referred to as 'E').

Catalogue numbers printed in bold indicate works included in the exhibition held at the Metropolitan Museum of Art, New York, 27 March–24 June 2001.

Abbreviations

b.c.	bottom centre
b.l.	bottom left
BR	Bentley 1969
b.r.	bottom right
c.	centre
c.r.	centre right
E	Erdman 1982
f.	following page
fo.	folio
inscr.	inscribed
irreg.	irregular
l.	left
l.c.	lower centre
l.r.	lower right
MS	manuscript
r.	right
t.r.	top right
u.l.	upper left
Lit	Literature

Authorship of entries is indicated in the following way:

CR	Christine Riding
DBB	David Blayney Brown
EEB	Elizabeth Barker
IW	Ian Warrell
LC-T	Lizzie Carey-Thomas
MJP	Martin Postle
MM	Martin Myrone
MP	Michael Phillips
NCM	Noa Cahaner McManus
RH	Robin Hamlyn

'One of the Gothic Artists'

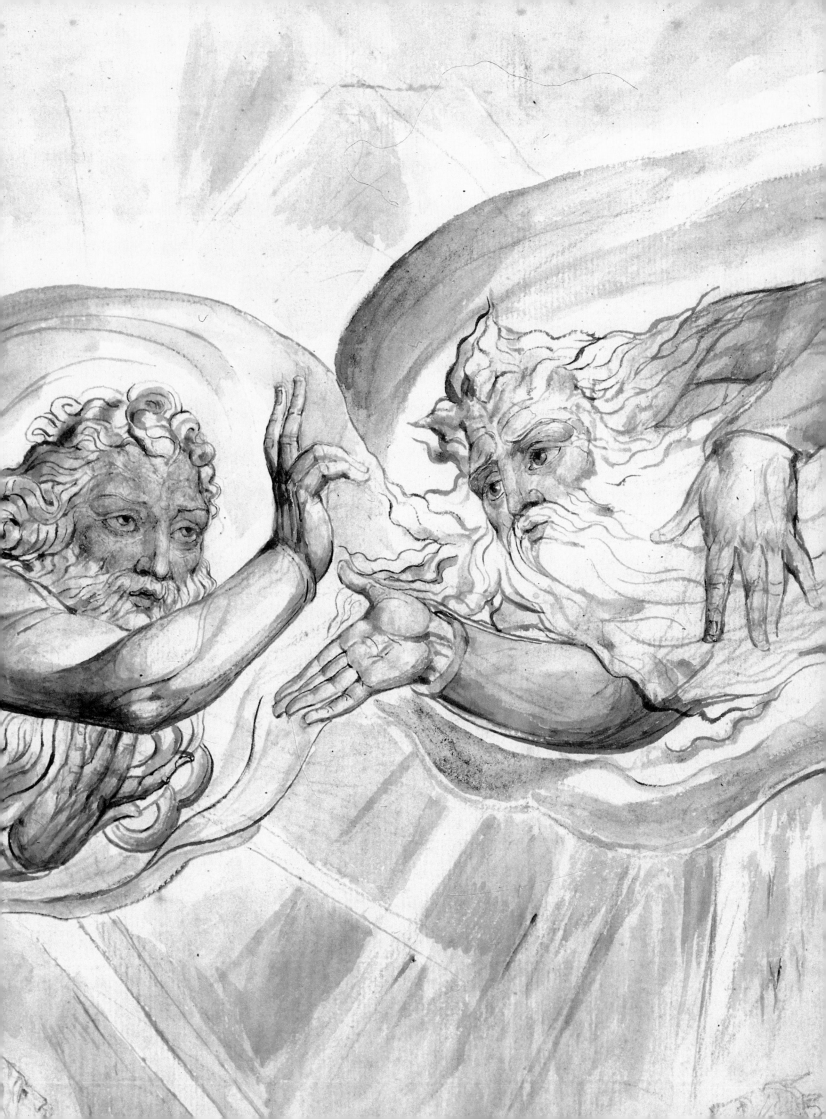

The idea of the Gothic played a central role in William Blake's conception of the artist, while medieval sculpture and architecture were important sources for his distinctive style. This section brings together works from across Blake's life – from his youthful copies of the medieval tombs in Westminster Abbey (nos.5, 7–15) through to his last and perhaps greatest series of illustrations, those for Dante's *Divine Comedy* (nos.68–96) – demonstrating the crucial part played by the Gothic on Blake's art, his imagination and his ideals. Blake's interest in the Gothic reflected contemporary ways of thinking about medieval culture, but the artist was unique in his single-minded pursuit of the spiritual essence of the Gothic.

The term 'Gothic' has a complex history. It entered usage in the seventeenth century usually as a term of abuse, referring to the long period after the fall of the Roman Empire and before the revival of classicism in the Renaissance, when European culture 'degenerated' into a state of barbarism. As a historical term, the Gothic encompassed a very wide period; as a stylistic term, it was used to refer not only to art and architecture of the Middle Ages, as we would define them, but was extended to include early Renaissance art and even Northern European art of a later period that did not conform to the classical and Italian models. This sense of what 'Gothic' represented continued during Blake's lifetime, with supporters of regular, classical architecture denigrating medieval art as 'confused and irregular' (see Stephen Riou, *The Grecian Orders of Architecture*, London 1768).

However, from the middle of the eighteenth century, new attitudes towards the Gothic emerged. The distinctive pointed arches and organic tracery of medieval architecture appeared, often rather flippantly, as decorative forms in interior design, at the same time as more serious antiquarian research was popularised. The melancholy associations of ruins and churches appeared as important features in a whole school of poetry – the 'graveyard poets', who included Robert Blair, Thomas Gray and Edward Young. Significantly, Blake was to produce designs illustrating their work (nos.16, 37–40, 29–36). The 'Gothic', with its various associations with superstition, chivalry and mystery, was a popular mode of writing in this period, allied to a new appreciation for the emotive potential of prose, and the desire for sensationalist aesthetic experiences represented by ideas of the sublime. Meanwhile, medieval and Elizabethan literary forms were imitated, and Thomas Chatterton and James Macpherson wrote pastiches of ancient British

and medieval poems with great popular success. In place of the rationalism and urbane wit of earlier eighteenth-century 'neoclassical' literature, these writers sought to engage the emotions with themes of darkness, terror and tragedy.

Beyond its populist, sensationalist aspects, the Gothic represented a source of spiritual authenticity. As the Revd John Milner wrote, the visitor to a Gothic church 'instinctively experiences … a frame of mind that fits him for prayer and contemplation', which was impossible to achieve in a classical setting ('Observations on the means necessary for further illustrating the ecclesiastical architecture of the middle ages', reprinted in *Essays on Gothic Architecture*, London 1800). Even Sir Joshua Reynolds, the most important spokesman for classical values in art, recognised the imaginative potential of Gothic forms (Wark 1975, p.242).

All these phenomena had political and patriotic implications, above all during the period of the French Revolution and the Napoleonic Wars when architectural styles became deeply embroiled with notions of national identity. The Gothic was increasingly perceived (erroneously) as having originated in Britain and thus had specific resonance as *the* national style. In parallel, the style became associated with the perceived Saxon/medieval origins of the British Constitution and the idea of native

Overleaf: 'St Peter and St James with Dante and Beatrice' (no.92, detail)

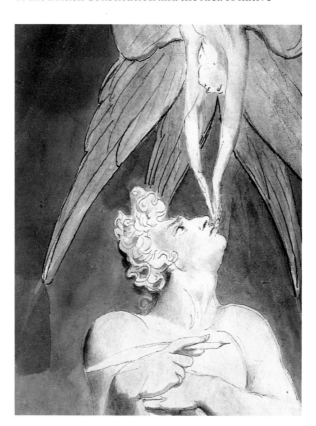

'*Night Thoughts*, Night VII', page 72 (no.34, detail)

liberties, while the classical style represented the paganism and oppressive tyranny of the ancient Greek and Roman civilisations. Writing in the *Builder's Magazine* (March 1777), the antiquarian John Carter argued 'that Gothic architecture has been ages back the taste of Englishmen' and that modern Britons should 'not entirely be led away with Grecian architecture alone, because it is the invention of foreigners'. This antagonistic debate about the relative values of Gothic and classical forms continued throughout the late eighteenth and early nineteenth centuries, reaching a crescendo in the early Victorian period.

Blake's lifelong interest in the Gothic reflects all these debates and ideas. We are told that when he was only about ten years old, he was already buying prints by Albrecht Dürer and copying from Michelangelo and Raphael (see no.142) – all of whom would have been described as 'Gothic' – at the same time as he was drawing from casts of classical sculptures. His apprenticeship to the antiquarian engraver James Basire exposed him to medieval antiquities, including the tomb monuments of Westminster Abbey, which he drew from extensively and whose forms recur again and again in his art. His earliest writings, the poems and plays gathered together in *Poetical Sketches* (no.17) and the poem *Tiriel* (nos.19–28), show Blake's knowledge of fashionable imitations of medieval and Elizabethan forms, and subjects taken from a real or imagined national history. For him, as for other artists and writers of the time, medieval and ancient British subjects were important for their representation of themes of liberty and national pride. The arches and tracery of Gothic architecture proliferate in Blake's art, from the *Tiriel* illustrations to the Dante series which was incomplete at his death. These forms are recalled variously by his decorative motifs, through the stylised arrangement of human forms, or as an architectonic compositional format for his complex pictorial meditations on the Bible.

For Blake medieval sculpture and architecture provided not only the forms and themes that could inspire his art but also embodied his artistic ideal, in which spirituality and aesthetic value were inseparable. In this sense, the Gothic was not simply a style that existed at a particular point in history – which could be revived for its sentimental or historical associations – but an absolute ideal of artistic integrity. Against Sir Joshua Reynolds's valuation of the more refined and sophisticated forms of Italian Renaissance art, and his denigration of the 'ornamental' and Northern styles, Blake proclaims

the importance of genius above academic standards. At one point in his annotations to Reynolds's *Discourses* (no.233) he explicitly demands that 'Gothic' art be ranked with the Renaissance styles favoured by established taste: 'let them look at Gothic Figures & Gothic Buildings. & not talk of Dark Ages or of any Age! Ages are All Equal. But Genius is Always Above The Age.' (E.649) Reynolds, like most art critics and historians in the late eighteenth century, was concerned with establishing in decisive terms the historical and formal boundaries of 'true' taste, distinguishing 'good' from 'bad', debased 'Gothic' from the supreme 'Classical'. Blake, on the other hand, had a strong belief in the ahistorical value of all great art, and wrote that 'true Art is Calld Gothic in All Ages' (*A Vision of the Last Judgment*, E.559).

In his early engraving of Joseph of Arimathea, based on a supposed self-portrait by Michelangelo, his ideal artist is relocated to the shores of Britain in the 'Gothic' period (no.274). As the later inscription on the plate indicates, Joseph, Michelangelo and Blake himself should each be counted as 'one of the Gothic Artists'(no.2).

Blake's search for a true and spiritual way of making art continued in his technical experiments with what he called 'fresco' painting of biblical subjects painted for Thomas Butts from around 1799 (nos.57, 58). True fresco is the technique of painting with pure pigment on wet plaster, and was perfected in Italy in the sixteenth century. What Blake termed 'fresco' seems to have involved painting in thin glue-based washes over a white ground. The results of this experimental technique are unstable, and surviving examples are often badly discoloured and fragile.

Blake's imitation of the archaic technique of fresco-painting testifies to his rejection of modern art, and was a practical expression of his desire to forge a more primal, spiritual foundation for art. For Blake the oil colours used by most artists, certainly the artists associated with the Royal Academy, were transient and corrupting: 'Oil will not drink or absorb colour enough to stand the test of very little time and of the air. It deadens every colour it is mixed with, and in a little time becomes a yellow mask over all that it touches.' Consequently it was 'a fetter to genius, and a dungeon to art' (*Descriptive Catalogue*, E.530–1).

Throughout his life the Gothic represented for Blake a way out of the 'dungeon'. The political ideals, spirituality, pictorial forms and artistic techniques associated with the Gothic were thus decisive in shaping his art. MM, CR

1 THOMAS PHILLIPS (1770–1845)
William Blake 1807
Oil on canvas, 92.1×72 (36¼×28⅜)
National Portrait Gallery, London
Lit: Cunningham 1833, I, pp.11–13; Keynes 1977, pp.121–8

This portrait is perhaps the best-known and most widely reproduced image of the artist. In order to achieve the desired 'rapt poetic expression' in his sitter, the Royal Academician Thomas Phillips is reputed to have encouraged Blake to recount a meeting with the archangel Gabriel in his studio. Blake describes how during the encounter Gabriel commends Michelangelo for his accurate depiction of angels. Blake, it was claimed, believed that angels 'descended to painters of old, and sat for their portraits'. Praised as being a faithful likeness of the artist by his contemporaries, the portrait was painted after Blake had completed his drawings to Robert Blair's *The Grave*, published by R. H. Cromek in 1808 (no.16). Although the origins of the painting are not known, it has been suggested that it was initiated by Cromek. Schiavonetti's *A Portrait of Mr Blake*, engraved after Phillips's painting, appears as the frontispiece to the book.

The painting was exhibited at the Royal Academy in 1807 and was acquired by the National Portrait Gallery in 1866. LC-T

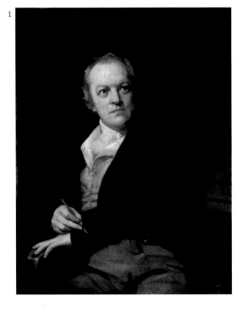

1

2 **Joseph of Arimathea among the Rocks of Albion 1773–9/c.1810**
Engraving printed in brown ink on paper, with some grey wash , framing lines
22.8×11.9 (9×4⅝)
Etched inscr. upper right 'JOSEPH / of Arimathea / among the Rocks of Albion' and below 'Engraved by W Blake 1773 from an old Italian Drawing / This is One of the Gothic Artists who Built the Cathedrals in what we call the Dark Ages / Wandering about in sheep skins & goat skins of whom the World was not worthy / such were the Christians / in all Ages / Michael Angelo Pinxit'
Lent by the Syndics of the Fitzwilliam Museum, Cambridge
Lit: Bindman 1975, pp.13–16; Essick 1980, pp.178–86; Essick 1983, no.I: 2E; Hamlyn 1992; Eaves 1992, pp.256–7

Blake originally engraved this image as an exercise begun in 1773 while still apprenticed to the engraver James Basire (1730–1802). The figure is copied from a detail on the far right-hand side of Michelangelo's fresco of the *Crucifixion of St Peter* in the Pauline Chapel of the Vatican, completed in 1549, a work Blake could only have known through reproductive prints. A likely source was a print by Nicolas Beatrizet (*c.*1515–1565) showing Michelangelo's figure isolated against a blank background. The figure was sometimes identified as a self-portrait by Michelangelo, and this may have added to the appeal of the image for Blake. He did not copy from the Beatrizet engraving precisely, showing the man with his eyes open rather than closed, altering some of the details of his beard and right hand and introducing a completely new background of rocks and sea.

In its reinterpretation of Michelangelo it can rightly be seen as particularly revealing of Blake's nascent artistic outlook. Unlike Sir Joshua Reynolds, for whom Michelangelo was an artist to be admired but copied and adapted

cautiously in order to produce a more refined and polished academic art, Blake considered Michelangelo as exemplary in his selfless, spiritual dedication to art. The isolation of Blake's Joseph, who appears as a kind of castaway, and the brooding seascape suggest an early sympathy by the artist with the work of several painters who were coming to prominence in the 1770s, including Henry Fuseli, James Barry and John Hamilton Mortimer. Although each of these had some affiliation to the Royal Academy, their art showed a turbulent emotionalism that was quite different from traditionalist, academic art.

In this second state Blake transformed his original image into an ambitious statement of his ideal of the Christian artist. The rather mechanical cross-hatching of the original print was vigorously reworked, and the etched inscription added, identifying the figure as 'Joseph of Arimathea'. According to legend, Joseph brought Christianity to England and built a cathedral in Glastonbury within decades of Christ's death. Blake thus presents him both as a founding figure of the Christian faith in Britain and as a model artist, whose creativity was fused with his faith. For Blake medieval churches and cathedrals were the absolute embodiment of true, honest and primal Christianity: the 'Gothic Church is representative of true Art' (*A Vision of the Last Judgment*, no.59, E.559). In historical terms Blake considered Gothic architecture as the starting point of English art (see Eaves 1992, p.142). The inscription suggests that, as a Christian and a true (Gothic) artist, Joseph is isolated from society: 'Wandering about in sheep skins & goat skins of whom the World was not worthy / such were the Christians / in all Ages.' We might, perhaps, interpret this print as a melancholic self-image of Blake, as well as a more abstracted meditation on the role of the artist. MM

Joseph of Arimathea
among The Rocks of Albion

Engraved by W. Blake 1773 from an old Italian Drawing
This is One of the Gothic Artists who Built the Cathedrals in what we call the Dark Ages
Wandering about in sheep skins & goat skins of whom the World was not worthy
such were the Christians
Michael Angelo Pinxit in all Ages

3 The Laocoön as Jehovah with Satan and Adam *c.*1820
Copy A
Engraving 26.3 × 21.6 (10⅜ × 8½)
on paper 38.5 × 27.7 (15⅛ × 10⅞)
Lent by the Syndics of the Fitzwilliam Museum, Cambridge
Lit: Bindman 1978, no.623; E.272–5, 819; Essick 1983, no.XIX: 1A; Essick 1991, pp.111–12; Essick and Viscomi 1993 (facsimile Copy B)

Like the *Joseph of Arimathea* (no.2), this image shows Blake using a conventional engraving as the basis of a startling statement of his artistic beliefs. Blake had made a drawn copy of the ancient sculptural group of Laocoön with his sons from a plaster cast in the Royal Academy in 1815, in preparation for his illustration to the article on 'Sculpture' by John Flaxman in Abraham Rees's *Cyclopaedia* (published 1816–17). The Laocoön group was one of the most admired pieces of antique sculpture in the late eighteenth century, the subject of much pedantic debate as well as passionate aesthetic criticism. In this image Blake has renamed Laocoön 'King Jehovah' and his sons as Satan and Adam. The serpents are titled 'Good' and 'Evil'. These figures are surrounded with a dense graffiti of textual commentary. Like *Joseph*, these assert the absolute indissolubility of Christian faith and the creative imagination, with statements such as:

> The Old & New Testaments are the Great Code of Art
> Jesus & his Apostles & Disciples were all Artists …

> Prayer is the Study of Art
> Praise is the Practise of Art …

The epigrammatic style of these statements was a convention of the time, apparent in Lavater's *Aphorisms on Man* (published in English in 1788) and Henry Fuseli's 'Aphorisms on Art', written at the end of the 1780s although unpublished until after his death. The use of such epigrams as a dense graphic graffiti in this image was, however, unique to Blake, and finds parallel only in the comic satires and caricature prints of his age.

Though the Laocoön was generally considered a masterpiece of ancient art, Blake departs from conventional wisdom in suggesting that it was 'copied from the Cherubim of Solomons Temple'. As in the contemporary *On Homer's Poetry* (no.4), Blake was here heretically identifying ancient Greece and Rome as copyists (and destroyers) of an older, truer Hebrew culture. For Blake the Laocoön was merely a mechanical, spiritless copy of an older work. MM

4 On Homer's Poetry and **On Virgil** 1821
Copy B
Relief etching printed in black ink on paper
24.5 × 34.3 (9⅝ × 13½)
Lent by the Syndics of the Fitzwilliam Museum, Cambridge
Lit: Bindman 1978, no.622; E.269–70; Essick and Viscomi 1993 (facsimile Copy A)

This single relief etched sheet presents Blake's arguments against the classical art and literature of ancient Greece (represented by Homer) and Rome (Virgil). In Blake's day the sculptures and writings of the ancients were the absolute model of great art, whose splendours were supposedly neglected in the Middle Ages until rediscovered in Renaissance Italy. Writers on art often proposed that it was not possible to achieve greatness in the modern day without copying and learning from the ancients. Classical art encompassed the ideal of beauty, in a way that was perfected and rational. Deviating from their model was to fall into irrationalism, epitomised by the supposedly superstitious and barbaric Middle Ages. Here, as in *Laocoön* (no.3), Blake suggests that the ancient Greeks and Romans were in fact the perverters of true art, represented in the spiritually full creations of the ancient Hebrews and the Middle Ages: 'The Classics it is the Classics! & not Goths nor Monks, that Desolate Europe with Wars.' According to Blake, the very rationalism of classical art destroyed artistic truth and value, which lay in spiritual qualities. He particularly identifies the Greeks and Romans as the people who turned art into a commodity: 'Rome & Greece swept Art into their maw & destroyd it a Warlike State can never produce Art … Mathematic Form is Eternal in the Reasoning Memory: Living Form is Eternal Existence. Grecian is Mathematic Form Gothic is Living Form.' Blake's comments, written after the extended wars with France and against a background of continuing imperial expansion, can be read as applying to his own times: his Britain was indeed a 'Warlike State'. MM

Westminster Abbey drawings
1774–9

In 1772 Blake was apprenticed to the engraver James Basire for a period of seven years. Why Blake's father apprenticed him to an engraver and not a painter is unknown. Certainly Basire's premium was lower than that habitually demanded by a painter (painting being considered of a higher standing than engraving), so it may have been all that his father could afford. There is nothing to suggest that Blake felt deprived by his career taking a more commercial direction. He studied prints produced by Renaissance masters such as Albrecht Dürer (see no.214) and Marcantonio Raimondi, and, as Blake later stated, it was primarily through engravings that in his youth he came into contact with masterpieces of Western art.

Apart from the occasional holiday or short break, Blake lived with Basire and his wife in Great Queen Street, Covent Garden. Basire's competent and conventional line-engraving technique gave Blake the grounding that was necessary for his more commercial work. It also acted as the bedrock from which developed his highly individual and innovative method of engraving. Via Basire, Blake also came into contact with one of the most profound influences on his art, his personal philosophy and his perception of the prophetic role of the artist: medieval Gothic.

Basire had succeeded George Vertue (1684–1756) in 1756 as engraver to the Society of Antiquaries in London, and much of his workshop's output was of an antiquarian nature. By 1774 Blake was copying the tombs and other medieval features in Westminster Abbey. According to Benjamin Heath Malkin, 'he drew in every point he could catch, frequently standing on the monument and viewing the figures from the top'. These drawings (signed by Basire, as was common practice in workshops) were published as engravings in two antiquarian folios; Richard Gough's *Sepulchral Monuments in Great Britain* (published in London from 1786) and the Society of Antiquaries' *Vetusta Monumenta* (published in 1789). (Some engravings feature in both publications; all the drawings shown here were produced for Richard Gough, with no.5 being a replica of that done for *Vetusta Monumenta*.) Both projects reflect not only the general interest at that time in the nation's past but also the growing concern amongst scholars for a more archaeological approach to ancient artefacts and architecture.

On one level Blake's exposure to the Gothic, as represented by Westminster Abbey, was to produce an aesthetic response. This is evident in the strong outlines and flowing contours that pervade his *oeuvre*, and the stylised postures and gestures of his figures. Occasionally it appears in the compositions of his works, where the figures themselves form shapes that are reminiscent of Gothic ornament (for example, see *Christ in the Sepulchre, Guarded by Angels*, no.55).

Perhaps more importantly, Blake responded to the spirituality of this essentially Christian style. It is telling that one of his earliest visions was reputedly in Westminster Abbey. This intensely spiritual response by Blake was to manifest itself repeatedly in his preoccupation with visualising the themes of judgement and salvation, and also informed his interpretation of other poets' visions, above all that of the medieval Italian poet, Dante Alighieri (see *Divine Comedy*, pp.74–97). CR

Lit: Bindman 1971, pp.11–15; Butlin 1978, pp.27–30; Butlin 1981, pp.1–15, nos.1–50; Essick 1991, pp.118–20; Hamlyn 1992

5 **Countess Aveline: Three Details from her Tomb** *c.*1775
Pen and ink, watercolour and gold, framing lines 24.5 × 20 (9⅝ × 7⅞) on paper 30.3 × 24.4 (12 × 9 ⅝)
The Bodleian Library, The University of Oxford
Lit: Butlin 1981, no.14
These are replicas of drawings made for the engraving in *Vetusta Monumenta*.

6 AFTER WILLIAM TOREL (ACTIVE 1290–1291)
Tomb Effigy of Queen Eleanor
Gilded plaster on board
35 × 219 (13¾ × 86¼)
The Victoria & Albert Museum

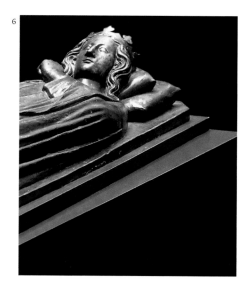
6

Basin. del.

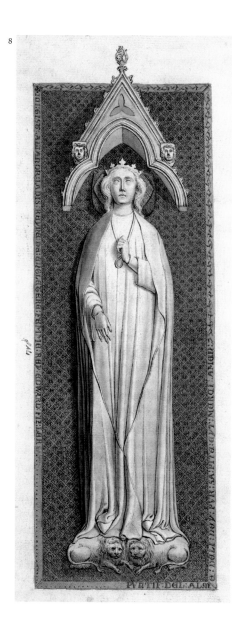

8

Drawings for Richard Gough

The Bodleian Library, The University of Oxford (Gough maps 225)

Most of these drawings bear James Basire's signature and not William Blake's. It was customary for the master of an engraver's workshop to sign any work by apprentices. CR

7 **Queen Eleanor, Side View of her Tomb** *c.1774*

Pen and ink and grey wash 12.7 × 2.1 (5 × .78) on paper 24.1 × 30.5 (9½ × 12)

Engraved for Gough's *Sepulchral Monuments*, I, 1786, pl.23

Lit: Butlin 1981, no.23

Queen Eleanor was the wife of Edward I.

8 **Queen Eleanor, her Effigy on the Tomb Seen from above** *c.1774*

Pen and ink and grey wash 30.8 × 10.8 (12⅛ × 4¼) on paper 36.2 × 28 (14¼ × 11)

Engraved for Gough's *Sepulchral Monuments*, I, 1786, pl.23

Lit: Butlin 1981, no.24

9 **Queen Eleanor, Head and Shoulders from her Effigy** *c.1774*

Pencil (oval) 33.6 × 29.5 (13¼ × 11⅝) on paper 48.8 × 30.5 (19¼ × 12)

Engraved for Gough's *Sepulchral Monuments*, I, 1786, pl.23

Lit: Butlin 1981, no.25

10 **The Children of Edward III, their Effigies Seen from above** *c.1777*

Pen and ink and grey wash 27.3 × 17.1 (10¾ × 6¾) on paper 48.5 × 29.8 (19⅛ × 11¾)

Engraved for Gough's *Sepulchral Monuments*, I, Pt 2, 1796, pl.34

Lit: Butlin 1981, no.37

11 **Queen Philippa, Head and Shoulders from her Effigy** *c.1774*

Pencil (oval) 33.6 × 29.5 (13¼ × 11⅝) on paper 48.8 × 30.5 (19¼ × 12)

Engraved for Gough's *Sepulchral Monuments*, I, Pt 2, 1796, pl.49

Lit: Butlin 1981, no.40

Queen Philippa was the wife of Edward III. Thomas Stothard, Blake's close friend at the time, described this drawing as by Blake.

12 **Edward III, Side View of his Tomb** *c.1774*

Pen and ink wash 28.5 × 21.9 (11¼ × 8⅝) on paper 33 × 27.3 (13 × 10¾)

Engraved for Gough's *Sepulchral Monuments*, I, Pt 2, 1796, pl.54

Lit: Butlin 1981, no.41

13 **Edward III, his Effigy Seen from above** *c.1774*

Pen and ink and grey wash 26.6 × 1.2 (10½ × 4¾) on paper 31.4 × 24.4 (12⅜ × 9⅝)

Engraved for Gough's *Sepulchral Monuments*, I, Pt.2, 1796, pl.54

Lit: Butlin 1981, no.42

14 **Edward III, Head and Shoulders from his Effigy** *c.1774*

Pencil (oval) 34 × 29.2 (13⅜ × 11½) on paper 48.8 × 30.5 (19¼ × 12)

Engraved for Gough's *Sepulchral Monuments*, I, Pt.2, 1796, pl.55

Lit: Butlin 1981, no.43

15 **Queen Anne, Head and Shoulders from her Effigy** *c.1774*

Pencil (oval) 34.9 × 29.2 (13¾ × 11½) on paper 49.5 × 30.5 (19½ × 12)

Engraved for Gough's *Sepulchral Monuments*, I, Pt.2, 1796, pl.64

Lit: Butlin 1981, no.47

Queen Anne was the wife of Richard II.

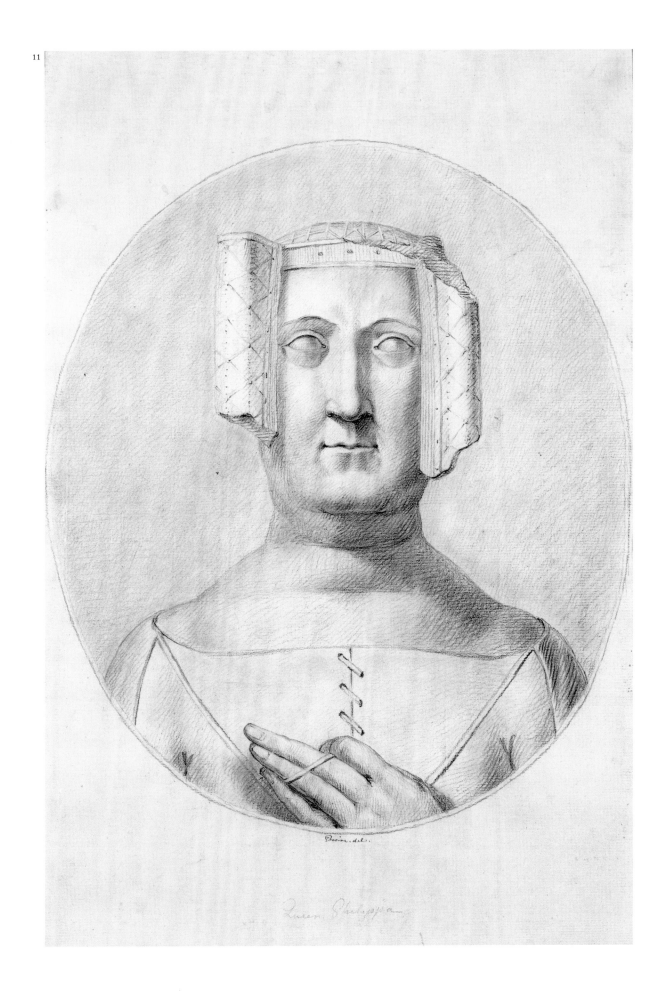

Boine. del.

Queen Philippa

16 LOUIS SCHIAVONETTI (1765–1810)
AFTER WILLIAM BLAKE
Death's Door
Robert Blair (1699–1746), *The Grave*, 1808
Open at p.32 and facing plate 'Death's Door'
Etching 23.5 × 13.8 (9¼ × 5½) (framing lines)
Tate Library

Lit: Butlin 1981, nos.609–38; Essick and Paley 1982

In September 1805 Robert Cromek
commissioned Blake to design and engrave
illustrations for a prestigious edition of Robert
Blair's poem, *The Grave*. A number of leading
artists of the day subscribed to the publication,
and it would have been an important source of
income for Blake. In November 1805 a *Prospectus*
was published, naming Blake as the designer
and engraver, but Cromek, anxious about
Blake's bold copper-plate technique, eventually
made a safer choice in asking Louis Schiavonetti
to etch and engrave Blake's designs. The book
was published in 1808 and, although it received
a lukewarm reception, was successful enough to
be republished in 1813. Though lacking what
Blake would consider to be a 'Gothic' truth of
line, the plates nonetheless show Blake's Gothic
style in its most overt form.

Blake's twelve designs for *The Grave*
illustrate the progress of man through life. In
'Death's Door' an old man is seen entering the
state of death, while above the door a
rejuvenated youth is bathed in light. The motif
of the rising youth also appears in *America*,
plate 8 (no.124). MM

17 **Poetical Sketches. By W.B.**
London, printed 1783
Copy Q
Open at pp.6–7: 'To Morning'; 'Fair Elenor'
The Preston Blake Library, City of Westminster
Archives Centre

Lit: E.408–45, 846–9, 967–70

This collection of youthful writings by Blake
was his first printed work. According to the
'Advertisement' at the beginning of the volume,
Blake wrote the poems when he was between the
ages of twelve and twenty (i.e. 1769–77). The
printing was paid for by John Flaxman and the
Revd A.S. Mathew. Twenty copies are known, a
number of which Blake himself gave away to
friends. The book consists of songs, poems, short
prose pieces and a play fragment, 'King Edward
the Third'. These are notable for Blake's
precocious sense of romanticism apparent in
their imitations of Elizabethan styles and
medieval subject matter, showing a rejection of
the classical conventions of earlier eighteenth-
century English poetry. 'Fair Elenor', for
example, can be seen as part of the 'Gothic'
literature of the period, and in his imitations of
Spenser, Milton and Shakespeare Blake follows
poets like Thomas Gray and William Collins in a
search for an emotional, sentimentally affecting
poetic voice. MM

18 **The Penance of Jane Shore in St Paul's
Church** *c.*1793
Pen and ink and watercolour
24.5 × 29.5 (9⅝ × 11⅝)
Tate; presented by the Executors of W. Graham
Robertson through the National Art Collections
Fund 1949

*Lit: Butlin 1978, pp.17–18; Butlin 1981, no.69; Butlin
1990, no.14*

The source for this scene was Rapin de Thoyras's
History of England, first published in English in
1732–7. Jane Shore was the mistress of Edward
IV. When the king died in 1483, she was accused
of harlotry and imprisoned in the Tower of
London by the Protector (the future Richard III).
The Ecclesiastical Court condemned her to do
public penance (and humiliation) in St Paul's
Church, which she did, according to Rapin de
Thoyras, 'with so much modesty and decency,
that such as respected her Beauty more than her
fault, never were in greater admiration of her,
than now'. Butlin has suggested that Blake
'chose the subject as a protest against orthodox
sexual morality' (Butlin 1981, p.23).

The work is a finished version of a
watercolour (private collection) that Blake
painted in *c.*1779. The title, *The Penance of Jane
Shore*, appeared in a list of subjects from English
history written in Blake's Notebook of about
1793. Blake was at this time planning to publish
The History of England, a small book of Engravings
(see p.122) and it is possible that he intended to
include an engraving of this work as part of the
series. It also bears strong stylistic similarities to
the engraving of *Edward & Elenor* (no.123)
published on 18 August 1793 and listed in Blake's
Prospectus of that year. CR

16 ▶

Through length of days; and what he can he
 will :
His faithfulness stands bound to see it done.
When the dread trumpet sounds, the slumb'ring
 dust,
Not unattentive to the call, shall wake ;
And every joint possess its proper place,
With a new elegance of form, unknown
To its first state. Nor shall the conscious soul
Mistake it's partner ; but, amidst the crowd
Singling it's other half, into it's arms
Shall rush, with all th' impatience of a man
That's new come home, and, having long been
 absent,
With haste runs over every different room,
In pain to see the whole. Thrice happy meeting !
Nor time, nor death, shall ever part them more !

 'Tis but a night, a long and moonless night ;
 We make the grave our bed, and then are gone !

 Thus at the shut of ev'n, the weary bird
 Leaves the wide air, and in some lonely brake
 Cow'rs down, and dozes till the dawn of day ;
 Then claps his well-fledg'd wings, and bears away.

THE END.

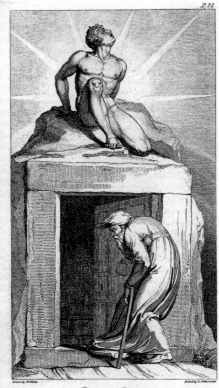

Deaths Door.

'Tis but a Night, a long and moonless Night,
We make the Grave our Bed, and then are gone !
London Published May 1st. 1808 by Cadell & Davies, Strand.

Tiriel c.1785–89

Tiriel was Blake's first prophetic book. It remained in draft manuscript form until published in full by W.M. Rossetti in 1874. To accompany the text, Blake produced a set of twelve pen and grey wash illustrations. The nine that survive are shown here. The poem deals with a confusing range of themes, from political tyranny to the proper means of child-rearing, but, together with the illustrations, it marks the emergence of Blake's original vision.

The complex narrative follows the misadventures of Tiriel, the blind King of the West and the son of the senile Har and Heva. With his brothers Ijim and Zazel he revolted against his father, becoming a tyrant, enslaving his own sons and the sons of Zazel, and sending Ijim into the wilderness. His sons eventually rebelled, and Tiriel exiled himself to the wilderness. He eventually summons his sons to attend to their mother, Myratana, on her deathbed. This is the opening scene of the poem (section 1). After her death Tiriel again wanders off, denounced as a tyrant by his sons and aware of his own impending death. He encounters his parents in their paradise-like garden. In their senility they are terrified of him, but are persuaded by their nurse Mnetha to take pity on him and feed him milk and fruits (sections 2 and 3). Knowing that the simple provisions of the garden cannot satisfy him, Tiriel then sets off into the wilderness once more until he is identified by his brother Ijim and carried back to his palace (section 4). Ijim expects Tiriel's children to rebel against his hypocrisy, but they submit to their fate when Tiriel summons storms and pestilence, killing one hundred of his one hundred and thirty sons and four of his five daughters (section 5). His surviving daughter, Hela, then denounces him to Har, for which Tiriel turns her hair into snakes (section 6). Led by Hela, Tiriel goes into the mountains, where Zazel and his sons come out of their caves and curse him (section 7). With Hela he returns to the garden of Har and Heva, where, railing against the poisonous hypocrisy of mankind and parents' misguided upbringing of children, Tiriel dies (section 8).

The existence of illustrations for this piece might well relate to Blake's proposal for an engraved poem recorded in his *An Island in the Moon* of c.1784 (see no.106). There he wrote that in this planned volume 'I would have all the writing Engraved instead of Printed & at every other leaf a high finishd print' (E.465). The use of monochrome and their finished state suggest that Blake's *Tiriel* designs were meant to be engraved, though their horizontal format means that they would have been difficult to integrate satisfactorily into a printed octavo or quarto volume.

The lucidly delineated spaces, the figures' restrained gestures and the sharp linearity of the drawing in the *Tiriel* illustrations owe much to the example of Blake's contemporaries, Henry Fuseli, George Romney and James Barry. Blake's use of a relatively conventional style here may explain why the images so often depart from the words. It was not until he developed a style and symbolic language more truly his own that word and image were brought into a more complete relationship.

W.M. Rossetti scathingly referred to the poem as 'erratic Ossianism'. Ossian was supposed to be an ancient Celtic bard, whose 'works' were published by James Macpherson from 1760. These vivid tales of ancient heroism and tragedy quickly became cult reading, although their authenticity was doubted and it was eventually demonstrated that they were forgeries by Macpherson. Blake himself believed the poems to be authentic and wrote that 'I own myself an admirer of Ossian equally with any other poet' (BR.665–6). The deranged figure of Tiriel and the bleak landscapes he travels through are truly Ossianic in character, revealing the concern with primal anti-rationalism that was a characteristic of Blake's time. In his poetic persona Blake himself sometimes took on a bardic role (see nos.128 pl.54, 221, 298 pl.54).

Scholars remain divided about the precise significance of this work. Some see the poem as a precursor of Blake's later symbolic writings, the cycle of revolution, tyranny, hypocrisy and death that characterises Tiriel's life foreshadowing the character of Urizen (see nos.295–7). More generally, the poem has been interpreted as allegorising Blake's fierce and enduring opposition to materialism and rationalism. The names of his characters come from a range of sources: Tiriel and Zazel may come from Cornelius Agrippa's *Occult Philosophy*, though Hebrew sources are more likely; Heva is the Latin name for Eve; while Ijim seems to derive from the Bible via the spiritualist writings of Emmanuel Swedenborg (see no.232). Erdman (1954, pp.133–8) argued that this 'murky parable of the decline and fall of a tyrant prince' was an allegory of the madness of King George III and his loss of the American colonies. Other commentators have read the poem in terms of class struggle, as a psychological drama based around the Oedipus complex or as an allegory about art itself. Literary precedents from Shakespeare's *King Lear* to Sophocles' *Oedipus at Colonnus* have been proposed.

Whatever the exact meaning and significance of *Tiriel*, the poem and accompanying illustrations are particularly important in marking the maturation of Blake's imagination, drawing on contemporary interests in ancient and medieval legend and myth. More significant still is Blake's recognition that the conventional means of integrating text and engraved image did not fulfil his artistic or literary ambitions. It was his frustration with conventional methods that pushed him towards the extraordinary development of relief-etched books in the late 1780s. MM

Lit: Bentley 1967 (facsimile); Bindman 1977, pp.43–8; Essick 1980 pp.81, 113; Butlin 1981, nos.78–83, nos.198–200; E.276–85, 814–15, 945–7

19 **Tiriel**
Manuscript in ink
8 leaves 15.7 × 21 (6⅛ × 8¼) in blue-grey paper wrappers, bound in blue morocco
Open at fo.1
The British Library Board

19

Opposite: 'Har and Heva Bathing, Mnetha Looking on' 1785–9 (no. 21, detail)

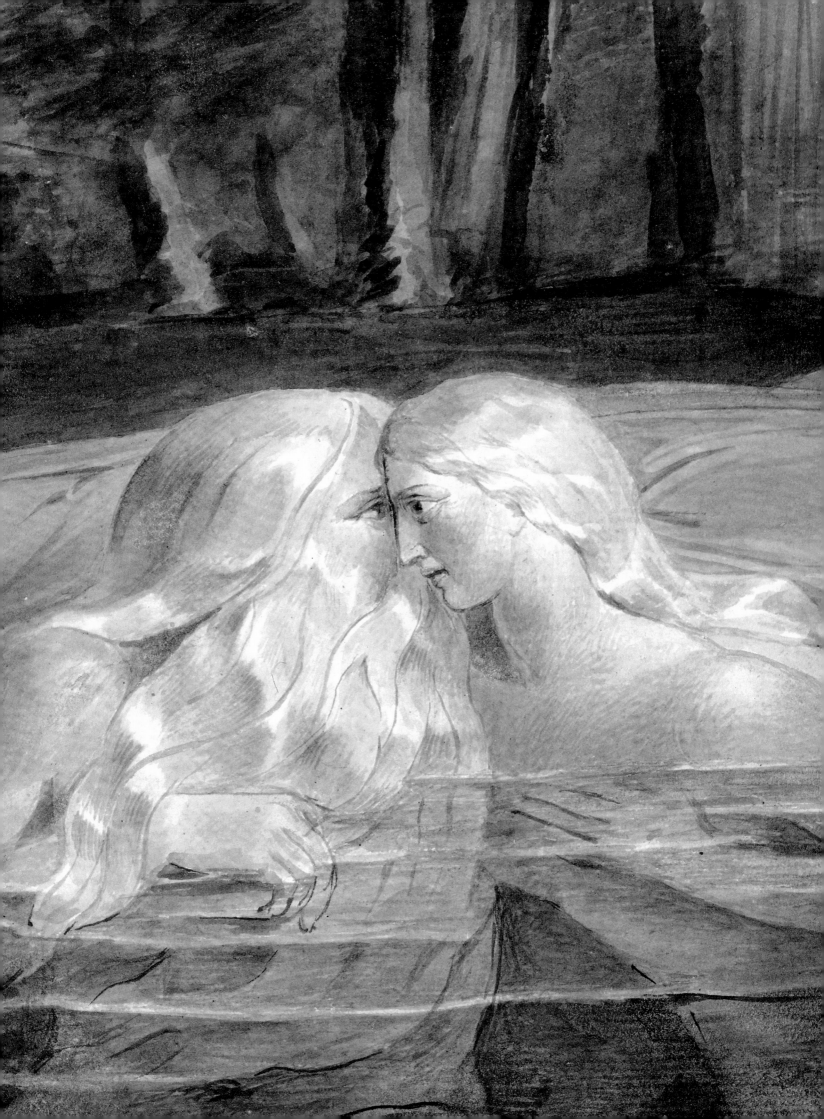

20 Tiriel Supporting the Dying Myratana and Cursing his Sons
Pen and black ink and grey wash 18.6 × 27.2
(7⅜ × 10¾)
The Paul Mellon Collection, Yale Center for
British Art
Lit: Butlin 1981, no.198 1

This illustrates section 1, lines 12–32. Tiriel has
returned to his palace with his dying wife,
Myratana, and here threatens his sons, who had
rebelled against him (lines 27–32, E.277):

> Look at my eyes blind as the orbless scull
> among the stones
> Look at my bald head. Hark listen ye
> serpents listen
> What Myratana. What my wife. O Soul O
> Spirit O fire
> What Myratana. art thou dead. Look here
> ye serpents look
> The serpents sprung from her own
> bowels have draind her dry as this
> Curse on your ruthless heads. for I will
> bury her even here.

Elaborating imaginatively on the original text,
Blake shows the eldest son, Heuxos, is crowned
as a king, perhaps representing material power.
His brothers wear a laurel wreath (representing
poetry) and vine-leaves (physical pleasures).
The pyramid in the background appears in
his later work as a symbol of ancient Egypt,
and so slavery.

21 Har and Heva Bathing, Mnetha Looking on
Pen and ink and grey wash over pencil
19.2 × 28 (7½ × 11)
Lent by the Syndics of the Fitzwilliam Museum,
Cambridge; bequeathed by Sir Edward Marsh,
KCVO, CB, CMG, through The National Art
Collections Fund, 1953
Lit: Butlin 1981, no.198 2

Har and Heva (Eve) are Tiriel's senile parents.
This scene does not appear in Blake's poem,
although one passage does refer to Har and
Heva being 'like two children … Playing with
flowers. & running after birds' (section 2, lines
5–8). In this image, the two are watched by their
nurse, Mnetha.

22 Har Blessing Tiriel while Mnetha Comforts Heva
Pen and grey wash 18.3 × 24.3 (7¼ × 9⅝)
The British Museum, London
Lit: Butlin 1981, no.198 4

This image illustrates a scene in section 2 where
the blind and deranged Tiriel returns to his
parents' garden having wandered in exile
following his children's revolt. At first his wild
appearance frightens Har and Heva, but Mnetha
persuades them to take pity on him
(lines 29–31, E.278):

> He [Tiriel] kneeled down & Mnetha said
> Come Har & Heva rise
> He is an innocent old man & hungry
> with his travel
> Then Har arose & laid his hand upon
> old Tiriels head

20
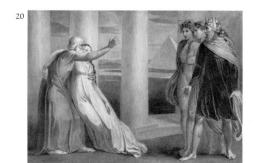

21
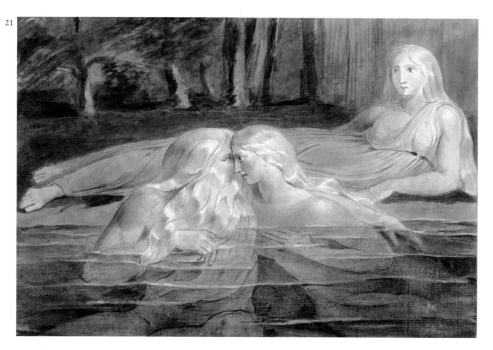

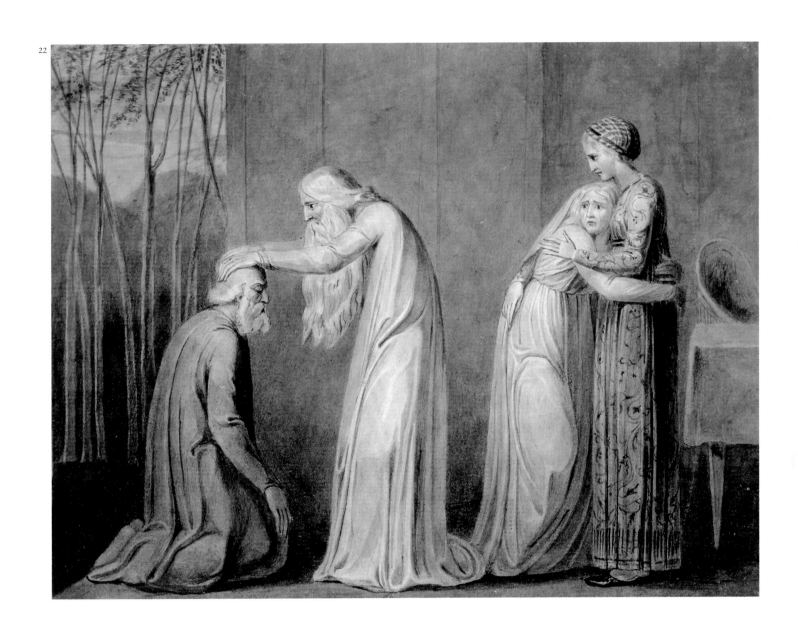

23 The Blind Tiriel Departing from Har and Heva

Monochrome wash over pencil drawing
18.5 × 27.7 (7⅛ × 10⅝)
Collection of Robert N. Essick
Lit: Butlin 1981, no.198 6

This illustrates the last lines of section 3. Tiriel leaves his parents again, who watch him go with a momentary sense of despair (lines 33–6, E.279):

> Then Mnetha trembling at his frowns led him to the tent door
> And gave to him his staff & blest him. he went on his way
> But Har & Heva stood & watchd him till he enterd the wood
> And then they went & wept to Mnetha. but they soon forgot their tears.

24 Tiriel, Upheld on the Shoulders of Ijim, Addresses his Children

Pen and black ink and grey wash with some pencil 18.5 × 27.4 (7⅛ × 10¾)
The Victoria & Albert Museum
Lit: Butlin 1981, no.198 7

This illustrates section 4. Tiriel has been carried back to his palace by his brother Ijim, who expects Tiriel's sons and daughters to denounce their father. The kneeling figure on the right is Tiriel's eldest son, Heuxos.

25 Tiriel Denouncing his Sons and Daughters

Pen and ink and grey wash 18.2 × 27 (7⅛ × 10⅝)
Keynes Family Trust, on loan to the Fitzwilliam Museum, Cambridge
Lit: Butlin 1981, no.198 8

This illustrates section 5, where Tiriel wishes 'Thunder & fire & pestilence' on his children.

23

24
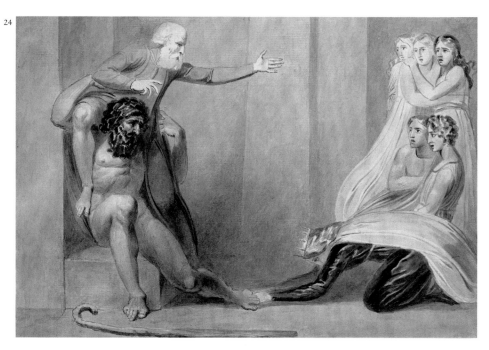

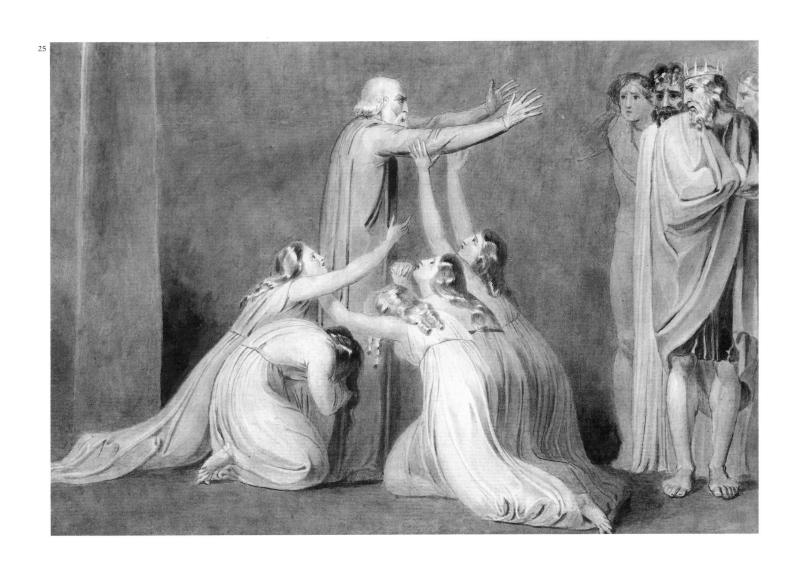

26 Tiriel Led by Hela

Pen and ink and grey wash 17.8 × 26.9 (7 × 10⅝)

Private Collection

Lit: Butlin 1981, no.198 10

This image illustrates section 6, lines 40–9. Following a curse by Tiriel, Hela's hair is transformed into snakes (lines 44–5, E.283):

> … her dark hair upright stood while snakes infolded round
> Her madding brows. her shrieks apalld the soul of Tiriel.

27 Har and Heva Asleep with Mnetha Guarding them

Pen and ink and grey wash over pencil 19.2 × 28 (7½ × 11)

Lent by the Syndics of the Fitzwilliam Museum, Cambridge

Lit: Butlin 1981, no.198 11

This is another illustration of the infantile senility of Har and Heva. There are two separate sections in the poem that describe scenes of this nature. Section 2, line 9, refers to Har and Heva sleeping like infants 'delighted with infant dreams'. Section 7, line 21, similarly refers to the couple sleeping 'as babes. on loving breasts'.

28 Hela Contemplating Tiriel Dead in a Vineyard

Pen and ink and grey wash 17.8 × 27.1 (7 × 10⅝)

Private Collection

Lit: Butlin 1981, no.198 12

This image obviously illustrates the final scene, the death of Tiriel. However, in the manuscript Blake has Har and Heva standing by the body, which was 'outstretchd' at the door of Har's tent.

26

27

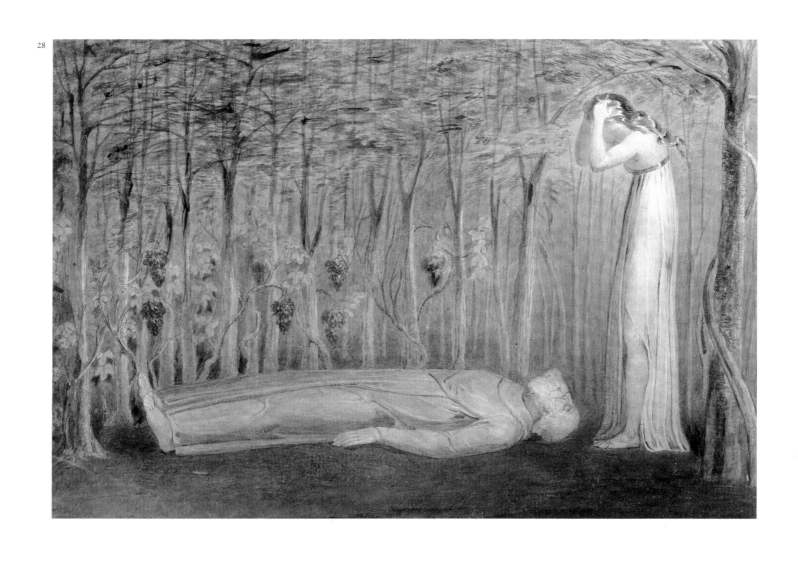

Illustrations to Edward Young's
The Complaint: or Night-Thoughts on Life, Death, & Immortality (1742–1745), *c.*1795–7

From the 1720s English writers began to explore the imaginative possibilities of the 'Gothic' world. Their works were characteristically melancholic and reflective, often set in graveyards, with the over-arching themes of human mortality and salvation. The pioneers of the new literary style earned the sobriquet 'graveyard poets'. Such examples as Thomas Parnell's *Night-piece on Death* (1721), Edward Young's *The Complaint: or, Night-Thoughts on Life, Death, & Immortality*, Robert Blair's *The Grave* (1743) and Thomas Gray's *Elegy Written in a Country Church-Yard* (1751) continued to be highly fashionable in Blake's lifetime. This is not surprising, as their subject and tone echoed a new emphasis in the late eighteenth century on the emotional and the irrational in art and literature that emerged with ideas about sensibility and the sublime. Indeed, part of the attraction of Young's *Night Thoughts* in particular was the relationship that Edmund Burke and others had made between 'darkness' and the production of 'sublime ideas'.

Blake was commissioned to produce illustrations not only for *Night Thoughts* but also for Gray's *Elegy* (for illustrations to Gray's poems see nos.37–40) and *The Grave* (no.16). And in his later years Blake produced a single watercolour image after James Hervey's *Meditations among the Tombs* (no.61). Hervey's popular work, in a similar vein to the 'graveyard poems', was first published in 1746.

By far the most ambitious of Blake's book illustrations, in terms of scale and number, are those he executed for *Night Thoughts*. Only a small selection is included here. Young's vast poem, in blank verse, comprises almost 10,000 lines divided into nine books, which meditate on (as the subtitle suggests) life's vicissitudes, death and immortality. In the text the poet contemplates the deaths of Lucia, Narcissa and Philander (loosely identified as Young's wife, his stepdaughter and her husband). As Young explains in his Preface, the three deaths act as a catalyst to his night-time musings:

> it [the poem] differs from the common Mode of Poetry, which is from long Narrations to draw short Morals. Here, on the contrary, the Narrative is short, and the Morality arising from it makes the Bulk of the Poem. The Reason of it is, That the Facts mentioned did naturally pour these moral Reflections on the Thought of the Writer.

Thus the poem is, in effect, an outpouring of Young's feelings as he reflects on the wider Christian theme of hope and salvation.

The commission for the illustrations was made probably in 1795 by the leading London bookseller, Richard Edwards (1768–1827), who intended producing a deluxe engraved version of the poem. His brother, Thomas Edwards, later commented that he was in possession of Young's own copy of *Night Thoughts*, which was autographed by the poet. It was this copy that was cut-up and mounted for Blake to then add his designs. Blake approached this immense task with enthusiasm, perhaps in the hope that such a commission, involving Young's celebrated poem, might lead to the fame and patronage he had hoped for. Within a space of approximately two years he had executed 537 watercolours. The designs were to have been engraved and published in four volumes. In the event Blake only engraved forty-three designs, selected from the first four *Nights*, in 1796 and 1797. These were printed in a single volume (1797). As with other publishing schemes of the 1790s, such as Henry Fuseli's 'Milton Gallery' and John Boydell's 'Shakespeare Gallery', the project was abandoned largely due to the financial constraints experienced during the war with France, which stifled artistic patronage and ended the lucrative export trade.

As with *Paradise Lost* (nos.258–68) and the *Divine Comedy* (nos.68–96), Blake engaged yet again with a poem whose subject and language suited his temperament and imaginative skills. Blake made a virtue of the rather awkward format to produce compositions that are astonishingly inventive and diverse. The relationship between the poem and the illustrations constitutes a role reversal; the design – instead of occupying a specific section of the page or restricted to the borders – literally envelopes the text, which is visually subordinate. His compositions are thus uninhibited by the text panel, and figures often move freely behind it (no.33).

Blake was never an uncritical reader. Although the general theme of *Night Thoughts* was to his taste, occasionally he did reinterpret and add emphasis to compensate for, in Blake's view, a tendency in the text to over-rationalise and moralise. He gave emphasis to the poem as a Christian narrative by including numerous images of Jesus Christ; for example, at the beginning of both volumes of the collected watercolour designs Blake added images of the Resurrection of Christ, a subject of minor interest in the poem. Blake also added details that had resonance as part of his own philosophy. In Night VIII, page 14 (no.35), he illustrates the lines, 'Ah! What avails his Innocence? The Task / Injoin'd, must discipline his early Pow'rs', by showing a youth being instructed by an older man holding a pair of compasses, a device used in *The Ancient of Days* (no.297), *Newton* (no.249) and in *There is No Natural Religion* (no.107) to symbolise the limiting of creation by reason without imagination. CR

Lit: Keynes 1927; Bindman 1977, pp.109–13, pls.90–3; Butlin 1978, pp.66–71; Erdman and Grant 1980; Butlin 1981, pp.178–255, nos.330–4; Hamlyn 1996

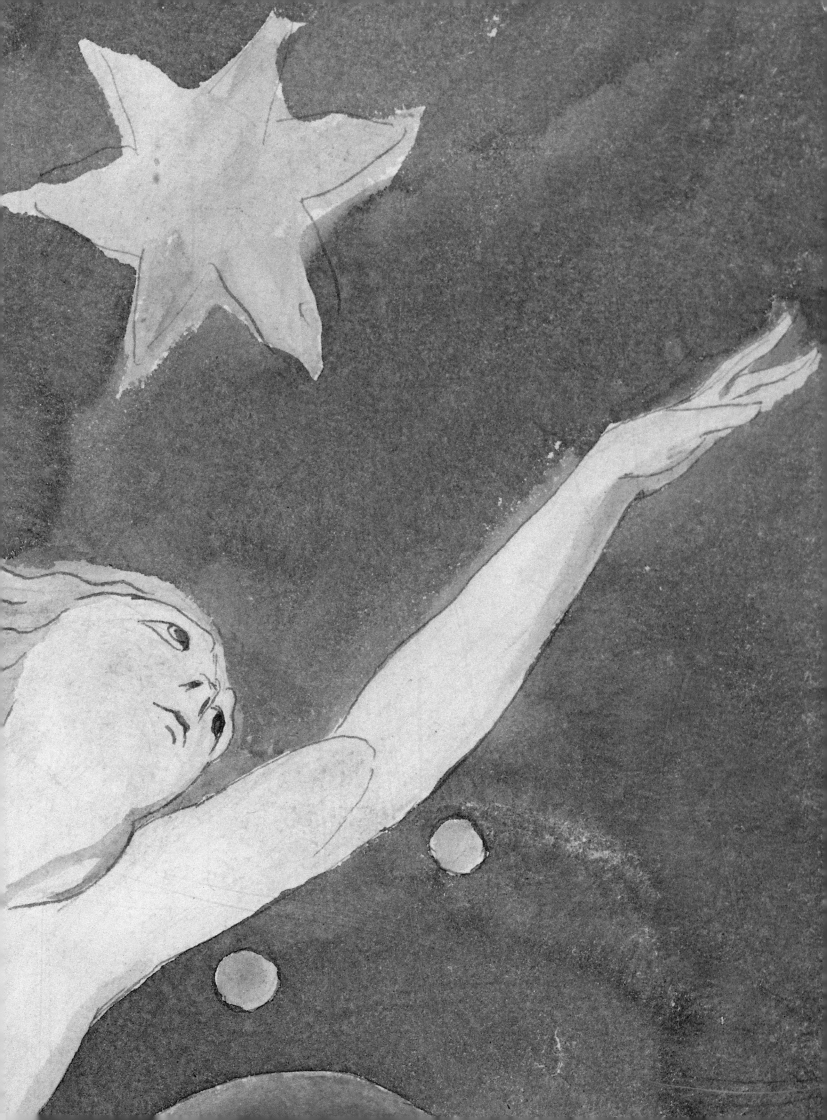

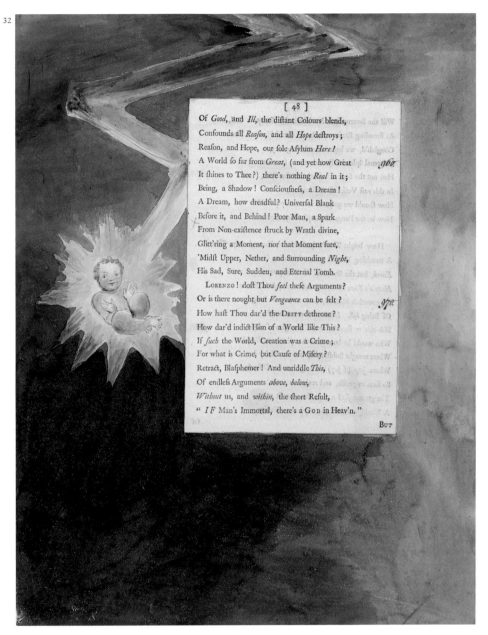

[48]

Of *Good*, and *Ill*, the diftant Colours blends,
Confounds all *Reafon*, and all *Hope* deftroys ;
Reafon, and Hope, our fole Afylum *Here !*
A World fo far from *Great*, (and yet how Great *960.*
It fhines to Thee ?) there's nothing *Real* in it ;
Being, a Shadow ! Confcioufnefs, a Dream !
A Dream, how dreadful ? Univerfal Blank
Before it, and Behind ! Poor Man, a Spark
From Non-exiftence ftruck by Wrath divine,
Glitt'ring a Moment, nor that Moment fure,
'Midft Upper, Nether, and Surrounding *Night*,
His Sad, Sure, Sudden, and Eternal Tomb.

 Lorenzo ! doft Thou *feel* thefe Arguments ?
Or is there nought, but *Vengeance* can be felt ? *970.*
How haft Thou dar'd the Deity dethrone ?
How dar'd indict Him of a World like This ?
If *fuch* the World, Creation was a Crime ;
For what is Crime, but Caufe of Mifery ?
Retract, Blafphemer ! And unriddle *This*,
Of endlefs Arguments *above, below,*
Without us, and *within,* the fhort Refult,
" I F Man's Immortal, there's a God in Heav'n. "

 But

Night Thoughts

Each: pen and black ink and watercolour over pencil on paper approx. 42 × 32.5 (16½ × 12¾), cut-out with ruled red ink lines approximately 22.5 × 15 (8⅞ × 5⅞) framing letterpress page
The British Museum, London
Blake almost always marked the lines he proposed illustrating and these are quoted here. CR

29 *Night Thoughts,* **Night V, page 11**
'*Truths,* Which Eternity lets fall on Man / With double Weight, through these revolving Spheres, / This Death-deep Silence, and incumbent Shade.' (lines 73–5)
Lit: Butlin 1981, no.330 166
By showing a figure ('And thy dark Pencil, *Midnight*! darker still / In Melancholy dipt') handing down a book to a waking man in bed, Blake seems to be making a reference to Young and the inspiration of his *Night Thoughts*.

30 *Night Thoughts,* **Night VI, page 36**
'*Nature* revolves, but Man *advances*; Both / Eternal, *that* a Circle, *this* a Line.' Nature is shown as a ringed serpent, the traditional symbol of eternity; from it 'Th' aspiring soul / Ardent, and tremulous, like Flame, ascends;' (lines 692–3)
Lit: Butlin 1981, no.330 257

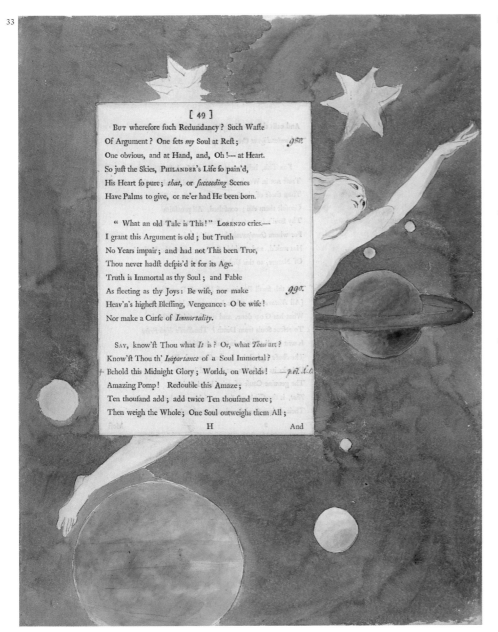

33

33

31 *Night Thoughts*, **Night VI, page 37**
'Here, dormant Matter, waits a call to Life; /
Half-life, half-death join There; Here, Life and
Sense.' (lines 722–3)
Lit: Butlin 1981, no.330 258
Blake shows a figure that is half-human, half-
tree. Butlin comments that 'Dormant matter,
or a state of half-death, is typified by Blake as
the roots and branches of a tree, symbolising
vegetative [i.e. material] existence' (Butlin
1978, p.69).

32 *Night Thoughts*, **Night VII, page 48**
'Before it, and Behind! Poor Man, a Spark / From
Non-existence struck by Wrath divine'
(lines 964–5)
Lit: Butlin 1981, no.330 320
Blake shows a lightning streak terminating in a
spark containing a babe.

33 *Night Thoughts*, **Night VII, page 49**
'So just the Skies, PHILANDER'S Life so pain'd'
(line 982)
Line 995 is marked with a cross and has a note
'–p.61 L.12': 'Behold this Midnight Glory;
Worlds, on Worlds!'
Lit: Butlin 1981, no.330 321

34 *Night Thoughts*, **Night VII, page 72**

'*Hope*, like a Cordial, innocent, tho' strong, /
Man's Heart, at once, *inspirits*, and *serenes*.'
(lines 1465–6)
'Tho' quite forgotten Half your *Bible's* Praise'
(line 1477) alludes to the poetic nature of
the Bible.

Lit: Butlin 1981, no.330 344

Blake shows a six-winged angel, 'Hope',
inspiriting a kneeling writer, who may be a poet
– perhaps an allusion to Blake himself.

35 *Night Thoughts*, **Night VIII, page 14**

'Ah! What avails his Innocence? The Task /
Injoin'd, must discipline his early Pow'rs'
(lines 258–9)

Lit: Butlin 1981, no.330 360

A seated man with a pair of compasses indicates
to a frowning child a triangle.

36 *Night Thoughts*, **Night IX, page 56**

'What Knots are ty'd? How soon are they
dissolv'd, / And set the seeming marry'd Planets
free?' (line 1142)

Lit: Butlin 1981, no.330 474

Here Blake shows his enduring interest in the
Gothic by the repetition and stylised nature of
the angels. This design might be a reference to
Newtonian ideas on planetary motion, and thus
should be viewed in relation to Blake's image of
'Newton' (no.249).

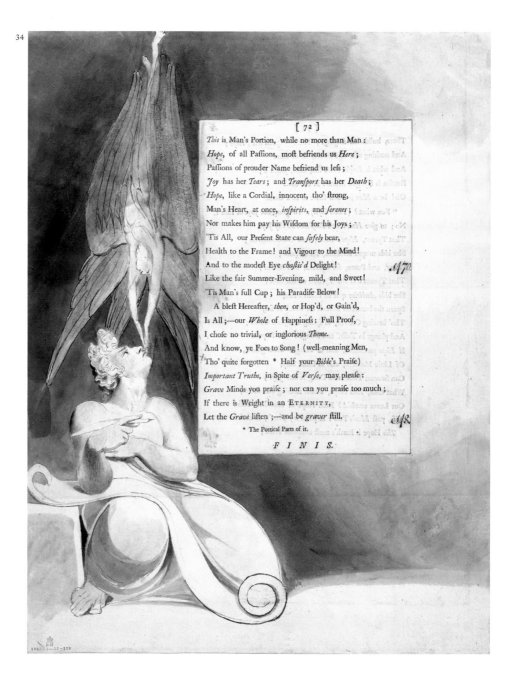

34

[72]

This is Man's Portion, while no more than Man :
Hope, of all Passions, most befriends us *Here* ;
Passions of prouder Name befriend us less ;
Joy has her *Tears* ; and *Transport* has her *Death* ;
Hope, like a Cordial, innocent, tho' strong,
Man's Heart, at once, *inspirits*, and *serenes* ;
Nor makes him pay his Wisdom for his Joys ;
'Tis All, our Present State can *safely* bear,
Health to the Frame ! and Vigour to the Mind !
And to the modest Eye *chastis'd* Delight ! 1470
Like the fair Summer-Evening, mild, and Sweet !
'Tis Man's full Cup ; his Paradise Below !

 A blest Hereafter, *then*, or Hop'd, or Gain'd,
Is All ;––our *Whole* of Happiness : Full Proof,
I chose no trivial, or inglorious *Theme*.
And know, ye Foes to Song ! (well-meaning Men,
Tho' quite forgotten * Half your *Bible's* Praise)
Important Truths, in Spite of *Verse*, may please :
Grave Minds you praise ; nor can you praise too much ;
If there is Weight in an ETERNITY,
Let the *Grave* listen ;––and be *graver* still.
 * The Poetical Parts of it.

 F I N I S.

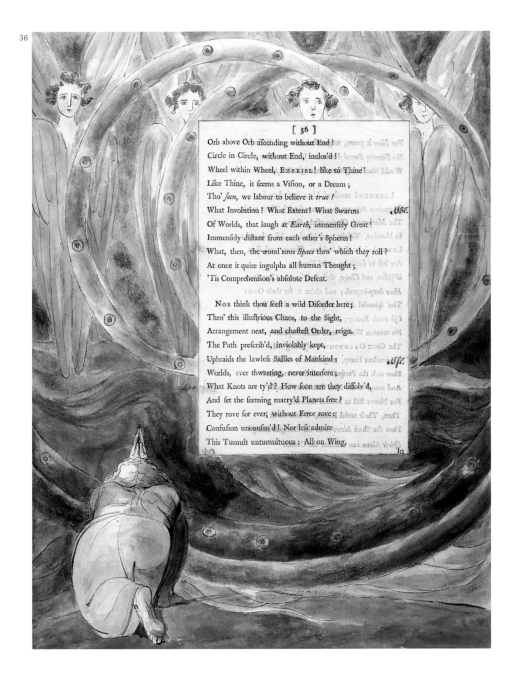

[56]

Orb above Orb ascending without End !
Circle in Circle, without End, inclos'd !
Wheel within Wheel, Ezekiel ! like to Thine !
Like Thine, it seems a Vision, or a Dream ;
Tho' *seen*, we labour to believe it *true* !
What Involution ! What Extent ! What Swarms
Of Worlds, that laugh at *Earth*, immensely Great !
Immensely distant from each other's Spheres !
What, then, the wond'rous *Space* thro' which they roll ?
At once it quite ingulphs all human Thought ;
'Tis Comprehension's absolute Defeat.

Nor think thou seest a wild Disorder here ;
Thro' this illustrious Chaos, to the Sight,
Arrangement neat, and chastest Order, reign.
The Path prescrib'd, inviolably kept,
Upbraids the lawless Sallies of Mankind :
Worlds, ever thwarting, never interfere ;
What Knots are ty'd ? How soon are they dissolv'd,
And set the seeming marry'd Planets free ?
They rove for ever, without Error rove ;
Confusion unconfus'd ! Nor less admire
This Tumult untumultuous : All on Wing,

In

Illustrations to Thomas Gray's poems, *c*.1797–8

Each: pen and watercolour over pencil on paper, approx. 42 × 32.5 (16½ × 12⅞), framing letterpress page
Paul Mellon Collection, Yale Center for British Art

Blake's friend John Flaxman commissioned this series of illustrations to the collected poems of Thomas Gray (1716–71) for his wife Nancy. The commission was almost certainly inspired by Blake's *Night Thoughts* designs, *c*.1795–7, or perhaps was encouraged by Henry Fuseli, who preferred Gray's poetry to Young's. As early as 1771 Fuseli had illustrated *The Descent of Odin* by Gray and in 1775 dismissed *Night Thoughts* as 'Pyramids of dough'.

As with *Night Thoughts*, pages from a copy of Gray's poems (1790 edition) were separated and put onto paper. Blake then composed his designs *around* the printed page. He also marked in the margins the lines from the text that would be illustrated. And again the designs make a virtue of the format, with figures moving freely behind the text panel (no.40) or sitting cheekily on top (no.37).

Blake completed 116 designs. Unlike those for *Night Thoughts*, there appears to have been no intention of engraving them. Although the format is similar, the subjects of Gray's poems (and thus Blake's treatment of them) are more varied than *Night Thoughts*. Blake moves from mythological figures to humanoid cats and reptilian goldfish (no.37), from fashionably dressed ladies and gentlemen to moody gothic architecture (no.38). Nancy Flaxman concluded that 'He has treated his Poet most Poetically'. CR
Lit: Tayler 1971; Bindman 1977, pp.109, 113–14, 182, 185; Butlin 1978, pp.66, 72–4; Butlin 1981, p.178; no.335, pp. 255–74

37 'Ode on the Death of a Favourite Cat. Drowned in a Tub of Gold Fishes', title-page
Blake executed six designs for this poem.
Lit: Butlin 1981, no.335 7

The poem commemorates the death of Horace Walpole's cat Selima, who drowned, as the subtitle states, in a goldfish bowl. Gray, however, makes allusions to the proverbial similarities between women and cats, i.e. their vanity and self-indulgence, thus additionally making the poem a cautionary tale on females and temptation: 'What female heart can gold despise? / What cat's averse to fish?'

In this illustration Blake underlines the double meaning of Gray's poem by humanising the cat, which wears a shawl and a corset. The goldfish have been transformed into scaly, anthropomorphic figures. CR

38 'A Long Story', page 3
Blake executed twelve designs for this poem.
Lit: Butlin 1981, no.335 25

First published in 1753, this poem was inspired by the visit of two distinguished ladies to Gray's house, who, on finding him not at home, left their cards so that he could return the visit. Gray expanded on this short episode to produce a work in the spirit of mock romance and fairy-tale. No.38 illustrates the text:

> In Britain's isle, no matter where,
> An ancient pile of building stands:
> The Huntingtons and Hattons there
> Employed the power of Fairy hands
>
> To raise the ceiling's fretted height,
> Each pannel [*sic*] in atchievements
> [*sic*] clothing,
> Rich windows that exclude the light,
> And passages, that lead to nothing.

Blake's whimsical composition shows the fairies at work amongst the ogee arches and fan vaulting of the Gothic architecture. CR

39 'The Bard: A Pindaric Ode', title page
Blake executed fourteen designs for this poem.
Lit: Butlin 1981, no.335 53

This famous poem, the first of four poems in the series of illustrations with legendary themes ('The Bard', 'The Fatal Sisters', 'The Descent of Odin' and 'The Triumphs of Owen'), tells the story of a bard, who, standing on a rock above the River Conway, confronts King Edward I of England, as he returns with his victorious army from the conquest of Wales. The king had previously condemned all the bards to death. The bard, the lone survivor, prophesies the downfall of the king's family and the return of the Welsh to the English throne (as represented by the Tudor dynasty). This return also heralds the renaissance of native poetry. The bard then plunges to his death.

Blake was fascinated by this poem, which was also the subject of an earlier watercolour exhibited at the Royal Academy in 1785 (now lost) and a tempera painting shown in his exhibition of 1809 (no.221). The image of the bard often appears in Blake's work and was a figure with whom he identified, as in 'The Song of the Bard', plate 54 in *Songs of Innocence and of Experience* (p.268).

In this illustration Blake shows the bard as an idealised representation of 'the poet', exuding visionary authority. He wears a blue robe spangled with stars, an allusion to the occult nature of his power and knowledge, and holds a large harp (symbol of Wales), as he gazes out from the rocks over the river. CR

40 'The Bard: A Pindaric Ode', page 7
Lit: Butlin 1981, no.335 59

This design illustrates the bard's prediction concerning the future King Edward III:

> From thee be born, who o'er thy
> country hangs
> The scourge of Heav'n.
> What terrors round him wait!
> Amazement in his van, with
> flight combin'd,
> And Sorrow's faded form, and
> Solitude behind.

Blake shows the king (almost a Urizenic figure), 'the scourge', with a whip (or scourge) ready to strike, and the 'terrors' themselves terrified: 'Amazement' looking upwards with 'Flight' on the right, the bent figure of 'Sorrow' on the left, and 'Solitude' in the distance, far left. CR

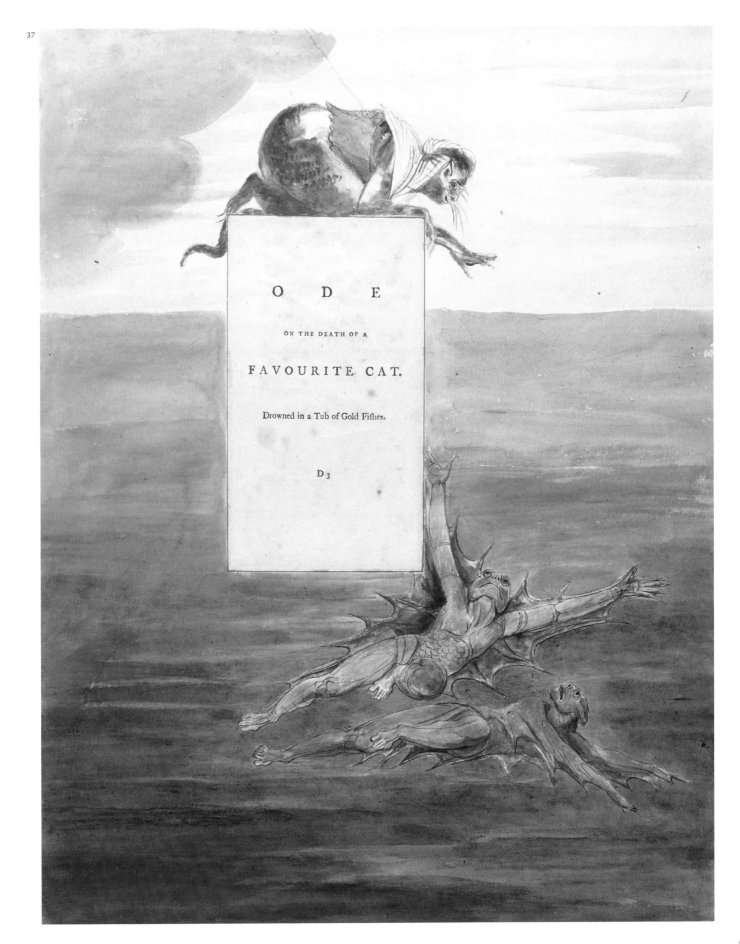

ODE

ON THE DEATH OF A

FAVOURITE CAT.

Drowned in a Tub of Gold Fishes.

D 3

Biblical subjects 1799–1810

The Bible was one of Blake's most important sources of subject matter and he produced hundreds of drawings and paintings on biblical themes. One hundred and thirty-five of these were commissioned by Thomas Butts (1757–1845), Blake's most significant patron. Butts was a civil servant who commissioned Bible subjects from Blake for about a decade following their meeting around the mid-1790s, but particularly in the period 1799–1805. Blake's main series of Bible illustrations for Butts seem to have ended in 1809, when his patronage continued with the commissioning of replicas of the *Milton* series.

For Blake the Bible was not a simple record of historical events, nor even a form of spiritual document, but the embodiment of the whole history of mankind, past, present and future. The Bible provided the key to understanding everything, for all time: 'The Hebrew Bible & the Gospel of Jesus are … Eternal Vision or Imagination of All that Exists' (*A Vision of the Last Judgment*, E.554). As ever, Blake conceived the spiritual and the creative to be inextricably united; the Bible was itself the greatest work of poetry: 'The Jewish & Christian Testaments are An original derivation from the Poetic Genius' (*All Religions are One*, Principle 6; E.1). In Blake's view the Bible formed the basis of true art, as opposed to the false, pagan art of Classicism. His Bible illustrations can be subdivided into groups, the most important dealing with the Life of Christ, apocalyptic subjects from the Book of Revelation, and Old Testament subjects that pre-shadow Christ's life (an approach suggested in the later *Allegory of the Spiritual Condition of Man*, no.60). It is, however, unclear whether Blake was following a programme, or how Butts intended to display these works.

The earliest Bible illustrations painted for Butts date from around 1799 to 1803 and were done in tempera, using a technique that Blake later called 'fresco'. Blake painted around fifty such works, thirty of which are known today. The main subject of these works is the Life of Christ, with some Old Testament subjects. From 1800 Blake was also producing an even more extensive series of watercolours on biblical subjects for Butts. About eighty of these are known, mostly from 1800–5, though a few can be dated later, up to 1809. These vary considerably in their style and treatment, from the boldly worked pieces from around 1800 to the more carefully worked examples from 1805 and later. Watercolour, as a medium that could not be adjusted and reworked like oil painting, and as a mode of colouring rather than 'blotting and blurring' drawing, also resonated for Blake with a sense of authenticity and honesty; indeed, fresco could be classified as a form of watercolour (see *Advertisement*, E.527).

The temperas and watercolours have a wide range of stylistic sources, from Rembrandt and seventeenth-century Dutch art through to the Antique and Early Renaissance. The rigidity and stylisation of many of the figures show a particular debt to Gothic art. In terms of subject matter the series is relatively traditional, with many of the subjects having specific pictorial precedents. As a whole, the Bible illustrations testify to Blake's enduring wish to be taken seriously as a history painter. Although the Butts commission provided the immediate stimulus to the biblical series, they also reflect a change in Blake's personal and religious outlook. After the pessimism of the mid-1790s, this period saw Blake developing a more positive view. The possibility of salvation through Christ is a running theme throughout his Bible illustrations. MM

Lit: Bindman, 1977, pp.117–31, 141–4; Butlin 1981, pp.316–72, nos.376–526

The Old Testament

41 The Angel of the Divine Presence Bringing Eve to Adam *c.1803*
Watercolour, pen and black ink over pencil
41.8 × 32.3
Signed with monogram b.l. 'WB inv'
Metropolitan Museum of Art: Rogers Fund, 1906
Lit: Butlin 1981, no.435

This watercolour, painted for Thomas Butts *c.*1803, ultimately derives from Genesis 2: 22: 'And the rib, which the LORD God had taken from man, made he a woman, and brought her unto the man.' Unlike conventional depictions of Eve's creation in which the first woman is shown emerging from Adam's side, Blake depicts Eve arriving in Eden fully formed in this watercolour. In a scene that evokes a ritual of marriage, the Angel of the Divine Presence presents to Adam a golden-haired creature who meets and returns the wide-eyed, evidently pleased gaze of her future mate. Elements of the landscape enhance the meaning of the scene: grape vines symbolise marriage, vividly plumed birds represent their newly created souls, and a giant oak leaf forecasts their future suffering. EEB

42 David Delivered out of Many Waters *c.1805*
Pen and watercolour 41.5 × 34.8 (16⅜ × 13¾)
Signed 'WB' b.l.
Tate; presented to the National Gallery by G.T. Saul 1878; transferred to the Tate Gallery 1909
Lit: Butlin 1981, no.462; Butlin 1990, no.41

The extraordinary symbolism of this illustration of a number of passages from Psalms 18 was unprecedented in modern art, and can only have appeared in medieval religious decorations. The stylised treatment of the figures and repetitive pictorial rhythm show how far Blake felt freed from the constraints of naturalistic representation. The cherubim embody the Seven Eyes of God, who, together with the flying Christ figure, represent the ideal form of redemption. The figure at the bottom of the composition is David as an old man, being delivered out of the waters. The outstretched arms of David and of Christ foreshadow the Crucifixion. MM

Opposite: 'Eve Naming the Birds' *c.*1810 (no. 58, detail)

43 Job and his Daughters c.1799–1800

Pen and tempera on canvas 25.8 × 37.1
(10⅛ × 14⅝)
on stretcher 27.3 × 38.4 (10¾ × 15⅛)
National Gallery of Art, Washington, Rosenwald
Collection 1943.11.11
Lit: Butlin 1981, no.394

The story of Job, drawn from the biblical book
of Job and the apocryphal Testament of Job, was
the subject of two major cycles of illustrations
by Blake. The first was the series of twenty-one
watercolours for Thomas Butts largely dating
from 1805–6 (but with two executed in the
1820s), and another series of twenty-one for
John Linnell (no.218). This tempera dates from
1799–1800 and represents Job telling the story of
his tribulations to his three daughters. Behind
the figure of Job are three panels showing his
experiences; to the left, the destruction of his
servants by the Chaldeans, with Satan overhead;
to the right, the destruction of Job's ploughman
by Satan; and in the centre, 'The Lord Answering
Job out of the Whirlwind' – a design that
appears as a separate illustration in Blake's
Job series of engravings (no.218). The theme
can be seen as the transformation of experience
into art: it illustrates Job making a story out
of his life, and also has Blake referring to his
own art. MM

43

The New Testament

44 The Angel Gabriel Appearing to Zacharias c.1799–1800

Pen and ink, tempera and glue size
on canvas 26.7 × 38.1 (10½ × 15)
Signed 'WB' b.l.
Metropolitan Museum of Art; bequest of
William Church Osborn, 1951
[not exhibited at Tate Britain]
Lit: Butlin 1981, no. 400

Upon learning that his barren wife will bear a
child (St John the Baptist), the priest Zacharias is
struck mute. Blake painted this subject, taken
from Luke 1: 5–13, in the richly textured glue and
watercolour technique he later dubbed 'portable
fresco'. Its striking light effects may have been
inspired by Rembrandt. Bindman (1977, p.121,
126) has suggested that Blake may have
consulted an engraving after Rembrandt's
Christ Presented to the People in preparing this
design. EEB

45 The Flight into Egypt 1799

Tempera on canvas 41.5 × 52 (16⅜ × 20½)
Signed 'WB inv [in monogram] 179[9?]' b.r.
Lent by the family of George Goyder,
deceased 1997
Lit: Butlin 1981, no.404

This is one of the earliest of Blake's tempera
paintings, and among the most moving. The
subject is taken from Matthew 2: 13–14:

> And when they were departed, behold,
> the angel of the Lord appeareth to Joseph
> in a dream, saying, Arise, and take the
> young child and his mother, and flee into
> Egypt, and be thou there until I bring
> thee word: for Herod will seek the young
> child to destroy him. When he arose, he
> took the young child and his mother by
> night, and departed into Egypt.

MM

46 The Rest on the Flight into Egypt 1806

Watercolour, brush and wash, and pen and black
ink over pencil 34.9 × 36.6 (13¾ × 14½)
Signed '1806 WB inv' b.r.
Metropolitan Museum of Art; Rogers Fund,
1906
Lit: Butlin 1981, no.472

The Holy Family pauses on its travels in an
imagined landscape of lyric beauty, with verdant
hills, a winding river and distant pyramids
illuminated by the setting sun. According to the
apocryphal gospel of the pseudo-Matthew,
which inspired many depictions of the subject,
the enormous palm tree would bow its branches
and release its fruit to the weary travellers. Blake
drew on a long tradition of devotional imagery
in composing the present scene. The Virgin
seated on the ground nursing the infant Jesus
recalls Renaissance Madonnas; the erect pose
and elongated second toe of St Joseph resembles
classical sculpture; and the donkey derives from
a seventeenth-century engraving of the same
subject (and had already been used by Blake in
the large colour print *The Night of Enitharmon's
Joy*, no.250). EEB

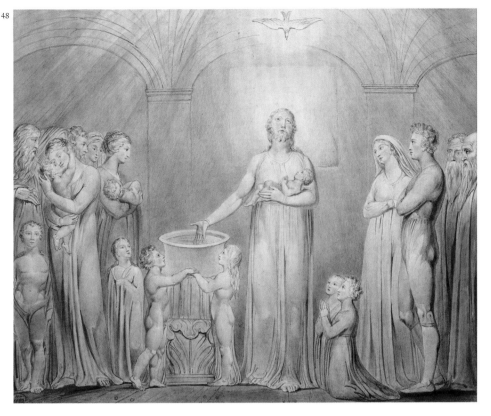

48

47 **Christ in the Carpenter's Shop: the Humility of the Saviour** *c.*1803–5
Pen and watercolour over pencil
31.5×34.5 (12½×13½)
Signed 'WB inv [in monogram]' b.l.
The New Art Gallery Walsall
Lit: Butlin 1981, no.474

The story of Christ in his father's carpenter's shop is apocryphal, originating in a very slight reference in Luke. The giant compasses that Christ holds appear elsewhere in Blake's work as a symbol of reason (see nos.35, 107, 249, 297). In this context the two parts of the compass may represent Christ's synthesis of reason and imagination or, if they are considered as dividers, perhaps what Blake viewed as Christ's wish to separate the 'Prolific' and the 'Devouring' (as in his earlier *Marriage of Heaven and Hell*, E.40). MM

48 **Christ Baptising 1805**
Pen and black ink and watercolour over pencil on paper 31.9×38.4 (12½×15⅛)
Signed 'WB inv [in monogram] 1805' b.l.
Philadelphia Museum of Art; gift of Mrs William T. Tonner
Lit: Butlin 1981, no.485

This is an allegorical interpretation of St John, 3: 22: 'After these things came Jesus and his disciples into the land of Judaea; and there he tarried with them, and baptized.' Blake provides a specific setting for this scene, suggestive of a church interior. MM

49 The Parable of the Wise and Foolish Virgins
c.1805
Watercolour, brush and wash, pen and black ink
over pencil 35.6 × 33.1 (14 × 13)
Signed 'WB inv' in monogram b.r.
Metropolitan Museum of Art: Rogers Fund, 1914
Lit: Butlin 1981, no.478

The subject is taken from Matthew 25: 1–13. As
the central maiden gestures towards the domes
of a distant city where her careless counterparts
might purchase oil for their neglected lamps, an
angel overhead heralds the imminent arrival of
the bridegroom, signalling the irreparable error.
This is the earliest of four versions of the subject
to be painted by Blake. It is composed within a
single plane resembling a classical low-relief
sculpture. Here the wise virgins' calm
composure contrasts markedly with the
agitation, movement and colour of their foolish
companions; in later depictions of the subject,
painted *c.*1822–5 for John Linnell, William
Haines and Sir Thomas Lawrence, Blake
heightened the emotion of the scene by
exaggerating the gestures of the figures and
increasing the intensity of the light effects. EEB

50 The Agony in the Garden *c.*1799–1800
Tempera on iron 27 × 38 (10⅝ × 15)
Signed 'WB inv' in monogram b.r.
Tate; presented by the Executors of W. Graham
Robertson through the National Art Collections
Fund 1949
Lit: Butlin 1981, no.425; Butlin 1990, no.38

This is an illustration of Luke 22: 41–4. Christ is
in the Garden of Gethsemane, just before his
betrayal by Judas: 'and there appeared an angel
unto him from heaven, strengthening him. And
being in an agony he prayed more earnestly: and
his sweat was as it were great drops of blood
falling down to the ground.' MM

51 The Crucifixion: 'Behold Thy Mother' *c.*1805
Pen and watercolour 41.3 × 30.0 (16¼ × 11¹³⁄₁₆)
Signed 'WB inv' in monogram b.l.
Tate; presented by the Executors of W. Graham
Robertson through the National Art Collections
Fund 1949
Lit: Butlin 1981, no.497; Butlin 1990, no.47

This illustrates a scene taken from John 19: 26–7:
'When Jesus therefore saw his mother, and the
disciple standing by, whom he loved, he saith
unto his mother, Woman, behold thy son! Then
saith he to the disciple, Behold thy mother! And
from that hour that disciple took her unto his
own home.' MM

**52 The Soldiers Casting Lots for Christ's
Garment 1800**
Pen and ink and watercolour with some
scratching out 42 × 31.4 (16½ × 12⅜) on paper,
irreg. 44 × 33.5 (17⅜ × 13¼)
Signed 'WB inv [in monogram] 1800' b.c.
Lent by the Syndics of the Fitzwilliam Museum,
Cambridge; given by the Executors of
W. Graham Robertson through the National Art
Collections Fund, 1949
Lit: Butlin 1981, no.495

The subject, from John 19: 23–4, shows the
Roman soldiers who put Christ to death
gambling for the last item of his clothing, his
cloak. The unusual device of showing the
crucified thieves flanking Christ is possibly
derived from Nicolas Poussin's 'Crucifixion' of
1643–4 (Wadsworth Atheneum), which Blake
could have seen in a London saleroom in 1794 or
known through an engraving. MM

53 The Body of Christ Borne to the Tomb
c.1799–1800
Tempera on canvas, mounted on card
26.7 × 37.8 (10½ × 14⅞)
Signed 'WB inv' in monogram b.l.
Tate; presented to the National Gallery by
F. T. Palgrave 1884; transferred to the Tate
Gallery 1934
Lit: Butlin 1981, no.426; Butlin 1990, no.39

The procession from Calvary is not described in
the Bible, so this scene is an invention of Blake's.
The prominent figure in the foreground
carrying a staff and jar is Joseph of Arimathea,
according to Blake the archetypal artist and the
founder of Christianity in England (see nos.2,
273, 275). MM

54 The Entombment *c.*1805
Pen and watercolour 41.7 × 31 (16½ × 12½)
Signed 'WB inv' in monogram b.l.
Tate; presented by the Executors of W. Graham
Robertson through the National Art Collections
Fund 1949
Lit: Butlin 1981, no.498; Butlin 1990, no.48

This work illustrates several lines from Luke and
John. The main source is Luke 23: 53, describing
Christ's body being wrapped in linen and laid in
the sepulchre, and 23: 55, mentioning the arrival
of the three Marys: 'And the women also, which
came with him from Galilee, followed after, and
beheld the sepulchre and how his body was laid.'
The figure kneeling on the left is Joseph of
Arimathea, while the standing bearded figure is
Nicodemus. Their presence in this scene was
suggested in John 19: 38–9. MM

55 Christ in the Sepulchre, Guarded by Angels
c.1805
Pencil, pen and ink and watercolour (approx.)
42 × 30.2 (16½ × 11⅞) on paper 43.2 × 31.7
(17 × 12½)
Signed 'WB inv' in monogram b.l.
The Victoria & Albert Museum
Lit: Butlin 1981, no.500

This watercolour is based on an obscure
reference in Exodus 25: 20: 'And the cherubims
shall stretch forth their wings on high, covering
the mercy seat with their wings, and their faces
shall look one to another; toward the mercy seat
shall the faces of the cherubims be.' The
composition makes explicit reference to Gothic
architecture and to the tombs of Countess
Aveline and of Aymer de Valence in Westminster
Abbey, which Blake had drawn during his
apprenticeship (see nos.5–15). This work was
shown at the Royal Academy in 1808, and along
with no.52, was also in Blake's exhibition of
1809–10, one of four he wished 'were in Fresco,
on an enlarged scale to ornament the altars of
churches' (*Descriptive Catalogue*, E.549). MM

55

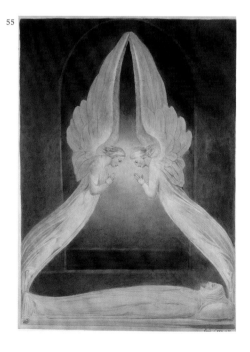

Opposite: 'Christ in the Sepulchre, Guarded by Angels'
*c.*1805 (no. 55, detail)

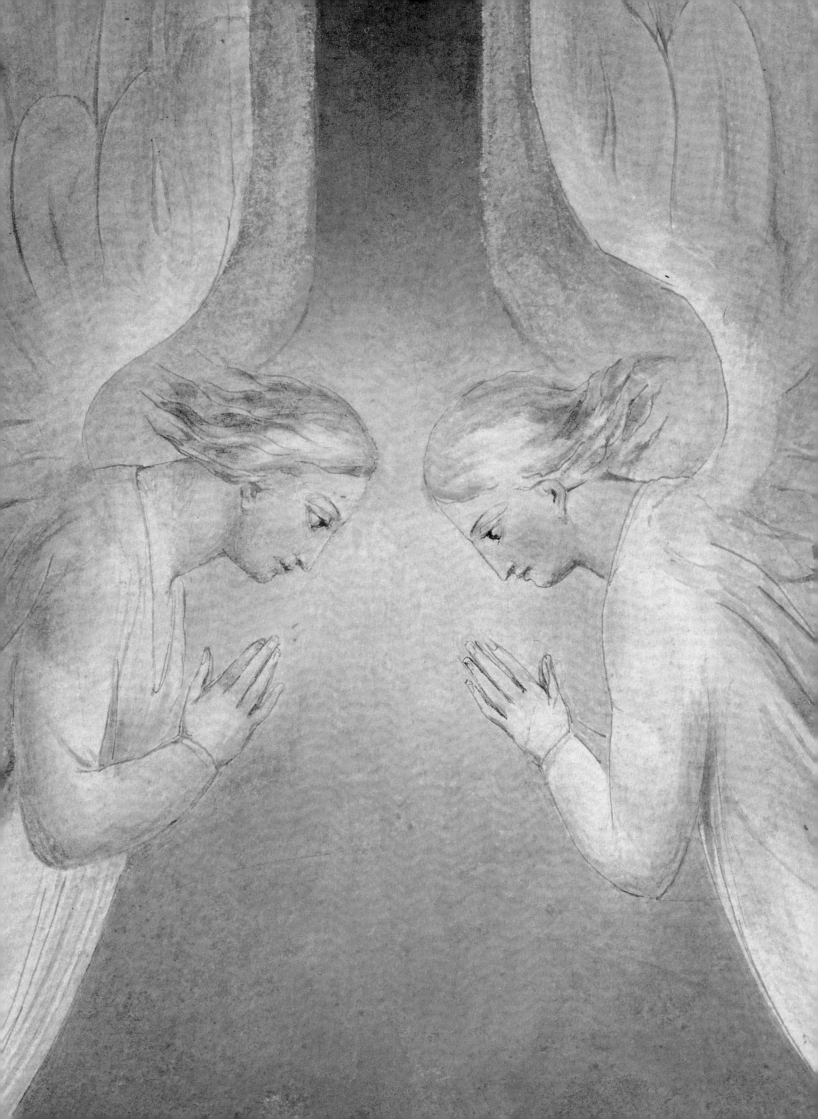

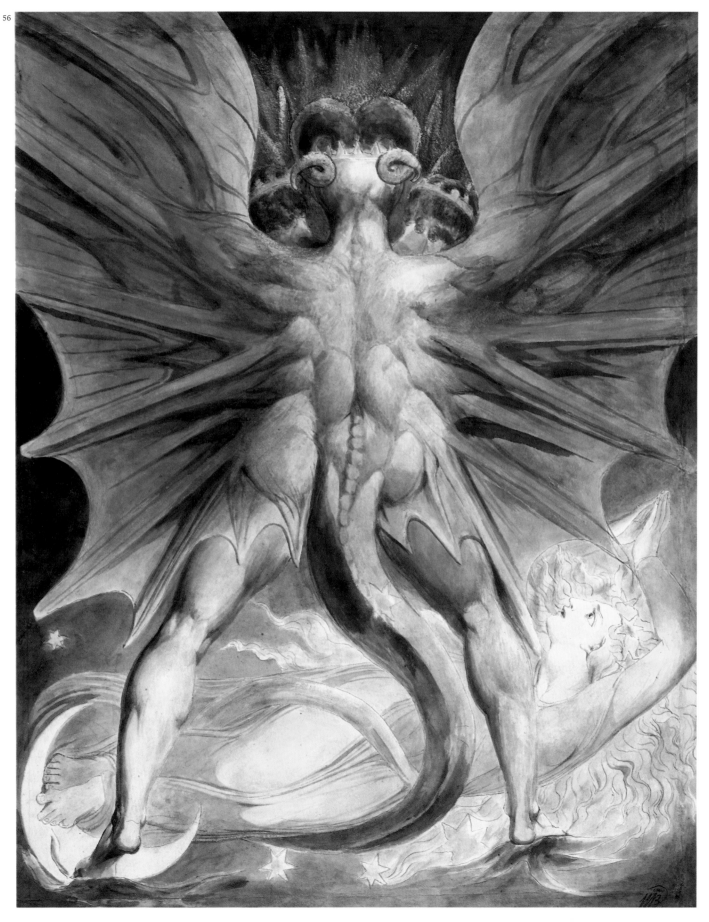

56 The Great Red Dragon and the Woman Clothed with the Sun *c.*1803–5

Watercolour and graphite 43.5×34.5 (17⅛×13½) on paper 54.5×43 (21½×17)

Signed 'WB inv' in monogram b.r.

Brooklyn Museum of Art; gift of William Augustus White

Lit: Butlin 1981, no.519

This is one of a group of watercolours by Blake from this date, showing incidents from Revelation. This image relates to Revelation 12: 1–4, with the Red Dragon waiting to devour the 'woman clothed with the sun, and the moon under her feet, and upon her head a crown of twelve stars'. The woman stands for Israel, pregnant with a child who will rule from a throne in heaven. MM

Later religious subjects

57 Adam Naming the Beasts 1810

Pen and tempera on fine linen 75×62.2 (29½×24½)

Signed 'Fresco by Willᵐ Blake 1810' t.r.

Glasgow Museums: Pollok House, The Stirling Maxwell Collection

Lit: Butlin 1981, no.667

This, and its companion *Eve Naming the Birds* (no.58), formed part of a group of four 'frescoes' painted for Thomas Butts around 1810. The others are *Virgin and Child in Egypt* (Victoria & Albert Museum, London) and *Christ Blessing* (Fogg Art Museum, Cambridge, Massachusetts). These four half-length figures, painted almost to life scale, together with the *Allegory of the Spiritual Condition of Man* (no.60), may have formed a distinct decorative scheme, complementing the earlier cycles of biblical illustrations. This pair of works could be said to represent the creation and fall of Man, while the other pair of the Virgin and Christ represents Man's salvation. MM

58 Eve Naming the Birds *c.*1810

Pen and tempera on fine linen 73×61.5 (28¾×24¼)

Glasgow Museums: Pollok House, The Stirling Maxwell Collection

Lit: Butlin 1981, no.668

This is the companion to no.57. Like its partner, the frontal pose and highly stylised features of this figure have a strongly archaic quality. MM

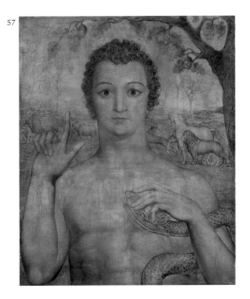

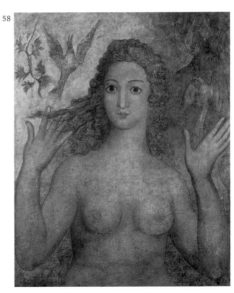

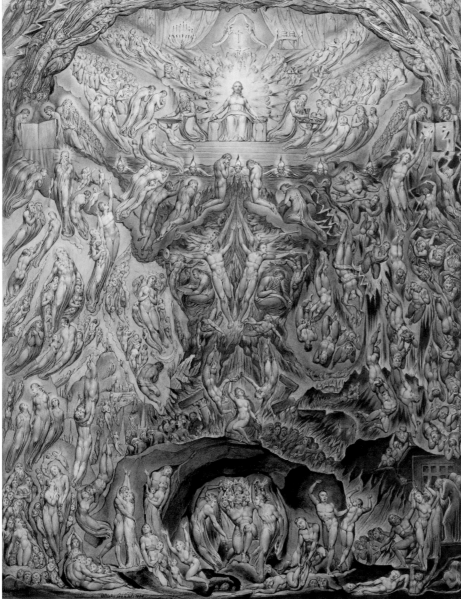

59 A Vision of the Last Judgment 1808

Pen and watercolour over pencil approx.
51×39.5 (20×15½)
Signed 'W Blake inv & del: 1808' b.l.
Petworth House, The Egremont Collection (The
National Trust – to which allocated by HMG, after
acceptance in lieu of tax)
Lit: Butlin 1981, no.642

Blake produced a number of versions on the theme
of the Last Judgement from 1806 to the end of his
life. These include *A Vision of the Last Judgment*, 1806
(Pollok House), *The Fall of Man*, 1807 (The Victoria &
Albert Museum), *The Last Judgment*, c.1809 (The
National Gallery of Art, Washington), as well as
'The Day of Judgment', from Blair's *The Grave*.

No.59 was commissioned by the Countess
of Egremont in 1807 on the advice of Ozias
Humphrey (1742–1810), the artist and patron of
Blake, exhibited at the Royal Academy in 1808
(one of only a few works by Blake to be exhibited
there). The picture was not reviewed but
nonetheless the exhibition of this work was one
way in which Blake could reassert his artistic
presence, having lost to Louis Schiavonetti the
commission to engrave his own designs for *The
Grave* (no.16), which were published in July 1808.

Blake described the composition, which is
closely based on the Pollok House version, in a letter
(now lost) to Ozias Humphrey, of which three drafts
survive (quoted in full in Butlin 1981, pp.467–8, and
E.552–4). The description begins as follows:

> Christ seated on the Throne of Judgment
> before his feet & around him the heavens
> in clouds are rolling like a scroll ready to
> be consumed in the fires of the Angels who
> descend with the[ir] Four Trumpets
> sounding to the Four Winds

Beneath the Earth is convulsed with the labours
of the Resurrection – in the Caverns of the Earth
is the Dragon with Seven heads & ten Horns
chained by two Angels, & above his Caverns on
the Earths Surface is the Harlot siezed & bound
by two Angels with chains.

The left side of the design shows the
'Resurrection of the Just' and the right, 'the
Resurrection & Fall of the Wicked'. Adam and Eve,
'representatives of the whole Human Race', kneel
in humiliation before the throne of Christ.

As with *An Allegory of the Spiritual Condition of
Man* (no.60) and the *Epitome of James Hervey's
'Meditations among the Tombs'* (no.61), the composition
is indebted to Michelangelo's *Last Judgment* in the
Sistine Chapel (see also no.2, for reference to
Michelangelo as 'One of the Gothic Artists'). CR

Opposite: 'A Vision of the Last Judgment' 1808 (no.59, detail)

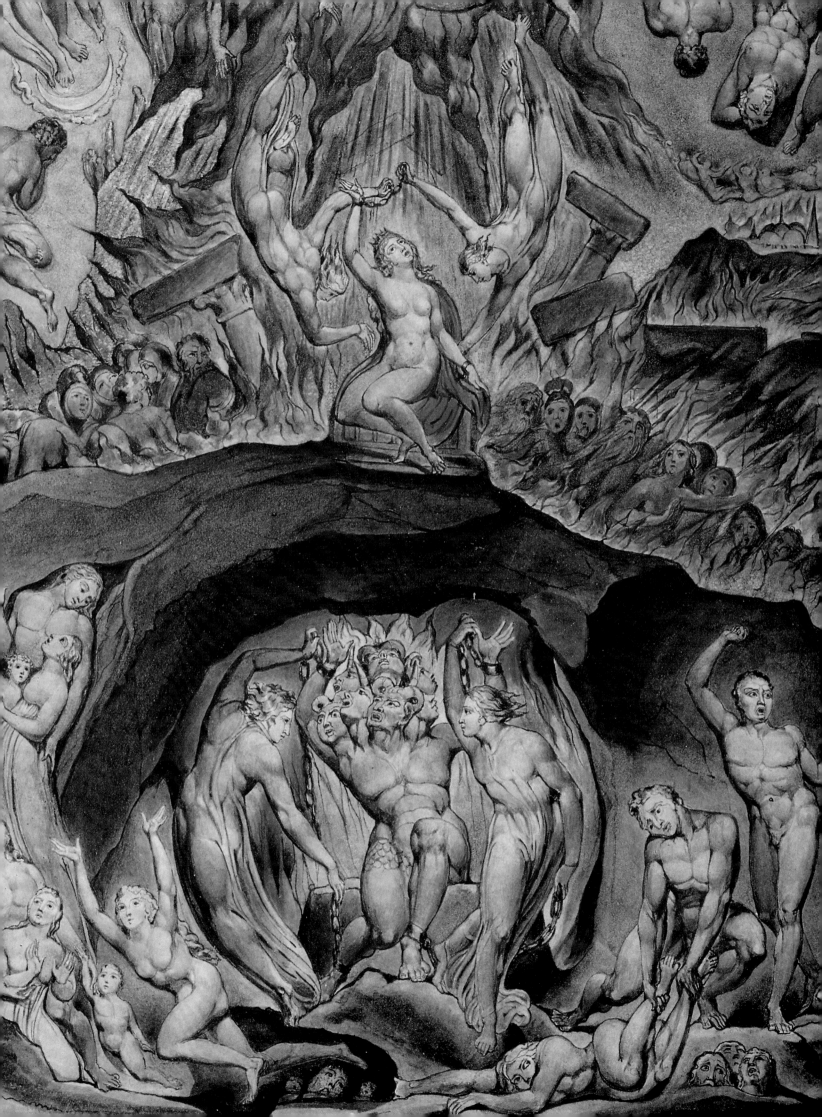

60 An Allegory of the Spiritual Condition of Man ?1811

Pen and ink and tempera on canvas
151.6 × 121.3 (59⅝ × 47¾)
Signed 'P[ainte]d in [fresc]o by Wᵐ[?] Blake 1811[?]
Lent by the Syndics of the Fitzwilliam Museum, Cambridge; given by the Executors of W. Graham Robertson through the National Art Collections Fund, 1949
Lit: Butlin 1981, no.673

This is the largest surviving picture by Blake. Like *A Vision of the Last Judgment* (no.59) and the *Epitome of James Hervey's 'Meditations among the Tombs'* (no.61), this is an elaborate representation of some kind of theological text, but no exact source has yet been identified. Consequently, much of the imagery remains mysterious. The three figures in the foreground have been identified as Faith, Hope and Charity, though the central figure's role as Charity is disputed. Instead, that figure and the rising figure above it may represent two different aspects of Charity. The latter figure is being carried up by angels towards the Holy Ghost. The theme of the picture may, therefore, be the redemption of the human soul through the Christian Virtues. Down the left-hand side a series of vignettes tells the story of Israel from the Creation to the Crucifixion. On the right-hand side there is a sequence showing the story of the Christ Redemption, from the Ascension to the Last Judgement. Read from top left down and from bottom right up, these add up to the complete story of man's progress from Creation to Redemption. The extensive landscape at the bottom of the image includes, to the left, a Druid's temple and a classical building, representing primitive and cultured religion respectively, and to the right, a shepherd, alluding to the themes of innocence and imagination. MM

61 Epitome of James Hervey's 'Meditations among the Tombs' *c.*1820–5

Pen and ink and watercolour with some gold on paper 43.1 × 29.2 (16¹⁵⁄₁₆ × 11½)
Signed 'W Blake inv & [?]…' b.l.
Tate; given by G. T. Saul to the National Gallery in 1878; transferred to the Tate in 1909
Lit: Butlin 1981, no.770; Butlin 1990, no.71

Together with *A Vision of the Last Judgment* (no.59) and *An Allegory of the Spiritual Condition of Man* (no.60), this small but complex image can be interpreted as a summation of Blake's understanding of the Bible. James Hervey (1714–58) was a Calvinist minister with strong links to Methodism and a popular religious writer, whose *Meditations among the Tombs* was first published in 1746. It was a great success and was republished many times into the nineteenth century. Blake first encountered the text in around 1784–5, and Hervey appeared in his *Jerusalem*, plate 72 (no.303). There he appears with Archbishop Fénelon, Madame Guyon, St Theresa of Avila and the Methodist George Whitefield as one of five Christian thinkers who guard the gate to Beulah (the state of the unconscious). Hervey, like his companions in *Jerusalem*, had a strong belief in the regeneration of the inner self, though *Meditations* also shares much of the melancholic spirit that infused Young's *Night Thoughts* (see nos.29–36) and Robert Blair's *The Grave* (no.16). Blake's painting attempts to encompass the whole of Hervey's reflections on bereavement, mortality and the Resurrection in a single image, but typically he uses his source matter as a starting point for a much more personal statement.

Fortunately, Blake introduced the names of each of the figures on the canvas. At the bottom of the image the figure with his back to the viewer is Hervey himself. To his left is the 'Angel of Providence' and to his right a 'Guardian Angel'. Hervey stands before an altar bearing the Eucharist, above which is Christ, flanked by Moses (the Law) and Elias (Divine Vision). Behind this group an enormous Gothic window rises, containing a spiraling staircase upon which a series of scenes from the Old Testament are played out, demonstrating the right and wrong ways to salvation. This leads upward to God the Father, here represented as a source of wrathful fire. The pillar of figures to the far left represents different stages of man's life rising up towards 'Mercy', assisted by angels. The similar grouping under the word 'Wrath' to the right includes 'Virgin', 'Widow', 'Lost Child', 'She died on the Wedding Day' and 'Orphan'. Despite the identification of almost every figure, the precise meaning of this image remains elusive. MM

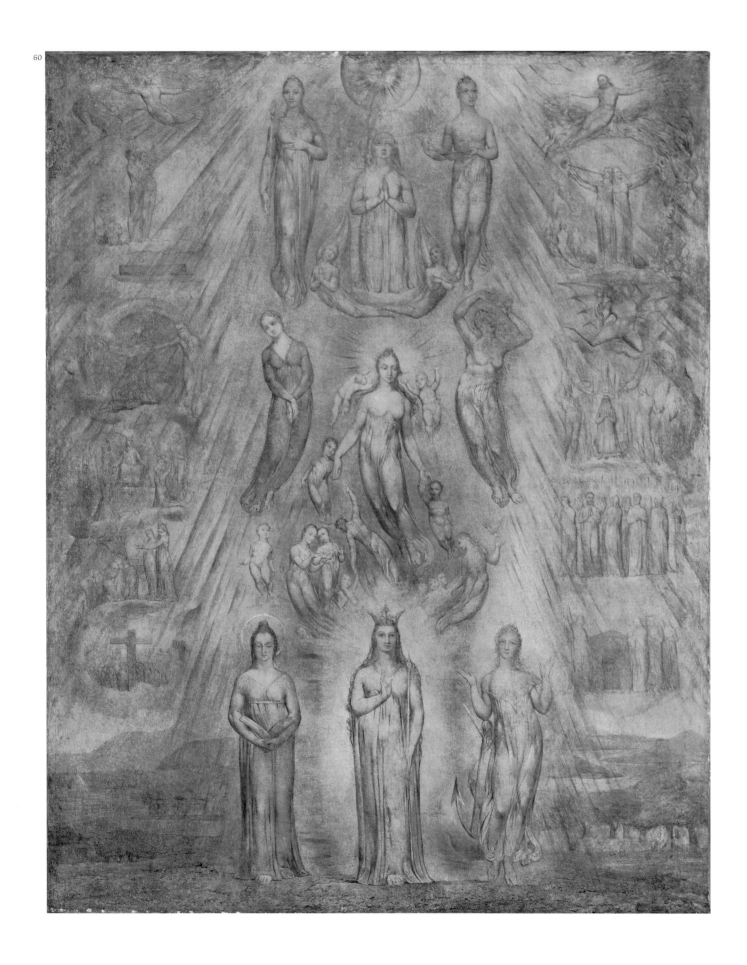

Chaucer's Canterbury Pilgrims

62 Sir Jeffery Chaucer and the Nine and Twenty Pilgrims on their Journey to Canterbury ?1808

Pen and ink and tempera on canvas 46.7×137 (18⅜×53¹⁵⁄₁₆)
Signed 'W Blake 180[8?]' b.l. in gold
Glasgow Museums: Pollok House, The Stirling Maxwell Collection
Lit: Butlin 1981, no.643; Essick 1983, no.XVI; Hamlyn and Moore 1993

Chaucer's *Canterbury Tales* is considered the first great work of English literature. Although the 'Gothic' qualities of Chaucer's text were sometimes condemned by critics who favoured regular and polished 'classical' verse, the vitality and sophistication of *The Canterbury Tales* ensured that it was generally held in high esteem. Blake's painting aims to encompass the whole of this long and complex literary work in a single image. It shows Chaucer and the twenty-nine pilgrims of *The Canterbury Tales* in procession, riding out from the Tabard Inn in Southwark at the beginning of their journey to Canterbury. From right to left they are: the Knight, the Squire with his Yeoman, the Abbess, her nun and three priests, the Friar, the Monk, the Tapiser, the Pardoner, 'Our Host' at the centre, then the Shipman, Haberdasher, Dyer, Franklin, Physician, Plowman, Lawyer, Parson, Merchant, the Wife of Bath, Miller, Cook, Oxford Scholar, Chaucer and finally the Reeve. For Blake, Chaucer had produced characters embodying timeless truths:

> The characters of Chaucer's Pilgrims are the characters which compose all ages and nations: as one age falls, another rises, different to mortal sight, but to immortals only the same; for we see the same characters repeated again and again, in animals, vegetables, minerals, and in men; nothing new occurs in identical existence; Accident ever varies, Substance can never suffer nor decay.
> (E.532)

Moreover, in his representation of a pilgrimage Chaucer was depicting the pilgrimage of mankind itself: 'Every age is a Canterbury Pilgrimage; we all pass on, each sustaining one or other of these characters; nor can a child be born, who is not of these characters of Chaucer.'

Blake's tempera painting originates in the failure of his 1806 scheme to publish a print of *Chaucer's Canterbury Pilgrims* as a commercial project. With the right marketing, single-plate publications could be enormously profitable. However, he changed his plans when he found out that Robert Cromek (see no.16) was planning to publish a print of the same subject by Thomas Stothard (no.63). Blake suspected that they had stolen the idea from him and set out instead to produce a tempera painting of the subject that would form a centrepiece for his own exhibition of works. This eventually opened at his brother James's shop in Golden Square in September 1809. The exhibition of sixteen works included a number of tempera paintings and watercolours borrowed back from Thomas Butts, and a much earlier work, *The Penance of Jane Shore* (see no.18). The exhibition was accompanied by a *Descriptive Catalogue*, which is one of the most important statements on art by Blake, detailing his beliefs about fresco painting, his artistic ideology and his views on modern art. His commentary on *Sir Jeffery Chaucer* provides a wealth of information about its symbolism and significance for Blake, but also sets out its purpose as a demonstration of his executive abilities, which had been publicly doubted, and as an attempt to win patronage for himself, rather than 'to get patronage for others' – obviously referring to Stothard (*Descriptive Catalogue*, E.537–8). On 15 May 1809 Blake had announced the publication of a print after his own painting in a *Prospectus*, and drafted an essay on art that he intended to present to an engraver's society (The Chalco-graphic Society) when it was published the following year. This is known as the *Public Address* and is a further testament to the way that the circumstances surrounding his production of this image stimulated Blake to his most coherent and vitriolic thinking about the state of the modern art world. MM

63 THOMAS STOTHARD (1755–1834)

The Pilgrimage to Canterbury 1806–7
Oil on oak panel 31.8×95.2 (12½×37½)
Tate; purchased by the National Gallery 1884
Lit: Hamlyn and Moore 1993

This was the painting executed by Stothard for publication as a print by Cromek. Stothard was one of the most commercially successful artists of his generation, bringing the latest stylistic and thematic innovations of high art into a decorative format highly suited to book illustration and decorative wares. Where Blake uses an insistent, and stylised, frontality in the presentation of his figures, Stothard employs more varied poses and a greater sense of pictorial depth, while exploiting the historic costumes for decorative effect. Blake's sources include early Netherlandish and German art, which he would have seen in the collection of Charles Aders, and perhaps the figures on the Parthenon frieze, familiar through engravings. Stothard is clearly indebted to more modern art. In his *Descriptive Catalogue* Blake took the opportunity to criticise Stothard and his picture, for example: 'The scene of Mr S—'s picture is by Dulwich Hills, which was not the way to Canterbury … but the painter's thoughts being always upon gold, he has introduced a character that Chaucer has not; namely, a Goldsmith' (E.540). Ultimately, Blake compares Stothard to the worldly artists Rembrandt and Rubens (who, of course, used oil paint), while Blake compares himself to Raphael and Michelangelo. MM

Opposite: 'Sir Jeffery Chaucer and the Nine and Twenty Pilgrims on their Journey to Canterbury' ?1808 (no.62, detail)

62
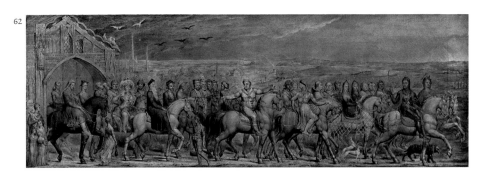

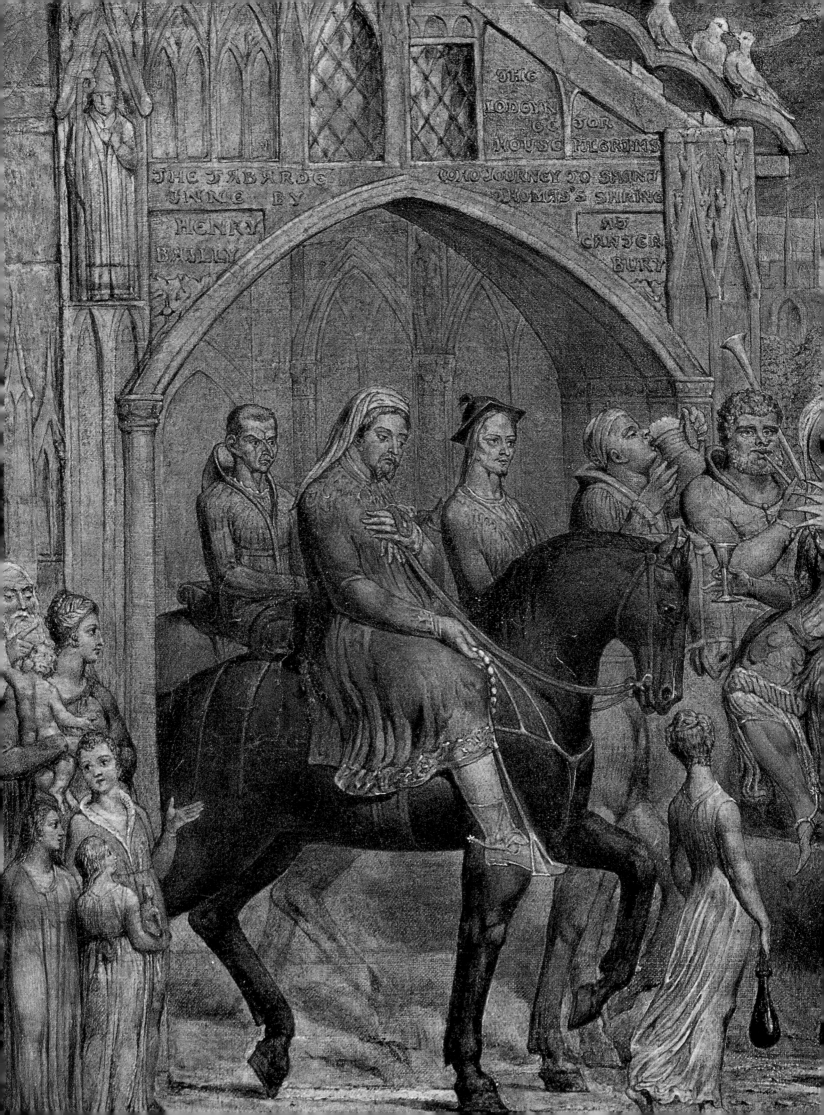

THE JABARDE
INNE BY
HENRY
BAILLY

THE
LODGYN
GG FOR
HOUSE PILGRIMS
WHO JOURNEY TO SHRINE
THOMAS'S SHRINE
AT
CANTER
BURY

Illustrations to Dante's
Divine Comedy, 1824–7

The *Divina Commedia* (*Divine Comedy*) is the most important work of the medieval Italian poet, Dante Alighieri (1265–1321). Completed just before his death, the epic poem comprises the *Inferno*, the *Purgatorio* and the *Paradiso*. As conceived by Dante, Hell is a succession of graduated circles in a pit to which categories of tortured sinners are eternally assigned. Purgatory is a mountain rising in circular ledges on which are placed various groups of repentant sinners. Dante the Pilgrim is guided through Hell and Purgatory by the ancient Roman poet, Virgil. At the top of the Mountain of Purgatory is the Earthly Paradise (Garden of Eden), where Dante encounters his idealised love, Beatrice. She guides him upwards through the heavenly spheres of the Blessed towards Paradise; a world of beauty, love and light, which leads ultimately to redemption.

Blake's illustrations to the *Divine Comedy* were commissioned by his friend and fellow artist, John Linnell (1792–1882). Work began in the autumn of 1824. The series was to have been published as engravings but by Blake's death in 1827 only seven plates had been engraved and the designs themselves were in various stages of completion. Nonetheless, with 102 in the main series of watercolours (and additional associated sketches) Blake had produced a substantial body of work. Why the vast majority – approximately three-quarters – illustrate scenes from the *Inferno* is not clear. Blake's intentions for the scheme as a whole are not known, but the ratio of seventy-two designs for the *Inferno*, twenty for the *Purgatorio* and ten for the *Paradiso* suggests that his death interrupted the production of other designs. In total the designs are certainly the most significant of Blake's unfinished projects and in general, by demonstrating the extraordinary power and breadth of his imagination, rank amongst his greatest achievements.

In the eighteenth century Dante was not always held in high esteem – or indeed read at all, because of the paucity of translations in English. In 1782 Horace Walpole described him as 'extravagant, absurd, disgusting, in short a Methodist parson in Bedlam'. However, by the time Blake embarked on his Dante project in 1824, Dante was more widely read in England than ever before. His rich and evocative text, and in particular the *terribilità* of his vision of Hell, had proved irresistible to leading artists from the second half of the eighteenth century, like Joshua Reynolds and Henry Fuseli. For example, Reynolds's *Ugolino and his Children in the Dungeon*

was exhibited at the Royal Academy in 1773 (see no.66). But the 1814 complete English translation of the *Commedia* by H. F. Cary made it available to a generation of Romantic poets and artists, such as Coleridge, Keats and Shelley, and the French painter Eugène Delacroix, whose *Barque of Dante* (Musée du Louvre) was exhibited in Paris in 1822 to great acclaim.

The first acknowledged translation into English of any part of the *Divine Comedy* was by the artist Jonathan Richardson, who produced a version of the tragic story of Count Ugolino (*Inferno*, XXXIII) in 1719. Chaucer had previously introduced the story to the English language by paraphrasing it in *The Canterbury Tales* (1380s). The Ugolino episode was favoured by subsequent translators, poets and also by artists.

Blake seems to have known Dante's work by about 1790; he would have been familiar with the Italian poet through his friends and acquaintances, such as Fuseli, Hayley and the sculptor John Flaxman. Blake's *Head of a Damned Soul* in Dante's '*Inferno*' (no.65) *c.*1788–90/1792 was engraved after Fuseli. Blake (possibly setting out to challenge Reynolds) had included his own version of the Ugolino episode for plate 12 in *The Marriage of Heaven and Hell* (1790–3, no.127) and plate 16 in *For Children: The Gates of Paradise* (1793, no.130), as well as in the background of his portrait of Dante (no.64), one in a series of eighteen Heads of Poets (*c.*1800–3) commissioned by the poet and biographer, William Hayley, who was also a pioneering translator of Dante into English. Blake certainly knew Flaxman's highly successful outline *Compositions* from Dante which were published in Rome (1793) and in London (1807). Indeed, in his *Public Address* (1809–10) Blake accused Flaxman of stealing his 'Dante' ideas for a number of these *Compositions* (E.572).

Although he was to express serious theological reservations about Dante, there is little doubt that Blake admired him as an 'artist'. In plate 22 of *The Marriage of Heaven and Hell* (no.127), for example, Dante was ranked alongside Shakespeare as a source for an 'infinite number' of volumes. Given the inherent 'otherworldliness' of the *Divine Comedy* and above all its themes of judgement and salvation, it seems inevitable that Blake should engage with Dante's text just as he had previously with Milton's *Paradise Lost* and *Paradise Regained*. However, it is highly unlikely – in his perennially impoverished state – that Blake could have embarked on such an ambitious project without first receiving a commission.

Having been commissioned by Linnell, Blake began reading the *Divine Comedy* in earnest. According to the diarist, Henry Crabb Robinson, Blake was using H. F. Cary's translation (probably the 1819 edition) when Robinson visited him on 17 December 1825. Blake had learnt Italian (to what extent is unclear) for the express purpose of reading Dante's work in the original. He used an Italian edition of the *Divine Comedy* (perhaps that of 1564, which has many woodcut illustrations in it), while referring to Cary's translation – and any other he had to hand – as a guide. The frontispiece to the 1564 edition has obvious links with Blake's illustration of the same subject (nos.68, 69).

After Blake's death Samuel Palmer, a fellow artist and Blake acolyte, wrote an account of a visit made to Blake's house on 9 October 1824:

> we [he and Linnell] found him lame in bed, of a scalded foot (or leg). There, not inactive, though [almost] sixty-seven years old, but hard-working on a bed covered with books sat he up like one of the Antique patriarchs, or a dying Michael Angelo. Thus and there was he making in the leaves of a great book (folio) the sublimest design from his (not superior) Dante. He said he began them with fear and trembling … He designed them (100 I think) during a fortnight's illness in bed! (BR.313)

How far Blake's designs go beyond straightforward illustration to form a commentary on Dante's text has been the subject of much debate. His annotations and his conversations with Crabb Robinson on the subject of Dante underline Blake's fundamental objections to the poet's vision, which in general terms he found to be too compliant with the orthodoxy of the Roman Catholic Church. On 10 December 1825 he informed Crabb Robinson that '*Dante* saw devils where I see none – I see only good' (BR.313).

Two of Blake's drawings, for example, are annotated with comments that are highly critical of Dante's perceived materialism and his preoccupation with judgement and vengeance. On one (*Homer Bearing the Sword, and His Companions*) he stated: 'Every thing in Dantes Comedia shews That for Tyrannical Purposes he has made This World the Foundation of All & the Goddess Nature Memory is his Inspirer & not Imagination the Holy Ghost' (E.689). And

on another (*The Circles of Hell*, no.68) Blake concludes that Dante's Hell, a tiered system of punishment and retribution, 'must have been originally Formed by the devil Him self & So I understand it to have been …': 'Whatever Book is for Vengence for Sin & whatever Book is Against the Forgiveness of Sins is not of the Father but of Satan the Accuser & Father of Hell.' For Blake the forgiveness of sins was fundamental to the teachings of Jesus Christ; it was thus the bedrock of Christianity itself.

According to Crabb Robinson, Blake went so far as to say Dante 'was an atheist – A mere politician busied ab[ou]t this world as Milton was till in his old age he returned back to God whom he had had in his childhood.' The latter part of this comment is ambiguous – it is not clear who returned to God, Dante or Milton. But Crabb Robinson also recounted how Blake had spoken 'of Dante as being now with God' (BR.316–17) suggesting that in Blake's mind the poet had come to understand the error of his ways.

Within the watercolour designs themselves Blake's interpretation is, on occasion, as subtle as the choice of colour. Throughout the series, for example, Dante is clothed in red, Virgil in blue. Blake associated these colours with Luvah and Los, two of the Four Zoas, who represent the four fundamental aspects of man (for further discussion on the Four Zoas see no.300). In Blake's writings Luvah represents the emotions and Los the creative imagination, both of which are essential to the artist. Given that Blake saw the imagination as the primary means to salvation within this materialistic world, he seems to suggest that Virgil (imagination) is the guide to Dante (emotions) through Hell (earth).

In 1953 Albert Roe presented the most extreme interpretation to date of how Blake's drawings critiqued or diverged from Dante's text. In Roe's opinion Blake substituted Dante's system of Hell, Purgatory and Paradise for a more complicated path to salvation: from Ulro (this material world) through Generation (the act of true love) one passed to Beulah (the realm of the subconscious), from which one could pass onto the spiritual Eden (the highest state) or fall back to Ulro. On these terms, according to Roe, Dante never reached the spiritual Eden, choosing instead a materialistic version of Paradise.

Roe's interpretation was addressed – and to a large extent redressed – by David Fuller in 1988. In his discussion Fuller accepts that certain

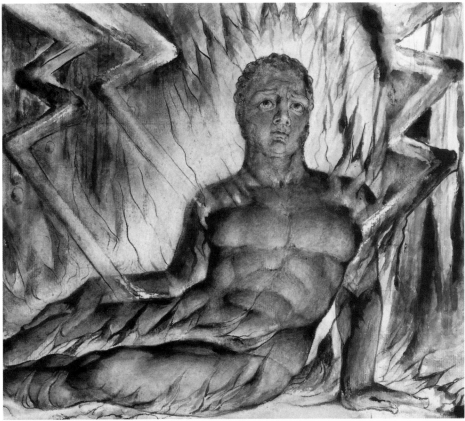

'**Capaneus the Blasphemer**' (no.79, detail)

drawings are critical of Dante, but suggests that the greater part are literal to the text. In fact, Blake's drawings vary greatly between illustration, interpretation and correction. The majority are purely artistic responses to Dante's text (see, for example, *Capaneus the Blasphemer* (no.79), *Geryon Conveying Dante and Virgil downwards towards Malebolge* (no.81) and *Cerberus* (no.75)). Others, through subtle alterations or additions to the details given by Dante, are more complex and intimate Blake's misgivings and objections – see *The Mission of Virgil* (no.72), *The Circle of the Lustful* (no.74), *Beatrice Addressing Dante from the Car* (no.92) and *The Queen of Heaven in Glory* (no.96).

The Mission of Virgil on one level illustrates the text quite closely. Blake shows Dante the Pilgrim's fear and trepidation at the start of his journey (communicated to us through the overwhelming presence of the 'Angry God of this World' at the top and the crouched figure at the bottom left) and represents symbolically Virgil's encouraging message and Dante taking heart to venture on. On another level this complex design is also loaded with meaning additional to the text. For example, Blake's inclusion of a cloven hoof for the 'God' figure might be his signal to the reader that Dante's

vision of Hell was 'formed by the devil Him self'. Satan, in Blake's writing, represented Error. The worshipping figure before him can be seen to represent papal authority. Thus Blake infers that the doctrines of the temporal Church are founded not on goodness/truth but on evil/error.

Robin Hamlyn has put forward another interpretation. In his opinion Blake alludes to Dante's previous reference to the Roman empire and the Papacy in Rome (*Inferno* II, lines 21–6) by giving the 'God' figure the cloven hoof and thunderbolts, visual references to Jupiter, the chief deity of the classical pantheon. By this means Blake suggests that the tyranny and vengeance of the ancient Roman god finds its direct descendant in the God of Christianity as represented by the Church on earth.

In either case, as Dante the Pilgrim finds salvation by returning to this Church – thus endorsing its doctrines on sin and punishment – Blake is warning us to be cautious of the *Divine Comedy* as a whole. CR

Lit: Roe 1953; Raine 1968, I, p.423 n.14; Keynes 1971, pp.212, 224–8; Bindman 1977, pp. 202, 216–19; Butlin 1978, p.148–55; Klonsky 1980; E.572, 688–91; Fuller 1988, pp.349–73; Butlin 1981, I, pp.554–94, nos.812–26; Butlin 1990, pp.202–41; Hamlyn 1998, pp.ix–xv.

The inspiration of Dante

64 Dante Alighieri *c.*1800–3
Pen and ink and tempera on canvas
42.5 × 87.8 (16¾ × 34½)
Manchester City Art Galleries
Lit: Wells and Johnston 1969; Butlin 1981, no.343 4
One of the eighteen Heads of Poets painted for
William Hayley for his library in 'The Turret',
Felpham. The choice of subjects was Hayley's
and included Homer, Cicero, Chaucer, Tasso,
Spencer, Shakespeare, Milton (no.254) and Pope.

The head of Dante is based on a portrait in
Raphael's *Disputa*, known to Blake through an
engraving. The scene to the right, showing
Count Ugolino and his sons, is taken from
Inferno XXXIII, 29–91. CR

65 WILLIAM BLAKE AFTER HENRY FUSELI
(1741–1825)
**Head of a Damned Soul, Perhaps Ruggieri
degli Ubaldini, Archbishop of Pisa,** *c.*1789–90
Etching and engraving printed in black ink on
paper 35 × 26.5 (13¹¹⁄₁₆ × 10⁶⁄₁₆)
Lent by the Syndics of the Fitzwilliam Museum,
Cambridge
Lit: Essick 1983 no.XXXII: 1D; Weinglass 1994, no.83
This print was most probably produced in
connection with J.C. Lavater's *Essays on
Physiognomy* (1788–99), for which Blake did a
number of engravings. CR

66 JOHN DIXON (1740–1811)
AFTER SIR JOSHUA REYNOLDS (1723–1792)
Ugolino
Mezzotint 50.4 × 62 (19¾ × 24½)
Published 4 February 1774,
The British Museum, London
*Lit: Penny and Newman 1986, pp.251–2; Postle 1995,
pp.138–56*
This print is a reproduction of Reynolds's
painting exhibited at the Royal Academy in
London in 1773. The subject is taken from the
Inferno and shows Count Ugolino de Gherareschi
imprisoned with his two sons and two
grandsons, contemplating his fate. In one of the
most horrific incidents in the *Inferno*, Ugolino
eventually turns to cannibalism to survive. The
painting can be seen as an example of Reynolds's
programmatic approach to history painting, the
practical expression of the theories he
promulgated as President of the Royal Academy.

The figure of Ugolino was based on his usual
model, George White, while the boy on the far
right was modelled on Reynolds's pupil, James
Northcote (see no.121). Observation is fused with
knowing references to the Old Masters: the pose
of Ugolino is taken from a work by
Michelangelo, while the group on the right is
based on a picture by Annibale Carracci.

Following the theories on expression of the
seventeenth-century French artist Charles Le
Brun , Reynolds has given great emphasis to
Ugolino's features, which reveal his mental
turmoil. MM

67 Count Ugolino and his Sons in Prison *c.*1826
Pen and ink, tempera and gold on panel
32.7 × 43 (12⅞ × 16⅞)
Signed 'W. BLAKE fecᵗ' b.r.
Lent by the Syndics of the Fitzwilliam Museum,
Cambridge
Lit: Butlin 1981, no.805
In stark contrast to Reynolds's treatment of the
same subject, Blake's Ugolino is boldly
conceived. Where Reynolds proposed that ideal
form was achieved through observing and
abstracting from reality, Blake instead presents
an individual vision that barely refers to
observed reality at all, but is determined by
more abstract formal qualities. The curving
bodies of the two angels form a Gothic ogee arch,
while the frontal posture of Ugolino and the
symmetrical arrangement of his sons and
grandsons suggest a medieval sculptural
scheme. Where Reynolds sought to emulate the
painters of sixteenth- and seventeenth-century
Italy in a sophisticated and complex
composition, and in his exploitation of the
colouristic and tonal effects of oil painting,
Blake insists on a simplicity resonant of Gothic
art appropriate to the source. His use of tempera
as a medium reinforces this rejection of later
artistic models. MM

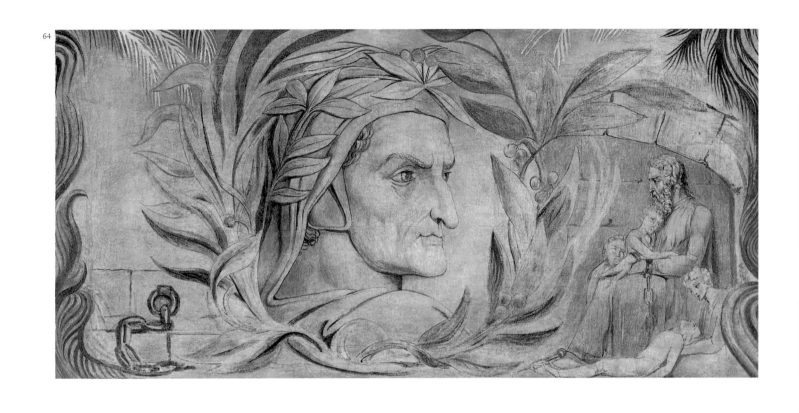

The *Divine Comedy* illustrations

All quotations from *The Divine Comedy* are taken from H. F. Cary's translation, published as *The Vision; or Hell, Purgatory, and Paradise of Dante Alighieri*, London and New York, 1814. Blake inscribed each of his illustrations with the title of the relevant part of *The Vision* and the canto number. CR

68 The Circles of Hell

Watercolour over pencil
51.5 × 36.3 (20¼ × 14¼)
The British Museum, London
Lit: Butlin 1981, 812 101

This illustration shows the nine circles of Hell, numbered 1–9 with key characters and information added. The note on the right refers to the fact that man passes through the centre of the earth when travelling from Hell to Purgatory. The two inscriptions on the bottom left and right are crucial to an understanding of Blake's objections to Dante's vision of Hell (see pp.74–5). This is very much a 'working drawing' showing Blake familiarising himself with Dante's 'Hell'.

69 *Dante con Lespositione Di Christoforo Landino, et di Allesandro Vellutello, Sopra la sua Comedia dell'Inferno, del Purgatorio, & del Paradiso …*

Venice 1564
Open at the frontispiece to the *Inferno*, Canto I
The British Library Board

70 Dante Running from the Three Beasts

Pen and ink and watercolour over pencil
37 × 52.8 (14½ × 20¾)
The National Gallery of Victoria, Melbourne, Australia; Felton Bequest, 1920
Lit: Butlin 1981, no.812 1; Butlin and Gott 1989, no.3

Inferno I, 1–90

Dante the Pilgrim (in Roe's interpretation, the fallen Albion) is lost in a gloomy forest (representing materialism) and is prevented from ascending a mountain by three wild beasts, a leopard, a lion and a wolf. For Dante these would have symbolised lust, pride and avarice respectively (in Blakean terms insatiable selfhood, and dependence on reason and materialism). Virgil (or Los representing imagination or Poetic Genius) comes to his aid. In the text Virgil promises to show Dante the punishments of Hell and Purgatory, and informs him that Beatrice will conduct him into Paradise. Dante follows Virgil.

70

Opposite: 'Dante Running from the Three Beasts' (no. 70, detail)

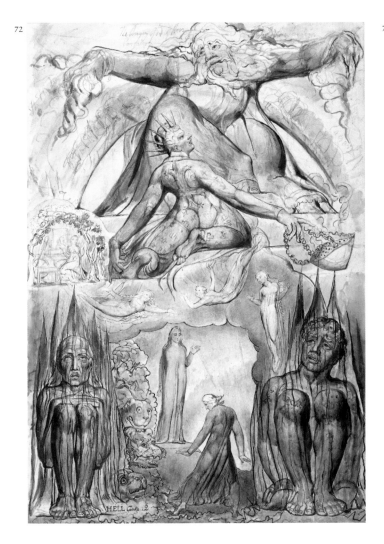

72

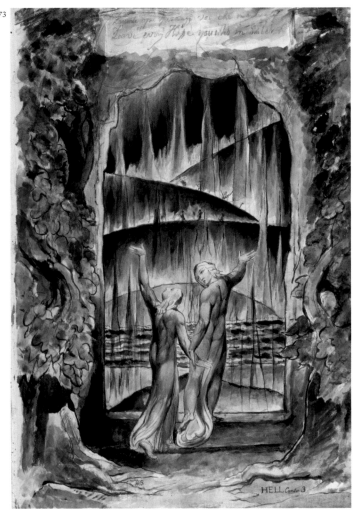

73

71 Dante and Virgil Penetrating the Forest
Pen and ink and watercolour over pencil
37.1×52.7 (14 9/16 × 20¾)
Tate; purchased with the assistance of a special
grant from the National Gallery and donations
from the National Art Collections Fund, Lord
Duveen and others, and presented through the
National Art Collections Fund 1919
Lit: Butlin 1981, no.812 2; Butlin 1990, no.131

Inferno II, 139–142
Virgil leads Dante through the forest. Blake
shows the trees as oaks, which, with their
association with Druids, may represent Error.

72 The Mission of Virgil
Pen and ink and watercolour over pencil with
some scratching out 52×36.5 (20½ × 14⅜)
Birmingham Museums & Art Gallery
Lit: Butlin 1981, no.812 3

Inferno II, 10–126
In the text Dante the Pilgrim questions whether
he has the strength and courage to continue
with the terrifying journey that Virgil has
proposed. Virgil comforts him by relating how
Beatrice had entrusted him with his mission to
save Dante. Dante resolves to continue.

According to Roe, Blake shows Dante taking
his first step towards salvation by passing
through the entrance of the created world.
According to Butlin (1981, p.556) the figure
above ('The Angry God of this World') is
Jehovah, God of negative repressive religion,
and the figure kneeling before him is the
embodiment of Rome's religious and imperial
power. The two crouching figures below
represent his enslaved subjects (Hamlyn
interprets these figures as, left, an embodiment
of Dante's fear and apprehension for the journey
ahead, and, right, an embodiment of Dante,
enslaved by fear, being freed by Virgil's
encouraging message, as shown by the shackle
chain breaking – Dante, *Inferno*, 1998, p.xvii).
Beatrice is shown in the cloud, centre right.
The figures, centre left, appear to be the Virgin
Mary at a spinning wheel directing Lucia to
go to Beatrice.

73 The Inscription over Hell-Gate
Pen and watercolour over pencil and chalk
52.7×37.4 (20¾ × 14¾)
Tate; purchased with the assistance of a special
grant from the National Gallery and donations
from the National Art Collections Fund, Lord
Duveen and others, and presented through the
National Art Collections Fund 1919
Lit: Butlin 1981 no.812 4; Butlin 1990, no.132

Inferno III, 1–20
In the text Dante and Virgil arrive at the gates of
Hell. Dante reads the inscription, and they both
enter. In Roe's opinion Blake has interpreted
Dante's Hell as being this created world, a
conjecture dismissed by Fuller. In Cary's
translation the inscription reads:

> Through me you pass into the city of woe:
> Through me you pass into eternal pain:
> Through me among the people lost
> for aye.
> Justice the founder of my fabric movd:
> To rear me was the task of power divine,
> Supremest wisdom, and primeval love.
> Before me things create were none,
> save things
> Eternal, and eternal I endure.
> All hope abandon ye who enter here.

Blake quotes the last line both in Italian
('Lasciate ogni speranza voi ch inentrate', which
does not correspond entirely with Dante's
original) and in English, which appears to be
Blake's own translation. Blake illustrates the
moment when Dante, showing concern at the
inscription, is comforted by Virgil; 'And when
his hand he had stretch'd forth / To mine, with
pleasant looks, whence I was cheer'd, / Into that
secret place he led me on.' The graceful,
synchronised poses of Dante and Virgil can also
be seen in *The Ascent of the Mountain of Purgatory*,
(no.84).

**74 The Circle of the Lustful: Francesca da
Rimini ('The Whirlwind of Lovers')**
Pen and ink and watercolour over pencil with
some scratching out 37.5 × 53 (14⅝ × 20½)
Birmingham Museums & Art Gallery
Lit: Butlin 1981, no.812 10

Inferno V, 25–45, 127–42
Dante and Virgil have entered the second circle
of Hell. Dante witnesses the punishment of
carnal sinners, who are tossed about by 'the
stormy blast of Hell'. Amongst them he meets
Francesca da Rimini. She is consigned to Hell
with her brother-in-law, Paolo, after their
adulterous relationship was discovered and
avenged by her tyrannical husband. Dante, on
hearing her sad story, through pity falls fainting
to the ground.

This design has been quoted often as a
typical 'correction' of Dante. On the whole Blake
is faithful to the text but clearly cannot accept
that, despite the earnestness of their love and
Dante's sympathy with the lovers' plight, Paolo
and Francesca are technically sinners in the eyes
of the Church and must remain in Hell. Blake
'remedies' this legalistic approach to show the
embracing lovers, as Butlin states, 'in the sun of
Eden, having found salvation in the re-
enactment of their first kiss' (Butlin 1981, p.559).
This work was one of seven Dante designs that
Blake engraved during 1826–7.

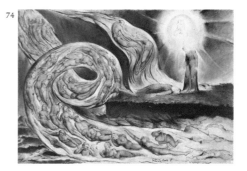
74

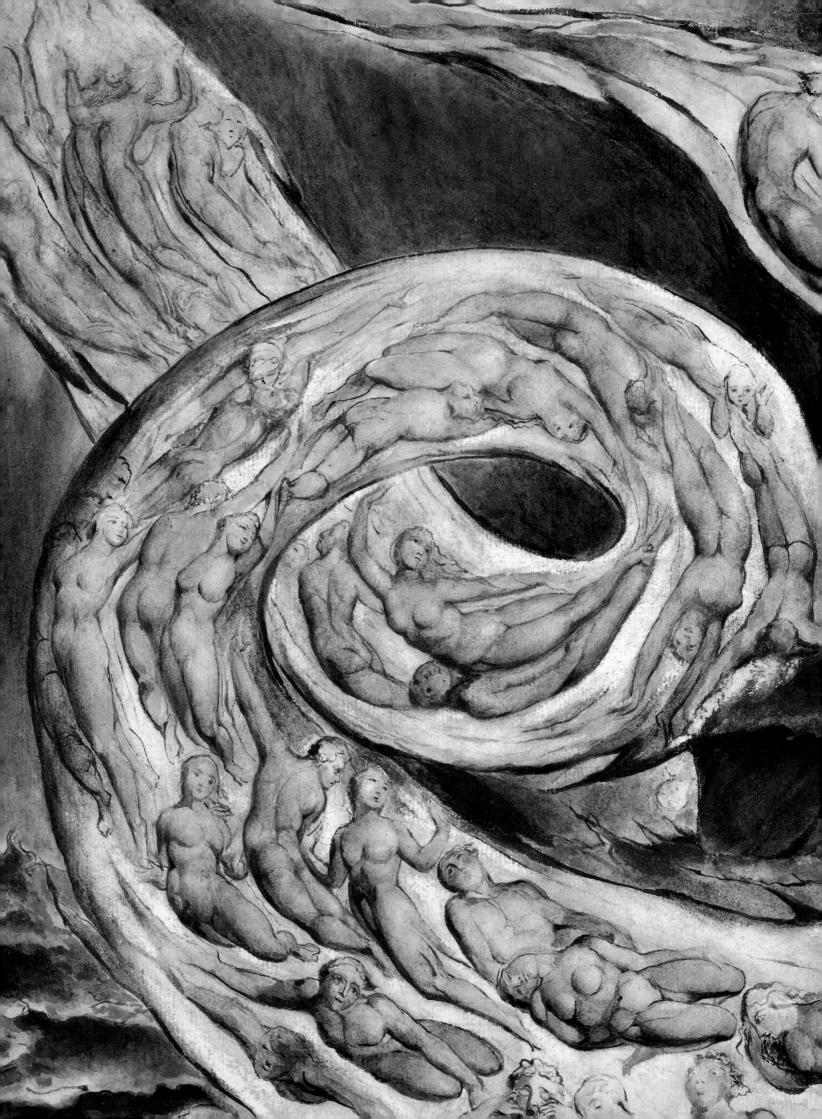

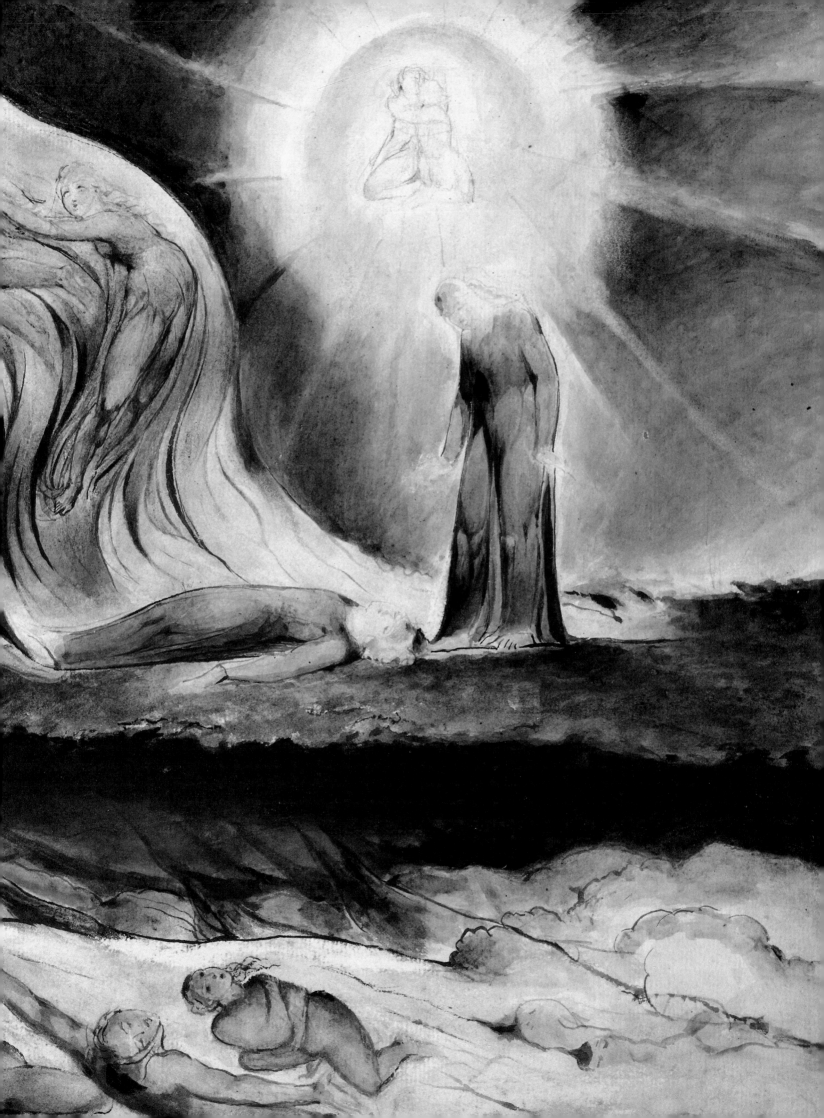

75 Cerberus (first version)

Pen and ink over pencil and watercolour

37.2×52.8 (14⅝×20¾)

Tate; purchased with the assistance of a special grant from the National Gallery and donations from the National Art Collections fund, Lord Duveen and others, and presented through the National Art Collections Fund 1919

Lit: Butlin 1981, no.812 12; Butlin 1990, no.134

Inferno VI, 12–24

Dante and Virgil move on to the third circle, where the Gluttonous are punished. There they find Cerberus, 'cruel monster, fierce and strange, / Through his wide threefold throat, barks as a dog / Over the multitude immers'd beneath'. Blake is faithful to the text but adds a cave (not mentioned by Dante) as a means of showing the weight of the material world (see also *The Simoniac Pope,* no.82). Virgil can be seen about to feed earth to the monster.

76 The Stygian Lake, with the Ireful Sinners Fighting

Pen and ink and watercolour over pencil

52.7×37.1 (20¾×14⅝)

The National Gallery of Victoria, Melbourne, Australia; Felton Bequest, 1920

Lit: Butlin 1981, no.812 15; Butlin and Gott 1983, no.8

Inferno VII, 105–26

In the fifth circle of Hell Dante and Virgil encounter the Wrathful bogged down in the river Styx, 'A miry tribe, all naked, and with looks / Betok'ning rage … Cutting each other piecemeal with their fangs'. Blake's powerful design underlines the aggression of these sinners (it is ambiguous whether or not they are naked as in the text). The figures lying below the water line are the slothful sinners, 'foul & lazy mist within', two of whom are asleep.

77 The Angel Crossing the Styx

Pen and ink and watercolour over pencil

37.2×52.7 (14⅝×20¾)

The National Gallery of Victoria, Melbourne, Australia; Felton Bequest, 1920

Lit: Butlin 1981, no.812 19; Butlin and Gott 1983, no.9

Inferno VIII, 67–75, and IX, 64–85

Dante and Virgil have been conveyed by the ferryman, Phlegyas, to the city of Dis. Dante is prevented from entering the city gates by a thousand and more fallen angels ('Who is this,' / They cried, 'that, without death first felt, goes through / The regions of the dead?'). Virgil informs Dante that 'even now … comes / One whose strong might can open us this land.' Blake shows the angel striding towards the city, 'onward passing proudly sweeps / Its whirlwind rage, while beasts and shepherds fly.' (See *The Circle of the Lustful: Francesca da Rimini*, no.74, for a similar treatment of figures swept up in a whirlwind.)

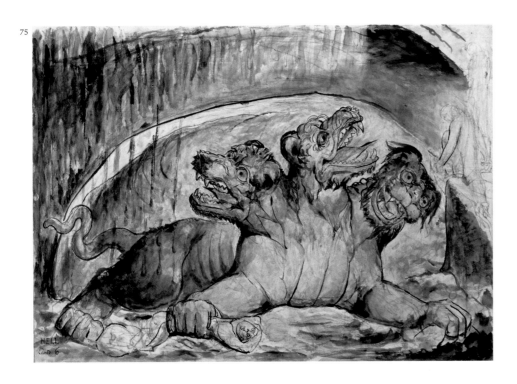

75

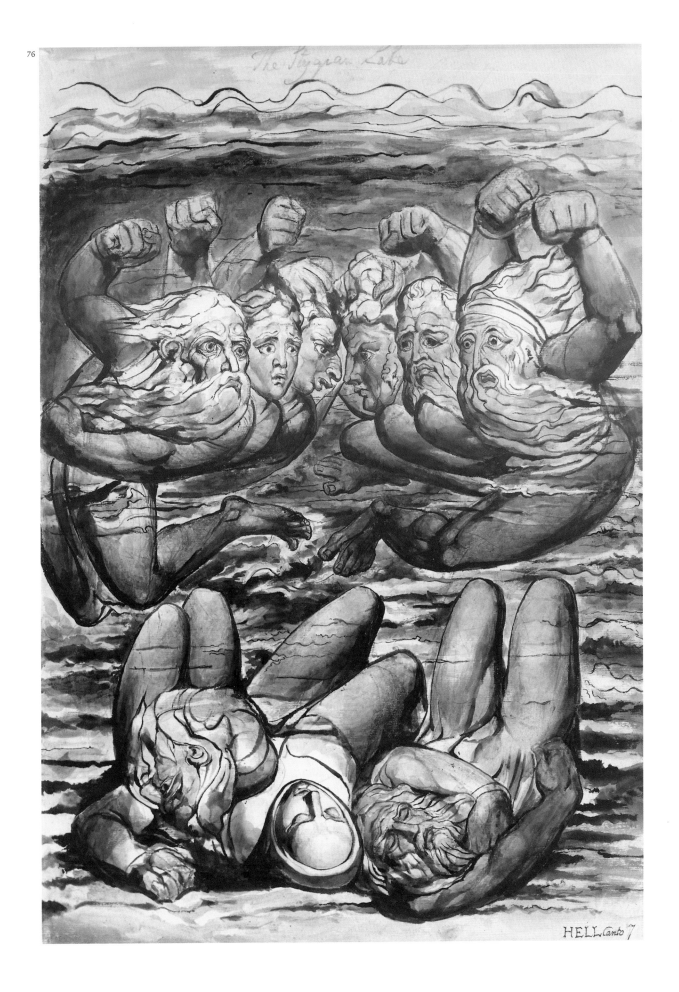

The Stygian Lake

HELL Canto 7

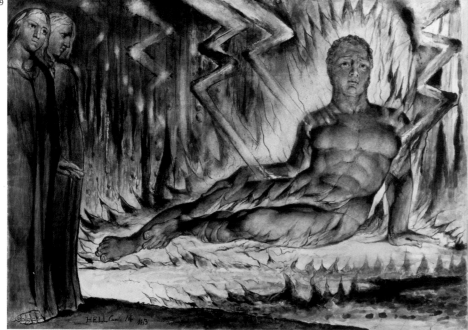

79

78 **The Hell-Hounds Hunting the Destroyers of their Own Goods**

Pen and ink and watercolour over black chalk and pencil 37.3 × 52.8 (14¾ × 20⅞)

The National Gallery of Victoria, Melbourne, Australia; Felton Bequest, 1920

Lit: Butlin 1981, no.812 25; Butlin and Gott 1983, no.11

Inferno XIII, 109–28

Still in the second compartment of the seventh circle, Dante and Virgil watch as two notorious spendthrifts, Giacomo da Sant'Andrea and Lano da Siena, are chased through the wood of the Suicides by 'black female mastiffs, gaunt and fleet'.

79 **Capaneus the Blasphemer**

Pen and ink and watercolour

37.3 × 52.7 (14¾ × 20¾)

The National Gallery of Victoria, Melbourne, Australia; Felton Bequest, 1920

Lit: Butlin 1981, no.,812 27; Butlin and Gott 1983, no.12

Inferno XIV, 42–72

Dante and Virgil have entered the third compartment of the seventh circle, where the Blasphemers are to be found. Dante asks 'who / Is yon huge spirit, that, as seems, heeds not / The burning, but lies writhen in proudscorn, / As by the sultry tempest immatur'd?' The figure is Capaneus, one of the seven kings who besieged Thebes. After defying Jupiter, he was killed by a thunderbolt. Even under such torment, Capaneus remains defiant: 'still he seems to hold, God in disdain'.

80 **The Symbolic Figure of the Course of Human History Described by Virgil**

Pen and ink and watercolour over pencil and ?black chalk 52.7 × 37.2 (20¾ × 14⅝)

The National Gallery of Victoria, Melbourne, Australia; Felton Bequest, 1920

Lit: Butlin 1981, no.812 28; Butlin and Gott 1983, no.13

Inferno XIV, 94–119

Virgil speaks to Dante of a huge ancient statue, which stands within Mount Ida on the island of Crete; 'Of finest gold / His head is shap'd, pure silver are the breast / And arms; thence to the middle is of brass, / And downward all beneath well-temper'd steel, / Save the right foot of potter's clay'. Each section of the sculpture, except that of gold, 'is rent throughout; / And from the fissure tears distil', joining to form the three rivers of Hell (Acheron, Styx and Phlegethon) which in turn form the lake of Cocytus. Blake adds the crown, orb and sceptre to the figure thus making it representative of the exercise of tyrannical earthly power.

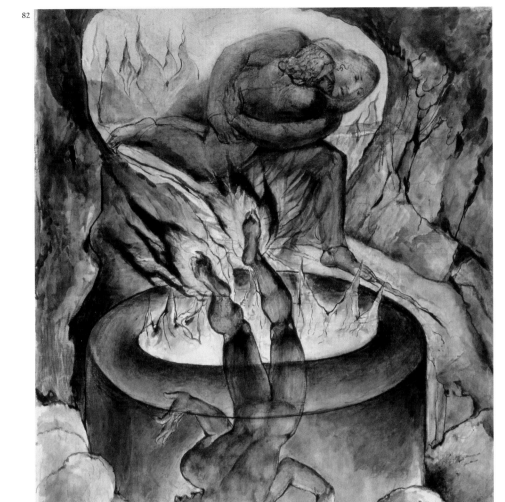

82

81 Geryon Conveying Dante and Virgil down towards Malebolge

Pen and ink and watercolour over pencil or chalk
37.1 × 52.7 (14⅝ × 20¾)
The National Gallery of Victoria, Melbourne, Australia; Felton Bequest, 1920
Lit: Butlin 1981, no.812 31; Butlin and Gott 1983, no.14
Inferno XVII, 1–27 and 70–126

Still in the third compartment of the seventh circle, Dante and Virgil are confronted by the monster Geryon. Eventually, they both descend towards Malebolge, the eighth circle, seated on Geryon's back. Blake's depiction of the monster is faithful to the text.

82 The Simoniac Pope

Pen and ink and watercolour over pencil and chalk 52.7 × 36.8 (20¾ × 14½)
Tate; purchased with the assistance of a special grant from the National Gallery and donations from the National Art Collections Fund, Lord Duveen and others, and presented through the National Art Collections Fund 1919
Lit: Butlin 1981, no.812 35; Butlin 1990, no.137
Inferno XIX, 31–126

Malebolge, the eighth circle for fraudulent sinners, is divided into ten ditches. In the third, Dante and Virgil come across those who have been guilty of simony (the buying or selling of ecclesiastical preferment). Blake illustrates the section of the text where Virgil grabs Dante in order to carry him away from the anger of Pope Nicholas III. As with all simoniacs, the pope is suspended head downwards in an aperture of fire. Blake shows the scene in a cave (not mentioned by Dante) as a means of giving weight to the material world (see also *Cerberus*, no.75). He also shows the pope suspended but visible in an appropriately font-like well.

83 Lucifer

Pen and ink and watercolour over pencil and black chalk 52.8 × 37.2 (20¾ × 14⅝)

The National Gallery of Victoria, Melbourne, Australia; Felton Bequest, 1920

Lit: Butlin 1981, no.812 69; Butlin and Gott 1983, no.28

Inferno XXXIV, 10–75

In the fourth and final round of the ninth circle of Hell – where those who betrayed their masters are frozen – is Lucifer himself, frozen from his waist down at the centre of the world. In the text Lucifer has three heads (shown by Blake) in the mouth of each are the ultimate betrayers, Brutus, Cassius and Judas, 'Who hath worst punishment … [with] his head within / And plies the feet without'.

84 The Ascent of the Mountain of Purgatory

Pen and ink and watercolour over pencil 52.8 × 37.2 (20¾ × 14⅝)

Tate; purchased with the assistance of a special grant from the National Gallery and donations from the National Art Collections Fund, Lord Duveen and others, and presented through the National Art Collections Fund 1919

Lit: Butlin 1981, no.812 74; Butlin 1990, no.145

Purgatorio IV, 31–45

At the end of Inferno Dante and Virgil, having climbed out of Hell and 'again beheld the stars' (line 133, Canto XXXIV), at the start of *Purgatorio* begin the ascent of the Mountain of Purgatory. Weary of the long climb, Dante calls to Virgil: '"Parent belov'd! / Turn, and behold how I remain alone, / If thou stay not." – "My son!" he strait reply'd, / "Thus far put forth thy strength"'. As with *The Inscription over Hell-Gate*, no.73, Blake shows the figures of Dante and Virgil with graceful, echoing poses.

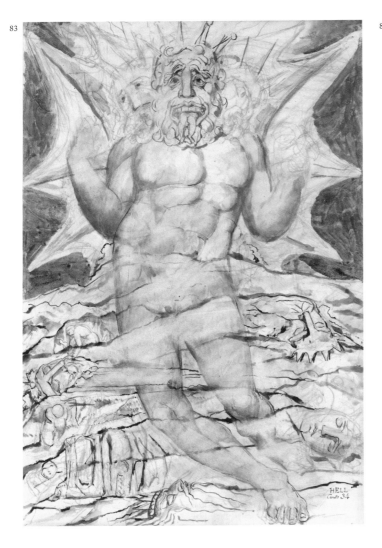

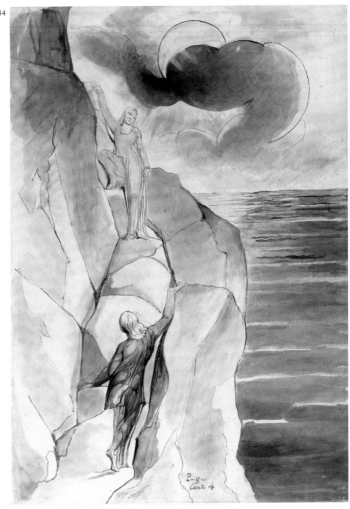

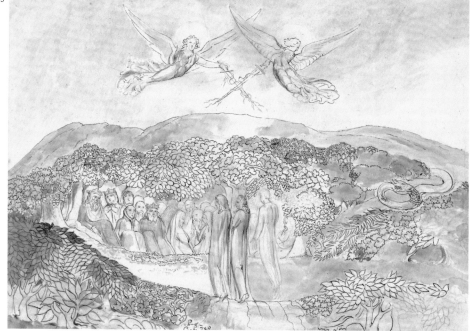

85 The Lawn with the Kings and Angels

Pen and ink and watercolour over pencil
37.3 × 52.8 (14⅝ × 20¾)
The National Gallery of Victoria, Melbourne,
Australia; Felton Bequest, 1920
Lit: Butlin 1981, no.812 76; Butlin and Gott 1983, no.31
Purgatorio VII, 64–90 and VIII, 1–39 and 94–108

Dante and Virgil are led to the Valley of
Negligent Rulers by the poet Sordello. The kings
are protected from a large serpent by two angels
'with two flame-illumin'd swords, / Broken and
mutilated of their points'. Blake places the
group under trees, which symbolise error, thus
preventing them from seeing the angels above
their heads. In contrast, the three poets, who
may be interpreted as representing the
imagination, are shown standing at a distance
from the trees.

86 Dante and Virgil Approaching the Angel Who Guards the Entrance of Purgatory

Pen and ink and watercolour over pencil
52.7 × 37.3 (20¾ × 14⅝)
Tate; purchased with the assistance of a special
grant from the National Gallery and donations
from the National Art Collections Fund, Lord
Duveen and others, and presented through the
National Art Collections Fund 1919
Lit: Butlin 1981, no.812 78; Butlin 1990, no.146
Purgatorio IX, 73–105

Dante and Virgil approach the angel guarding
the entrance of Purgatory, who is seated at the
top of three steps. The lower step is made of
white marble (representing sincerity), the
middle step of dark rugged stone (contrition)
and the upper step of bright red porphyry (piety
and virtue).

87 The Angel Descending at the Close of the Circle of the Proud

Pen and ink and watercolour over pencil
51.8×36.4 (20⅜×14⅜)
The British Museum, London
Lit: Butlin 1981, no.812 82

Purgatorio XII, 11–73

In the text Virgil points out to Dante the pilgrim the images of the Proud sculpted on the mountain path in their punished state. Like Dante, Blake links pagan and Christian acts of pride. Jupiter (see also no.72) wields one of the thunderbolts that killed the giants, seen beneath his feet, who tried to depose him. One of the serpents born out of their blood is visible. Lucifer, fallen from heaven, is shown upside down (bottom centre; see also no.83). Virgil speaks to Dante, 'Behold / That way an angel hasting towards us!' Blake shows the angel running with wings outspread. RH, CR

88 The Angel Inviting Dante to Enter the Fire

Pen and ink and watercolour over pencil and black chalk 52.8×37.3 (20¾×14⅝)
The National Gallery of Victoria, Melbourne, Australia; Felton Bequest, 1920
Lit: Butlin 1981, no.812 84; Butlin and Gott 1983, no.32

Purgatorio XXVII, 5–18

Dante, accompanied by Virgil and the Roman poet Statius, reaches the end of the uppermost ledge of the Mountain of Purgatory. Here the Lustful are purged by fire. The text describes:

> So day was sinking, when the'
> angel of God
> Appear'd before us …
> Forth of the flame he stood upon
> the brink,
> And with a voice, whose lively
> clearness far
> Surpass'd our human, 'Blessed
> are the pure
> In heart,' he sang: then near him
> as we came,
> 'Go ye not further, holy spirits!'
> he cried,
> 'Ere the fire pierce you: enter in;
> and list
> Attentive to the song ye hear
> from thence.'

In Roe's opinion the purging fire equates with Blake's own writings, where it represents the imagination.

89 Dante and Statius Sleeping, Virgil Watching

Pen and ink and watercolour over pencil
52×36.8 (20½×14½)
The Visitors of the Ashmolean Museum, Oxford
Lit: Butlin 1981, no.812 86

Purgatorio XXVII, 70–108

As described in the text, Blake shows Dante, Virgil and Statius each lying on an individual step ('each of us had made / A stair his pallet'). Dante falls asleep and dreams of Leah and Rachel, which Blake represents in the radiant sphere above. Roe interprets this as a full moon, which is an addition made by Blake, and not the planet Venus, which is mentioned in Dante's text. By this means Blake suggests that 'the danger of female passivity still remains in the state of sleep in Beulah; both Rachel and Leah are indulging in selfish pursuits' (Butlin 1981, p.583).

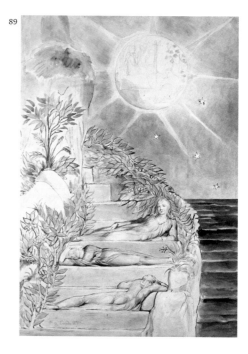

89

Opposite: 'Dante and Statius Sleeping' 1824–7 (no.89, detail)

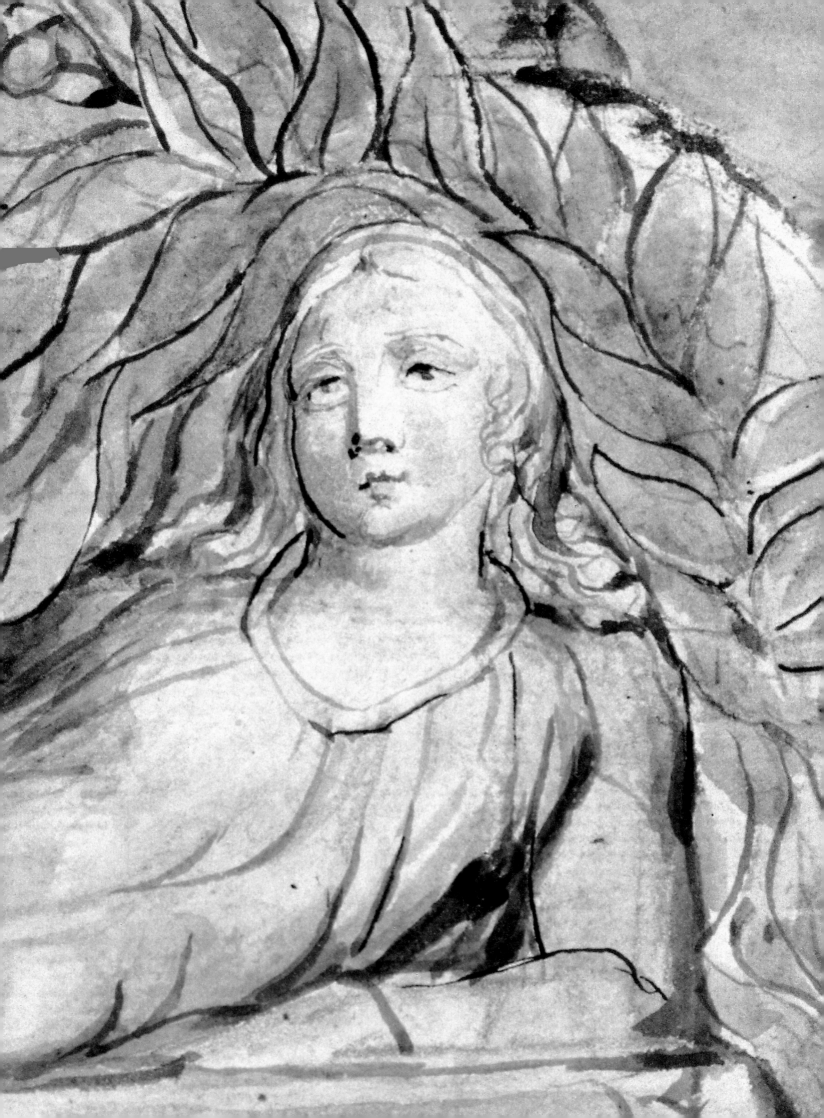

90 Beatrice on the Car, Matilda and Dante
Pen and ink and watercolour over pencil
36.7 × 52 (14½ × 20½)
The British Museum, London
Lit: Butlin 1981, no.812 87

Purgatorio XXIX, 13–150
Dante bids farewell to Virgil (who can be seen
with Statius between the trees on the right) and
looks across the River Lethe towards the Earthly
Paradise (Garden of Eden). He is greeted on the
other bank by Matilda, who tells him to look at
the approaching procession. Dante describes:
'And lo! a sudden lustre ran across / Through the
great forest on all parts, so bright / I doubted
whether lightning were abroad.' Beatrice can be
seen standing on a spectacular car, which is
drawn by a gryphon; 'So beautiful / A car in
Rome ne'er grac'd Augustus' pomp.'

91 Beatrice Addressing Dante from the Car
Pen and ink and watercolour
37.2 × 52.7 (14⅝ × 20¾)
Tate; purchased with the assistance of a special
grant from the National Gallery and donations
from the National Art Collections Fund, Lord
Duveen and others, and presented through the
National Art Collections Fund 1919
Lit: Butlin 1981, no.812 88; Butlin 1990, no.148

Purgatorio XXIX, 92–129; XXX, 31–3, 64–81
The scene takes place in the Earthly Paradise
(Garden of Eden). Beatrice upbraids Dante for
his doubting and apprehensiveness during his
journey ('What! and hast thou deign'd at last /
Approach the mountain? Knewest not, O man!
/ Thy happiness is here?') For Dante the gryphon
symbolises Christ and Beatrice the Church. The
three maidens are Faith (centre, in white), Hope
(left, in green) and Charity (left, in red). The
heads representing the four Evangelists can be
seen amongst the wings either side of Beatrice.

As with *The Circle of the Lustful: Francesca da
Rimini* (no.74), this design has been interpreted
as critical of Dante's text. Whereas Dante
describes Beatrice with a laurel wreath, Blake
shows her with a golden crown. Faith points
towards a book (Church doctrines?) and the
wheel of the car is a swirling vortex, which in
Milton, plate 17, represents the passageway
between the material world and eternity.
As Butlin states, 'It is difficult to avoid the
conclusion that this exquisite watercolour
shows the poet Dante submitting himself to the
mystery of the Church, the Female Will, Blake's
Vala in her fallen state as Rahab or the Whore
of Babylon, an interpretation confirmed by the
next illustration' (Butlin 1978, p.153), which is
The Harlot and the Giant, in the National Gallery
of Victoria, Melbourne.

92 The Recording Angel
Pen and ink over pencil and watercolour
52 x 36 (20½ × 14⅛)
Birmingham Museums & Art Gallery
Lit: Butlin 1981, no.812 92

Paradiso XIX, 79–81, 112–16
Beatrice and Dante ascend to the sixth circle of
Heaven. Here they encounter the spirits of just
rulers who are represented by individual lights.
These unite in the form of an eagle, the emblem
of the Holy Roman Empire, which in Dante's
opinion was God's vehicle for meting out justice
to mankind. The eagle speaks of the fate of
unjust rulers and it is during this prophesy that
the Recording Angel is mentioned indirectly. In
explanation of Blake's decision to illustrate this
figure, Roe opines, 'From his appearance, from
the fact that only his left foot is shown, and from
his activity of writing, it is clear that this figure is
intended to represent Urizen in the guise of the
'angel' of convention and tradition who upholds
the Moral Law' (Roe 1953, p.180).

**93 St Peter and St James with Dante
and Beatrice**
Pen and ink and watercolour over pencil
37.1 × 52.7 (14⅝ × 20¾)
The National Gallery of Victoria, Melbourne,
Australia; Felton Bequest, 1920
Lit: Butlin 1981, no.812 95; Butlin and Gott 1983, no.37
Paradiso XXV, 13–24
Beatrice and Dante witness the meeting of
St Peter and St James, 'In circles each about the
other wheels, / And, murmuring cooes his
fondness'. St Peter's gesture of benediction may
allude to Dante's description earlier in the text:
'standing up / At my baptismal font, shall claim
the wreath / Due to the poet's temples: for I there
/ First enter'd on the faith, which maketh souls /
Acceptable to God: and, for its sake, / Peter had
then circled my forehead thus.'

90

91

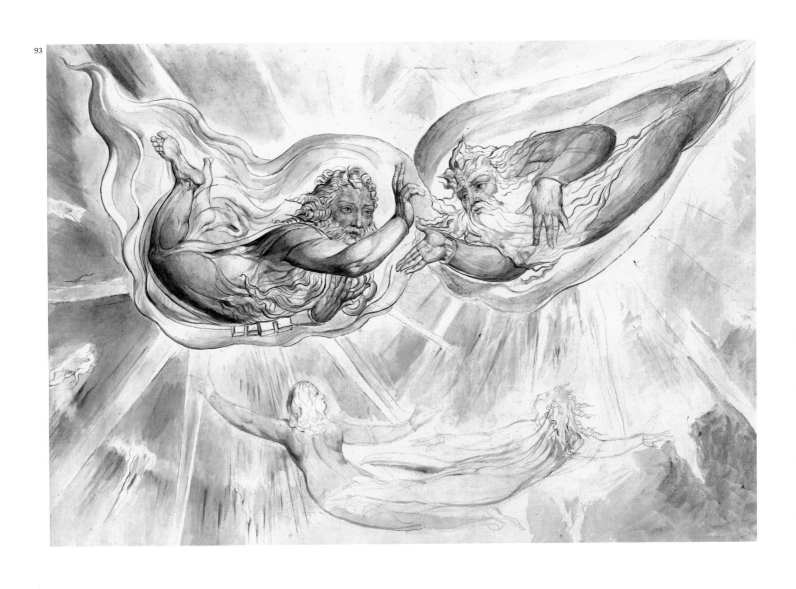

94 The Vision of the Deity, from Whom Proceed the Nine Spheres

Pen and ink and watercolour over pencil
51.8×36.7 (20⅜×14½)
The Visitors of the Ashmolean Museum, Oxford
Lit: Butlin 1981, no.812 97

Paradiso XXVIII, 16–39, 98–126
In the text Dante describes the nine circles of Paradise: 'There wheel'd about the point a circle' of fire, / More rapid than the motion which first girds / The world. Then, circle after circle, round / Enring'd each other.' Instead of showing the circles with God at the centre, Blake shows them revolving around the earth, an allusion to his inscription on the illustration *Homer bearing the Sword* (Fogg Art Museum, Harvard University), 'Every thing in Dantes Comedia shews that for Tyrannical Purposes he has made this World the Foundation of All'.

95 Dante in the Empyrean, Drinking at the River of Light

Pen and ink and watercolour over pencil
52.8×36.7 (20¾×14⅝)
Tate; purchased with the assistance of a special grant from the National Gallery and donations from the National Art Collections Fund, Lord Duveen and others, and presented through the National Art Collections Fund 1919
Lit: Butlin 1981, no.812 98; Butlin 1990, no.149

Paradiso XXX, 61–96
In the text Dante says, 'I look'd; / And in the likeness of a river saw / Light flowing', and later,

> Never did babe, that had outslept
> his wont,
> Rush, with such eager straining, to
> the milk,
> As I toward the water, bending me,
> To make the better mirrors of mine eyes
> In the refining wave; and, as the eaves
> Of mine eyelids did drink of it …

Blake adds figures above Dante on the left and right. Butlin describes these figures as an aged poet, left, above a scene of painting and engraving, which collectively represents the Arts, and Enion, right, Blake's 'earth-mother' above Vala, the Female Will, which represents Nature. Thus in Roe's interpretation Art and Nature, via the River of Divine Imagination, are directed towards the Eternal (Butlin 1981, p.587).

96 The Queen of Heaven in Glory

Pen and ink and watercolour over pencil and black chalk 37.1×52.8 (14⅝×20¾)
The National Gallery of Victoria, Melbourne, Australia; Felton Bequest, 1920
Lit: Butlin 1981, no.812 99; Butlin and Gott 1989 no.38
Paradiso XXX, 97–126; XXXI, 1–21, 115–42; XXXII, 1–9
Dante concludes *Paradiso* with a vision of the triumphant Church, presided over by the Virgin Mary. Blake's design, the last in the series, is a critique of Dante's conclusion – that salvation can be reached through the Church. For Blake the Church (i.e. the Virgin Mary, kneeling centre top, and Beatrice, seated below) represents the Female Will in its fallen state. The various inscriptions on the design itself underline this view: for example, 'Mary' holding a 'Sceptr[e]' (the worldly power of the Church Trimuphant) and 'Looking [glass]' (which reflects the material world), and on the right a figure labelled 'Dominion' holding a 'Bible Chaind round'. All the figures in the design appear to be female and are assembled on a large flower, representative of the vegetable world. CR

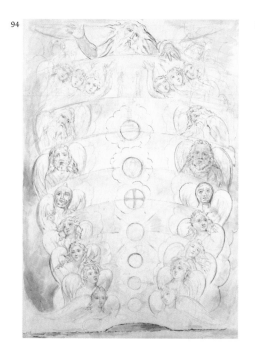

94

95

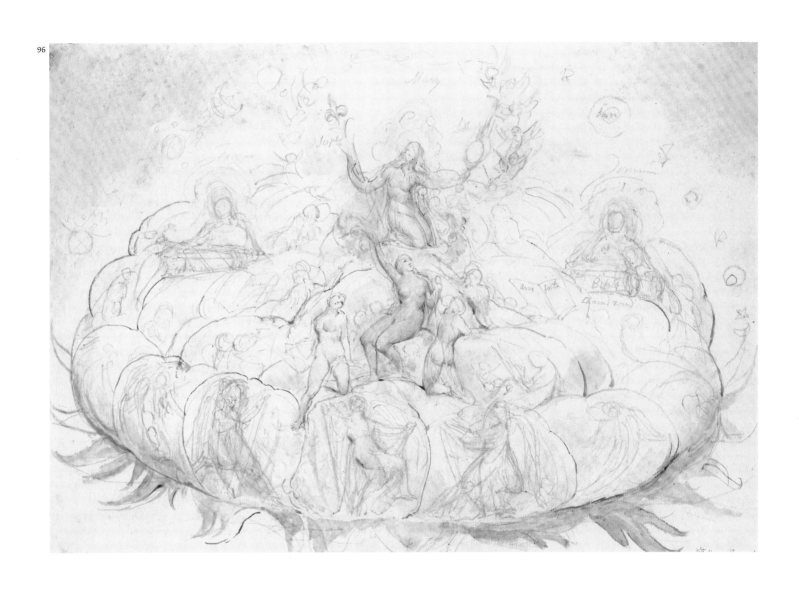

'The Furnace of Lambeth's Vale'

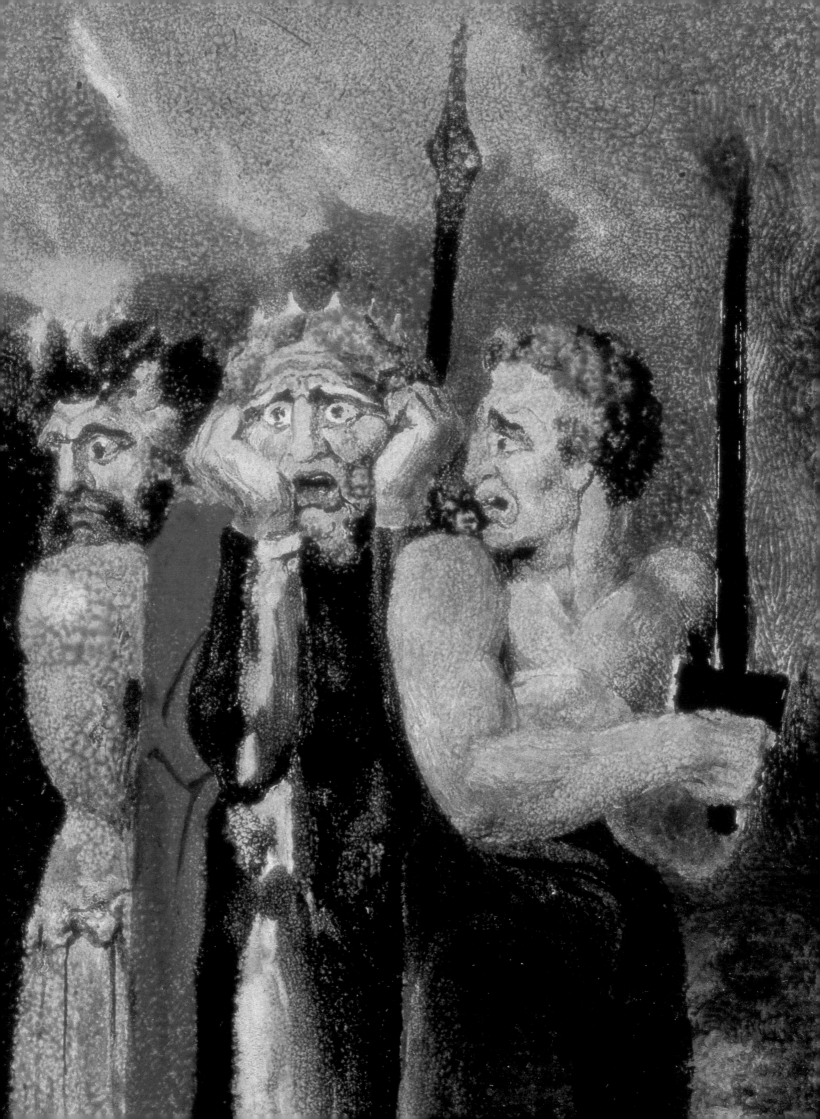

Blake's Printmaking Studio: No.13 Hercules Buildings, Lambeth

No.13 Hercules Buildings, Lambeth, was the residence of William Blake and his wife Catherine during the most creative and productive period in his life. It was here during the early 1790s that Blake produced *Songs of Experience, The Marriage of Heaven and Hell, Visions of the Daughters of Albion, America a Prophecy, The First Book of Urizen* and much else. Here he developed his method of colour printing that in 1795 led to the production of the great series of large colour prints including *Newton, Nebuchadnezzar* and *The Night of Enitharmon's Joy* (nos.249, 247, 250). And here also, on October 10, 1793, Blake issued a prospectus addressed 'To the Public', proclaiming his 'method of Printing which combines the Painter and the Poet' and listing his illuminated books and prints for sale. As far as we know, this was the only time in his life that he did so. But apart from the works themselves, we know little. If we are to discover Blake during this extraordinary period it is necessary to reconstruct the circumstances of his life, especially its physical and creative centre, the drawing and printmaking studio in which he created his works. In these two small ground-floor rooms Blake wrote his poems and drew his designs, etched them on copper plates and, with Catherine's help, printed them on his rolling press. Apart from a single fragment of one of his relief-etched copper plates (no.112a), no trace remains of Hercules Buildings, his studio, his press or the copper plates he made to reproduce his works at this time, but it is possible to build on a few surviving records.

In 1918, No.13 Hercules Buildings was razed together with the rest of the terraced row in which Blake lived during the revolutionary decade of the 1790s. A drawing by Frank Emanuel shows Blake's house in the context of the entire row of Hercules Buildings, derelict with the ivy nearly covering the front of the building not long before it was pulled down (no.97). The last glimpse we have is that recorded by an anonymous contributor to the *Spectator*, 6 May 1916. Ironically, it is also our most vivid and factual account:

> The front door of Blake's house is nailed up, and any one fortunate enough to gain an entrance must make his way through the passage of the house next to it [...] And so we get to Blake's garden door, up a few shallow steps, and into the narrow passage with its little archway, which leads to the front door and the two rooms, back and front of the ground floor.

Tatham, Blake's contemporary biographer, speaks of it as 'a pretty, clean house of eight or ten rooms,' where at first the Blakes lived in some comfort, keeping a servant [...] Even now, the house, through its present decay, with ceilings and floors breaking and doors hanging loose, shows its possibilities of comfort. The small square rooms are light and well proportioned; there are still some pretty Georgian hob grates left, and the many roomy cupboards suggest a use for Mrs. Blake's neat household skill, and for the housing of copperplates and engraving tools [...] No one can stand before this blackened shell of a home, once alive with so much fire and passionate vision, without a sense of awe.

This provides the plan of the ground floor, where Blake set up his rolling press and established his studio along lines and with equipment that had not changed significantly since the seventeenth century (no.99).

Contemporary maps show Lambeth as still being a village only recently brought into the world by the opening of Westminster Bridge in 1757, with Hercules Buildings leading off Westminster Bridge Road at an angle to the south west (no.141). Across the road from No.13 were gardens and fields stretching down to Bishop's Walk, Stangate and the Thames; and, beyond, the prospect of Westminster Abbey, the Houses of Parliament and the west end of the city, with the arches of Westminster Bridge spanning the river to the right. Hercules Buildings was a location chosen with care. Not only did it give Blake immediate access to the walks on Peckham Rye that he loved to recall from his childhood. Crossing Westminster Bridge, within half an hour's walk, he would be in Golden Square and the family home at 28 Broad Street. Walking across Lambeth Marsh and Blackfriars Bridge he could be in the City and conduct business in St Paul's Churchyard, the centre of the bookselling trade, including that of his principal employer during the late 1780s and early 1790s, the liberal bookseller Joseph Johnson. In May 1793, Johnson and Blake together published Blake's *For Children: The Gates of Paradise* (no.130). Thanks to research of Keri Davies in the correspondence of Francis Douce in the Bodleian Library, we now know that other examples of Blake's works were seen at Johnson's. During the early 1790s, Johnson's bookshop was a meeting place for writers and

artists, political reformers and radicals, including Joseph Priestley, Thomas Paine, the great defence lawyer Thomas Erskine, William Godwin, Mary Wollstonecraft and Blake's close friend and fellow artist Henry Fuseli. The Strand was also close, where many of the print dealers were located (no.131). And south of the river, an easy walk beyond the pleasure gardens of Vauxhall, was Battersea, still a village of about 350, Catherine's family home where she and Blake first met and on 18 August 1784 were married in St Mary's, Battersea parish church.

No.13 Hercules Buildings was one of a terrace of twenty-four houses. It was separated by a lane between Nos. 14 and 15, which led to the grounds of Hercules Hall, built by Philip Astley, the celebrated circus owner, and lived in by him from 1788. No.13 was one of the three largest private houses in the row. These were comfortable middle-class homes and, in the Lambeth Parish Poor Rate Assessment for March 1791, Blake's was one of the most highly rated at £20 (no.98). Like the other houses that made up Hercules Buildings, No.13 was built on three floors over a basement. The description published in the *Spectator* makes clear that the ground floor was made up of one room at the front and one at the rear, with the passage at the side leading from the front door through 'an archway' to the back door and step entering the garden. The stair leading to the two upper floors would have been off the passage; and the entrance to the stair leading down to the basement would have been built under it. On the first floor there would have been two rooms, one at the front and one at the rear, with a single large window at either end, and presumably one smaller window on each landing of the stair at the rear. The front room on the first floor would have been used as the drawing room, probably opening into the room at the rear. These two rooms would have been ideal for exhibiting Blake's works. They would also have enjoyed fine views. From the front drawing room, north and west, would be seen the Thames and landscape of the city; and from the back, east and south, the garden, Hercules Hall (at a right angle), and, beyond, market gardens and orchards, St George's Fields and the Surrey hills. On the second or upper floor would have been the bedrooms, more of the 'small square rooms [...] light and well proportioned' of the description, possibly including a room for the maid servant the Blakes were said to keep during the first part of their residence

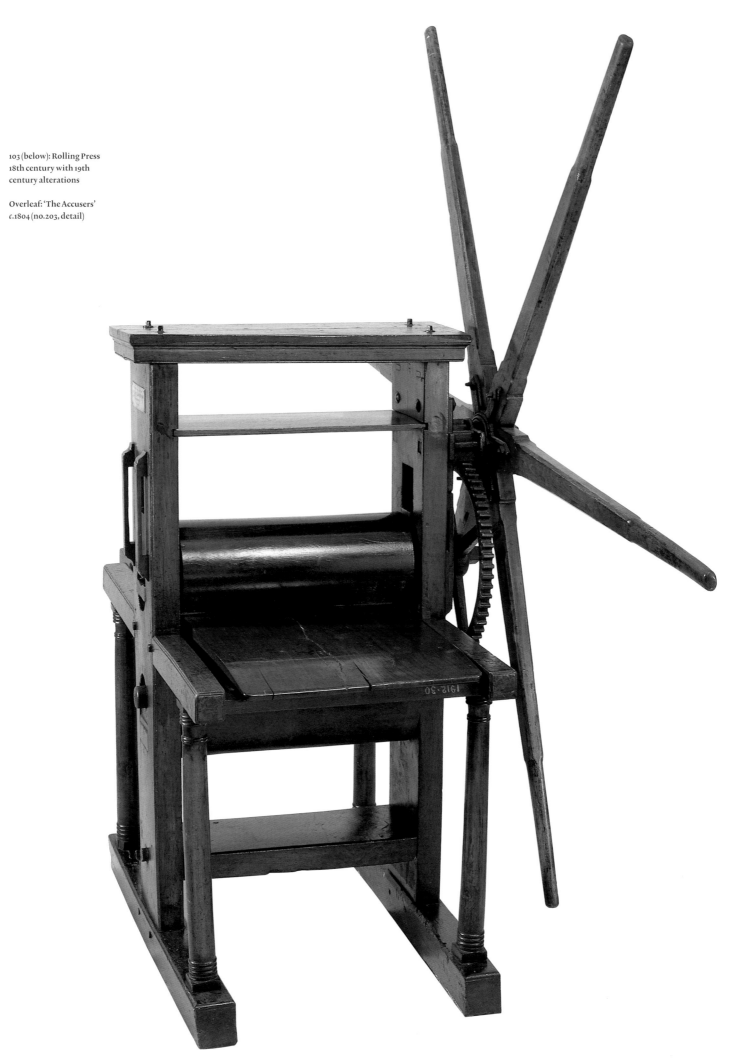

103 (below): Rolling Press
18th century with 19th
century alterations

Overleaf: 'The Accusers'
c.1804 (no.203, detail)

in Lambeth. This left the two rooms on the ground floor.

Writing in the *South London Observer*, June and July 1912, Richard C. Jackson recalled the ground floor of Blake's residence as it had been described to him by his father. Jackson remembered his father asserting 'that Blake should say he never enjoyed any one of his etching-painting rooms, as he had in his panelled room (his 'atelier') at Lambeth'. Jackson continued:

> When quite a boy my father took me to Blake's house at Lambeth, and the then occupier took us all over the premises, and entertained us at tea in what she called William Blake's 'painting room' (a panelled room), which, to the best of my knowledge, was on the ground floor back, looking on to the then spacious and beautiful garden, where the luxurious vine was still to be seen nestling round the open casement, well remembering, to this very day, sitting beneath Blake's fig tree.

This would account for the room at the back on the ground floor. The other room, at the front, would have been Blake's printmaking studio.

Blake's printmaking studio would have been furnished with the benches, drying lines and equipment needed to carry out the work of an independent printmaker, set up around his rolling press. The rolling press, unchanged in type from the seventeenth to the early nineteenth centuries, stood approximately five feet in height, the bed of the press at waist height, with the star wheel or cross used to turn the rollers reaching as high as six to seven feet. The rolling press shown here (no.103) is of the type that was used by Blake, apart from the gearing mechanism which is a later addition. Blake's press would have weighed as much as 300 kilos (700 lbs) and required at least four strong men to move it. We know that it was capable of being dismantled and 'put up' again, as Blake described in a letter to William Hayley, 13 December 1803, following his return to London from Felpham.

If the printmaking studio occupied the ground floor front room, and Blake's 'etching-painting' room was on the ground floor at the back, looking on to the 'spacious' garden, this would have made the best practical use of the two rooms. The room at the front offered easy access and faced north and west. This provided light from the north, favoured by artists, that was continuous throughout the day together with the last light of the day from the west. As printmaking was his livelihood this would have been a matter of priority for Blake in choosing to live in Hercules Buildings. The room at the rear also enjoyed good, continuous light, as it faced south and east. For drawing and painting it would have been ideal. Overlooking the garden, it would have been quiet and without distraction. Both were essential for Blake to be able to concentrate upon the minute detail of writing his text in reverse and drawing designs surrounding them in an acid resist on polished copper plates (the largest plates used to print *Songs of Experience* measure less than 12.5 × 7.5 cm, or 5 × 3 in). After printing sets of impressions on his rolling press and hanging the dampened sheets on lines to dry, they would be gathered together, pressed, and stored in sets of monochrome impressions. A few copies would be brought to the room at the rear, where, again, concentration, quiet and a clean work area were essential. In preparation for sale, these impressions were coloured by hand with water-colours. In some cases, points of detail were finished using a fine pencil brush, or pen and ink.

In the early 1790s the area immediately surrounding Hercules Buildings was still a small community served by neighbourhood shops and gardens and a few public houses. Anyone passing Hercules Buildings would see William and Catherine at work together, at the bed and wheel of their rolling press, through the single large window that was only a few steps back from the road. It would not have taken long before it was known locally that a printmaker was working in the neighbourhood. But within two years a change in their circumstances took place. By the winter of 1792–3, in reaction to events in France, a writer and publisher of prints of Blake's radical persuasion was at grave risk of being indicted for sedition, committed to prison to await trial and there be at risk of dying of 'gaol fever' – typhus. As we shall see, the vale of Lambeth became overshadowed and No.13 Hercules Buildings a house where William and Catherine lived in fear of the anonymous informer. MP

97 FRANK EMANUEL (1865–1948)
Hercules Road, Lambeth 1914
Pencil on art board
18.6 × 25 (7⅜ × 9⅞)
London Metropolitan Archives, Corporation of London

98 **Poor Rate Book for Parish of St Mary, Lambeth 1790**
Entry for 10 March 1791 (pp.272–3)
37.5 × 48.5 (14¾ × 19⅛)
London Borough of Lambeth Archives

99 ABRAHAM BOSSE (1602–1676)
a) **'Cette figure vous montre Comme on Imprime les planches de taille douce' 1642**
['This figure shows you how to print the plates in soft engraving']
Engraving 21.7 × 31.6 (8½ × 12½)
on paper 25.7 × 32.5 (10⅛ × 12¾)
The British Museum, London
b) **'Graveurs en taille douce au Burin et a Leave forte' 1642** ['Soft ground engravers with the burin']
Engraving 21.8 × 31.5 (8½ × 12½)
on paper 25.8 × 31.9 (10⅛ × 12½)
The British Museum, London

100 **America a Prophecy 1793**
Plate 1: Frontispiece
a) Facsimile relief-etched plate made by Christopher Bacon, Bewick Studios, after Copy C in Houghton Library, Harvard University, by kind permission
Copper 23.4 × 16.9 × 0.15 (9¼ × 6⅝ × 0.059)
b) 2 impressions printed by Michael Phillips from no.100a
Blue-green ink on paper 26 × 19 (10¼ × 7½)

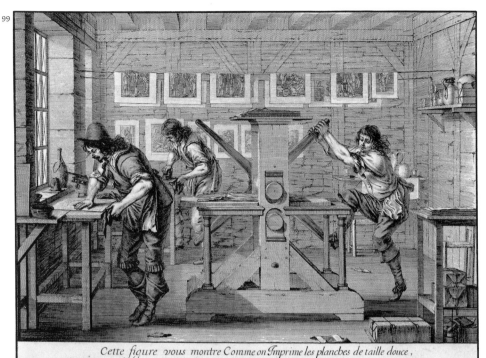

99

Cette figure vous montre Comme on Imprime les planches de taille douce,

Lancre en est faite dhuille de noix,bruslee et de noir de lie de vin,dont le meilleur vient Dallemagne.L'imprimeur prend de Cete ancre auec vn tampon de linge,en ancre sa planche vn peu chaude,lessuye apres legerem/auec dautre linge,et acheue de la nettoyer auec la paume desa main.Cela fait il met cette planche a lenuers sur la table desa presse. apliqúe dessus vne foeuille de papier trempe et reposé.et Couure cela d'une foeuille dautre papier et d'un ou deux Langes,puis en tirant les bras de sa presse il fait passer sa table auec sa planche entre deux rouleaux

faict a leauforte par Bosse a Paris en Lisle du palais lan 1642 , auec priuilege

101 America a Prophecy 1793
Plate 2: Title-Page
a) Facsimile relief-etched plate made by
Christopher Bacon, Bewick Studios, after Copy C
in Houghton Library, Harvard University, by
kind permission
Copper 23.5×16.7×0.15 (9¼×6⅝×0.059)
b) 2 impressions printed by Michael Phillips
from no.101a
Blue-green ink on paper 26×19 (10¼×7½)

102 America a Prophecy 1793
Plate 12: 'Thus wept the Angel voice …'
a) Facsimile relief-etched plate made by
Christopher Bacon, Bewick Studios, after Copy C
in Houghton Library, Harvard University, by
kind permission
Copper 23.5×16.9×0.15 (9¼×6⅝×0.059)
b) 2 impressions printed by Michael Phillips
from no.102a
Blue-green ink on paper 26×19 (10¼×7½)

103 Rolling Press
18th century with 19th century alterations
Hardwood, lignum vitae and iron
246×75×110 (96⅞×29½×43¼)
By courtesy of the Board of Trustees of
the Science Museum
Lit: Keynes 1971, pp.122–9

104 Some engraving and etching tools
The Victoria & Albert Museum
Lit: Essick 1980

Blake's invention of relief etching was
revolutionary but the materials, methods and
tools that he used for this process – and also for
his more conventional etchings and engravings
– were essentially the same as those used by
earlier generations of printmakers as well as
Blake's own contemporaries. The small selection
of tools displayed here are very similar to the
sorts of tools that Blake would always have had
to hand in his studio. They should be seen in
conjunction with the rolling press (no.103) and,
more particularly with the two sequences of
works that look in more detail at how Blake
went about producing a printed image – one of
the wood-engravings for Thornton's *Virgil*
(no.217) and the creation of plate 2 from the
Illustrations of The Book of Job (no.218). Above all,
perhaps, these implements convey a real sense of
the physicality of the process which lay behind
the production of so many of his images,
seemingly so easily won. RH

Blake's Illuminated Printing

The earliest account of Blake's method of 'Illuminated Printing' is that of J. T. Smith, who became acquainted with Blake in 1784 through his friendship with Blake's younger brother, Robert. In 1787 Robert died, aged nineteen, but spiritually became an inspiration for Blake, as Smith described:

> Blake, after deeply perplexing himself as to the mode of accomplishing the publication of his illustrated songs, without their being subject to the expense of letter-press, his brother Robert stood before him in one of his visionary imaginations, and so decidedly directed him in the way in which he ought to proceed, that he immediately followed his advice, by writing his poetry, and drawing his marginal subjects of embellishments in outline upon the copper-plate with an impervious liquid, and then eating the plain parts or lights away with aquafortis considerably below them, so that the outlines were left as a stereotype. The plates in this state were then printed in any tint that he wished, to enable him or Mrs. Blake to colour the marginal figures up by hand in imitation of drawings. (BR.460)

John Linnell, who met Blake in 1818, later annotated a copy of Smith's account. The details he supplies are of particular value as Linnell was also a skilled printmaker:

> The liquid mentioned by M^r Smith with which he says Blake used to Draw his subjects in outline on his copper plates was nothing more I beleive [*sic*] than the usual stopping [out] as it is called used by engravers made chiefly of pitch and diluted with Terps. (BR.460, n.1)

Linnell then added:

> The most extraordinary facility seems to have been attained by Blake in writing backwards & that with a brush dipped in a glutinous liquid for the writing is in many instances highly ornamental & varied in character as may be seen in his Songs of Innocence and the larger work of one hundred plates called Jerusalem. (BR.460, n.1)

The exact formula of the stopping-out liquid or etching ground that Blake used is unknown. Contemporary handbooks give several recipes that Blake could have made up or altered to suit his purpose. What we do know is that the liquid had to flow easily from Blake's pen or brush and not run. It then had to harden sufficiently to resist the acid eating it away and biting through the surface of the copper plate. Both properties were crucial. When the liquid was fluid it provided a medium that was free and immediately responsive to the hand of the artist. When it became solid it made possible by etching the transformation of a freely drawn artefact composed of poetry and design into one capable of reproduction. By creating a formula possessing these contrary aspects, and putting it to use in just this manner, Blake unified the relationship of the poet and the painter with that of the book producer.

As an apprentice, Blake learned the traditional method of intaglio etching. Robert Dossie's *Handmaid to the Arts* (second edition, 1764) was a standard handbook during the period. It offers the following definition and instruction:

> ETCHING … is engraving by corrosion, produced by the means of *aqua fortis*, instead of cutting with a graver or tool. The manner (in a general view) by which this is performed, is the covering the surface of the plate with a proper varnish or ground, as it is called, which is capable of resisting *aqua fortis*, and then scoring or scratching away, by instruments resembling needles, the parts of this varnish or ground, in the places where the strokes or hatches of the engraving are intended to be. Then, the plate being covered with *aqua fortis*, the parts that are laid naked and exposed by removing the ground or varnish, are corroded or eaten by it, while the rest, being secured and defended, remain untouched.

Blake's method could be described as the 'contrary state' of conventional intaglio etching. Instead of covering the plate with a ground and cutting his design into it with engraver's tools, Blake worked directly in the medium respectively of the poet and the painter using a quill pen or fine 'pencil' brush. Dipping his pen or brush into his impervious liquid he wrote and drew directly upon the polished surface of the copper, just as a writer would write out fair copy and as an artist would draw.

In order to write on the copper Blake had to be skilled at reverse or mirror writing. Although the principle of reversal in printmaking was established in the course of his apprenticeship, Blake may not have acquired extensive use of this specialist skill during the 1770s. However, on the final leaf of the manuscript of *An Island in the Moon*, written during the early 1780s, we can see amongst examples of Blake practising copper-plate script an attempt to write in the same professional hand the first letters of his surname 'Bla' in mirror writing (no.106). Significantly, it is in this manuscript that we also find a self-parody of ambitions to produce illustrated books with the 'writing Engraved instead of Printed,' and drafts of three songs that in 1789 will be included in *Songs of Innocence*, 'Holy Thursday', 'Nurses Song' and 'The Little Boy Lost'. In 1788, the first plates etched by his new process, measuring no more than 6 × 4 cm (2¼ × 1½ in), and some less than 5 × 3 cm (2 × 1¼ in) show Blake at a primitive stage in the development of this skill (nos.107, 109). By 1789, when he was etching the plates for *Songs of Innocence* and *The Book of Thel*, mirror writing in both cursive and roman has been all but mastered (nos.126, 128).

For the design, Blake may have drawn his images directly and freely on the polished and degreased copper plate at the time that he wrote his text in mirror writing. However, in the *Manuscript Notebook* (see no.162) there are a number of drawings that Blake copied for images reproduced in the illuminated books. There are also preliminary drawings, including two in preparation for the Title-Page of *America a Prophecy* (no.114) These examples clearly suggest that his larger designs were not created spontaneously on copper but prepared beforehand or salvaged from other projects. The idea of combining text and design on a single copper plate, and introducing interlinear designs and figures that feature in plates like those found in *The Marriage of Heaven and Hell* (no.127) may derive from his ownership of *A Political and Satirical History of the Years 1756 and 1757* (1758; nos.125, 105). Blake obtained his copy of this book of engraved plates 'May 29 1773' at the beginning of his apprenticeship. Many of the plates are composites of text and design and in a number the text is interpolated with hieroglyphs (no.105 pl.43). Like the illuminated books, these plates were also printed from copper plates.

With the text of his poem written in reverse on the plate, and the design drawn surrounding

'Songs of Innocence' 1789, Title-Page plate (no.111c, detail)

and interlining it, the liquid was then left to dry and harden before etching (see *Songs of Innocence* Title-Page, copper plate, first stage, no.111a). Then, using a soft sealing wax, Blake formed a small border of the wax resembling a little wall or rampart around the edge of the plate to contain the acid, as revealed by late (and posthumous) impressions where he has printed these protected relief borders to help frame the image. This also preserved the backs of the plates. For example, the backs of plates of *Songs of Innocence* were later used to relief etch plates for *Songs of Experience* shown by comparisons of the plate sizes and by the appearance of copper-plate makers stamps inadvertently inked and printed in posthumous impressions.

Blake's method of etching also demanded special care in order to avoid what is known as 'underbiting'. This occurs when the acid having bitten away the exposed surface begins to erode text and design from below the ground, first by biting down and then sideways, causing the ground to lift or 'scale' (see *Songs of Innocence* Title-Page, copper plate, second stage, no.111b). Blake prevented underbiting by removing the acid from the plate after a shallow bite and carefully repainting or surrounding vulnerable areas with stopping out liquid before further etching. Of his original relief-etched copper plates only a single fragment (measuring $8 \times 5.7 \times 0.14$ cm, $3\frac{1}{8} \times 2\frac{1}{4} \times 0.06$ in) has survived, from a cancelled plate for *America a Prophecy*, 1793 (no.112). We can see from an enlargement of this fragment how shallow the first bite was by noticing how Blake minutely repainted or carefully surrounded several of the relief surfaces with stopping-out liquid before again subjecting the plate to the acid. For example, at top right there is evidence of meticulous repainting of the broad copper-plate letters 'ecy' of 'Prophecy' and, below, of surrounding a number of letters and words in the much smaller semi-cursive text. We can also see, at the left edge of the fragment, an escarpment formed by the acid biting at the base of the wax wall. Repainting with acid resist was done when this plate had been etched only to a depth of approximately 0.05 mm. The plate was then etched again, approximately a further 0.07 mm, amounting to a total bite of 0.12 mm, or less than $\frac{1}{32}$ of an inch.

As the unprotected surfaces are bitten away, those forming Blake's text and design that have been protected appear to emerge from the copper and are left standing in relief (final stage, nos.111c, 112a). Blake refers to this process on

plate 14 of *The Marriage of Heaven and Hell*:

> But first the notion that man has a body
> distinct from his soul, is to be expunged;
> this I shall do, by printing in the infernal
> method, by corrosives, which in Hell are
> salutary and medicinal, melting apparent
> surfaces away, and displaying the infinite
> which was hid. (E.39; no.127)

Blake's method is symbolic of his philosophy of
mind, the firm belief in innate ideas that was
profoundly opposed to the empiricism of John
Locke as expressed in his *An Essay Concerning
Human Understanding* (1690):

> Let us then suppose the Mind to be, as we
> say, white Paper, void of all Characters,
> without Ideas; How comes it to be
> furnished?… to this I answer, in one
> word, from Experience. In that, all our
> Knowledge is founded; and from that it
> ultimately derives it self. (no.108)

In his annotations to Sir Joshua Reynolds's
Discourses (no.233), Blake noted that he had read
Locke's *Essay* 'when very Young'. His opposition
to empiricism and to all who believed in its
principles was fundamental:

> Reynolds Thinks that Man learns all that
> he Knows I say on the Contrary That Man
> Brings All that he has or Can have Into
> the World with him. Man is Born Like a
> Garden ready Planted & Sown …
> (E.656)

For a man with Blake's training, the analogy
between Locke's metaphor for the human mind
as *tabula rasa*, a blank slate, and a copper plate
prepared for intaglio etching would have been
apparent. Its contrary, etching in relief by biting
the surfaces of the copper away to reveal from
within poetry and design, would have similarly
been appreciated as a corresponding metaphor
for the existence of innate ideas: for the divine
within man, awakened and raised to life.

Once the plate had been etched and cleaned
it was ready to be inked. Blake mixed his inks
until they were tacky and stiff. This prevented
running and also produced the characteristic
granulated effects he obtained when the
impression was lifted from the plate. Inking
only the relief surfaces with a dauber or ball
required great skill and time. This was made
easier when text and design were etched close

together as in the plate of 'Holy Thursday' of
Songs of Innocence (no.128 pl.19). It was more
difficult with a shallow bite where large spaces
or whites were etched, as seen on the *America*
fragment. After inking, wiping the borders and
shallows of the plate was a slow and painstaking
process. This may suggest why Blake later
stopped wiping the relief borders that had been
protected by the wax wall during etching.
Printing the borders in later copies was then
turned to advantage, by using them to frame
the text and design.

Once the plate had been inked and any
residue wiped away, it was then placed on the
bed of the rolling press, the sheet of paper to be
printed laid over it and felt blankets laid over all.
On the evidence of watermarks, Blake's choice of
paper for printing his illuminated works was
that made by Edmeads & Pine and J. Whatman:
'The most beautiful wove paper that could be
procured,' (E.693) as he stated in his *Prospectus*.
Up to three weeks before printing, the paper was
dampened and pressed and allowed to 'rot' in
order for the ink to be fully absorbed. As the
plate was inked on the relief surfaces very little
pressure was required as Blake turned the star
cross of his press evenly and slowly till the whole
had passed through the rollers. The blankets
were then turned back and the impression
carefully lifted away. Applying little pressure
resulted in no raised or embossed areas on
the verso. This left both sides available for
printing in the manner of a book which was
characteristic of the way Blake first produced
his illuminated books.

In 1789 and during the early 1790s, Blake
printed several copies of each work in
monochrome for stock. In the *Prospectus*
addressed '*To the Public*' of 10 October 1793,
announcing 'the several Works now published
and on Sale at Mr. Blake's, No.13 Hercules
Buildings, Lambeth', he states that the
'Illuminated Books are Printed in Colours'. This
suggests that Blake printed his works in colours
other than black, such as the sea blues and
greens used to print copies of *America* (no.115).
It may also refer to the fact that within a single
work some plates were printed in one colour and
other plates in another, as in Copy B of *The
Marriage of Heaven and Hell*. Following these early
print-runs, it is possible that Blake hand-
coloured in watercolour more than one copy at
a time. This is suggested by similarities in the
style and choice of the watercolours he used.
But no two copies are coloured in exactly the
same way. During this period Blake's palette was

confined to a very small selection of pigments.
The variation in colouring, though sometimes
slight, more likely suggests that following a
print-run Blake coloured a sample copy and
perhaps one other in preparation for sale, and
prepared the other copies to order at the time
of sale or as the finished copy was sold.

During the summer and early autumn of
1793 Blake began to print the first copies of *Songs
of Experience*, made up of only seventeen plates
(no.129). In marked contrast to the copies of
Songs of Innocence coloured by hand in
transparent watercolour wash produced at this
time (no.128), these first copies of *Songs of
Experience* were colour printed using opaque
pigments that produced brooding autumnal
colours of great depth and richness. Blake's
method involved two printing stages, as the
early experiments in registering the plates for
Songs of Experience show (nos.117c, d). To print
these copies successfully demanded
extraordinary care, especially during the second
printing stage. If the plate applied with colours
was not printed in register with the
monochrome impression, a doubling effect was
produced (no.118a).

Blake's method was without precedent, but
called upon aspects of both traditional multiple-
plate and '*à la poupée*' colour-printing techniques
(applying different colours to the copper plate
using small doll-like dabbers or brushes). First,
the plate was registered on the bed of the rolling
press using a sheet of paper marked with the
outline of the copper plate, so that it could be
removed and later returned to exactly the same
place in relation to the printed impression.
The text and some parts of the design were first
printed in monochrome using oil-based ink.
Then, removing the copper plate, the remnants
of the oil-based ink were wiped away. Using
small stubble brushes, opaque colour pigments
mixed with what gives every appearance of
being a water-based binder were applied '*à la
poupée*' to the areas of the design and interlinear
decoration, in the shallows as well as on the
relief plateaus. The plate was then returned to
the press, registered with the monochrome
impression and printed a second time (possibly
not by passing the plate and impression through
the rolling press again, but by Blake carefully
applying pressure with his finger tips or by
using the palm of his hand). By carefully
bonding together the plate and impression,
and then gently pulling them apart, the colour-
printed areas of design and interlinear
decoration produced highly reticulated surfaces

often of great richness and individuality. After the opaque colour pigments had dried and were sealed by the binder, each plate was then finished by hand, using a fine camel-hair brush and watercolours, and, in some cases, a finely trimmed quill pen and ink for outlines and features of the hands and faces. When finished, each impression is noticeably different, with some examples of the same plate colour printed using an entirely different palette of colours (no.18).

From 1794 until 1796 Blake produced his illuminated books, large and small collections of prints taken from them, and separate plates predominantly in this way (nos.203, 204). For separate plates without text, a second impression appears to have been taken using the same residual colour pigments, as can be seen by comparing the two impressions of *The Accusers* where elements of the monochrome printing can be seen in the second impression (see nos. 203, 212) These experiments eventually led to the development of the method Blake used to produce his large colour prints beginning in 1795 (nos.241–253). If the skill and time required by Blake's method is not appreciated, it can lead to misunderstanding regarding the audience and market he sought for his illuminated books and separate plates.

Quality monochrome impressions were about half the price of an impression either coloured by hand or colour-printed '*à la poupée*'. A monochrome print colour-printed '*à la poupée*' and then finished in another medium, like James Northcote's *Le triomphe de la Liberté en l'élargissment de la Bastille, dédié à la Nation Françoise*, engraved, colour printed '*à la poupée*' and finished in watercolour and then body colour by James Gillray, demanded a price far beyond the reach of all but the most dedicated connoisseur. Of a number of examples of this print produced in monochrome, only one colour-printed example is known. In a contemporary hand, it has been priced 25 shillings (nos.121a, b).

Blake's method of colour printing was even more exacting, requiring registration, a second printing as well as detailed finishing by hand in watercolour and pen and ink (no.00). Because of the time and skill required to produce each example, thus limiting their numbers to a very few copies, Blake's colour-printed works may have been aimed at an even more exclusive market. A public market for his illuminated books and prints may have been sought, as the *Prospectus* clearly suggests. This may have

included his works produced by colour printing. But the market that we know he found was essentially private, composed of friends and acquaintances who appreciated them, who were able to pay a commensurate price and by doing so assist Blake, like the miniature painter Ozias Humphrey and the connoisseur and amateur printmaker George Cumberland. This may also explain why the few that were produced have survived.

Blake's colour-printed illuminated books and separate prints need to be distinguished from his other productions. Blake also made plates for the international market for line engravings. Line engravings of history paintings were considered the most prestigious and expensive because the engraved copper plate was acknowledged to be the most time consuming to make (nos.122, 123). Blake's separate monochrome line engravings of *Job* and *Edward & Elenor*, listed in the *Prospectus* (nos.122, 123), were intended for this market. Blake could also produce prints that could be made and printed relatively quickly and sold for a few pence.

The separate intaglio etching entitled *Our End is come*, printed in monochrome and 'Publishd June 5: 1793 by W Blake Lambeth', could be produced quickly, printed in substantial numbers and sold cheaply (no.191). The separate printing in relief of 'A Song of Liberty', in the surviving copy printed in monochrome on a single leaf as a small three-plate octavo pamphlet, Copy M, is another example (no.192b). 'A Song of Liberty' is normally found as the last three plates in *The Marriage of Heaven and Hell*, plates 25, 26 and 27 (no.127). Copy M has been produced with the first side blank so that only when it is opened can the title be seen and the first two plates read. The extremely narrow inside margins make clear that it was not intended for binding. The difference can be seen by comparing it with the second copy of *A Song of Liberty* also found separately printed, Copy L (no.192a). Copy L has been printed on a larger, quarto-size sheet. The first plate is printed on the first side, indicating that it was planned to continue the sequence of plates of *The Marriage of Heaven and Hell* without a break. The generous inner margins also make clear that it was printed to allow for binding. In contrast, Copy M of *A Song of Liberty*, produced to be issued separately on a single sheet folded in half, may have been intended to sell cheaply or given away. Copy M of *A Song of Liberty* and *Our End is come* may be the only examples of Blake's

graphic works produced at this time that were intended to engage publicly in the political debate brought about and inflamed by the Revolution in France. But there is no record of Blake publishing or issuing either in this way.

Blake's colour-printed works also need to be distinguished from the copies that he typically produced later in life. After 1800, and particularly in the last decade of his life, Blake printed the plates of his illuminated books on one side of the leaf, abandoning his former practise of printing on both sides to produce facing pages in the manner of a book. He also printed the plate borders in order to help frame the text and design and by hand added framing lines around the printed borders. The plates were extensively decorated using opaque watercolour and in a few examples enhanced with crushed gold leaf. These elaborately painted and decorated copies, like *Jerusalem* Copy E (no.303), in contrast with the other four copies of *Jerusalem* that Blake printed in black and subtly highlighted with additions in grey wash and pen and ink, and *Songs* Copy Y (no.298) – again, in contrast to *Songs* Copy BB (private collection, Germany) printed in black and highlighted in charcoal grey wash – were aimed at yet another market, a luxury market of wealthy collectors. These copies of the illuminated books may also have been produced in this way to appeal to the rapidly growing taste for medieval illuminated manuscripts that took place at this time.

Blake's colour-printed works should perhaps be thought of in similar terms with the large colour prints, first produced in 1795 with other copies printed on paper watermarked 1804 (which in fact were monotypes, where only two or three impressions were possible, nos.241–253). There is no record of the large colour prints being offered publicly for sale. When they were sold it was to a patron, Thomas Butts, for whom they were produced on commission in the time-honoured tradition of patron and artist. With an appreciation of how they were made, we should not doubt Blake's ambition in producing his colour-printed illuminated books and separate prints, as he recalled when writing to Dawson Turner, 9 June 1818, who had enquired after the illuminated books and colour prints produced in the 1790s. Blake remarked: 'The few I have Printed & Sold are sufficient to have gained me great reputation as an Artist, which was the chief thing Intended.' (E.771) These are indeed amongst the supreme examples of work by England's most original graphic artist. MP

105 ANON

**A Political and Satirical History of the Years
1756 and 1757**

London: n.d [1758]
William Blake's copy
Open at title-page
Michael Phillips

105

Plate 23

A List of the Pedigrees of some Eminent Geese 23
Shortly to appear in Public.

Neck and Giblets a famous Goose belonging
to Esq.r Goose cap bred out of Waddle by
the Wild Gander Lord Anser
who flew all round and
Came back again.

Lord Leo's Old Grey Gander Nefa-
rio famous for sucking of Golden
Eggs his Daughter runs in the
same track with Lord Anser.

Sly a famous Goose of Lord Leo's his
breed is very low & being fond of Dab-
ling in the Dirt is turn'd off the Com-
mon but is to be kept at the expence
of the Farmers round about.

Gabble & Hiss an excellent Goose for the
High Road he was bred out of Little Tony
this Goose has been remarkable in all y.e Dirty
Courses he has waddled thro' for bringing
the other Geese on thier Way.

Lord Leo's Smilum this Goose was bred out
of that great Sporter Hold-his-nest this
is y.e most Goodnatur'd Goose in the World
even in the Dirtyest Roads.

Publish'd according to Act Oct.r 20. 1756. by Edwards & Darly at the
Acorn facing Hungerford Strand.

PLATE 23

Plate 33

the Author of a late Lett.r 2 the Merch.ts of 33
Y let the Stricken go Weep
Sir don't a fraid of the or
Suppose Condemn'd die like a
of the Rab Indecent dare truth 2 prop.
Down with 'em at once by a 12 A B 3
D'ye h my Good friends things are quite right
and if Ill me tis nothing Spite
Indecent & Dull Sirs Against me & m
Which the Sirs Insist on is fun
Run on in this Say the was damn'd sick
There was fogs & hard gales damp een'd Nick
Say a word of w was the Occasion
Wed Enough w.th stand an Invasion
Don't at on provisions nor Contract nor Bargain
know the 's poi'd Cr out it's gon
The Merch persuade we hold of their
they're much better of than if in privat
Say just what please if it in this Strain
Suppose t they In and Cr Ah! Rogues in grain
No for that Sir suppose rogu'd
Don't mind it at while the trouts are prorogu'd
Cast up Accounts & so set right
And if like Achitophel bid us good Night
By way of a script thing let me say
know talk of the 20.th of May
Say t m Wages & Vails are the Aim
Think a little on t Sir and Blush for Shame

Publish'd according to Act Nov.r 3. 1756 by Edwards & Darly facing Hungerford Strand

PLATE 33

Plate 43

And I wish I had been a Parson — Orator Humbug to Admiral Bungy — I wish I had been an Admiral

No soon Came un Quite Convinced of our tricks
1 thing b 2 let know a for ever G
t was a pr d for me and will pro il for thee
could I guess n gorgeous piles P R dforth is of these las
w V s stil our Auction Ba My triump
w s Routs and w pol s madeup of Shams
the l se which they now h delight in must th the
And some th are thee nay some wish to set U free
others of Contra mind 2 see you th are much Inclin'd
have surpriz'd w of a secret your advis it
a War is going on n Hell & they have hit upon
You Command in Chief L i's Alarm d thief
Zounds Sir hope d start a command a fart
Blood I'll command have a the Chaplain shall lie part
I'll go & the Command sollicit, and then U t again revisit

Publish'd according to Act Nov.r 4. 1756 by Edwards & Darly facing Hungerford Strand

PLATE 43

106 An Island in the Moon *c.1782–1784*
MS fo.16 verso. Sketches in pen and ink with
copperplate lettering and autograph signatures
including 'Bla' in mirror writing on paper
18.1 × 30.8 (7⅛ × 12⅛)
Lent by the Syndics of the Fitzwilliam Museum,
Cambridge
Lit: Butlin 1981; no.149

107 There is No Natural Religion *1788/1795*
Copy L
Plate b11 (b10) 'Application. He who sees the
Infinite in all things sees God … '
Relief etching printed in light green ink with
some colour printing in olive brown with some
black wash 5.5 × 4 (2⅛ × 1⅝) on paper,
29.5 × 23 (11⅝ × 9)
The Pierpont Morgan Library, New York
*Lit: Eaves, Essick and Viscomi 1993 (facsimile
Copies G, I, L)*

108 JOHN LOCKE (1632–1704)
**An Essay Concerning Human
Understanding** *1726*
9th edn
Book Two, Chapter I, Part 2
Open at Vol.1, pp.66–67
The British Library Board

109 All Religions are One *1788/1795*
Copy A
a) Plate 3: 'The Argument As the true method of
knowledge is experiment … '
Relief etching printed in green ink with some
colour printing in olive brown
10.8 × 8.6 (4¼ × 3⅜)
on paper 37.5 × 27 (14¾ × 10⅝)
b) Plate 4: 'Principle 1ˢᵗ That the Poetic Genius
is the true Man … '
Relief etching printed in green ink
11.8 × 9.8 (4⅝ × 3⅞)
on paper 37.8 × 27 (14⅞ × 10⅝)
The Huntington Library, Art Collections and
Botanical Gardens
Lit: Eaves, Essick and Viscomi 1993 (facsimile Copy A)

110 The Marriage of Heaven and Hell *1790–1793*
Plate 14
a) Facsimile relief-etched plate made by Michael
Phillips after Copy B in Bodleian Library,
Oxford, by kind permission
Copper, 14.9 × 10.1 × 0.15 (5⅞ × 4 × 0.06)
b) Impression printed by Michael Phillips
from 110a
Charcoal black ink on paper 22 × 16 (8⅝ × 6¼)

107

Opposite: 'There is No Natural Religion' 1788/1795
(no.107, detail)

Application

He who sees the In-
finite in all things
sees God. He who
sees the Ratio only
sees himself only

Three stages of relief etching

111 Songs of Innocence 1789

Plate 3: Title-Page

a) Plate with text and design in stopping-out liquid ready for relief etching made by Michael Phillips from a 1:1 negative taken from Alexander Gilchrist, *The Life of William Blake*, 1863 (vol.2, pl.23)

Copper, 12.4×7.4×0.15 (4⅞×2⅞×0.06)

b) Plate with text relief etched following first bite made by Michael Phillips from a 1:1 negative taken from Alexander Gilchrist, *The Life of William Blake*, 1863 (vol.2)

Copper, 12.1×7.4×0.15 (4¾×2⅞×0.06)

c) Plate with text and design relief etched following second bite made by Michael Phillips from a 1:1 negative taken from Alexander Gilchrist, *The Life of William Blake*, 1863 (vol.2)

Copper, 12.1×7.4×0.15 (4¾×2⅞×0.06)

d) Impression printed from no.111c by Michael Phillips

Printed in blue ink on J. Whatman laid paper; watermark 1802, 20×14 (7⅞×5½)

e) From *Songs* Copy F 1789

Relief etching printed in green ink finished with pen and ink and watercolour

18.4×12.1 (7¼×4¾)

Paul Mellon Collection, Yale Center for British Art

111a

111b

111c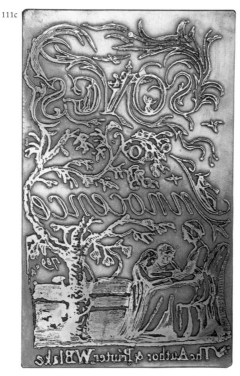

111d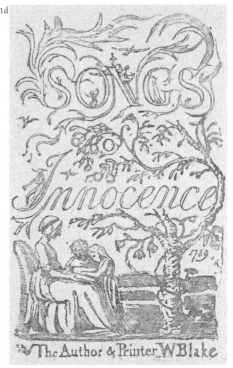

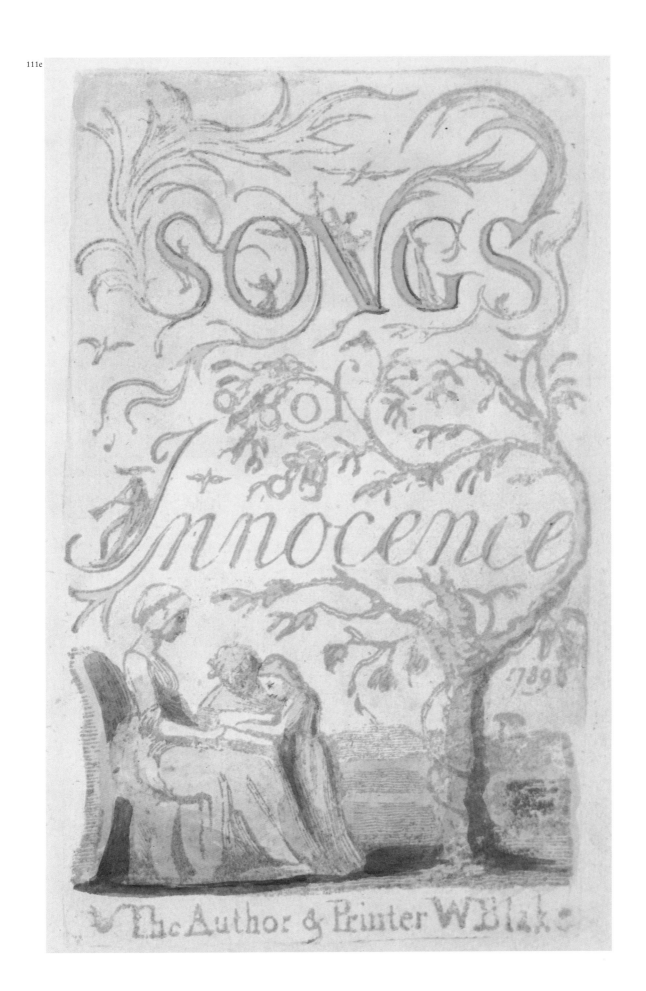

112a

112 America a Prophecy 1793

a) Fragment of relief-etched plate for cancelled
plate (a)
Copper 8 × 5.7 × 0.14 (3⅛ × 2¼ × 0.06)
National Gallery of Art, Washington, Rosenwald
Collection 1943
Lit: Essick 1980 pp.92–4
b) Proof impression of cancelled plate (a)
'A Prophecy/The Guardian Prince of
Albion burns in his nightly tent … '
Relief etching printed in charcoal grey
ink on paper
23.5 × 16.7 (9¼ × 6⅝)
The Lessing J Rosenwald Collection,
Library of Congress

113 America a Prophecy 1793

Sketch for bottom of the Title-Page of
America c. 1793
'A Figure Bending over a Corpse in the Rain … '
Pencil on paper 24.7 × 32.9 (9¾ × 13)
The British Museum, London
Lit: Butlin 1981, no.223

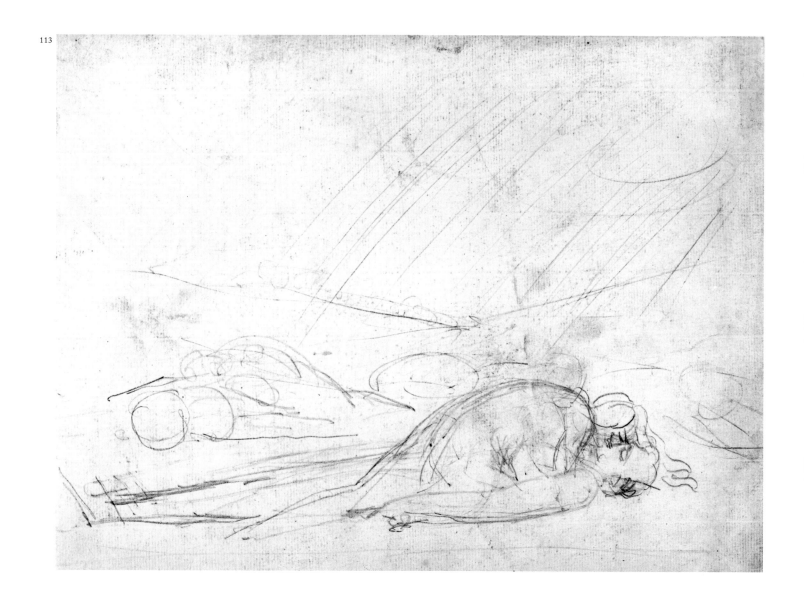

114 **America a Prophecy 1793**
Sketch for a Title-Page, probably first idea for
America c. 1792–1793
Pencil on paper 38.1 × 26.3 (15 × 10⅜)
Inscr. 'THE AMERICAN WAR'? centre and
'Angels to be very small [continues]' lower centre
The British Museum, London
Lit: Butlin 1981, no.223A

115 **America a Prophecy 1793**
Plate 1: Frontispiece
Plate 2: Title-Page
Copy C 1793
relief etchings, printed in blue-green ink
Bequest of Phillip Hofer, Department of
Printing and Graphic Arts, Houghton Library,
Harvard University

116 **America a Prophecy 1793**
Cancelled plate (d): 'A Dream of Thiralatha'
Colour-printed relief etching 11.8 × 17.2
(4⅝ × 6¾) on paper 21 × 24.1 (8¼ × 9½)
National Gallery of Art, Washington, Rosenwald
Collection, 1943
Lit: Essick 1983, no.IX:1B

114

115

PLATE 1

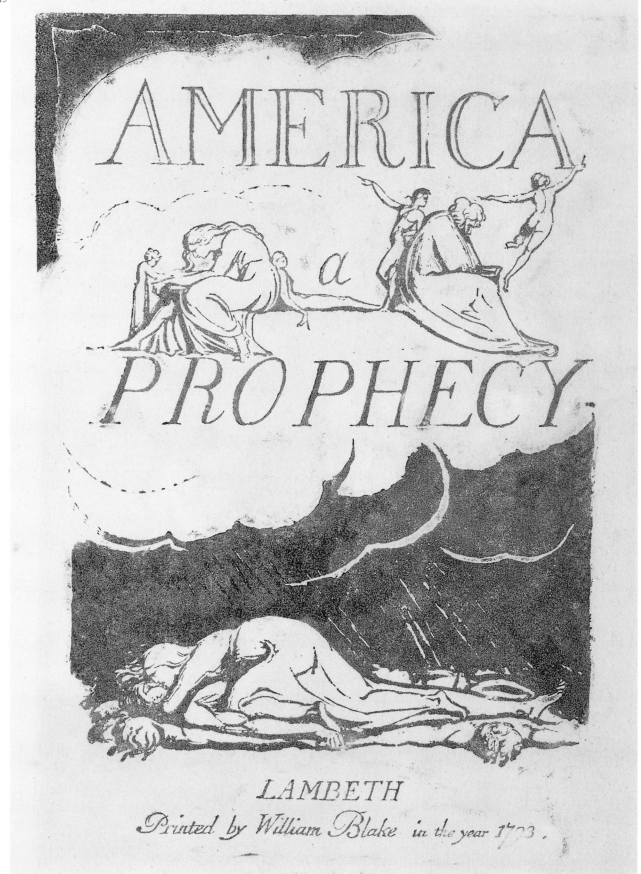

AMERICA
a
PROPHECY

LAMBETH
Printed by William Blake in the year 1793.

PLATE 2

117d

Blake's Colour Printing: A Two-stage Process

117 **Songs of Experience 1793/1794**
Plate 29: Title-Page
a) Facsimile relief-etched plate made by
Christopher Bacon, Bewick Studios, from
posthumous copy [b] in Houghton Library,
Harvard University, by kind permission
Copper 7.4 × 11.7 × 0.15 (2⅞ × 4⅝ × 0.06)
b) Impression by Michael Phillips printed from
no.117a
Yellow-ochre ink on paper 19.2 × 13.8 (7½ × 5⅜)
c) From Copy T1 1793/1794
Colour-printed relief etching finished with
watercolour on paper
18.6 × 12 (7⅜ × 4¾)
National Gallery of Canada, Ottawa
d) From Copy T1 1793/1794
Ultra violet photograph showing date '1794'
beneath colour printing
National Gallery of Canada, Ottawa

118 **Songs of Experience 1793/1794/1806**
Plate 38: 'Nurses Song'
a) From Copy E 1794/1806
Colour-printed relief etching 1794 hand-
coloured 1806
11.1 × 7 (4⅜ × 2¾) on paper 17.5 × 11.8 (6⅞ × 4⅝)
The Huntington Library, Art Collections and
Botanical Gardens
b) From Copy G 1793/1794
Colour-printed relief etching finished with
watercolour 18 × 12 (7⅛ × 4¾)
The Keynes Family Trust on loan to the
Fitzwilliam Museum, Cambridge

119 **Visions of the Daughters of Albion 1793**
Plate 1: Frontispiece
a) Proof impression 1793
Copy a
Printed in black ink with black tempera colour
printing 17.1 × 11.9 (6¾ × 4⅝) on paper
The Lessing J. Rosenwald Collection, Library
of Congress
b) Colour-printed relief etching finished in pen
and black ink and watercolour 1794–6
17 × 12 (6¾ × 4¾) on paper 35.5 × 26.7 (14 × 10½)
Tate; purchased with the assistance of a special
grant from the National Gallery and donations
from the National Art Collections Fund, Lord
Duveen and others, and presented through the
National Art Collections Fund 1919
Lit: Butlin 1990, no.21

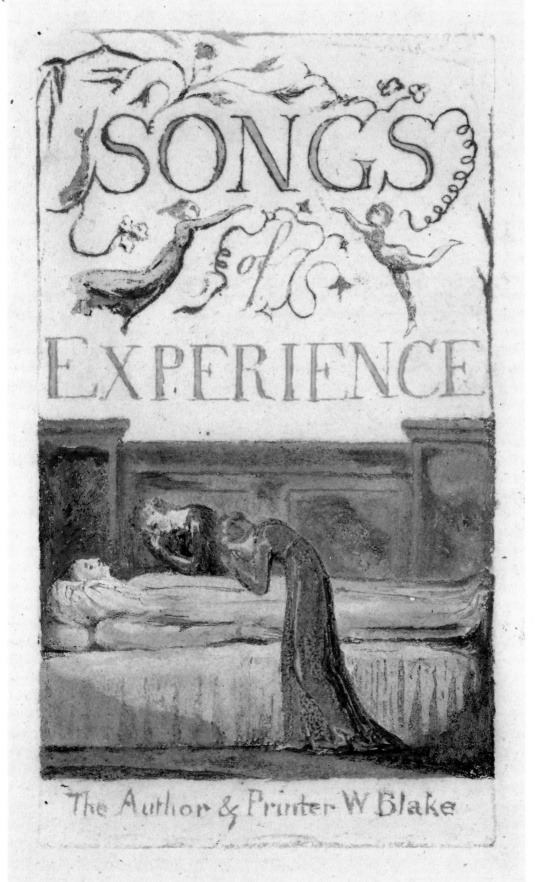

The Ox in the slaughter house moans Chap: IX

(text within Blake's etching plate)

120 **The First Book of Urizen** *c.* 1794
Proof impression, plate 25: 'The Ox in the
slaughterhouse …'
Colour-printed relief etching
16.3 × 10.2 (6½ × 4) on paper 25.5 × 18.4 (10 × 7¼)
Lent by the Syndics of the Fitzwilliam
Museum, Cambridge

121 JAMES GILLRAY (1757–1815) AFTER JAMES
NORTHCOTE (1746–1831)
**Le triomphe de la Liberté en l'élargissment
de la Bastille, dédié à la Nation Françoise**
Published 12 July 1790
a) Engraving, printed monochrome 32.5 × 37.5
(12¾ × 14¾) on paper 35.5 × 39.5 (14 × 15½)
Andrew Edmunds, London
b) Engraving, colour printed *à la poupée*,
finished with body colour
32.5 × 37.5 (12¾ × 14¾)
on paper 35.5 × 39.5 (14 × 15½)
Priced in a contemporary hand '25s'
Andrew Edmunds, London

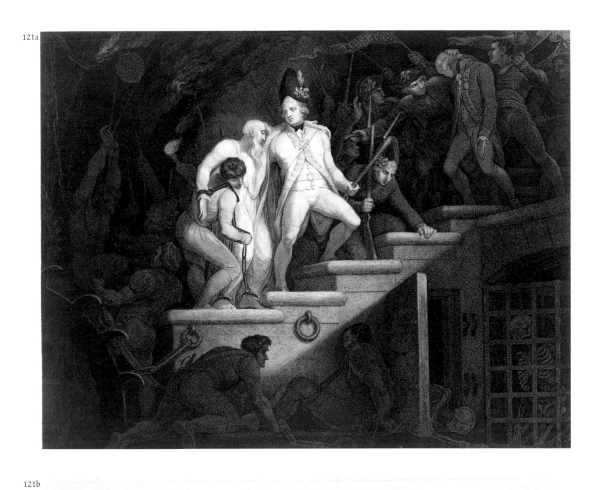

Prospectus 'To the Public', 10 October, 1793 'the numerous great works now in hand'

In his *Life of William Blake* (1863 Vol.2, pp.263–4), Alexander Gilchrist describes a 'Prospectus issued by Blake' while living in Lambeth dated October 10, 1793, as follows: 'The original is in engraved writing printed in blue on a single leaf about 11 × 7½ inches.'

Gilchrist's description, together with his transcription, is our only record of this document. It reads as follows:

> *To the Public.*
> The Labours of the Artist, the Poet, the Musician, have been proverbially attended by poverty and obscurity; this was never the fault of the Public, but was owing to a neglect of means to propagate such works as have wholly absorbed the Man of Genius. Even Milton and Shakespeare could not publish their own works.
> This difficulty has been obviated by the Author of the following productions now presented to the Public; who has invented a method of Printing both Letter-press and Engraving in a style more ornamental, uniform, and grand, than any before discovered, while it produces works at less than one fourth of the expense.
> If a method of Printing which combines the Painter and the Poet is a phenomenon worthy of public attention, provided that it exceeds in elegance all former methods, the Author is sure of his reward.
> Mr. Blake's powers of invention very early engaged the attention of many persons of eminence and fortune; by whose means he has been regularly enabled to bring before the Public works (he is not afraid to say) of equal magnitude and consequence with the productions of any age or country: among which are two large

highly finished engravings (and two more are nearly ready) which will commence a Series of subjects from the Bible, and another from the History of England.

The *Prospectus* lists 'the several Works now published and on Sale at Mr. Blake's, No.13, Hercules Buildings, Lambeth,' including six works 'in Illuminated Printing', each of which is said to be 'Printed in Colours, and on the most beautiful wove paper that could be procured.' It concludes:

> No Subscriptions for the numerous great works now in hand are asked, for none are wanted; but the Author will produce his works, and offer them to sale at a fair price.

The works advertised for sale were listed as follows:

> 1. Job, a Historical Engraving. Size 1 ft. 7½ in. by 1 ft. 2 in.: price 12s. [no.122]
> 2. Edward and Elinor, a Historical Engraving. Size 1 ft. 6½ in. by 1 ft. price 10s. 6d. [no.123]
> 3. America, a Prophecy, in Illuminated Printing. Folio, with 18 designs. price 10s. 6d. [no.124]
> 4. Visions of the Daughters of Albion, in Illuminated Printing. Folio, with 8 designs, price 7s. 6d. [no.125]
> 5. The Book of Thel, a Poem in Illuminated Printing. Quarto, with 6 designs, price 3s. [no.126]
> 6. The Marriage of Heaven and Hell, in Illuminated Printing. Quarto, with 14 designs, price 7s. 6d. [no.127]
> 7. Songs of Innocence, in Illuminated Printing. Octavo, with 25 designs, price 5 s. [no.128]

> 8. Songs of Experience, in Illuminated Printing. Octavo, with 25 designs, price 5s. [no.129]
> 9. The History of England, a small book of Engravings. Price 3s. [no copy is recorded]
> 10. The Gates of Paradise, a small book of Engravings. Price 3s. [no.130]

If Blake prepared his works for exhibition, as the *Prospectus* suggests, it is likely that they would have been on view in the drawing room on the first floor of No.13 Hercules Buildings.

This was Blake's only known attempt at bringing his works before the public while living and working in Lambeth. October 1793 was also a time when the anti-Jacobin Terror in Britain was at its height. On the same day that Blake purportedly issued his *Prospectus* addressed '*To the Public*,' two local loyalist meetings were held in the immediate vicinity (no.199). No evidence survives to indicate what happened on that day or later. As only one copy of the *Prospectus* has ever been seen, and it is now lost, it would appear that it may have been suppressed. And the only copies of the works advertised for sale that are known to have been sold directly by Blake during this period were obtained by his closest friends, who were also sympathetic to his political views, George Cumberland, Samuel Rogers, Ozias Humphrey, John Flaxman and George Romney. MP

122 Job, a Historical Engraving 1793 122

First State

Line engraving 34.4 × 48.2 (13½ × 19) on paper
41.5 × 54.5 (16⅜ × 21½)

Inscribed beneath 'Painted and Engraved by
William Blake/JOB/ [remainder trimmed off]'
(Inscr. second state 'Published 18 August 1793 by
W Blake N° 13 Hercules Buildings Lambeth')
The Keynes Family Trust, on loan to the
Fitzwilliam Museum, Cambridge
Lit: Essick 1983 no.v:1A

This print illustrates lines from Chapter 7 verses
17 and 18 of the Book of Job, 'What is man, …
that thou shouldest visit him every morning,
and try him every moment?' The subject of Job
had interested Blake since about the mid-1780s.
Like its companion *Ezekiel*, published more than
a year later, *Job* is concerned with the physical
and mental trials borne by an individual and
thus identifiable with the artist's own spiritual
and political struggles, much as an earlier and
equally grand treatment of a Job subject by
James Barry, another radical who was much
admired by Blake, can be related to that artist's
tribulations. The importance of Job to Blake is
also evident in his return to a sustained
exploration of the subject in the 1820s (no.218).
This impression of the 1793 print is unique,
suggesting that there were no purchasers for it,
or at least very few. RH

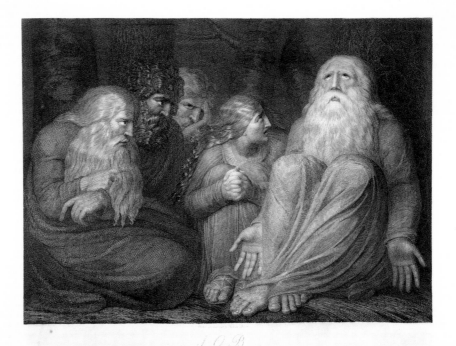

123 Edward & Elenor 1793

Line engraving 30.7 × 45.7 (12⅛ × 18) on paper
41.2 × 53.5 (16¼ × 21⅛)
Engraved inscription 'Painted and Engraved by
William Blake/EDWARD & ELENOR/Published
18th August 1793 by W Blake Nº 13 Hercules
Buildings Lambeth'
The British Museum, London
*Lit: Butlin 1978, p.35; Butlin 1981, pp.21–2; Essick 1983,
no.IV*

This engraving was published on 18 August
1793 and listed in Blake's *Prospectus* of that year.
Whether Blake first executed a watercolour
design which was then engraved is not known.

As with *The Penance of Jane Shore* (no.18), Blake
produced an illustration from English medieval
history on the subject of female virtue. Eleanor
of Castile (d.1290) accompanied her husband
Prince Edward (the future Edward I) to the Holy
Land. There he was stabbed with a poisoned
knife by an assassin posing as a Christian.
Tradition has it that Eleanor saved her
husband's life by sucking the poison from
the wound in his arm. CR

124 America a Prophecy 1793

'Lambeth/Printed by William Blake in
the year 1793.'
Copy F 1793
18 relief-etched plates printed in greenish black
ink with white line engraving on some plates
and some grey wash average size 23 × 17 (9 × 6¾)
on 10 leaves 36.2 × 23.3 (14¼ × 9⅛)
The British Museum, London
*Lit: Bindman 1978 nos.146–63 Dörrbecker 1995
(facsimile Copy H)*

Dated '1793' on its Title-Page, *America* was the
first of Blake's Prophetic Books, and the first
instalment of the 'Bible of Hell' announced in
The Marriage of Heaven and Hell (no.127), in which
Blake developed his myth of human history
from Creation to Redemption. With *Europe*
(no.299), with which it was often issued, *America*
is the most concerned with contemporary
events. The American Revolution and its first
echoes in Europe are presented as an upsurge of
cosmic Energy, personified by Orc, the 'lover of
wild rebellion', who breaks his chains of
bondage – forged by his parents Los and

Enitharmon – to challenge the Old Order of the
Fallen world epitomised by 'Albion's Angel',
a compound of the reactionary and autocratic
Urizen and King George III. Blake returned in
more detail to Orc's captivity in *The First Book of
Urizen* (no.296). His vision of America released
from a material Empire to shine as a beacon of
political and spiritual liberty, did not preclude
one of Britain itself, cleansed and regenerated as
a universal force for good (see *Jerusalem*, no.303).
America broke new ground in being more richly
illustrated than Blake's earlier narratives, while
using pictorial imagery to expand upon or
complement, rather than merely visualise, the
text. There are eighteen plates, including Title-
Page and two-page 'Preludium'. Coloured copies
are rare, the minority having been issued in
monochrome, heavily printed to yield a
powerful chiaroscuro which Blake generally
emphasised by additions in grey wash. Bindman
(1982, p.37) associates the resulting contrasts
with the fitful birth of the New Order from the
gloom of the Old. DBB

123

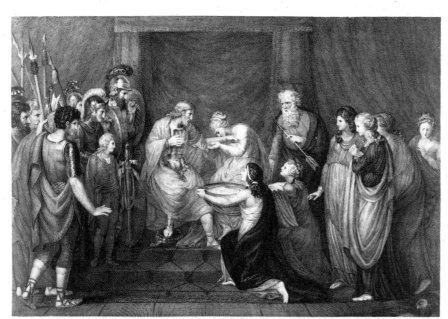

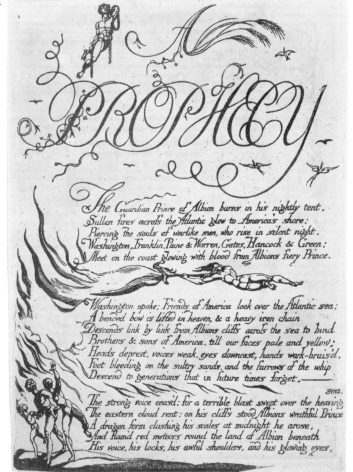

The Guardian Prince of Albion burns in his nightly tent,
Sullen fires across the Atlantic glow to America's shore;
Piercing the souls of warlike men, who rise in silent night,
Washington, Franklin, Paine & Warren, Gates, Hancock & Green;
Meet on the coast glowing with blood from Albions fiery Prince.

Washington spoke; Friends of America look over the Atlantic sea;
A bended bow is lifted in heaven, & a heavy iron chain
Descends link by link from Albions cliffs across the sea to bind
Brothers & sons of America, till our faces pale and yellow;
Heads deprest, voices weak, eyes downcast, hands work-bruis'd,
Feet bleeding on the sultry sands, and the furrows of the whip
Descend to generations that in future times forget.————

 sea.
The strong voice ceas'd; for a terrible blast swept over the heaving
The eastern cloud rent; on his cliffs stood Albions wrathful Prince
A dragon form clashing his scales at midnight he arose,
And flam'd red meteors round the land of Albion beneath
His voice, his locks, his awful shoulders, and his glowing eyes,

PLATE 5

Preludium

The shadowy daughter of Urthona stood before red Orc.
When fourteen suns had faintly journy'd o'er his dark abode;
His food she brought in iron baskets, his drink in cups of iron:
Crown'd with a helmet & dark hair the nameless female stood;
A quiver with its burning stores, a bow like that of night,
When pestilence is shot from heaven; no other arms she need:
Invulnerable tho' naked, save where clouds roll round her loins,
Their awful folds in the dark air; silent she stood as night;
For never from her iron tongue could voice or sound arise;
But dumb till that dread day when Orc assay'd his fierce embrace.

Dark virgin; said the hairy youth, thy father stern abhorr'd;
Rivets my tenfold chains while still on high my spirit soars;
Sometimes an eagle screaming in the sky, sometimes a lion,
Stalking upon the mountains, & sometimes a whale I lash
The raging fathomless abyss, anon a serpent folding
Around the pillars of Urthona, and round thy dark limbs,
On the Canadian wilds I fold, feeble my spirit folds,
For chaind beneath I rend these caverns; when thou bringest food
I howl my joy; and my red eyes seek to behold thy face
In vain! these clouds roll to & fro, & hide thee from my sight.

PLATE 3

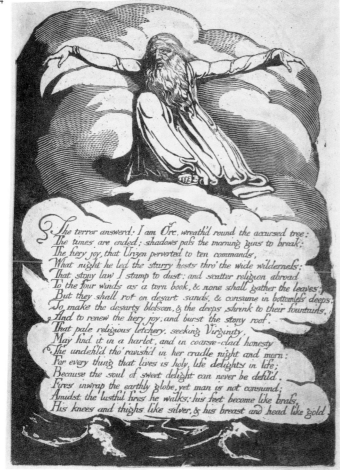

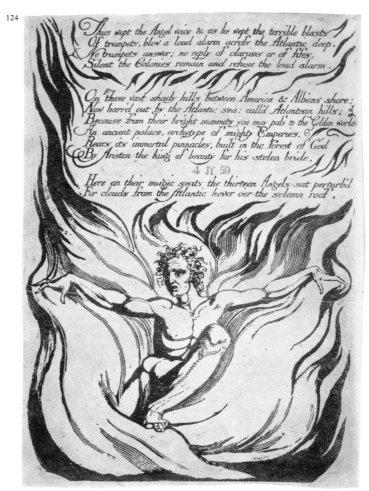

Thus wept the Angel voice & as he wept the terrible blasts
Of trumpets, blew a loud alarm across the Atlantic deep.
No trumpets answer; no reply of clarions or of fifes,
Silent the Colonies remain and refuse the loud alarm.

On those vast shady hills between America & Albions shore;
Now barrd out by the Atlantic sea: calld Atlantean hills:
Because from their bright summits you may pass to the Golden world
An ancient palace, archetype of mighty Emperies.
Rears its immortal pinnacles, built in the forest of God
By Ariston the king of beauty for his stolen bride.

4 JY 59

Here on their magic seats the thirteen Angels sat perturb'd
For clouds from the Atlantic hover o'er the solemn roof.

The terror answerd: I am Orc, wreath'd round the accursed tree:
The times are ended; shadows pass the morning gins to break;
The fiery joy, that Urizen perverted to ten commands,
What night he led the starry hosts thro' the wide wilderness:
That stony law I stamp to dust: and scatter religion abroad
To the four winds as a torn book, & none shall gather the leaves;
But they shall rot on desart sands, & consume in bottomless deeps,
To make the desarts blossom, & the deeps shrink to their fountains,
And to renew the fiery joy, and burst the stony roof.
That pale religious letchery, seeking Virginity,
May find it in a harlot, and in coarse-clad honesty
The undefil'd tho' ravish'd in her cradle night and morn:
For every thing that lives is holy, life delights in life;
Because the soul of sweet delight can never be defil'd.
Fires inwrap the earthly globe, yet man is not consumd;
Amidst the lustful fires he walks: his feet become like brass,
His knees and thighs like silver, & his breast and head like gold

PLATE 10

PLATE 12

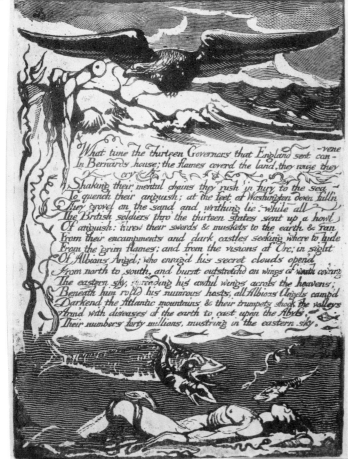

What time the thirteen Governors that England sent con- -vene
In Bernards house; the flames coverd the land, they rouze they
 cry
Shaking their mental chains they rush in fury to the sea -
To quench their anguish; at the feet of Washington down falln
They grovel on the sand and writhing lie, while all
The British soldiers thro' the thirteen states sent up a howl
Of anguish: threw their swords & muskets to the earth & ran
From their encampments and dark castles seeking where to hide
From the grim flames; and from the visions of Orc; in sight
Of Albions Angel; who enrag'd his secret clouds opend,
From north to south, and burnt outstretchd on wings of wrath covring
The eastern sky, spreading his awful wings across the heavens;
Beneath him rolld his numrous hosts, all Albions Angels campd
Darkend the Atlantic mountains & their trumpets shook the valleys
Armd with diseases of the earth to cast upon the Abyss,
Their numbers forty millions, mustring in the eastern sky.

PLATE 15

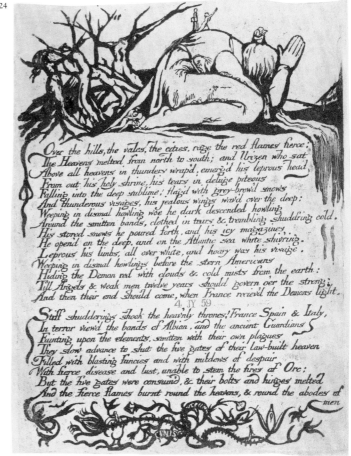

Over the hills, the vales, the cities, rage the red flames fierce:
The Heavens melted from north to south; and Urizen who sat
Above all heavens in thunders wrapd, emerged his leprous head
From out his holy shrine, his tears in deluge piteous
Falling into the deep sublime: flagd with grey-browd snows
And thunderous visages, his jealous wings wav'd over the deep:
Weeping in dismal howling woe he dark descended howling
Around the smitten bands, clothed in tears & trembling shuddring cold.
His stored snows he poured forth, and his icy magazines
He opend on the deep, and on the Atlantic sea white shivring.
Leprous his limbs, all over white, and hoary was his visage.
Weeping in dismal howlings before the stern Americans
Hiding the Demon red with clouds & cold mists from the earth:
Till Angels & weak men twelve years should govern o'er the strong:
And then their end should come, when France receiv'd the Demons light.

 4. JY 59

Stiff shudderings shook the heav'nly thrones! France Spain & Italy,
In terror viewd the bands of Albion, and the ancient Guardians
Fainting upon the elements, smitten with their own plagues
They slow advance to shut the five gates of their law-built heaven
Filled with blasting fancies and with mildews of despair
With fierce disease and lust, unable to stem the fires of Orc;
But the five gates were consum'd, & their bolts and hinges melted
And the fierce flames burnt round the heavens, & round the abodes of
 men

PLATE 18

125 **Visions of the Daughters of Albion 1793**

'The Eye sees more than the Heart Knows.
Printed by Will.ᵐ Blake: 1793'
Copy D 1793
6 (1, 2, 4, 6, 8, 10) out of 11 relief-etched plates
printed in yellow ochre ink finished with pen
and ink and watercolour approx. 11.5 × 17
(4½ × 6¾) on 6 leaves 37.5 × 27 (14¾ × 10⅝)
Gift of Roger Amory, Department of Printing
and Graphic Arts, Houghton Library, Harvard
University
*Lit: Bindman 1977, pp.73–4; E.45–51, 802, 900–1; Eaves,
Essick, Viscomi 1993 (facsimile Copy G); Viscomi 1993,
pp.133–42, 263*

Of all the books advertised in the *Prospectus
Visions* is the one that presents today's readers
with some of Blake's most seemingly 'modern'
imagery. The bound naked, tormented figures of
the Frontispiece are a preparation for this as are
the stormy sky and waters in which the
forbidding cliffs of Albion stand, as seen in the
Title-Page (pl.2)

Unlike the fearful maiden Thel (see no.126),
Oothoon, the central character of *Visions* is 'not
ashamed' of her sexual desire (pl.3). The pastoral
convention of the flower as a symbol of
innocence and beauty is overturned by Blake,
for when Oothoon plucks a marigold it
immediately awakes in her a soulful passion for
Theotormon: as pictured on the Title-Page and
described on pl.4, lines 11–15 she flies 'over the
waves … in wing'd exulting swift delight'.
Before she reaches Theotormon Oothoon is
raped by Bromion – '[he] rent her with his
thunders' (pl.4, line 16) – with the aftermath
also illustrated at the foot of the page. This is
anticipated in the presence of the brooding
winged figure seen behind her on plate 2.

The themes of oppression and the female
search for sexual fulfillment in *Visions* are
consistently linked and sometimes quite
explicitly alluded to, as in Blake's description
of the secret answering of desire, against all the
laws of religion, in females, and males, by
masturbation (pl.10, lines 3–11). The Daughters
of Albion (that is, the women of England) are
described as 'enslav'd' and weeping (as
illustrated on pl.10) and Oothoon is described
as 'the soft soul of America', a country of liberty
but also one where slavery was institutionalised.
The bondage of Bromion, Oothoon and
Theotormon shown in the Frontispiece takes
place against 'the voices of slaves … and
children bought with money, / That shiver in
religious caves' (pl.5, lines 8–9) and an African
slave is depicted on the same plate.
Theotormon's rejection of the defiled Oothoon
is countered by Oothoon herself in an act which
both mimics her rape and dispels its shame as
she calls on one of Theotormon's eagles to 'rend'
her breast in order to show that her heart still
remains true to him (pl.5; illustrated pl.6): the
body might be defiled, but the soul never. The
book ends with a lament by Oothoon,
concluding with words that sum up the essence
of her cause: 'for everything that lives is holy!'
(pl.11, line 10). The answering echoes from the
Daughters of Albion to her sighs imply that all
hopes are to remain, as the book's title states, a
'vision'.

The female Othoon who refuses to submit
to conventions or laws set out by Urizen
(nos.295–7) who appears in Blake for the first
time here (pl.8, line 3) and exemplified in the
actions of Bromion and Theotormon – has no
real equal in eighteenth-century writing.
However, there are strong parallels to be drawn
between Blake's theme here and the penetrating
indictment of 'the slavery which chains the very
soul of women' found in Mary Wollstonecraft's
A Vindication of the Rights of Women (1792). RH

125

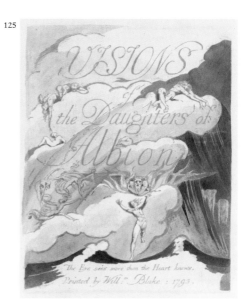

PLATE 2

125

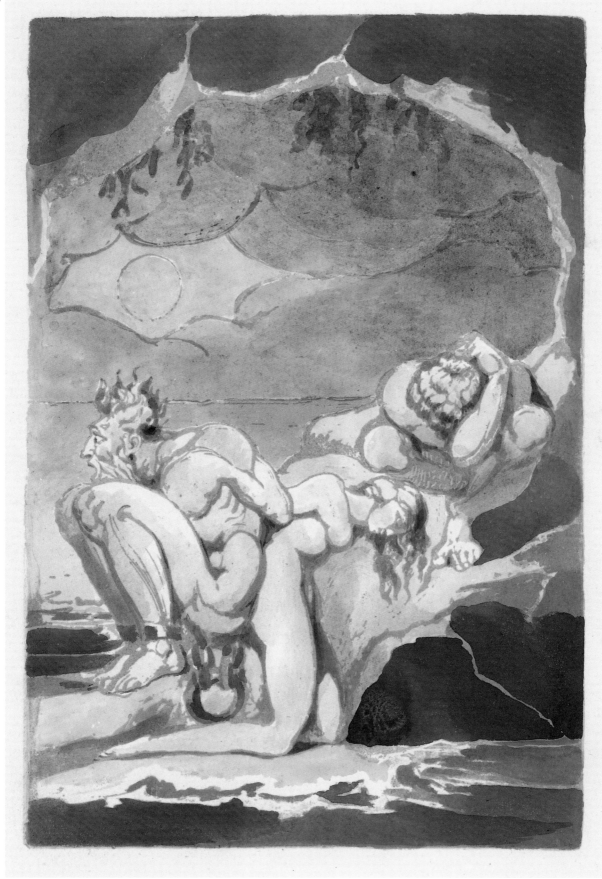

PLATE 1

126 The Book of Thel 1789

'The Author & Printer Will^m Blake 1789.'
Copy R 1789
4 (1, 2, 6(4), 7(5)) out of 8 relief-etched plates
printed in brown ink finished with pen and ink
and watercolour on 8 leaves 30.4 × 24.1 (12 × 9½)
including original paper wrapper
Paul Mellon Collection, Yale Center for
British Art

Lit: Eaves, Essick, Viscomi 1993 (facsimile Copy G)

This early (1789) example of Blake's illuminated
books is a pastoral poem, in which Innocence
confronts Experience and rejects it out of fear.
On a journey through the Vales of Har – already
described in *Tiriel* (nos.20–8) – the maiden Thel
questions various natural phenomena – a lily-of-
the-valley, a cloud, a worm, a clod of clay. Given
human forms and voices, they urge her to enter
into their cycles of life, death and renewal, but
afraid or unable to comprehend her unity with
them she withdraws to perpetual Innocence.
The motif of a tulip ravishing another on the
Title-Page portends the sexual dimension of
Thel's encounters with Experience, but her
retreat is negative and self-denying rather than
virtuous and exemplary. There is a short
illustrated text of four chapters, all but the
second having head and tail-pieces. Like the
related *Songs of Innocence and of Experience* (nos.128,
129), the surviving copies of *Thel* are printed and
washed in a wide spectrum of delicate colours
whose nursery charm has an ironic relationship
to the poem's more complex or ambivalent
messages. DBB

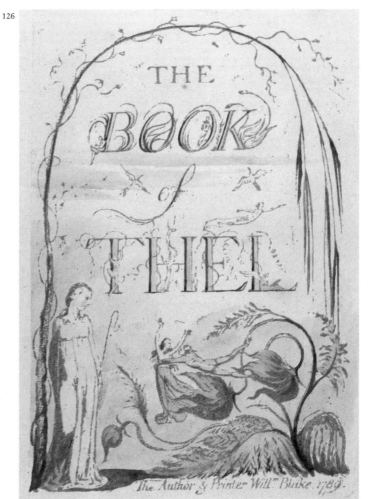

126

PLATE 2

126

PLATE 1

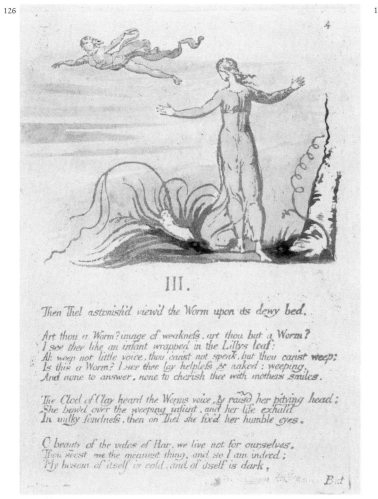

4

III.

Then Thel astonish'd view'd the Worm upon its dewy bed.

Art thou a Worm? image of weakness. art thou but a Worm?
I see thee like an infant wrapped in the Lillys leaf:
Ah weep not little voice. thou canst not speak, but thou canst weep:
Is this a Worm? I see thee lay helpless & naked: weeping,
And none to answer, none to cherish thee with mothers smiles.

The Clod of Clay heard the Worms voice, & raisd her pitying head;
She bowd over the weeping infant, and her life exhald
In milky fondness, then on Thel she fixd her humble eyes.

O beauty of the vales of Har. we live not for ourselves,
Thou seest me the meanest thing, and so I am indeed;
My bosom of itself is cold, and of itself is dark,

But

PLATE 6(4)

But he that loves the lowly, pours his oil upon my head.
And kisses me, and binds his nuptial bands around my breast.
And says; Thou mother of my children, I have loved thee.
And I have given thee a crown that none can take away
But how this is sweet maid, I know not, and I cannot know,
I ponder, and I cannot ponder; yet I live and love.

The daughter of beauty wip'd her pitying tears with her white veil,
And said. Alas! I knew not this, and therefore did I weep:
That God would love a Worm I knew, and punish the evil foot
That wilful, bruisd its helpless form: but that he cherishd it
With milk and oil, I never knew; and therefore did I weep,
And I complaind in the mild air, because I fade away,
And lay me down in thy cold bed, and leave my shining lot.

Queen of the vales, the matron Clay answerd; I heard thy sighs.
And all thy moans flew oer my roof, but I have calld them down:
Wilt thou O Queen enter my house. tis given thee to enter,
And to return; fear nothing, enter with thy virgin feet.

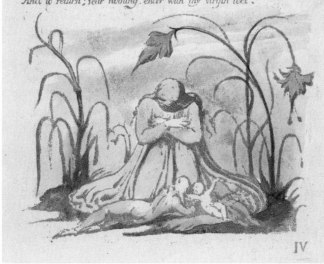

IV

PLATE 7(5)

127 The Marriage of Heaven and Hell
1790–1793/1793
(No name, place or date of publication given)
Copy E 1793
27 colour-printed relief-etched plates printed in
brown ink finished with some watercolour
approx. 15 × 10.5 (5⅞ × 4⅛) on paper approx.
26.6 × 19.7 (10½ × 7¾)
Lent by the Syndics of the Fitzwilliam Museum,
Cambridge
Lit: Eaves, Essick, Viscomi 1993 (facsimile Copy F)

This book embraces two important strands of
Blake's thinking in the period around 1790: his
disillusionment with and rejection of Emanuel
Swedenborg's thinking (see pp.186–7) and then
his reactions to contemporary political, social,
and religious issues. Created against the
repercussions of the French Revolution,
Marriage is particularly significant because it is
Blake's first sustained attempt at dealing with
burning issues of his time. His mental and, in
his printmaking, physical involvement in these
and his belief in his prophetic powers to
proclaim a new beginning is palpable. It can be
seen in the opening lines of plate 3: a 'new
heaven' which began 'thirty three years since' is
announced – an ironic reference to
Swedenborg's announcement of the New
Jerusalem in 1757 and also, of course, the year of
Blake's birth (*Marriage* being dated to 1790). And
there are autobiographical allusions in other
plates in the book (e.g. pl.14, see p.106; and pl.15,
see p.17). Blake's own guiding belief that Man's
spiritual life was shaped by his creative energy
(which for Blake included sexual energy) is

summed up in the line 'Energy is Eternal
Delight' (pl.4).

The title (pl.1) is a direct and satirical
reference to Swedenborg's 'A Treatise
Concerning Heaven and Hell' and the design
beneath it shows the flames of Hell lapping
against the clouds of heaven. The two figures,
the Devil and an Angel, unite as in marriage.
The world in which the book's action takes place
is beneath our material one which is represented
by tiny figures embowered beneath trees. The
significance of the 'contraries' signalled here,
and their meaning, are set out in the text and
designs of plate 3.

Nine complete copies of *Marriage* are known
and all conclude with 'A Song of Liberty'
(pl.25–7; no.192). The plate (24) which precedes
this includes the lines 'I have also: The Bible of
Hell: which the world / shall have whether they
will or no.' This refers to Blake's imminent
prophetic writings (for example, *America*,
nos.115, 124) and it is possible to see the
apocalyptic 'A Song of Liberty' which
immediately follows as a sort of prelude to these.
Beneath the image of King Nebuchadnezzar (see
also no.247) on plate 24 a final line points up the
tyranny of the laws of the material world which
constrain the individual's imagination. RH, MM

PLATE 1

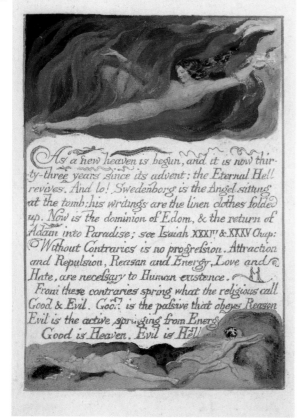

PLATE 3

PLATE 4

PLATE 6

PLATE 7

The ancient tradition that the world will be con-
sumed in fire at the end of six thousand years
is true, as I have heard from Hell.

For the cherub with his flaming sword is
hereby commanded to leave his guard at tree of
life, and when he does, the whole creation will
be consumed, and appear infinite. and holy
whereas it now appears finite & corrupt.

This will come to pass by an improvement of
sensual enjoyment.

But first the notion that man has a body
distinct from his soul, is to be expunged; this
I shall do, by printing in the infernal method, by
corrosives, which in Hell are salutary and me-
dicinal, melting apparent surfaces away, and
displaying the infinite which was hid.

If the doors of perception were cleansed
every thing would appear to man as it is, in-
finite.

For man has closed himself up, till he sees
all things thro' narrow chinks of his cavern.

PLATE 14

A Memorable Fancy

I was in a Printing house in Hell & saw the
method in which knowledge is transmitted from gene-
ration to generation.

In the first chamber was a Dragon-Man, clear-
ing away the rubbish from a caves mouth; within, a
number of Dragons were hollowing the cave,

In the second chamber was a Viper folding round
the rock & the cave, and others adorning it with gold
silver and precious stones.

In the third chamber was an Eagle with wings
and feathers of air, he caused the inside of the cave
to be infinite, around were numbers of Eagle like
men, who built palaces in the immense cliffs.

In the fourth chamber were Lions of flaming fire
raging around & melting the metals into living fluids.

In the fifth chamber were Unnam'd forms, which
cast the metals into the expanse.

There they were reciev'd by Men who occupied
the sixth chamber, and took the forms of books &
were arranged in libraries.

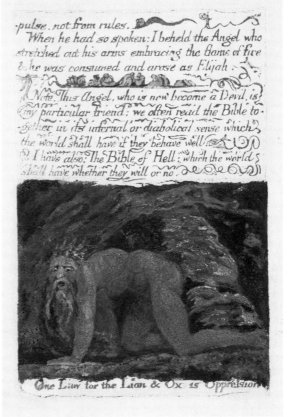

PLATE 15

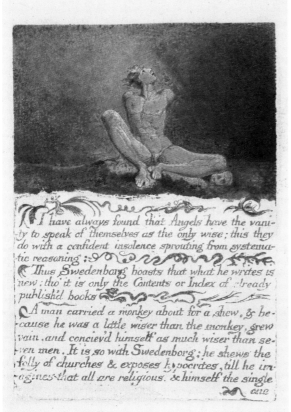

I have always found that Angels have the vani-
ty to speak of themselves as the only wise; this they
do with a confident insolence sprouting from systema-
tic reasoning:

Thus Swedenborg boasts that what he writes is
new; tho' it is only the Contents or Index of already
publish'd books.

A man carried a monkey about for a shew, & be-
cause he was a little wiser than the monkey, grew
vain, and concievd himself as much wiser than se-
ven men. It is so with Swedenborg; he shews the
folly of churches & exposes hypocrites, till he im-
agines that all are religious. & himself the single
one

PLATE 21

pulse, not from rules.

When he had so spoken: I beheld the Angel who
stretched out his arms embracing the flame of fire
& he was consumed and arose as Elijah.

Note. This Angel, who is now become a Devil, is
my particular friend: we often read the Bible to-
gether in its infernal or diabolical sense which
the world shall have if they behave well.

I have also: The Bible of Hell: which the world
shall have whether they will or no.

One Law for the Lion & Ox is Oppression

PLATE 24

Songs of Innocence 1789

'1789/The Author & Printer W Blake'
From *Songs* Copy F 1789
7 out of 31 relief etchings printed in green ink
finished with pen and ink and watercolour on
17 leaves 18.4×12.1(7¼×4¾)
Plate 2: Frontispiece
Plate 4: 'Introduction'
Plate 5: 'The Shepherd'
Plate 12: 'The Chimney Sweeper'
Plate 19: 'Holy Thursday'
Plate 23: 'Spring' pl.2: 'Little Girl Sweet
and Small'
Plate 54: 'The Voice of the Ancient Bard'
Paul Mellon Collection, Yale Center for
British Art
Lit: Lincoln 1991 (facsimile Copy W)

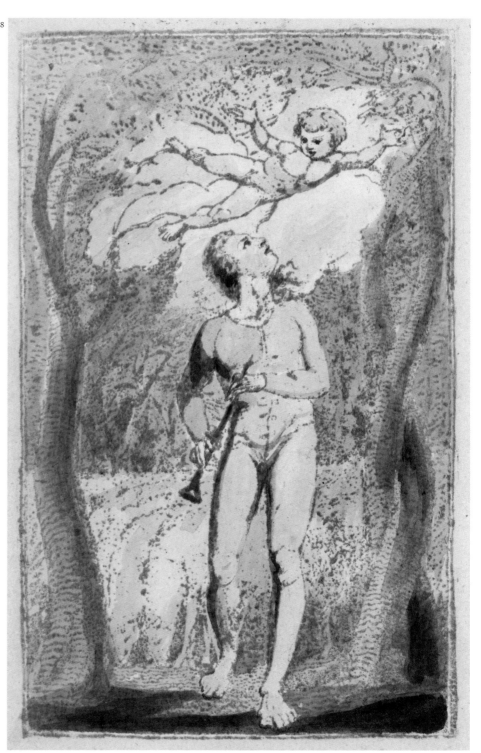

PLATE 2

The Chimney Sweeper

When my mother died I was very young,
And my father sold me while yet my tongue,
Could scarcely cry weep weep weep weep.
So your chimneys I sweep & in soot I sleep.

Theres little Tom Dacre who cried when his head
That curld like a lambs back, was shav'd, so I said.
Hush Tom never mind it, for when your heads bare,
You know that the soot cannot spoil your white hair.

And so he was quiet, & that very night,
As Tom was a sleeping he had such a sight,
That thousands of sweepers Dick Joe Ned & Jack
Were all of them lock'd up in coffins of black,

And by came an Angel who had a bright key,
And he opend the coffins & set them all free.
Then down a green plain leaping laughing they run
And wash in a river and shine in the Sun.

Then naked & white, all their bags left behind.
They rise upon clouds, and sport in the wind.
And the Angel told Tom if he'd be a good boy,
He'd have God for his father & never want joy.

And so Tom awoke and we rose in the dark
And got with our bags & our brushes to work.
Tho' the morning was cold, Tom was happy & warm,
So if all do their duty, they need not fear harm.

PLATE 12

HOLY THURSDAY

Twas on a Holy Thursday their innocent faces clean
The children walking two & two in red & blue & green
Grey headed beadles walkd before with wands as white as snow
Till into the high dome of Pauls they like Thames waters flow

O what a multitude they seemd these flowers of London town
Seated in companies they sit with radiance all their own
The hum of multitudes was there but multitudes of lambs
Thousands of little boys & girls raising their innocent hands

Now like a mighty wind they raise to heaven the voice of song
Or like harmonious thunderings the seats of heaven among
Beneath them sit the aged men wise guardians of the poor
Then cherish pity, lest you drive an angel from your door

PLATE 19

129 Songs of Experience 1794
'1794/The Author & Printer W Blake'
From 'Songs' Copy F 1793
8 out of 17 colour-printed relief etchings
finished with pen and ink and watercolour on 17
leaves 18.4 × 12.1 (7¼ × 4¾)
Plate 28: Frontispiece, printed in brick red ink
Plate 29: Title-Page 12.4 × 7.2, printed in golden
brown ochre ink
Plate 33: 'Holy Thursday', printed in green ink
Plate 46: 'London', printed in green ink
Plate 51: 'A Little Girl Lost', printed in golden
brown ochre ink
Plate 37: 'The Chimney Sweeper', printed in
charcoal green ink
Plate 42: 'The Tyger', printed in blue ink
Plate 50: 'A Little Boy Lost', printed in blue-
green ink
Paul Mellon Collection, Yale Center for
British Art
Lit: Lincoln 1991 (facsimile Copy W)

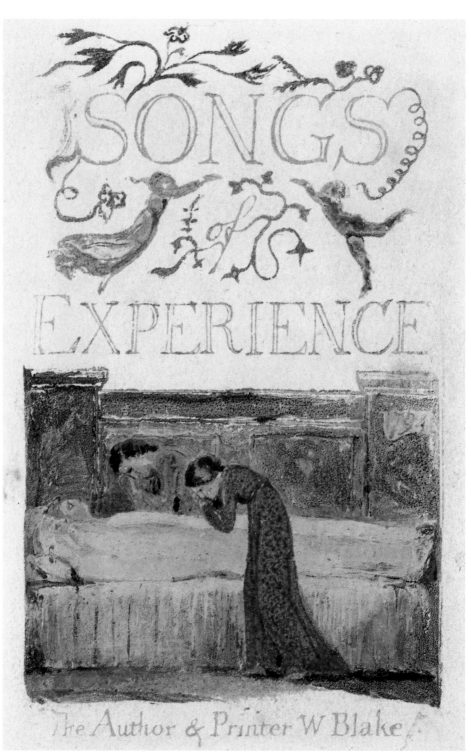

PLATE 29

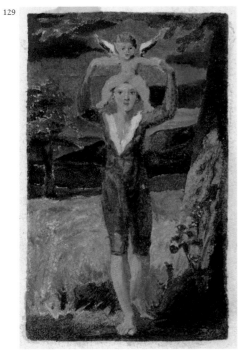

PLATE 28

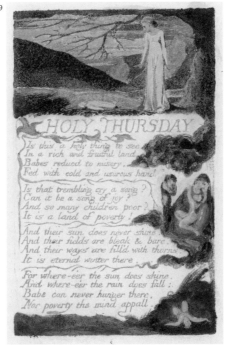

HOLY THURSDAY

Is this a holy thing to see
In a rich and fruitful land,
Babes reduced to misery,
Fed with cold and usurous hand?

Is that trembling cry a song?
Can it be a song of joy?
And so many children poor?
It is a land of poverty!

And their sun does never shine
And their fields are bleak & bare.
And their ways are filld with thorns
It is eternal winter there.

For where-eer the sun does shine.
And where-eer the rain does fall:
Babe can never hunger there,
Nor poverty the mind appall.

PLATE 33

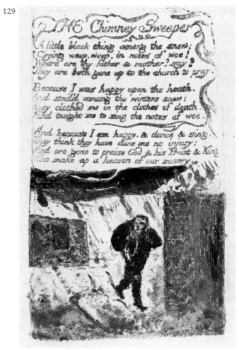

THE Chimney Sweeper

A little black thing among the snow:
Crying weep, weep, in notes of woe!
Where are thy father & mother? say?
They are both gone up to the church to pray.

Because I was happy upon the heath,
And smild among the winters snow:
They clothed me in the clothes of death,
And taught me to sing the notes of woe.

And because I am happy, & dance & sing.
They think they have done me no injury:
And are gone to praise God & his Priest & King
Who make up a heaven of our misery.

PLATE 37

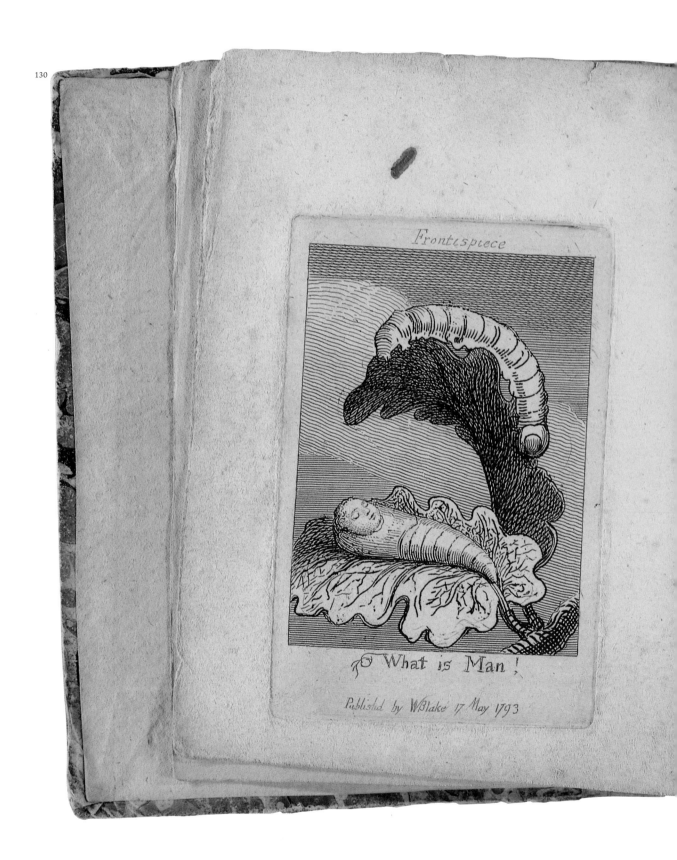

130 For Children: The Gates of Paradise 1793

'1793/Published by W Blake N°13/Hercules
Buildings Lambeth/and J. Johnson S.t Pauls'
Church Yard'
Copy E 1793
18 etched and engraved plates printed in black
ink approx. 6×5 (2¾×2) on 18 leaves
13.6×11.4 (5⅜×4½) in contemporary binding
Open at Plate 1: 'Frontispiece' and Plate 2:
'Title-Page'
Paul Mellon Collection, Yale Center for
British Art
*Lit: Bindman 1978, nos.115–32, 580–600; Erdman
and Moore 1977*

In this series of eighteen engravings Blake was
working in the tradition of the emblem book,
one enduring purpose of which is caught in the
title which Blake attached to a much larger
series of designs, some of them engraved for this
book, which he drew in his *Notebook* (see no.162):
'Ideas of Good and Evil'. The plates trace Man
from his birth to his death. Around 1818, Blake
re-worked the series with the title 'For the Sexes
The Gates of Paradise'. RH

Some contemporary prints

These prints illustrate some of the popular graphic techniques and reproductive imagery that represented the contemporary competition. The London print industry had become highly sophisticated during the past twenty years. The diversification of subject matter in the capital's exhibitions, first in the Society of Artists and then in the Royal Academy, had stimulated fresh technical responses among engravers as well as the popular demand on which they depended. Leading entrepreneurs in the field were Thomas Macklin, the promoter of an illustrated Bible with a hundred plates, including Fittler's, after pictures by de Loutherbourg (no.135) – a project on which he claimed to have lavished £30,000 – and Alderman John Boydell for whom Blake briefly worked as an engraver, who also commissioned pictures from leading artists and published prints after them, such as Sharp's *Lear* engraved after West (no.134) for his Shakespeare Gallery, launched in 1788, and Heath's *Major Peirson* after Copley's painting (Tate) first seen in 1784 (no.138). Sharp, a radical and millennarian, was temperamentally close to Blake as well as being the most highly regarded and expensive; he received £840 for his *Lear* plate, widely thought the best in the Boydell series, while West was paid £525 for the original painting.

History painting stood at the pinnacle of artistic achievement, and because line engraving was highest among intaglio methods it was initially always used for historical subjects. Using a steel graver or burin, lozenge-shaped with a wooden handle, the engraver incised furrows on a copper or steel plate, varying width and depth according to pressure (see Blake's copper plate for *Job* pl.2; no.218d). Tone could be varied or deepened according to the proximity of the incisions, or by striking others over them at an angle (cross-hatching). As in *Peirson*, the basic design was often first etched on the plate. After covering it with wax or varnish, the engraver drew with a needle, exposing lines that were bitten down when it was immersed in a solution of nitric acid.

Line engraving was time-consuming – nine months being set aside for printing 1,500 impressions of *Peirson* – restricted in tonal potential, and poorly susceptible to the contemporary vogue for hand-colouring. Thus publishers like Boydell and painters like West made increasing use of mezzotint, which could be engraved more quickly. With a toothed rocker, the plate was covered with multiple indentations which, when inked, would print a uniform black; this was, however, varied and reduced by scraping and burnishing the plate so that less ink was taken up by the smoother surface. Giving a soft and sensuous quality, and a velvety tone, mezzotint reproduced oil painting more effectively and was widely used for portraits and, as in Smith's plate after Morland, landscapes and the newly fashionable sentimental and genre subjects. Though not a new method, mezzotint reached a new perfection in the hands of London engravers. Its own disadvantages were that plates wore out sooner, allowing only small print runs of about a hundred impressions. Aquatint, seen in Alken's plate after Garrard, allowed an almost perfect imitation of wash drawing or – if afterwards hand-coloured – of watercolour. A form of tonal etching, it involved the covering of a copper plate with powdered resin, which was fused by heat. The plate was then plunged in acid that ran off the resin but bit spaces left in between, forming a granular layer. Varnish was applied to prevent the acid from biting areas to be left white in the printed impression. Stipple engraving, likewise, was essentially imitative. With dotted lines being etched using a roulette wheel or engraved with a burin, often printed in red ink, it gave convincing reproductions of chalk drawings. When the whole plate, rather than just outlines, was worked with dots and flicks, a fuller range of tonal effects corresponding to oil painting could be achieved. Schiavonetti's stipples after Wheatley's *Cries* show the medium in both monochrome and colour, and are examples of its widespread application to genre or 'fancy' subjects.

As an artist who had trained as a reproductive engraver and encountered difficulties as he tried to establish himself as a historical painter in the higher echelons of the Academy, Blake disapproved of methods of printmaking that forced his colleagues into a restrictive specialisation, and subservience to painters like Reynolds who affected lofty aloofness from the engravers who promoted their reputations. West, who sometimes acted as sole or joint publisher of prints after his own work – and to whom Blake is said to have given Copy K of *America a Prophecy* (New Haven, Beinecke Library) – constituted a more sympathetic example. While as late as 1799 Blake told Dr Trusler that he had no objection to engraving other artists' work, his own vocation as visionary poet and artist could be truly realised only by performing all stages of his work himself – as author and designer, engraver and publisher. DBB

131 RICHARD NEWTON (1777–1798)
William Holland's Exhibition Room *c.*1794
Watercolour over pen and blue ink on paper
44.7 × 67.7 (17⅝ × 26⅝)
The British Museum, London
Lit: Alexander 1998 pp.7–8

132 LOUIS SCHIAVONETTI (1765–1810) AFTER
FRANCIS WHEATLEY (1747–1801)
**Two bunches a penny primroses,
two bunches a penny**
from *Cries of London*
Colour printed stipple engraving 36 × 28
(14⅛ × 11) on paper 42.4 × 33.2 (16¾ × 13⅛)
Published 2 July 1793
The Victoria & Albert Museum

133 LOUIS SCHIAVONETTI (1765–1810) AFTER
FRANCIS WHEATLEY (1747–1801)
Milk below Maids
from *Cries of London*
Monochrome stipple engraving 35.9 × 28
(14⅛ × 11) on paper 57.5 × 44.4 (22⅝ × 17½)
Published 2 July 1793
The Victoria & Albert Museum

131

134 WILLIAM SHARP (1749–1824) AFTER BENJAMIN
WEST (1738–1820)
Shakspeare King Lear Act III. Scene iv
'King Lear in the Storm'
Line engraving 59.1×44.1 (23¼×17⅜) on paper
67.5×52.4 (26⅝×20⅝)
Published 25 March 1793
The British Museum, London

135 JAMES FITTLER (1758–1835) AFTER PHILIPPE
JACQUES DE LOUTHERBOURG (1740–1812)
The Destruction of Pharo's Host
Line engraving 31.8×26 (12½×10¼) on paper
43.2×31.8 (17×12½)
Published December 1793
David Alexander

136 SAMUEL ALKEN (1750–1815) AFTER GEORGE
GARRARD (1760–1826)
Soldier
Aquatint 36.9×47.7 (14½×18¾) on paper
41.3×51.4 (16¼×20¼)
Published February 1793
David Alexander

137 JOHN RAPHAEL SMITH (1752–1812) AFTER
GEORGE MORLAND (1763–1804)
Return from Market
Mezzotint 45.4×55.6 (17⅞×21⅞)
Published 1 July 1793
The British Museum, London

138 JAMES HEATH (1757–1834) AFTER JOHN
SINGLETON COPLEY (1737–1815)
**The Death of Major Peirson and the Defeat
of the French Troops in the Market Place
of Saint Heliers in the Island of Jersey,
Jany. 6, 1781 1788/1796**
Etching and engraving 57×77.5 (22½×30½)
on paper 66.3×81.5 (26⅛×32⅛)
Published April 25, 1796
The British Museum, London

139 JAMES BARRY (1741-1798)
**Lord Baltimore and the Group
of Legislators**
Etching and engraving 74×47.5 (29⅛×18¾) on
paper 79×56.4 (31⅛×22¼)
First State
Published 28 February 1793
The Visitors of the Ashmolean Museum, Oxford

'Marks of weakness, marks of woe'

The rural character of Lambeth, as it still existed in the autumn and winter of 1790–1791, suggests that by moving from the city south of the river the pastoral vision of Blake's earlier *Songs of Innocence* (1789) had in some sense been realised. From the windows of Hercules Buildings, gardens and open fields were everywhere in prospect. An Eden had been found in 'Lambeth beneath the poplar trees'.

But, by 1792, new housing began to encroach, and legislation by the City and Westminster forced the more obnoxious industries to become concentrated south of the river together with the poor and the homeless. The older parts of Lambeth, that backed onto the river between Lambeth Palace and Vauxhall, grew overcrowded, and the life expectancy of those working in the local manufactories short. The Westminster Lying-in Hospital, Asylum for Orphan Girls, workhouse and charity schools, were all within a short distance of Hercules Buildings: 'Perhaps you are not acquainted with Mr Blake's direction?,' wrote John Flaxman to William Hayley, 'it is No.13 Hercules Buildings near the Asylum, Surry [*sic*] Side of Westminster Bridge'. (BR.64) The rules and regulations they published governing their operation were

exclusive and unbending. The Asylum was no exception: 'III. No negro or mulatto child can be admitted. IV. No diseased, deformed or infirm child can be admitted' (no.145).

At the opposite end of Hercules Buildings from Westminster Bridge Road is Church Street. Turning to the right, about one hundred yards in the direction of the river, stood the parish church of St Mary, Lambeth (no.140b). Princes Street and Fore Street, the two main streets of the village, led south from St Mary's along the edge of the Thames. Both were narrow, cobbled and damp with raised cellar doors to protect against the high tides. Here were located most of the local manufactories. At right angles, Fore Street and Princes Street were intersected by unlit lanes and alleyways running down to the river. Here, crowded into single rooms, lived the workers and their families. Between 1866 and 1870, this area along the Thames was razed to build the Albert Embankment (see nos.140a–f).

In 1802, Dr Charles Stanger described the conditions that prevailed in streets and lanes like those along the Thames at Lambeth, in his *Remarks on the Necessity and Means of Suppressing Contagious Fever in the Metropolis*:

Air and light are, in a great measure, excluded from their habitations, whilst damp and cold frequently predominate. Human effluvia and exhalations from putrefying vegetable and animal substances, within and about their sordid dwellings, are constantly accumulating; and the atmosphere of one polluted cell is but exchanged, for that of another. (*Remarks*, 1802, pp.7–9)

At night, walking through the streets of Lambeth that backed onto the Thames, Blake saw and heard things far removed from the earlier pastoral vision he expressed in *Songs of Innocence*. These are the 'charter'd' streets 'near where the charter'd Thames does flow' that he describes in *London* (nos.160–2). Here he saw the 'marks of weakness, marks of woe', and heard the cries of infants and of men, that he records in his great poem:

In every cry of every Man,
In every Infants cry of fear,
In every voice: in every ban,
The mind-forg'd manacles I hear

140a

140b

It was also in these streets that Blake noted the lapwings and other birds that had been trapped on Kennington Common, caged and hanging in the windows, metaphors for the people themselves.

'Holy Thursday' and other *Songs of Experience* may reflect specific events that took place locally that spring. In the Lambeth parish ledger for February 1793 are accounts of a child found dead in Lambeth marsh, just as Blake depicts on the plate of 'Holy Thursday' of *Songs of Experience* (no. 154). In the lines themselves his reproach is unreserved:

> Is this a holy thing to see,
> In a rich and fruitful land,
> Babes reducd to misery,
> Fed with cold and usurous hand?
>
> Is that trembling cry a song?
> Can it be a song of joy?
> And so many children poor?
> It is a land of poverty!

Here also are accounts of a chapel being built on the village green that, by covenant, was exclusive to those who could afford fifty guineas to pay for a pew. These are the materials for Blake's 'The Little Vagabond', 'A Poison Tree', 'The Chimney Sweeper',

'The Garden of Love' and, underlying them all in *Songs of Experience*, 'The Human Abstract' (nos.149–52, 155–9, 298 pl.47).

Other poems of *Songs of Experience* also reflect events closer to Blake than we have understood. In the late eighteenth century the tiger was described as 'Fierce without provocation, and cruel without necessity, its thirst for blood is insatiable: Though glutted with slaughter, it continues its carnage.' The account in the editions of the *Encyclopedia Britannica* published at this time continues in the same vein:

> The tiger seems to have no other instinct but a constant thirst for blood, a blind fury which knows no bounds or distinction, and which often stimulates him to devour his own young, and to tear the mother to pieces for endeavouring to defend them.

This perception of the tiger was commonly applied as a metaphor to the French Revolution in general and in particular to the behaviour of the Paris mobs in August and September 1792. Blake was sympathetic to the Revolution, even following the August and September massacres. Ironically, 'The Tyger' may apply this contemporary perception to the paranoia in Britain: to the rise of the loyalist associations, Paine burnings and witch hunts of radical writers, artists, publishers and printmakers, as we shall see. MP

140 WILLIAM STRUDWICK (*c.* 1835–after 1901)
Photographs of Lambeth *c.*1866
a) Bishop's Walk, Lambeth, nearest to Blake's residence
b) End of Lower Fore Street looking towards St Mary's, Lambeth
c) End of Princes Street, Lambeth. Viewpoint: Looking down Broad Street to the river
d) Riverside, Princes Street [*sic*], Lambeth Reach. Viewpoint: Lambeth riverside between Broad Street and Vauxhall Stairs
e) Princes Street, Lambeth. Viewpoint: This shows John Cliff's Imperial Pottery on the near side left (sign on front elevation)
f) Drain-Pipe Pottery Works, Princes Street. River foreshore
London Borough of Lambeth Archives, Woolley Bequest

141 **Lambeth** *Photograph from Richard Horwood's Plan of London, 1799, showing Lambeth and Vauxhall* Guildhall Library, Corporation of London

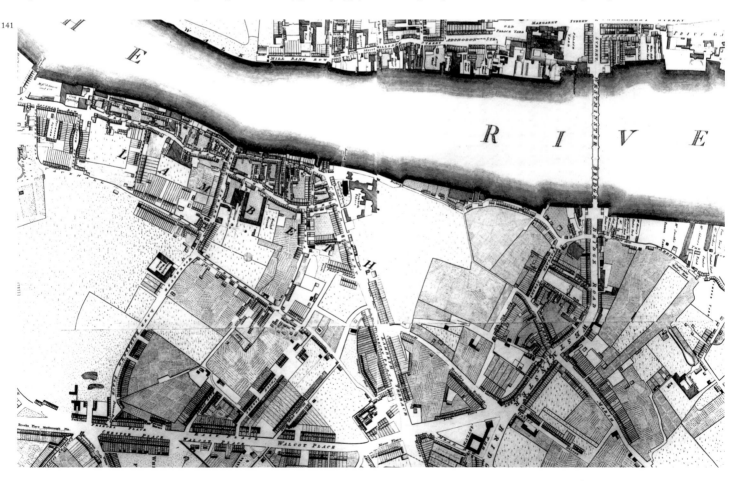

141

142 SISTO BADALOCCHIO (1581 OR 1585–1647) AND
GIOVANNI LANFRANCO (1582–1647) AFTER
ANNIBALE CARRACCI (1560–1609) AFTER
RAPHAEL SANZIO (1483–1520)
**Historia del Testamento Vecchio Dipinta in
Roma Nel Vaticano da Raffaelle Di Urbino …
Al Sig Annibale Carracci, 1603**
54 etchings
William Blake's Copy 1773
Open at pl.10 'Gen.[esis]3' ['The Expulsion']
Etching 13.4×18.1 (5¼×7⅛) on paper 17.3×23.4
(6¾×9¼) with two pencil drawings, on inside
margin and facing blank leaf
Michael Phillips

143 JOHN MILTON (1608–1674) ED. RICHARD
BENTLEY (1662–1742)
Milton's Paradise Lost: A New Edition
by Richard Bentley, DD
London 1732
With William Blake's annotations
Open at pp.398–9
Michael Phillips

144 **Songs of Innocence and of Experience 1794**
Plate 1: General Title-Page
a) Facsimile relief-etched plate made by Michael
Phillips after posthumous copy [b] c.1831 in
Houghton Library, Harvard University, by kind
permission
Copper 11.2×7×0.15 (4¾×2¾×0.06)
b) Impression printed from 144a by Michael
Phillips
 Blue ink 11.2×7 (4¾×2¾) on paper 20×14
(7⅞×5½)
c) from Copy C 1794
Relief etching printed in yellow ochre finished
in watercolour 11.2×7 (4¾×2¾) on paper
18×12.3 (7⅛×4⅞)
The Lessing J Rosenwald Collection, Library of
Congress

145 **An Account of the Institution and
Regulations of the Guardians of the Asylum
or House of Refuge situate in the Parish of
Lambeth, in the County of Surrey, For the
Reception of Orphan Girls 1793**
Open at pp.34–5 'Description of the objects of
the Charity, and Rules for their Admission'
The British Library Board

146 **Psalms and Hymns for the use of The Chapel
of the Asylum for Female Orphans
London 1797**
Frontispiece: William Skelton (1763–1848) after
Thomas Spence Duché (1763–1790)
'Hope delivering two Orphan Girls in distress to
the Genius of the Asylum'
Engraving 9.3×15.5 (3⅝×6⅛) (framing line)
Congregational Library, Memorial Hall
Trustees, London

147 **Songs of Experience 1793/1794**
Plate 51: 'A Little Girl Lost'
From Copy G c.1793–4
Colour-printed relief etching finished with
watercolour 11.8×7.1 (4⅝×2¾) on paper
18.1×12 (7⅛×4¾)
The Keynes Family Trust on loan to the
Fitzwilliam Museum, Cambridge

142

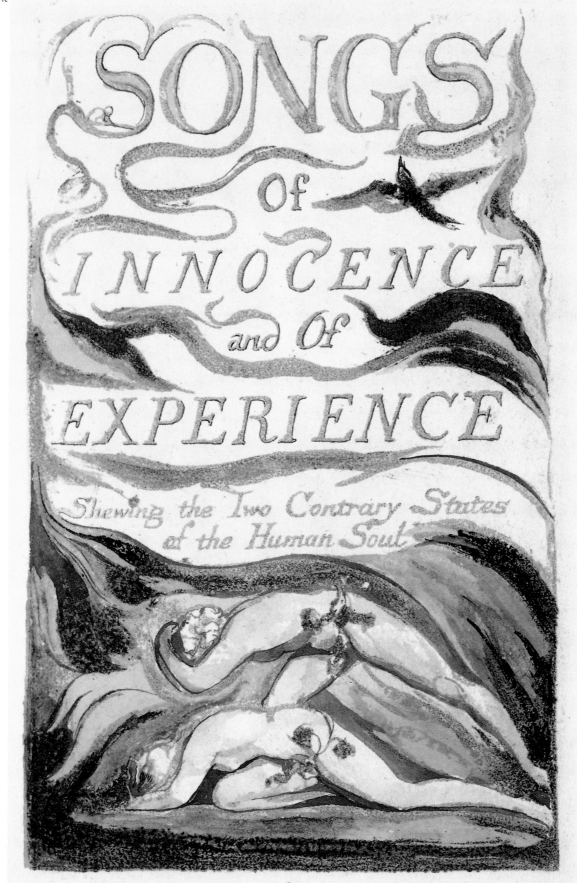

151a

152

THE Chimney Sweeper

A little black thing among the snow:
Crying weep, weep, in notes of woe !
Where are thy father & mother? say ?
They are both gone up to the church to pray.

Because I was happy upon the heath.
And smil'd among the winters snow:
They clothed me in the clothes of death.
And taught me to sing the notes of woe.

And because I am happy, & dance & sing,
They think they have done me no injury:
And are gone to praise God & his Priest & King
Who make up a heaven of our misery.

154

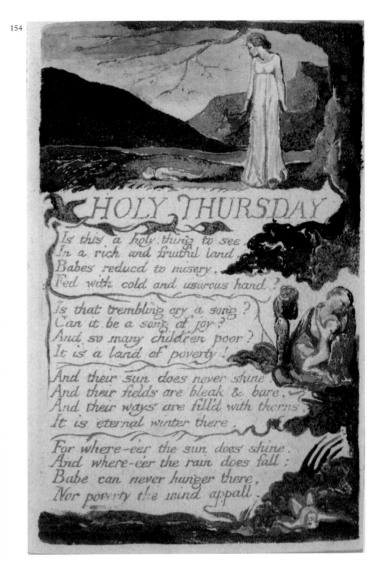

HOLY THURSDAY

Is this a holy thing to see
In a rich and fruitful land.
Babes reduced to misery.
Fed with cold and usurous hand ?

Is that trembling cry a song ?
Can it be a song of joy ?
And so many children poor ?
It is a land of poverty !

And their sun does never shine
And their fields are bleak & bare.
And their ways are fill'd with thorns
It is eternal winter there.

For where-eer the sun does shine.
And where-eer the rain does fall :
Babe can never hunger there,
Nor poverty the mind appall.

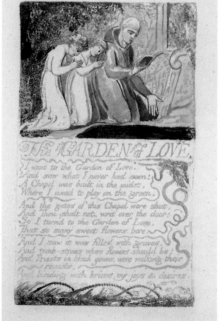

159

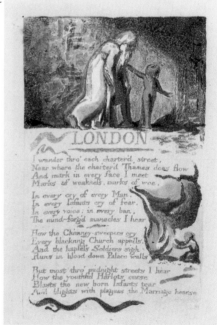

161c

London

I wander thro each dirty street
Near where the dirty Thames does flow
And see [mark] in every face I meet
Marks of weakness marks of woe

In every cry of every man
In every infants cry of fear
In every voice in every ban
The [german] mind forgd manacles I hear

How the chimney sweepers cry
Blackens oer the churches walls Every blackning church appalls
And the hapless soldiers sigh
Runs in blood down palace walls

But most the midnight harlots curse
I slept in the dark From every dismal street I hear
In the silent night Weaves around the marriage hearse
I murmured my fears And blasts the new born infants tear
And I felt delight But most the midnight harlots curse
Blasts the new born infants tear
In the morning I went And hangs with plagues the marriage hearse
As rosy as morn midnight
To seek for new joy But most the shrieks of youth
But I met with scorn But most thro midnight
Such Nobodaddy How the youthful
Father

Why darkness & obscurity
In all thy words & laws
That none dare eat the fruit but from
The wily serpents jaws
Or is it because secrecy gains females loud applause
The modest rose puts forth a thorn
The humble sheep a threatning horn
While the lilly white shall in love delight
Nor a thorn nor a threat stain her beauty bright

When the voices of children are heard on the green
And whisprings are in the dale
The days of youth rise fresh in my mind
My face turns green & pale

Then come home my children the sun is gone down
And the dews of night arise
Your spring & your day are wasted in play
And your winter & night in disguise

Are not the joys of morning sweeter
Than the joys of night
And are the vigrous joys of youth
Ashamed of the light

Let age & sickness silent rob
The vineyards in the night
But those who burn with vigrous youth
Pluck fruits before the light

The Tyger

Tyger Tyger burning bright
In the forests of the night
What immortal hand or eye
Could frame thy fearful symmetry

2 In what distant deeps or skies
Burnt the fire of thine eyes
On what wings dare he aspire
What the hand dare seize the fire

3 And what shoulder & what art
Could twist the sinews of thy heart
And when thy heart began to beat
What dread hand & what dread feet

In what furnace was thy brain
What the anvil what the dread grasp
Dare its deadly terrors clasp

Tyger Tyger burning bright
In the forests of the night
What immortal hand & eye
Dare frame thy fearful symmetry

Lambeth and the Terror

On 21 May 1792 a Royal Proclamation against seditious writings was published (no.169). It signalled the beginning of Prime Minister William Pitt's Reign of Terror, the systematic effort on the part of the government to seek out, demoralise and effectively destroy any organisation or individual that it deemed to be questioning the tenets of the constitution or the inherited right of British monarchy. The measures taken by Pitt and his newly appointed minister at the Home Office, Henry Dundas, was a direct result of the rapid growth of radical 'Jacobin' societies in Britain.

Inspired by the French Revolution, and the success of the revolt of the American colonies, societies were encouraging discussion of the reform of parliament, democratic representation and the abolition of monarchy on an unprecedented scale. Membership was largely made up of tradesmen and artisans, including authors and artists, printers and engravers, publishers, print sellers and booksellers; the trades and professions of which William Blake was a part. The immediate occasion was the publication in February 1792 of the Second Part of Thomas Paine's *Rights of Man* (no.167). It was reported that more than 100,000 copies had been distributed, largely by the London Corresponding Society and its network and particularly amongst the 'lower orders'. During the weeks that followed the Royal Proclamation was put into force. The Home Office, in combination with the judiciary, the newly founded London police force, alien office and secret service, set up a network headed by the Home Secretary, Henry Dundas. Local magistrates, Justices of the Peace, Post Office and Customs officers, together with informers, supplied the information required to identify suspicious persons and bring about their arrest (nos.181, 184).

In August the mood took on a new urgency. On the 15th the correspondent of *The Times* reported from 'Paris, Friday Night, 12 O'Clock (By Express)':

> This morning, the mob, to the number it is computed of 30,000 men, women and children, went to the Thuilleries and forced the Palace doors […] During this struggle, a great number of people were killed […] the King, the Queen, the Dauphin, and some of the Royal attendants flew to the National Assembly for protection. […] After a very tumultuous debate, in which the galleries

took a very considerable share, hooting and hissing all those who attempted to speak in favour of the Royal Family, and threatening them with instant destruction, a decree has been passed, by which the KING IS DETHRONED.

The reporter for the *World* described how the women of Paris had literally torn 'the dead bodies of the King's Swiss Guard to pieces, and practise with them the most shocking indecencies – breaking open the apartments in the *Thuilleries*, and dancing there while the floors were flowing with blood'. With the fall of the French monarchy on the 10th, followed on the 13th by imprisonment of the King and his family and then the declaration of the Duke of Brunswick that he would raze Paris if the National Assembly did not release the King, a second massacre was precipitated.

On 8 September, when the first descriptions were reported, alarm swept London. On 10 September, *The Times* recorded that on 'the 10th of August last ELEVEN THOUSAND PERSONS were massacred in Paris' and, during the three days from 4 to 6 September, a further 'TWELVE THOUSAND PERSONS […] their trunkless heads and mangled bodies carried about the streets on pikes'. On 20 September, the French were victorious at Valmy, confirming the Republic, followed by the decisive victory over the combined forces of Prussia and Austria at Jemappes on 6 October. The National Convention then offered its support to all willing to revolt, in particular beckoning to the peoples of England, Scotland and Ireland. The possible consequences for the British government and monarchy were clear. A vigorous popular counter-revolutionary movement backed by authority was urgently needed. The newspaper press was one means of serving notice to the public of the dangers of reform, and of the anarchy and bloodshed that resulted when authority was usurped. Covert support of a conservative backlash was another.

On 20 November 1792, the Association for the Preservation of Liberty and Property against Republicans and Levellers met at the Crown and Anchor Tavern in the Strand, with John Reeves, Esq., in the Chair. The following 'Considerations and Resolutions were entered into and agreed upon':

> Considering the danger to which the Public Peace and Order are exposed by the circulating of mischievous Opinions,

founded upon plausible but false reasoning; and that this circulation is principally carried on by the industry of Clubs and Societies of various denominations in many parts of the Kingdom. It appears to us, That it is now become the duty of all Persons, who wish well to their Native Country, to endeavour, in their several neighbourhoods, to prevent the said effects of such mischievous industry; and that it would greatly tend to promote these good endeavours, if Societies were formed in different parts of the Kingdom, whose object should be to support the Laws, to suppress seditious Publications, and to defend our Persons and Property against the innovations and depredations that seem to be threatened by those who maintain the mischievous opinions before alluded to.

The announcement appeared in the London *Public Advertiser* on Tuesday, 27 November 1793, followed by publication in newspapers throughout the country and separately printed, distribution to the officers of every country parish and city ward (no.178). The response was without precedent. In a matter of weeks more than 1600 local organisations were founded upon Reeves' model and had written to him declaring their support (nos.180, 182, 183). Requests for information leading to the identification and arrest of anyone found to be associated with the publication or distribution of seditious material, including pamphlets, posters, handbills or prints, or taking part in seditious meetings or uttering statements against the King, his government or the constitution, was also forthcoming (no.179).

Typical of hundreds of letters received is an anonymous note regarding sellers of prints and print shops, received by Reeves on 10 December: 'Print shops seem at this moment particularly to demand attention, as many are fill'd with Revolution Representations importd from France' (no.184). It and other information drawing attention to similar instances may have provoked the Association to publish the following notice in the *Public Advertiser* on 12 December, citing its authority in law:

> Complaints having been made of the licentiousness of certain Print-shops, wherein libellous Pictures and Engravings are daily exhibited, to the

LAMBETH,

December 10th, 1792.

AT a very numerous Meeting of the Inhabitants of the Parish of *Lambeth*, held this Day, in Consequence of public Advertisement, at *Cumberland Gardens, Vauxhall,*

JOSEPH WARING, Esq; in the Chair.

The following Declaration was read, and unanimously approved, viz.

We, the Inhabitants of the Parish of *Lambeth*, deeply sensible of the Blessings derived to us from the present admired and envied Form of Government, consisting of King, Lords, and Commons, feel it a Duty incumbent on us, at this critical Juncture, not only to declare our sincere and zealous Attachment to it, but moreover to express, in the most public Manner, and in the most pointed Terms, our perfect Abhorrence of all those bold and undisguised Attempts, that have been made and daily are making, in various Ways, to shake and subvert this our invaluable Constitution, which the Experience of Ages has shewn to be the most solid Foundation of national Happiness.

Resolved unanimously,

That we do form ourselves into an Association, and give every possible Effect to the well-timed and vigorous Exertions of other public Bodies, by counteracting, as far as we are able, all tumultuous and illegal Meetings of ill designing and wicked Men, and adopting the most effectual Measures in our Power for the Suppression of seditious Publications, evidently calculated to mislead the Minds of the People, and to introduce Anarchy and Confusion into this Kingdom.

Resolved unanimously,

That the following Declaration and Resolution be submitted to every Housekeeper for their Approbation and Signature.

Resolved unanimously,

That Books be now opened, and afterwards left at the following Places for the Signatures of such Inhabitants as are attached to the present happy Constitution, and are disposed to preserve Peace and good Order, viz. *Cumberland Gardens; New-Inn, Lambeth Marsh; Swan, at Stockwell; Horns, at Kennington,* and at the Vestry Room.

Resolved unanimously,

That the following Gentlemen, with the Chairman, be appointed a Committee for carrying the Designs of this Meeting into Execution, viz.

Rev. Dr. VYSE, Rev. Mr. PEARCE.

Bryant Barrett	Major Dellhost
John Henry Beaufoy	Capt. Stewart
D'Arcy Boulton	Messrs. Alexander
Robert Burnett	Biven
Charles Carfan	Gubbins
John Goodeve *Esqrs.*	Leavis
Samuel Payne	Lett
Thomas Snaith	Malcolm
Jonathan Stonard	Roberts
Stephen Swabey	Sutter
Francis Wilson	Willard

Resolved unanimously,

That the Proceedings of this Meeting be signed by the Chairman, and published in the Morning Papers.

Resolved unanimously,

That the Thanks of this Meeting be given to the Rev. Dr. VYSE, the Rev. Mr. PEARCE, and D'ARCY BOULTON, Esq; for their active Services on this Occasion.

J. WARING, Chairman.

Resolved unanimously,

That the Thanks of this Meeting be given to JOSEPH WARING, Esq; for his upright and impartial Conduct as Chairman.

At a Committee held at Vauxhall, December 12th, 1792.

The Committee being fully persuaded that much Mischief has been spread through this Country, by the Circulation of Newspapers filled with Disloyalty and Sedition, for the express Purpose of overturning our excellent Constitution,

Resolved unanimously,

That it be recommended to all good Englishmen, whether Masters of private Families, or Keepers of Inns, Taverns or Coffee Houses, to discontinue and discourage all such disloyal and seditious Newspapers, the Publishers of which manifestly appear to be in the Pay of *France.*

Resolved unanimously,

That it be recommended to the Parish Officers, to request every Person letting Lodgings in this Parish, to give them a particular Account of all Foreigners entertained at this Time at their respective Houses, and that the same be entered in a Book to be kept for that Purpose.

Lambeth Loyalist Declaration, 10 December 1792 (no.183)

great scandal and offence of his Majesty's loyal and affectionate subjects;

Resolved,

That the following authorities, by way of caution to the Proprietors of those shops, of the illegal and dangerous tendency of such practices be published:

'A libel, *Libellus famosus sive scriptus*, may be first pictures; as, to paint the party in any shameful and ignominious manner.' 5 Co. 125.

'The notion of a Libel may be applied to any defamation whatsoever, expressed either by signs or pictures.' Hawkins, *Pleas of Crown*, Book 1. Ch.3. f.193.

'A libel is a contumely or reproach published to any defamation of the Government, of a Magistrate, or of a private person; and it may be without writing; as by making a picture in an ignominious manner, or any ignominious sign to the reproach of another.' Lord Comyns *Digest*, Vol.4, p.50.

Support for Reeves and his Association was also forthcoming south of the Thames.

By September 1792, William and Catherine had been living in Lambeth for nearly two years. Blake's profession as printmaker and publisher was known to neighbours and apparent to passers by: his rolling press, standing nearly six feet in height must have been clearly visible through the single large ground-floor front window. Alexander Gilchrist interviewed Blake's surviving friends for what remains the standard biography, first published in 1863. Of the little information that he managed to collect for this time, one anecdote stands out:

> He courageously donned the famous symbol of liberty and equality – the *bonnet rouge* – in open day, and philosophically walked the streets with the same on his head. He is said to be the only one of the set who had the courage to make that profession of faith. Brave as a lion at heart was the meek spiritualist. Decorous Godwin, Holcroft, wily Paine, however much they might approve, paused before running the risk of a Church-and-King mob at their heels. All this was while the Revolution, if no longer constitutional, still continued muzzled; before, that is, the Days of Terror, in September '92, and subsequent defiance of kings and of humanity.

In the early 1790s Lambeth was still a small and close community. It had a population of fewer than 10,000. Most of this population lived along the Thames between Westminster Bridge and Vauxhall, with Hercules Buildings serving as one of the thoroughfares between the old village west of Lambeth Palace and the new access over the bridge to the city. To this small community, Blake's profession and his politics were clearly visible.

South of the Thames, response to Reeves's request for declarations of loyalty, and for assistance in identifying anyone associated with the production or distribution of seditious materials, was comprehensive. Lambeth was first to declare its loyalty, followed by Peckham, Battersea, Battersea Common, Clapham, Clapham Common and the Borough of Southwark (no.183).

On 15 December the declaration from the Village of Peckham was sent to Reeves. On the same day the Parish of Battersea also wrote:

> We resolve to discountenance and use our best Endeavours to suppress all treasonable & Seditious Publications of every Kind and strenuously aid & support the Magistrates in the firm and steady Execution of their Duty (no.182)

Battersea was a village with a population of 350. It was where Catherine was born and raised, where she and Blake first met and where he lived for a month so that they could be married in the parish church. Together with Battersea, representatives from Battersea Common, Clapham and Clapham Common published a joint Declaration and sent a copy to Reeves, proclaiming that every effort would be made to seek out and prosecute anyone associated with seditious publications. It was signed by one of Catherine's relations.

Lambeth posted its declaration to Reeves on 10 December, together with the adjoining village of Vauxhall:

> At a very numerous Meeting of the Inhabitants of the Parish of *Lambeth* [...] The following Declaration was read, and unanimously approved, viz. That we do form ourselves into an Association, and give every possible Effect to the well-timed and vigorous Exertions of other public Bodies, by counteracting, as far as we are able, all tumultuous and illegal Meetings of ill designing and wicked Men, and adopting the most effectual Measures in our Power for the Suppression of seditious Publications (no.183).

One resolution exceeded any of those adopted by Lambeth's neighbouring villages and boroughs, and by all but six of the 1600 associations that published their declarations of loyalty:

> That the following Declaration and Resolution be submitted to every Housekeeper for their Approbation and Signature.

No record survives of the response of the householders occupying Hercules Buildings in December 1792. There are accounts, like the following, of men who were prompted to express their view of the government and the King and suffered the consequences:

> At Barns in Lincolnshire a drunken Blacksmith for damning the King and calling the Government a despotism was sentenced by the Quarter Session. *To be kept in solitary confinement, without seeing or speaking to any person, except the person takes him his victuals, for the space of twelve months.*

Written on the back of this account at the time is the following gloss:

> By the wording of this sentence the man could receive no medical aid, no religious consolation, a more cruel sentence could hardly have been devised, the man who gave him his food would probably treat him with contempt and soon cease to speak to him. It is more than probable if the sentence was exactly inflicted that the man died a most miserable death before the term of his imprisonment expired.

We do not know what happened at Hercules Buildings when representatives of the Lambeth loyalist committee presented themselves in December 1792. When Blake was shown the declaration with its codicil against seditious publications, it would have taken great courage to stand apart from the neighbours and friends that he and Catherine had made by refusing to sign.

By June 1793 Blake's sense of peril was palpable, as he wrote in his *Manuscript Notebook*, fo.10:

'I say I shant live five years And if I live one it will be a Wonder June 1793.' On 10 October Blake issued his *Prospectus* of works for sale at his premises. That same day a newly founded Society of Loyal Britons, 'Instituted the 10th of October, 1793', held two meetings south of the Thames, one within a hundred yards of Blake's home and printmaking studio (nos.188–99). Contemporary descriptions of loyalist meetings make plain that at the conclusion of the meeting, a procession was organised to march through the town or village following a cart carrying an effigy of Thomas Paine. The procession included drummers and men on horseback carrying pikes and banners. Typically, it stopped before the homes of Dissenters and, in particular, before the home or premises of anyone thought to advocate reform of the constitution, question the right of monarchy, or who had shown signs of supporting the Revolution in France. Stones were thrown and violence was threatened. The procession then moved on to an open space or field where the effigy of Paine was executed before a firing squad. It was then taken to a large bonfire, hung from a gibbet and set alight. St George's Fields was a traditional site for a political display of this kind. The fires would have been seen from a great distance, and clearly from the upper windows at the rear of Hercules Buildings, as would be heard the songs and incantations of the crowds.

There is no record of anyone responding to Blake's *Prospectus* and coming to Lambeth to see his works advertised for sale. Nor is there any record of one of his works being sold that autumn. Within months Blake issued his illuminated books and separate plates predominately colour-printed, privately in numbers that can only be described as limited to a very few copies. A few unspecified works were also to be seen at Joseph Johnson's in St Paul's Churchyard. By 1795, he had developed the method he used to produce the large colour prints, a method that was only capable of producing two or three impressions, which were then finished by hand. Clearly, any ambitions that Blake had to engage publicly in the debate provoked by events in France had been suppressed, understandably, perhaps, for his own and Catherine's sake, who would have been made destitute if he had been imprisoned for publishing his views.

In September 1800, three weeks before he and Catherine left Lambeth at the invitation of William Hayley for the small coastal village of Felpham in Sussex, Blake wrote to his long-standing friend and steadfast supporter of his work, George Cumberland. It is a letter that has only recently come to light, now in the collection of Robert N. Essick, in which Blake speaks of being 'upon the verge of a happy alteration in my life'. But in the verses attached in a post script we glimpse the inner sense of what the past decade in London had been like:

> Dear Generous Cumberland nobly solicitous for a Friends welfare.
> Behold me
> Whom your Friendship has Magnified: Rending the manacles of Londons Dungeon dark
> I have rent the black net & escap'd. See My Cottage at Felpham in joy
> Beams over the Sea, a bright light over France, but the Web & the Veil I have left Behind me at London resists every beam of light; hanging from heaven to Earth Dropping with human gore. Lo! I have left it! I have torn it from my limbs
> I shake my wings ready to take my flight! Pale, Ghastly pale: stands the City in fear

As the final set of documents exhibited in this section record, at Chichester, in the Quarter Sessions in January 1804, Blake was tried for sedition. The fears he had harboured in London were now realized. MP

163 **Songs of Experience 1793/1794**
Plate 42: 'The Tyger'
From Copy G *c.*1793–1794
Colour-printed relief etching finished with watercolour 11 × 6.3 (4¾ × 2½) on paper 18.1 × 10.4 (7⅛ × 4⅛)
The Keynes Family Trust on loan to the Fitzwilliam Museum, Cambridge

The Tyger.

Tyger Tyger, burning bright,
In the forests of the night ;
What immortal hand or eye.
Could frame thy fearful symmetry?

In what distant deeps or skies.
Burnt the fire of thine eyes?
On what wings dare he aspire?
What the hand, dare sieze the fire?

And what shoulder, & what art.
Could twist the sinews of thy heart?
And when thy heart began to beat,
What dread hand? & what dread feet?

What the hammer? what the chain,
In what furnace was thy brain?
What the anvil? what dread grasp.
Dare its deadly terrors clasp!

When the stars threw down their spears
And water'd heaven with their tears:
Did he smile his work to see?
Did he who made the Lamb make thee?

Tyger Tyger burning bright,
In the forests of the night ;
What immortal hand or eye,
Dare frame thy fearful symmetry?

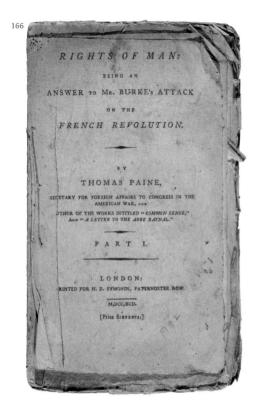

166

167

By the KING.

A PROCLAMATION.

GEORGE R.

WHEREAS divers wicked and feditious Writings have been printed, publifhed, and induftrioufly difperfed, tending to excite Tumult and Diforder by endeavouring to raife groundlefs jealoufies and difcontents in the minds of Our faithful and loving Subjeƈts, refpeƈting the Laws, and happy Conftitution of Government, Civil and Religious, eftablifhed in this Kingdom, and endeavouring to vilify and bring into contempt the wife and wholefome Provifions made at the time of the glorious Revolution, and fince ftrengthened and confirmed by fubfequent Laws, for the prefervation and fecurity of the Rights and Liberties of Our faithful and loving Subjeƈts: And whereas divers Writings have alfo been printed, publifhed, and induftrioufly difperfed, recommending the faid wicked and feditious Publications to the attention of all Our faithful and loving Subjeƈts: And whereas We have alfo reafon to believe that Correfpondences have been entered into with fundry perfons in foreign parts, with a view to forward the criminal and wicked purpofes above-mentioned: And whereas the Wealth, Happinefs, and Profperity of this Kingdom do, under Divine Providence, chiefly depend upon a due fubmiffion to the Laws, a juft confidence in the integrity and wifdom of Parliament, and a continuance of that zealous attachment to the Government and Conftitution of the Kingdom, which has ever prevailed in the minds of the People thereof: And whereas there is nothing which We fo earneftly defire, as to fecure the public Peace and Profperity, and to-preferve to all Our loving Subjeƈts the full enjoyment of their Rights and Liberties, both Religious and Civil: We therefore being refolved, as far as in Us lies, to reprefs the wicked and feditious praƈtices aforefaid, and to deter all perfons from following fo pernicious an example, have thought fit, by the advice of Our Privy Council, to iffue this Our Royal Proclamation, folemnly warning all Our loving Subjeƈts, as they tender their own happinefs, and that of their pofterity, to guard againft all fuch attempts which aim at the fubverfion of all regular Government within this Kingdom, and which are inconfiftent with the peace and order of Society; and earneftly exhorting them at all times, and to the utmoft of their power, to avoid and difcourage all proceedings tending to produce Riots and Tumults: And We do ftriƈtly charge and command all Our Magiftrates in and throughout Our Kingdom of *Great-Britain,* that they do make diligent enquiry in order to difcover the Authors and Printers of fuch wicked and feditious Writings as aforefaid; and all others who fhall difperfe the fame: And We do further charge and command all Our Sheriffs, Juftices of the Peace, Chief Magiftrates in Our Cities, Boroughs, and Corporations, and all other Our Officers and Magiftrates throughout Our Kingdom of *Great-Britain,* that they do, in their feveral and refpeƈtive ftations, take the moft immediate and effeƈtual care to fupprefs and prevent all Riots, Tumults, and other Diforders which may be attempted to be raifed or made by any perfon or perfons, which, on whatever pretext they may be grounded, are not only contrary to Law, but dangerous to the moft important Interefts of this Kingdom; and We do further require and command all and every Our Magiftrates aforefaid, that they do, from time to time, tranfmit to one of Our Principal Secretaries of State, due and full information of fuch perfons as fhall be found offending as aforefaid, or in any degree aiding or abetting therein; it being Our determination, for the prefervation of the Peace and Happinefs of Our faithful and loving Subjeƈts, to carry the Laws vigoroufly into execution againft fuch Offenders as aforefaid.

Given at Our Court at the *Queen's Houfe,* the Twenty-firft Day of *May,* One thoufand feven hundred and ninety-two, in the Thirty-fecond Year of Our Reign.

God fave the King.

LONDON: Printed by CHARLES EYRE and ANDREW STRAHAN, Printers to the King's moft Excellent Majefty. 1792.

170 Proclamation! Deputation of the People in Council. Vox populi! Fellow Citizens!
Broadsheet
London 1792
The British Library Board (press mark 648.c.26 (68))

171 RICHARD NEWTON (1777–1798)
A Proclamation in Lilliput 22 May 1792
Etching finished with watercolour 31×44.5 (12½×17½) on paper 25×45.5 (9⅞×18)
Published 22 May 1792
Benjamin Lemer
Lit: Alexander 1998, pp.116–17

172 RICHARD EARLOM (1743–1822) AFTER JOHANN ZOFFANY (1733–1810)
Invasion of the Cellars of the Louvre, 10 August 1792
Mezzotint 56.7×64 (22⅜×25¼)
Published 1 January 1795
The British Museum, London

173 JAMES GILLRAY (1757–1815)
Un petit Souper a la Parisienne – or – A Family of Sans-Culotts
Etching finished with watercolour 25.2×35.3 (9⅞×13⅞)
Published 20 September 1792
The British Museum, London

174 GEORGE CUMBERLAND (1754–1848)
MS letter to his brother Richard, 27 November 1792
The British Library Board

175 JOSEPH GURNEY (1744–1815)
The whole Proceedings on the Trial of an information exhibited ex officio by the King's Attorney General against Thomas Paine for a libel upon the Revolution and settlement of the crown … Tried … in the Court of the King's Bench … the 18th of December, 1792 … Taken in short-hand by J. Gurney 1792
London, 1793
Open at pp.4–5
The British Library Board

176 Albion rose or Glad Day 1780/c.1793
Etching and engraving 27×19.4 (10⅝×7⅝) on paper 30.8×23.3 (12⅛×9⅛)
Engraved inscriptions 'WB inv 1780' in image l.l. 'Albion rose from where he labourd at the Mill with Slaves/Giving himself for the Nations he danc'd the dance of Eternal Death.' below image
National Gallery of Art, Washington DC, Rosenwald Collection 1943
Lit: Essick 1983, no.VII:2D

177 ANON
A Song sung at the anniversary of the Revolution of 1688, held at the London Tavern, November 5, 1792
'See! Bright LIBERTY descending'
London, 1792
The British Library Board (press mark 648.c.26 (6))

178 J. MOORE [JOHN REEVES] 1752–1829
Association for Preserving Liberty and Property against Republicans and Levellers, November 20, 1792
Michael Phillips

179 **Association for Preserving Liberty and Property against Republicans and Levellers, Crown and Anchor Tavern, 6 December 1792**
(Broadsheet)
The British Library Board (press mark 648.c.26 (12))

170

PROCLAMATION!
Deputation of the PEOPLE, in Council. VOX POPULI!
Fellow Citizens!
THE *Time is at Hand* when the SOVEREIGNTY of the PEOPLE will no longer *Suffer* themselves to be DUPED and *Trifled* with by the *Lukewarmnefs* and APOSTACY of their SHAM *Representatives*, but depend on *Their OWN* EXERTIONS to procure a PARLIAMENTARY REFORM!

GOD SAVE THE PEOPLE!!

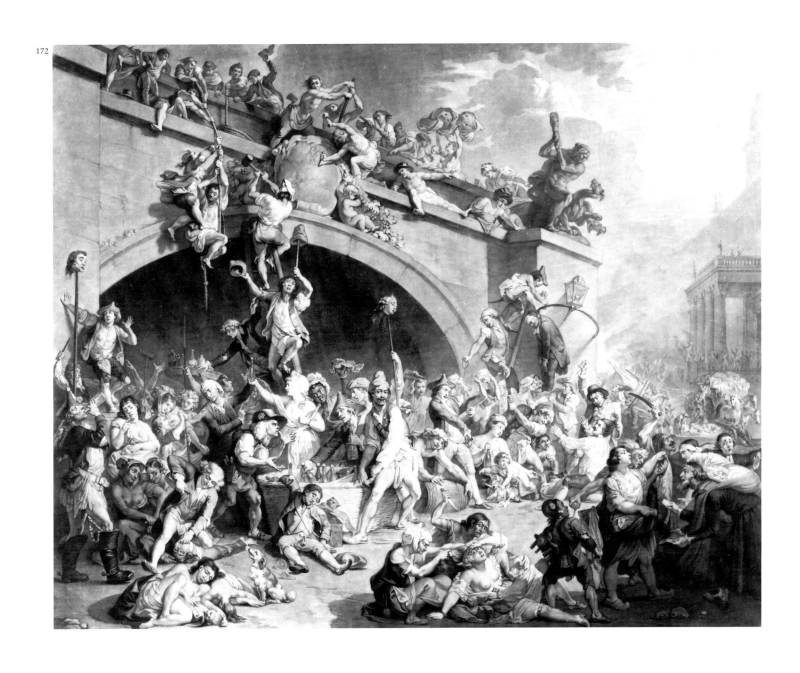

191

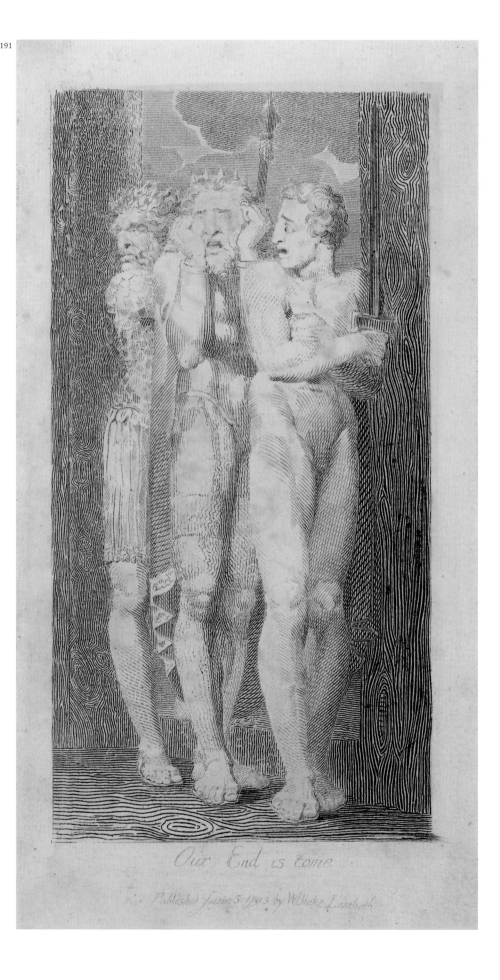

187 JAMES GILLRAY (1757–1815)
**The Blood of the Murdered crying out
for Vengeance**
Etching and watercolour 35 × 26 (13¾ × 10¼)
Published 16 February 1793
The British Museum, London

188 HENRY DELANEY SYMONDS
MS. Letter, 22 February 1793
fo.1 recto
Public Record Office, London

189 **'Reform in Parliament' Dated April 11, 1793**
45 × 27 (17¾ × 10⅝)
Public Record Office, London

190 **The King v [Daniel Isaac] Eaton, Old Bailey
Sessions May 1793**
Prosecution Lawyers Brief 'For publishing the
cheap Edition of Paines 2nd part of Rights of
Man'
4 folios, tied with pink ribbon t.l.
Public Record Office, London

191 **Our End is come**
Etching and engraving printed in olive green
ink 18.3 × 9.5 (7¼ × 3¾) on paper
23.5 × 14.4 (9¼ × 5⅝)
Etched inscription 'Publishd June 5: 1793 by
W Blake Lambeth'
Later bound as a Frontispiece to *The Marriage of
Heaven and Hell* Copy B
The Bodleian Library, The University of Oxford
[Press Mark: Arch.Gd.53]
Lit: Essick 1983, no.VIII:1A

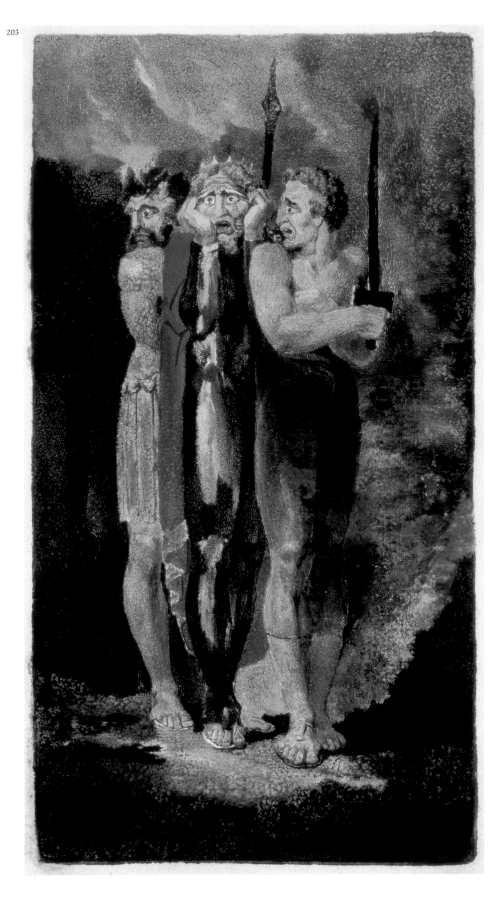

A Song of Liberty

1. The Eternal Female groand! it was heard over all the Earth:

2. Albions coast is sick silent; the American meadows faint!

3. Shadows of Prophecy shiver along by the lakes and the rivers and mutter acros the ocean? France rend down thy dungeon;

4. Golden Spain burst the barriers of old Rome;

5. Cast thy keys O Rome into the deep down falling, even to eternity down falling,

6. And weep and bow thy reverend locks!

7. In her trembling hands she took the new born terror howling;

8. On those infinite mountains of light now barrd out by the atlantic sea, the new born fire stood before the starry king!

9. Flagd with grey browd snows and thunderous visages the jealous wings wavd over the deep.

10. The speary hand burned aloft, unbuckled was the shield, forth went the hand of jealousy among the flaming hair, and

hurld the new born wonder thro' the starry night.

11. The fire, the fire, is falling!

12. Look up! look up! O citizen of London enlarge thy countenance; O Jew, leave counting gold! return to thy oil and wine; O African! black African! (go, winged thought widen his forehead.)

13. The fiery limbs, the flaming hair, shot like the sinking sun into the western sea.

14. Wakd from his eternal sleep, the hoary element roaring fled away:

15. Down rushd beating his wings in vain the jealous king; his grey browd councellors, thunderous warriors, curld veterans, among helms, and shields, and chariots horses, elephants: banners, castles, slings and rocks,

16. Falling, rushing, ruining! buried in the ruins, on Urthona's dens;

17. All night beneath the ruins, then their sullen flames faded emerge round the gloomy king.

18. With thunder and fire: leading his starry hosts thro' the waste wilderness

he promulgates his ten commands, glancing his beamy eyelids over the deep in dark dismay,

19. Where the son of fire in his eastern cloud, while the morning plumes her golden breast,

20. Spurning the clouds written with curses, stamps the stony law to dust, loosing the eternal horses from the dens of night, crying Empire is no more! and now the lion & wolf shall cease.

Chorus

Let the Priests of the Raven of dawn, no longer in deadly black, with hoarse note curse the sons of joy. Nor his accepted brethren whom, tyrant, he calls free; lay the bound or build the roof. Nor pale religious letchery call that virginity, that wishes but acts not!

For every thing that lives is Holy

192 The Marriage of Heaven and Hell 1790–1793

Plates 25–7: 'A Song of Liberty'

a) Copy L *c.*1793

Relief etching with white line work printed in
brown-black ink on paper 21.2 × 34.7 (8⅜ × 13⅝),
4° sheet, with centre-fold crease

Collection of Robert N. Essick

b) Copy M *c.*1793

Single 8° sheet [centre-fold crease]

Relief etching printed in dark brown ink
on paper 15.2 × 10.5 (6 × 4⅛)

Collection of E. B. Bentley and
G. E. Bentley Jr

192b

192b

193 **The Names of the Several Prisoners Confined in His Majestys Gaol of Newgate … Sept. 1792 to … Sept. 1793**
Vellum bound MS. open folio 69 verso 70 recto (June Sessions, 19 June 1793)
Public Record Office, London

194 GEORGE ROMNEY (1734–1802)
Sketchbook dated '1-June`93': 'Prison Scenes'
Pencil on two pages each 14 × 23.5 (5½ × 9¼) in sketchbook
Yale University Art Gallery; University Purchase, Everett V. Meeks, B.A. 1901, Fund

195 **MS Letter [Memo]. Luke Ideson. Poland Street 26 July 1793**
Public Record Office, London

196 RICHARD NEWTON (1777-1798)
Promenade in the State Side of Newgate 1793
Etching 41.6 × 70.8 (16⅜ × 27⅞)
Published 5 October 1793
The British Museum, London
Lit: Alexander 1998, pp.34–8, 147

197 THOMAS LLOYD
To the grand juries of the City of London and County of Middlesex, etc [A memorial 'respecting the improper conduct of the Jailer of Newgate, and the extortions and oppression practised by his connivance'.]
Signed at end 'Thomas Lloyd, Felons-side of Newgate'
Open at pp.4–5
The British Library Board

198 **Songs of Experience 1793/1794**
Plate 47: The Human Abstract
From Copy G *c.*1793-1794
Colour-printed relief etching finished with watercolour 11.1 × 6.5 (4¾ × 2½) on paper 18 × 11.9 (7⅛ × 4⅝)
The Keynes Family Trust on loan to the Fitzwilliam Museum, Cambridge

199 ANON
A Society of Loyal Britons. Instituted the 10th of October, 1793
Printed broadside with MS verso
Public Record Office, London

200 ANON
Rules, Articles and Regulations [of] Loyal Lambeth Association [dated 15 Nov 1793]
'No.1 Franklow copy'
Public Record Office, London

201 **The same**
Open pp.6–7
Public Record Office, London

202 **MS Informer Report**
Mr Lynam
Public Record Office, London

194

203 The Accusers 1793/c.1794-6
Colour-printed etching 21.5 × 11.8 (8½ × 4⅝)
on paper 34.5 × 24.7 (13⅝ × 9¾)
Second State
From Large Book of Designs, Copy A
The British Museum, London
Lit: Essick 1983, no.VIII:2B

204 The Accusers 1793/c.1794–6
Colour-printed etching 21.6 × 12.1 (8⅝ × 4¾) on
paper 32.1 × 24.1 (12⅝ × 9½)
Second State
From Large Book of Designs, Copy B
National Gallery of Art, Washington, Resenwald
Collection 1943
Lit: Essick 1983, no.VIII:2C

205 Lucifer and the Pope in Hell c.1794/c.1795-6
Colour-printed etching and engraving finished
with watercolour and pen and ink 18.3 × 24.6
(7¼ × 9⅝) on paper 19.9 × 27.4 (7⅞ × 10¾)
The Huntington Library, Art Collections and
Botanical Gardens
Lit: Essick 1983, no.X:1B

206 ISAAC CRUIKSHANK (1756–1811/16)
'A Picture of Great Britain in the Year 1793'
Monochrome etching 36.3 × 39 (14¼ × 15⅜) on
paper
Published 9 January 1794
The British Museum, London

207 JAMES GILLRAY (1757–1815)
**'Presages of the MILLENIUM, with The
Destruction of the Faithful ..'**
Etching finished with watercolour 32.5 × 37.5
(12¾ × 14¾) on paper 35.5 × 39.5 (14 × 15½)
Published 4 June 1795
Andrew Edmunds, London

**208 True Bill against William Blake returned at
the October Quarter Sessions, [Chichester]**
MSS Vol. marked: "ab. 1802 ab. 1804 Orders",
open at pp.3-4
Open: 31 × 45 × 4 (12¼ × 17¾ × 1⅝)
East Sussex Records Office, Lewes
Lit: BR, pp.131–4

207

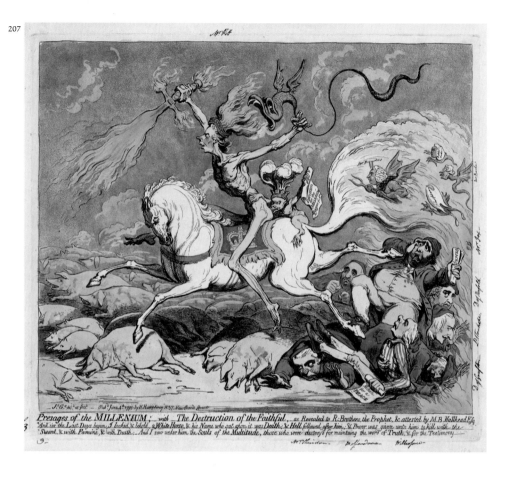

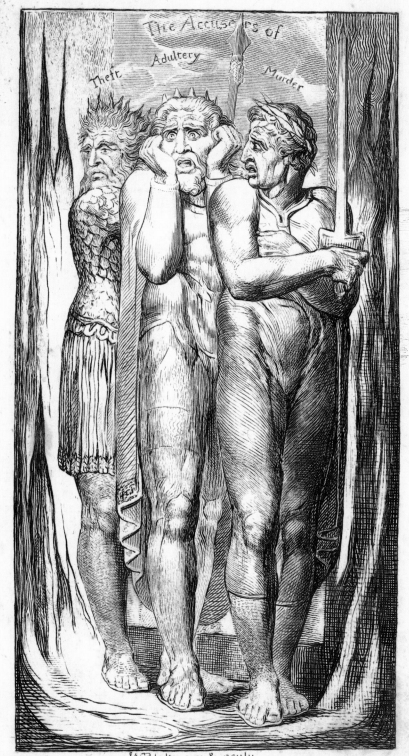

209 Rex vs. Blake: True Bill 'John Scholfield/John Cock/ Sworn in Court [12 August 1803]
'The Jurors for our Lord the king upon their oath'
Parchment folio
West Sussex County Record Office, Chichester
Lit: BR.131–4

210 Rex vs. Blake
Scholfield's MS. Deposition: 'The Information and Complaint of John Scholfield'
1 page, recto and verso
West Sussex County Record Office, Chichester
Lit: BR.124–5

211 MS letter William Blake to Thomas Butts, 16 August 1803
Open at fos. 1 verso – 2 recto
The Preston Blake Library, City of Westminster Archives Centre, London
Lit: Erdman 1982 pp.731–4

212 The Accusers *c*.1804
Copy E
Third State
Engraved and etched inscriptions above the figures within the image,
'The Accusers of Theft Adultery Murder'
Signed below image: 'WBlake inv & sculp' and below signature: 'A Scene in the Last Judgement/Satans' holy Trinity The Accuser The Judge & The Executioner'
Etching and engraving printed in black ink
18.4×10 (7¼×4) on paper 22.9×14.8 (9×5⅞)
Lent by the Syndics of the Fitzwilliam Museum, Cambridge
Lit: Essick 1983, no.VIII:3F

213 The Spiritual Form of Pitt Guiding Behemoth *c*.1805?
Tempera heightened with gold on canvas
74×62.7 (29⅛×24¾)
Tate; purchased by the National Gallery 1882; transferred to the Tate Gallery 1931
Lit: Butlin 1981, no.651; Butlin 1990, no.59

'I am contented whether I live by Painting or Engraving'

(Blake to Trusler, 23 August 1799; E.703)

The centrality to Blake's artistic achievement of his invention of relief etching and all that flowed from it is self evident. Its origins, as recounted by Blake, in a visionary experience (see p.104) meant that from the very beginning the process was endowed with a memorable and enduring significance that simultaneously ensured that Blake's belief in its possibilities would be, indeed had to be, completely unshaken. The groundwork for this was laid during Blake's apprentice years in Basire's workshop where he learnt how to become a reproductive engraver and also learnt from the work of old engravers such as Dürer (no.214). He acquired what, in an annotation to Reynolds's *Discourses* (see no.233), he later described as 'Mechanical Excellence', something which he rightly regarded as 'the Only Vehicle of Genius' (E.643). The successful acquisition of such excellence could only have reinforced Blake's belief in the 'genius' with which he believed he was born see (E.659) and correspondingly broadened his visionary horizons to the point where the revelation of a relief-etching process was rooted in actual experience. Of course, 'Mechanical Excellence' in using the sorts of engraving tools that are included here in the studio display (see no.104) also gave Blake the means of earning a living as a commercial reproductive engraver – the income from which significantly supported the uncommercial production of the illuminated books, the chief 'Vehicle' of his 'Genius'. It is important, then, that we do not lose sight of the fact that during his lifetime Blake was best known as a commercial engraver working in the accepted etching and engraving manner of his time.

One of the unique and remarkable aspects of Blake as an engraver is the way in which he regards his engraving tools, the inflexible metal burins and etching needles and the copper on which they go to work, in much the same way as a painter would view the springing suppleness of his brush on canvas. His own words, quoted at the head of this section of the exhibition, suggest the ease with which the physical connection between two very different mediums might be made as does another annotation to Reynolds: 'Precision of Pencil [the eighteenth century word for brush] … if it does not mean outline it means nothing' (E.657). The engraved plate is no longer the 'Labourd' work of a journeyman (E.644) but possesses an originality inseparable from the work which it is to reproduce. The stages in the engraving process for three different works by Blake which are shown here demonstrate the practical as well as the creative aspects involved in this reproductive process, ranging from the commercial work of the print after a design by Fuseli (nos.215, 216), Blake's first and only excursion into wood engraving (no.217) and his masterpiece in the use of the engraving burin alone to 'draw' his intaglio line on the copper plate, the illustrations to *Job* (no.218, plate 2). RH

Lit: Essick 1980; Viscomi 1993

214 ALBRECHT DÜRER (1471–1528)
Melancholy (Melencolia I) 1514
Second State
Line engraving (image) 24 × 18.8 (9½ × 7¾)
The British Museum, London
Lit: Gilchrist 1863, vol.1, p.303; Panofsky 1945, I, pp.156–71

Blake, rather unfashionably for the time, ranked the German engraver and painter Dürer as one of the few exponents of the 'true Style of Art' (E.580) along with a few other fifteenth- and sixteenth-century artists – Raphael, Michelangelo and Giulio Romano. With all of them it was the force of the 'distinct, sharp, and wirey … bounding line' they used to produce the truthful and distinctive effects of character and expression that Blake most admired. He later summed up 'Engraving is Drawing on Copper & Nothing Else' (*Public Address*; E.574). He spotted this in Dürer's work when he was buying and possibly copying from his prints in his youth (BR.422) and he found it in Basire's work. When it came to advertising the print of *Chaucer's Canterbury Pilgrims* (see no.62) Dürer was first in Blake's list of the 'old original Engravers' who inspired him (E.567), and whose technique he emulated in the *Pilgrims* print. In the figure of the Knight and his dog, there is a more obvious debt to Dürer's master print, the *Knight, Death and the Devil*. Dürer's inventive engraved line became associated by Blake with the 'Living Form' of the Gothic (*On Virgil*; E.270) as well as the truest way to 'copy Imagination' (*Public Address*, p.59; E.572).

The *Melencolia* hung close to Blake's engraving bench: the force and life of the lines drawn by Dürer with his burin were obviously constant reminders to Blake of what he should aspire to in his own printmaking. It is one of Dürer's most puzzling images, but just how Blake might have interpreted it is a matter for speculation. Despite his struggles, solitariness,

anger and rebelliousness, and his incursions into gothic darkness (see *Fair Elenor*, no.17; the *Night Thoughts* illustrations, nos.29–36); or the melancholy of Milton's 'Il Penseroso', no.271). Blake should not be seen as one of those Romantic artists for whom a saturnine, melancholy state of mind was a prerequisite for creativity: he refers to 'melancholy' once as a condition affecting him but as a 'Deep pit', a 'Disease', 'stupid' and to be kept from 'all good men' (to Cumberland, 2 July 1800; E.707) rather than as a productive force. Joyous energy was the mainspring of Blake's imagination.

Some sense of the other great value Blake must have attached to this image can be found in a few of the objects that Dürer depicts. Most noticeably, the compasses idly held by Melancholy, but also the geometric forms of sphere and rhomboid, the hourglass, the square of numbers and the comet. They all exemplify the rules of measurement and mathematics out of which, for example, the place of heavenly phenomena in the solar system can be calculated (see *Newton*, nos.248, 249). The sphere and the rhomboid were also shapes used in art academies for teaching drawing systems. They are reminders of how, if the imagination is hemmed in by rules which are the sole guide, physical and mental inaction along with hopelessness set in. RH

214

215 HENRY FUSELI (1741–1825)
The Fertilization of Egypt 1791
Pencil on paper 42.1×19.4 (16⅝×7⅝)
The British Museum, London
Lit: Schiff 1973 no.1038

216 WILLIAM BLAKE AFTER HENRY FUSELI
The Fertilization of Egypt 1791
a) Pen and ink and grey wash 19.4×15 (7⅝×5⅞) on paper
The British Museum, London
Lit: Butlin 1981, no.173
b) Engraving 19.4×15.2 (7⅝×6), from Erasmus Darwin, *The Botanic Garden*, vol.1 (1791)
Lit: Schiff 1973 cat. 974; Essick 1991, cat. XXI.1; Weinglass 1982 pp.22–3; Weinglass 1994, cat. 115
Tate Gallery Library

The Swiss-born history painter Henry Fuseli (1741–1825) admired Blake greatly, and while he was often troubled by the misinterpretation of his images by reproductive engravers, trusted him enough to provide only a sketch (no.215) for him to develop for this engraving (see also p.18). This plate is one of several reproductions made by Blake for Darwin's *Botanic Garden*, published by his friend the radical Joseph Johnson, in two volumes (1791 and 1795). Darwin's poem presents a systematic approach to natural history in elaborately poetic and symbolic form, an idea which may strike us as eccentric but which was much in keeping with the spiritual and creative potential seen in the new scientific disciplines at the time. This image shows the dog-headed god Anubis praying to Sirius, the dog-star, which rises 'at the time of the commencement of the flood'. MM

217 Illustrations to Robert J Thornton, 'The Pastorals of Virgil ...' 1821

a) Dr Robert J. Thornton 1768?–1837
The Pastorals of Virgil, with a Course of English Reading, Adapted for Schools: In which all the Proper facilities are given, enabling youth to acquire The Latin Language in the Shortest Period of Time. Illustrated by 230 Engravings
2 vols, 3rd edition, London 1821
Open Vol. I at plates 6–9 (plate 6: The Blighted Corn) facing p.15
18.6 × 11.8 × 3 (7⅜ × 4⅝ × 1¼)
The Preston Blake Library, City of Westminster Archives Centre
b) The Blighted Corn *c*.1820
Pencil, pen and ink and grey wash on paper approx. 4.1 × 9.6 (1⅝ × 3¾)
Lent by the Syndics of the Fitzwilliam Museum, Cambridge
c) The Blighted Corn
Engraved woodblock, hardwood 3.4 × 7.2 × 2.2 (1¼ × 2¾ × 1)
The British Museum, London

Lit: Keynes 1971, pp.136–42; Bain 1977; Essick 1980, pp.224–33; Butlin 1981, no.769; Essick 1991, no.LIII

The illustrations to Thornton's *Virgil* were commissioned by Robert Thornton (?1768–1837) from Blake in 1819. He made six drawings and engraved them on copperplates for the book and then a further twenty drawings illustrating Ambrose Philips's imitation of Virgil's *First Eclogue*, seventeen of which were engraved by Blake on woodblocks. It was a technique that Blake had never used before this commission.

The *Virgil* was for schoolboys (Latin was not thought essential for girls) and Thornton hoped that it would 'inculcate Morals and fire [scholars] with the thirst of emulating the Grecian and Roman Poets'. Furthermore, with its illustrations superior to those usually found in childrens' books and with words and pictures complementing each other, Thornton believed that the work would excite curiosity and spur boys 'onto the diligent reading' of Virgil's poetry.

In the market for children's books it was important that illustrations were produced quickly and cheaply. Woodblocks were cheaper than copper plates and usually an artist's designs were copied directly from a drawing onto the wood or just drawn on the block ready for the engraver. This meant that when printed the design would be reversed. Blake did not want this to happen so, as we can see from the drawing for 'The Blighted Corn' (no.217b), he carefully drew the image in reverse on the wood

so it would print the same way round as his original design. This was just as he would have done when working on copper for a more prestigious publication. Blake, following his pencil drawing on the block, would cut the designs out of the wood with his steel graver so that the forms and lines would print white against the black of the ink which covered those areas of wood which stood in relief. A journeyman wood-engraver would do the opposite, cutting the wood with incised lines, in which ink remained, as a way of showing forms and masses on the paper. Blake's method gives these illustrations great energy and drama because the work done by the engraving tool itself is so explicit. In addition, with a greater area of the block printing black than is the case with conventional wood cuts, the final image possesses a commanding power designed to catch a schoolboy's interest in the actual text it illustrates. These wood engravings were far more daring than anything produced by the journeyman wood engravers of the day and unsettled Thornton. RH

218 Illustrations of The Book of Job 1823–6/1874

Six out of 22 line engravings each approx. 19.8 × 15.2 (7¾ × 6) on India paper laid on paper approx. 51 × 34.5 (20 × 13½)
Tate; purchased with the assistance of a special grant from the National Gallery and donations from the National Art Collections Fund, Lord Duveen and others, and presented through the National Art Collections Fund 1919

Lit: Wicksteed, 1910 and 1924; Damon 1965; Wright, 1972; Lindberg, 1973; Bindman, 1978, pp.486–7; Bindman, 1987; Butlin, 1990, pp.188–201

Blake's illustrations to the Book of Job were among the projects initiated by John Linnell to alleviate his protégé's late financial difficulties. Having first asked for a set of repetitions of the *Job* watercolours that Blake had made for Thomas Butts, *c*.1805–6 (see pl.2a; Pierpont Morgan Library), drawing tracings of the originals which he then handed over to Blake for colouring (now mainly in Harvard, Fogg Art Museum), Linnell ordered twenty-two engraved subjects, for which a contract was issued in March 1823, and Blake made fresh pencil drawings, reducing the scale of the earlier watercolours and in some cases sketching ideas for border designs (see pl.2b; Fitzwilliam Museum). The engravings carry a publication date of 8 March 1825, but did not in fact appear until early the following year. (For Blake's earlier engraving of *Job and his Comforters*, see no.122.) The twenty-one illustrations, in both portrait and landscape format, are surrounded by open borders bearing simple outline designs and numerous engraved inscriptions taken or adapted from biblical texts; these elucidate or comment on the Bible story. Within each border, the plates carry the signature 'W. Blake inv. & sculp.', and beneath it, outside the margin, variations on the underline 'London. Published as the Act directs March 8: 1825 by William Blake No 3 Fountain Court Strand'; the first plate is mistakenly dated 1828. After the original printing of two separate sets, 215 marked as proofs and a further 100 on drawing paper, Linnell, according to his son, put the plates away until 1874, when he had a further 100 issued on India paper. The Tate set, as noted by Butlin, appears to belong to this late issue.

Blake did not restrict himself to a literal illustration of the biblical Job and his sufferings, but subjected it to a characteristically personal interpretation parallel with his own mythology, and especially with *Jerusalem* (no.303). Instead of the seemingly exemplary figure whose faith is sorely tested after the Devil had called it into

question, and who returns to his former prosperity after God judges him to have passed, Job is seen like Albion as we first encounter him, as a Fallen man, cut off from his spiritual life; and like Albion too he achieves Redemption through suffering. It is the nature of his faith that is at fault, and his awakening follows his outgrowing a complacent reliance on Hebraic moral law. His outward sufferings and those of his family mirror the internal processes that bring this change about. Corresponding to Job's regeneration is the transformation of the imager of the Divine in the course of the series, from a vengeful and arbitrary Old Testament Jehovah – in effect a mirror-image of Job himself – to Christ in glory. Both, it is understood, potentially exist in Job as in us all, and the difference is one of perception.

In plate 1 we encounter Job in his first prosperity. He sits surrounded by his dutiful family, reciting the Lord's Prayer after the day's work is done. But musical instruments hang unplayed in the tree above – a particular irony since Job had once been honoured as a patron saint of musicians. The mechanistic nature of his faith is stressed by the border quotation, 'The Letter Killeth/The Spirit giveth Life' (II *Corinthians*, iii, 6), while the cow and ram heads at the lower corners allude to his possessions, soon to be taken from him, and the altar to his sacrifices, eventually revealed as pointless. In plate 2 – traced in this exhibition through some of the main stages of its evolution from the watercolour made for Butts – Blake glosses the biblical account, envisaging a family gathering in their garden, before the angels, when Job and his relations study the scriptures and ask whether they have broken any Commandments. It is their self-doubt that is seen to give Satan his opportunity. Coming before God among the recording angels, he suggests his challenge, that Job's moral integrity will fail if his prosperity and possessions are taken away. The faces of Job and his wife in the flames surrounding Satan prefigure their coming torment. Complex border designs include a peacock (?pride) and parrot (?repetition), sheep pens (Job's property) and a Hebrew inscription, 'King Jehovah', alluding to Job's conception of a tyrannical God. In plate 11, the error of this conception is revealed to Job in a nightmare in which Satan, in the guise of Jehovah but entwined with a serpent and cloven-hoofed, appears to taunt him with breaking the Commandments. He points to the tables of Mosaic law that Job has disobeyed, and to the flames of Hell that will be

his punishment. Job's realisation that his God is really one with Satan is cathartic, leaving him open to spiritual renewal; he can now envisage the true Redeemer of the New Testament, and his own immortality. The border contains a variant, seemingly Blake's own, of Job, xix, 22–7, 'For I know that my Redeemer liveth … ', and climbing flames, indicative of the consumption of the mortal body as the prelude to the eternal life of the soul. As part of his renewal, Job is humbled, in plate 15, by a revelation of the extent of His Creation on land and sea – the giant Behemoth, seen in his traditional form as a sort of hippopotamus, and the sea-monster Leviathan. But though made by God, these creatures also symbolise the dominance of evil in the world, and are associated with war and hellish regions, and with scientific materialism – all anathema to Blake himself. In plate 18 he shows Job turning from the world to pray for the forgiveness of his false friends, and to embrace the divine light as the flame from his altar strikes the spiritual sun, rising from the night sky of the natural world; with their choirs of angels and sheaves of corn, the borders proclaim Job's imminent salvation and return to prosperity. The motifs below associate the artist's work – significantly marked by the palette and brushes and engraver's burin flanking Blake's signature – with prayer and praise, and with the redeeming work of Christ, whose words are in the open Bible alongside. Essick (1980, pp.236ff) has identified the burin as a relatively old-fashioned type used by Blake's early teacher Basire, and has found evidence of its use in the Job plates in tighter, thinner lines than those cut by a lozenge graver. This interjection from Blake's creative biography is a timely reminder that Job's achievement in envisioning a living God can be said to match the artist's poetic vision, and that Job connects with *Jerusalem* in its exposition of Blake's belief that art is praise. This is made explicit in the final plate 21, a positive counterpart of the first, where Job instructs his daughters – evidently a younger generation than those he had lost in the course of his trials – in music and singing. Their instruments are brought into use, and the border designs reverse those of the earlier plate while dismissing his former sacrifices; 'In burnt Offerings for Sin/thou hast had no Pleasure'. DBB

Plate 1: Job and his Family
'This did Job continually' (Job, i, 5)
Plate 2: Satan before the Throne of God
'Hast thou considered my Servant Job' (Job, I, 8)
'When the Almighty was yet with me. When my Children were about me' (Job, xxix, 5)
a) Pen and ink and watercolour over pencil
29.6×22.8 (11⅝×9)
The Pierpont Morgan Library, New York
Lit: Butlin, 1981, pp.411–2, no.550 2
b) Reduced study for engraving
Pencil with Indian ink and wash
14×10 (5½×3⅞)
Lent by the Syndics of the Fitzwilliam Museum, Cambridge
Lit: Butlin, 1981, p.428, no.557 9
c) Line engraving 21.3×16.8 (8⅜×6⅝) on paper
23.8×19.1 (9⅜×7½)
Proof impression with marginal drawing in pencil
National Gallery of Art, Washington DC, Rosenwald Collection, 1943
Lit: Butlin, 1981, p.434, no.559 2; Bindman, 1987, p.61
d) Copper plate 21.9×17.2×0.14 (8⅝×6¾×0.06)
The British Museum, London
Plate 11: Job's Evil Dreams
'With Dreams upon my bed thou scarest me & affrightest me with Visions' (*Job*, vii, 13–15)
Plate 15: Behemoth and Leviathan
'Behold now Behemoth which I made with thee' (Job, xl, 15)
Plate 18: Job's Sacrifice
'And my Servant Job shall pray for you' (*Job*, xlii, 8–10)
Plate 21: Job and his Family restored to Prosperity
'So the Lord blessed the latter end of Job more than the beginning' (*Job*, xlii, 12–13)

'Chambers of the Imagination'

'The Imagination is not a State: it is the Human Existence itself'
(*Milton: A Poem in 2 Books*, plate e, line 32)

When we look at Blake's art, read his writings, think about his achievements as a printmaker and contemplate his individualism and ambitions, we can have no doubt at all about the richness and extent of his imagination. His imagery is highly original and wholly his own as is his sense of design and colour. Sometimes the images have an immense power that transcends their modest scale and is quite independent of the intricacies of meaning that Blake attached to them, as in the case of the two versions of *Albion rose* (nos.176, 279) or *The Ancient of Days* (nos.299, 297). Even when illustrating other men's works, he brings these qualities to his response but also instinctively goes beyond mere illustration, entering into the originator's spirit and giving a portion of his own to it simultaneously, as with subjects from Dante (nos.68–96) and Shakespeare (nos.227, 228).

Technically, through his 'invention' of relief etching and then, from this, colour printing, he broke new ground in methods of reproductive print-making. When the method was used to make illuminated books of his own writings, not only was an entirely new kind of book invented but one that gave Blake as author and artist a perfect freedom to fulfil his self-created role of prophet – the word that in Hebrew means poet. But in the great bulk of these writings the mythology is obscure, for here Blake has created another world with inhabitants and landscapes that barely seem to have any point of contact with the natural world. His vocabulary and sentence construction, with its odd or even non-existent punctuation, often add to the obscurity. Sometimes there are poems that inspire, the most obvious example being 'Jerusalem' in the Preface to *Milton* (no.272 pl.2), even if the questions that it asks are too often ignored, but there are others, like *London* (no.298 pl.46), whose meanings can only be grasped, even if not fully understood, in Blakean terms. And there are sentences, 'proverbs' sometimes, of great vividness that can be quoted in isolation and convey, simply and immediately, essential truths: 'To see a World in a Grain of Sand / And a Heaven in a Wild Flower' (*Auguries of Innocence*, E.490); 'Great things are done when Men & Mountains meet' (*Notebook* p.43); 'Energy is Eternal Delight' (*Marriage of Heaven and Hell*, no.127 pl.4); 'Exuberance is Beauty' (*Marriage*, no.127 pl.9). Then we discover characters named 'Urizen', 'Enitharmon', 'Los', 'Orc' and 'Zoas', places called 'Golgonooza' or 'Cathedron', a part of the anatomy named 'Bowlahoola' – all of which are as puzzling to modern audiences as they were to all but very few of Blake's contemporaries, and the slightest hint of which can deter any potential reader.

In other words, though it is frequently difficult to fathom what Blake is about, the many-sided creative activity and energy informing his life and output speak loudly to us of a unique and extraordinary imagination at work. However, if we are to get anywhere near a fuller understanding of Blake's intentions and a truer measure of his achievements, this is only a starting point. Everything in Blake takes its place in a continually astonishing, integrated whole. Just as Gilchrist reported of Blake's conversation, that his mind and his talk 'kindled [the] imagination' (Gilchrist 1863, I, p.311), so his art should encourage us to look beyond the creativity and resourcefulness, easily labelled as the sum total of the 'imagination', to Blake's own ideas about his imagination and the importance it plays in man's nature.

Even knowing how precocious a writer, reader and thinker Blake was, it still comes as a surprise to learn just how early on in his life he seems to have formed a very clear idea of the nature and place of the imagination in his being – not only this, but he was prepared to dispute current modes of thinking about its nature and function. When, around the early 1800s, he was annotating Joshua Reynolds's *Discourses* (see no.233), he noted that he had read, and also annotated, Edmund Burke's *A Philosophical Enquiry into the Origin of Our Ideas of the Sublime and Beautiful* (first published 1757), John Locke's *An Essay Concerning Human Understanding* (see no.108) and Bacon's *Advancement of Learning* 'when very Young'. His response then to these writers, as it was when he came to look at Reynolds, was 'Contempt & Abhorrence … They mock Inspiration & Vision'. He added that 'Inspiration & Vision was then & now is & I hope will always Remain my Element my Eternal Dwelling place' (E.660–1). What these writers had in common was a view of the imagination, in Burke's words, as 'a sort of creative power of its own', which could represent 'at pleasure the images of things in the order and manner in which they were received by the senses, or in combining those images in a new manner, and according to a different order'. Burke emphasised that such a power was 'incapable of producing any thing absolutely new; it can only vary the disposition of those ideas that it has received from the senses' (Boulton 1968, pp.16–17).

Overleaf: 'The Ancient of Days' 1824? (no. 297, detail)

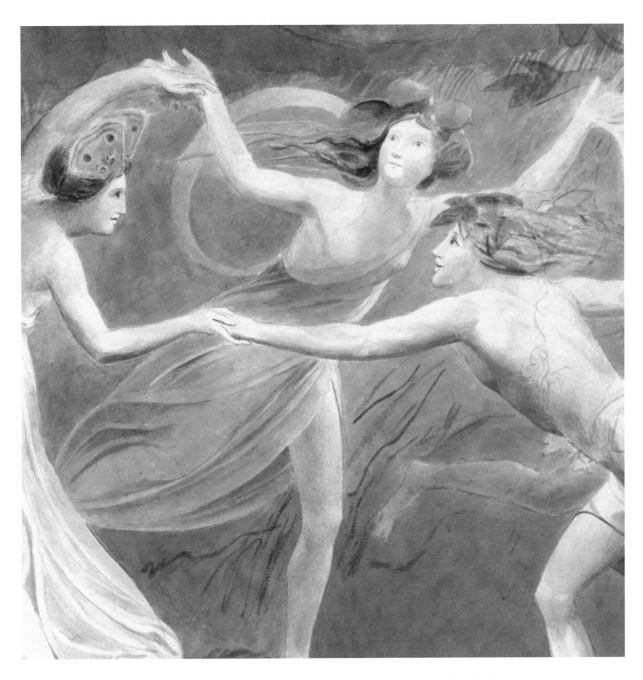

Of course, the very act of classifying and ordering
the senses in such a rational way was anathema to
Blake, as we know from his creation of Urizen and his
brass Book of Laws (no.296 pl.1) designed to repress
and 'fetter' the imagination, and his depiction of Isaac
Newton (nos.248, 249). But Blake's contempt does not
always seem to be as thoroughgoing as his response to
Reynolds's and Burke's 'sensationist' beliefs suggests.
In the first place 'memory', to which the senses
contribute, plays a crucial part in his work – despite
his approving quotation from John Milton regarding
'A Work of Genius is a Work' that is '"Not to be
obtained by the Invocation of Memory & her Syren
Daughters. but by Devout prayer to that Eternal

Spirit. who can enrich with all utterance &
knowledge … "' (E.646). He might have professed
'drawing from life always to have been hateful to him
[because of] looking more like death, or smelling of
mortality'. Yet, as a young student, 'still he drew a
good deal from life' (BR.423). By the time of the
Descriptive Catalogue 'a modern Man stripped from his
load of cloathing … is like a dead corpse';
'Imagination only, can furnish us with [flesh]
colouring appropriate [to the naked body], such as is
found in the Frescos of Raphael and Michael Angelo'
(E.545), though his earlier labours in the life class
informed all his later treatment of the human figure
in his art.

175

Mention of Michelangelo brings us to the figure of *The Ancient of Days* (nos. 297, 299), which was 'inspired … by the vision which … hovered over his head at the top of his staircase' in Hercules Buildings (BR. 470–1), though the vision was surely fed by the image of the Creator in the Sistine Chapel. It is even possible to see Blake subscribing to Burke's ideas about the sublime and beautiful. In *Los and Orc: Orc Chained* (no. 292) some aspects of the picture as well as the descriptive passages in the poetry that relate to it echo Burke's thoughts on ways of conveying a sense of the sublime, notably the use of 'sad and fuscous colours, as black, or brown' (Boulton 1968, p.82). Since, of course, Blake had never directly experienced this sort of landscape, it might be claimed as a product purely of his imagination. When in *The First Book of Urizen* (no. 296 pl. 17(15)) he so dramatically illustrates the act of creation with all its abstract, chaotic textures, the inspiration for this can be found in pictures of the same subject found in, for example, the works of the scientist Robert Fludd (1574–1637). Even in the tiniest details of Blake's work similar sources of inspiration, though of greater subtlety, can be traced: the use of a delicate green printing ink in some of the early illuminated books (for example *Songs of Innocence*, no. 128) appears to be a conscious evocation of alchemical formulae in which verdigris (green), made from copper, was used for healing and transmutation, comparable to the purpose of the poems; similarly, in *Mirth* (no. 236) Blake used stipple engraving as one way of relating this light-hearted subject, indicated by its treatment as well as its title, to the prevailing taste for fancy prints.

However, when we compare such facets of Blake's art with his comments to his friend John Flaxman, this apparently straightforward process becomes much more complicated: 'In my Brain are studies & Chambers filld with books & pictures of old which I wrote & painted in ages of Eternity. before my mortal life & whose works are the delight & Study of Archangels. Why then should I be anxious about the riches of fame of mortality … ' (E. 710). From his responses to Reynolds we can get nearer the meaning of this strikingly beautiful image. 'Mind and Imagination', he suggests, are 'above the Mortal & perishing Nature' (E. 660) and 'Man is Born Like a Garden ready Planted & Sown This World is too poor to produce one Seed' (E. 656), observations which help explain the references to 'Eternity' and an existence 'before my mortal life'. One instance of such a process in action for Blake can be identified in the formation of his 'Gothicised imagination' in Westminster Abbey, when he 'saw the simple and plain road to the style of art at which he

aimed, unentangled in the intricate windings of modern practice' (BR. 422). Another example is more exact because it helpfully identifies one of the 'Chambers' in Blake's brain – memory – and can also be retrospectively linked to the invention of relief etching revealed to William by his brother Robert (see p.104; nos. 164, 165); it is summed up in Blake's comment that '[I] See [Robert] in my remembrance in the regions of my Imagination' (E. 705). These were the cleansings of 'the doors of perception', when 'every thing would appear to man as it is: infinite' (*The Marriage of Heaven and Hell*, pl. 14; nos. 110, 127), made physically real in the case of the etched plates by the joint life which words and metal took on.

The ease with which this transition from his mortal, or 'vegetable', existence to a 'previous' infinite one, or from one chamber of his imagination to another, though puzzling for us, was made possible for Blake through what he had learned from Swedenborg (see pp. 186–7) about 'correspondences'; in his own words, that 'there exist in that Eternal World the Permanent Realities of Every Thing which we see reflected in this Vegetable Glass of Nature' (E. 555). But it did necessitate a sort of 'death' or a removal of 'filthy garments' of mortality (*Milton*, no. 272 pl. 43) – a metaphorical return to 'before my mortal life' accessed through sleep and dream – and a subsequent rebirth comparable to God creating man in his own image. When Blake in 1826 signed an autograph album with the words, 'Born 28 Novr 1757 in London & has died several times since' (E. 698), he must be referring to such a 'process'; and the allusion takes wing when we look at *Los Entering the Door of Death* (no. 289) – Los being both the imagination and William Blake – and one of its inscriptions: 'There is a Void outside of Existence, which if entered into / Englobes itself & becomes a Womb … ' There is a striking similarity between this view and that of one of Blake's contemporaries, the poet Samuel Taylor Coleridge (1772–1834), when he described the working of the most creative aspect of the imagination: 'It dissolves, diffuses, dissipates, in order to re-create … it struggles to idealise and to unify. It is essentially *vital*, even as all objects (as objects) are essentially fixed and dead' (*Biographia Literaria* (1817), ch. XIII). For Coleridge, like Blake, this was a means of discovering deeper truths about man's world or, as another of Blake's contemporaries, John Keats (1795–1821), described such rebirths, 'The Imagination may be compared to Adam's dream – he awoke and found it truth' (to B. Bailey 22 Nov. 1817; Gittings 1966, p.37). RH

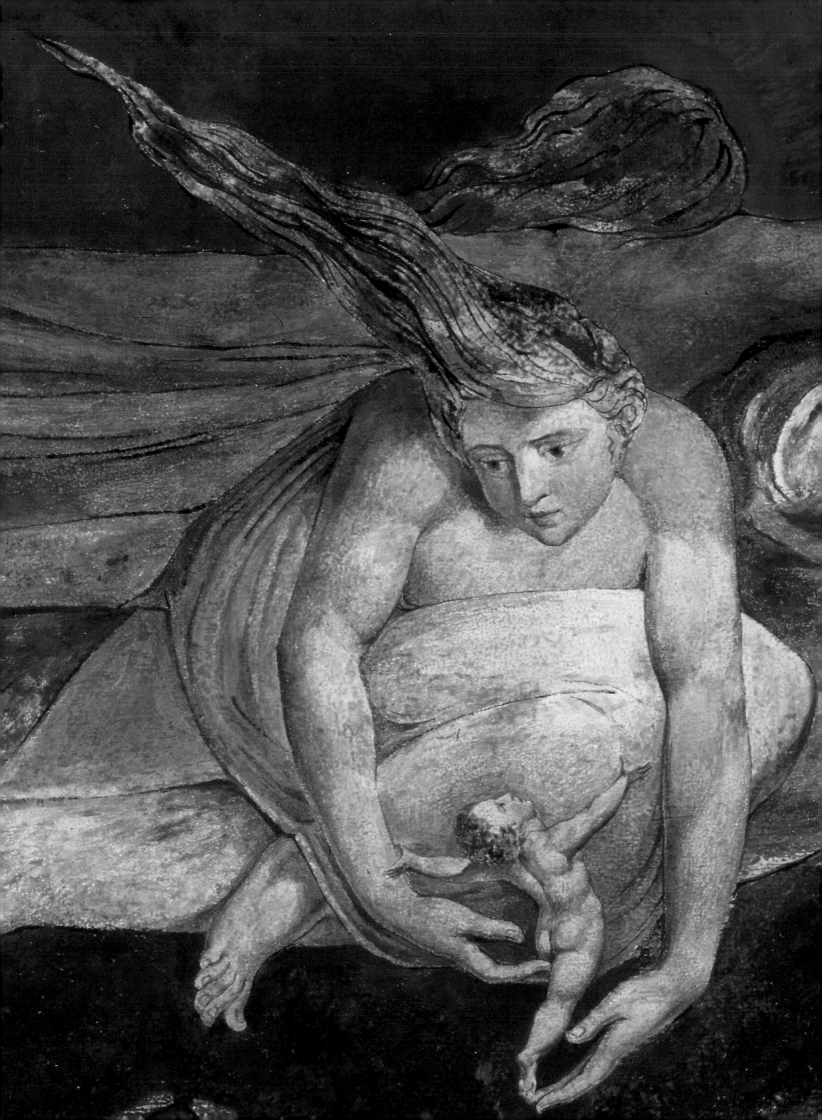

219 JAMES S. DEVILLE (1776–1846)

William Blake 1823

Plaster 29.3 (11½) high

Lent by the Syndics of the Fitzwilliam Museum, Cambridge

Lit: Keynes 1977, pp.133–4; BR.278–9

In September 1823, the sixty-six-year-old Blake had a life mask taken by the sculptor and phrenologist Deville. This is a plaster cast taken from the original mould.

Deville started his career in the studio of the sculptor Joseph Nollekens (1737–1823). He went on to practise as a portrait sculptor and a phrenologist at about the time of Nollekens's death. He also set up a phrenological 'museum', which included the moulds of busts of the famous people who had sat for Nollekens, and was located in the Strand, not far from William and Catherine Blake's last home in Fountain Court. Deville later added his own casts of notable people. According to George Richmond, Blake's life mask was made because Deville viewed it 'as representative of the imaginative faculty'. The artist's own interest in phrenology and physiognomy (see no.220) obviously made him a willing sitter despite the discomfort he had to endure: Richmond reported that the severe expression in the mouth was caused by the pain of hair being pulled out as the plaster was removed. RH

220 **The Man Who Taught Blake Painting in his Dreams** *c.1819–20*

Pencil on paper 30 × 34.5 (11¾ × 13⅝)

Lent by the Syndics of the Fitzwilliam Museum, Cambridge

Lit: Keynes 1977, pp.24–5, 131–3; Mellor 1978; Butlin 1981, no.753

This is one of Blake's 'visionary heads' made during the period 1819–25 (see nos.237–8, 257). There is of course an irony in the very idea of Blake portraying 'his' teacher since he held the belief that 'Taste & Genius are Not Teachable or Acquirable but are born with us' (E.659) or 'Genius … is the Holy Ghost in man' (*Jerusalem* pl.91, line 9; no.303). But we can still see this portrait of the teacher as a self-portrait in which Blake is drawing out what he is aware of within himself. Around 1815 J. Spurzheim's theories on phrenology, or 'science of the mind', gained a following, and Blake's portrait shows the sort of bumps on the skull that these theories associated with certain character traits. The well-developed bumps on the left and right of the head would have indicated to Spurzheim strong powers of imagination. Similar bumps are visible in the life mask and must have been what Deville noticed when he first saw Blake (no.219). The flame-like pattern on the forehead, not unlike the hairline seen in the portrait by Catherine (no.223), might refer to flames of inspiration or desire though its shape also suggests the tree of knowledge. RH

221 **The Bard from Gray 1809?**

Tempera heightened with gold on canvas 60 × 44.1 (23⅝ × 17⅜)

Signed 'WBlake [with traces of date]' b.c.

Tate; purchased Clarke Fund 1920

Lit: Butlin 1981, no.655; Butlin 1990, no.60; Shanes 1990, pp.40–6

Starting with Thomas Gray's poem 'The Bard' (1757) (see nos.39, 40) and continuing with the huge success of James Macpherson's fictional 'translations' of Ossian in the 1760s, the imagery of ancient British bards became popular among artists and the public. For painters with radical tendencies, such as Benjamin West, Henry Fuseli and J. M. W. Turner, the figure of the bard represented patriotism and ancient liberty in the face of political oppression. Blake's involvement in the subject went even further, being rooted in a genuine identification of his own purpose as a writer and artist with the mythical ideal of the bard. Blake saw them as his forerunners: they sang of loss, the future, and nationhood, all of which were important themes in his art. Here, the ancient Welsh bard of Gray's poem is shown defiantly mourning his fellow bards who have been killed by the conquering English King Edward I. The King is shown with Queen Eleanor (whose tomb effigy he had once drawn; nos.7–9) in the foreground. The floating spirits of the dead bards are weaving the 'winding sheet' in which the King and his descendants will be buried. It is not difficult to see Blake the 'prophet' imagining that his own art would similarly be part of the warp and woof of a funeral shroud for George III and his descendants.

This picture was included in Blake's 1809 exhibition, and in the *Descriptive Catalogue* he quoted from Gray's poem. Blake's accompanying text also stated that painting should not be 'confined to the sordid drudgery of facsimile' but should, like poetry and music, be 'elevated into its own proper sphere of invention and visionary conception' (E.541). This was a reiteration of his belief in the prophetic purpose and unity of the arts, an ideal exemplified for Blake by the ancient bards. RH

219

220

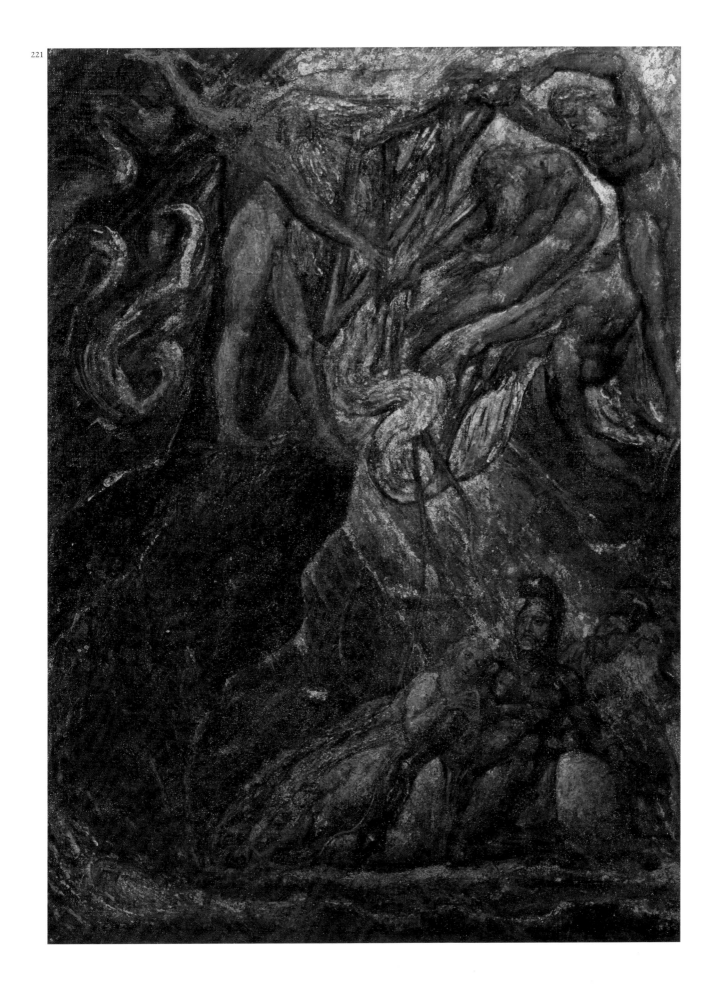

222 Catherine Blake c.1805
Pencil on paper 28.6 × 22.1 (11¼ × 8¾)
Tate; bequeathed by Miss Alice G. E. Carthew
1940
*Lit: Keynes 1979; Butlin 1981, no.683; Butlin 1990,
no.56; Schuchard 1992; Schuchard 1999*

When Blake married Catherine Boucher (or
Butcher) in 1782, she was a 'bright-eyed, dark
haired brunette' (Gilchrist 1863, I, p.38). She was
illiterate but he taught her to read and write
and, as Gilchrist noted, her spirit was
'influenced magnetically … by her husband's'
(Gilchrist 1863, I, p.316): she was 'wont to echo
what he said, to talk as he talked, on religion and
other matters' and she also learned to have
visions. She became a skilful assistant to Blake as
an engraver, painted using his tempera,
coloured and stitched his books, and she would
sit next to him for hours on end during those
nights while he was drawing and writing from
the 'immediate dictation' of spirits (to Butts, 25
April 1803; E.729). Catherine's imitation of his
painting style and technique as well as subject
matter is obvious in her picture *Agnes* (no.225).

They had no children but inevitably, given
the way in which sex appears in William's
writings, for example in *Thel* (no.126), in *Visions
of the Daughters of Albion* (no.125 pl.7) or in *Vala*
(no.300), the nature of their sexual relationship
is relevant to any account of their life together.
The idea that Blake once proposed introducing a
second wife into their home (Swinburne 1906,
p.16) might explain the reason for their 'stormy
times' when young, reported by Gilchrist.
A possible family connection with the
Moravian Church, and then their being
signatories to Swedenborg's New Jerusalem
Church, suggests that they would have been
well aware of these religions' beliefs in the
importance of sex in stimulating and achieving
a visionary trance-like state. Conceivably, it
might have been part of Blake's instruction
to her in how to have visions. RH

223 CATHERINE BLAKE (1762–1831)
Portrait of the Young William Blake
c.1827–31
Pencil on paper 15.5 × 10.4 (6⅛ × 4⅛)
Lent by the Syndics of the Fitzwilliam Museum,
Cambridge
Lit: Keynes 1977, pp.118–20; Butlin 1981, no.C3

224 CATHERINE BLAKE
**Head 'Taken from something she saw in
the Fire' c.1830**
Watercolour on paper 9.4 × 11.9 (3¾ × 4⅝)
With related inscription 'A Drawing made by
Mrs Blake taken from something she saw in the
Fire during her residence with me curious as
by her Fred K. Tatham'
Lent by the Syndics of the Fitzwilliam Museum,
Cambridge
Lit: Butlin 1981, no.c2

These works date from the years after William's
death when Catherine was living as a
housekeeper, firstly with the artist John Linnell
and then with the sculptor Frederick Tatham.
The portrait formed the basis of one of the heads
in a drawing, *William Blake in Youth and Old Age*,
by Tatham that was later inserted in a volume
containing a manuscript *Memoir* of the artist
along with the copy of *Jerusalem* shown in this
exhibition (no.303). Tatham's *Memoir* describes
the young Blake in terms which could only have
come from Catherine: 'His [yellow brown] locks
instead of falling down stood up like a curling
flame, and looked at a distance like radiations,
which with his fiery Eye & expansive forehead …
must have made his appearance truly pre-
possessing' (BR.518). Catherine's drawing was
made at a time when William used to 'come and
sit with her two or three hours every day' and
talk to her (BR.373). It is a good likeness, but
stylistically and in its idealisation of her
husband Catherine's work is very reminiscent of
William's 'visionary heads'. Likewise, while the
flame-like hair accords with her description of
the young William, it must also be a deliberate
allusion which recalls the flames of the
revolutionary Orc (for example, in *America*, pl.12;
no.124) or, more generally, the 'flames of mental
fire' mentioned in, for example, *Vala* or the *Four
Zoas* (see no.300; E.387). RH

225 CATHERINE BLAKE
Agnes c.1800
Tempera on canvas sight size 13.7 × 18.1
(5⅜ × 7⅛)
Lent by the Syndics of the Fitzwilliam Museum,
Cambridge; bequeathed by Sir Edward Howare
March, KCVO, CB, CMG, through the National
Art Collection Fund, 1953
Lit: Butlin 1981, no.c1

This illustrates a scene from Matthew Lewis's
popular Gothic novel, *The Monk* (1796). The novel
is set in Madrid during the time of the
Inquisition. Its sub-plot, the climax of which is
illustrated here, deals with the story of the
beautiful Agnes de Medina. Her parents always
intended her to become a nun, so when marriage
to the noble Raymond de la Cistinas seems a
possibility, she is forcibly sent to a convent. By
chance she and Raymond meet again and 'the
honour of Agnes was sacrificed'. A planned
elopement was discovered by Ambrosio (the
Monk of the book's title) and the now-pregnant
Agnes was cruelly incarcerated in a secret
dungeon. Catherine Blake's painting shows the
horrifying moment that Agnes' brother Lorenzo
discovers her, chained, half-naked and holding
the putrefying corpse of her baby who died
within hours of being born.

It is not surprising that Catherine should
have illustrated such a subject. The novel was
immensely controversial as well as popular, and
its scenes of rape, incest and necrophilia, as well
as its use of dreams, magic and death, created a
'Gothic' atmosphere that touched on the
interests of the Blake household. Furthermore,
central to the plot of *The Monk* was the
destructiveness of superstition, hypocrisy and
the laws of organised religion – themes that
recur throughout William's work. RH

223

225

(?1760–1820)

Manuscript Letter

Lambeth 14 September 1800

The Pierpont Morgan Library, New York

Lit: Keynes 1980, pls.v–vi; E.708–9

Although it is sent from Catherine to Anne
Flaxman, wife of Blake's old friend the sculptor
John Flaxman (1755–1826), this letter is in
Blake's hand and includes a poem by him. It was
written just a few days before the Blakes moved
to Felpham, where Flaxman's patron and friend
William Hayley lived, and at a time when
Catherine was exhausted by work but also, as
Blake wrote, 'like a flame of many colours of
precious jewels' at the prospect of change (to
Hayley, 16 Sept. 1800; E.709).

The poem gives a very good idea of the
Blakes' gratitude to the Flaxmans for making
the Felpham interlude possible and the
exultation they shared at the prospect of being
able to move from London. The 'blessd Hermit'
in the last verse refers to William Hayley, their
host in Sussex, who, on closer acquaintance,
Blake found too overbearing. RH

226

My Dearest Friend

I hope you will not think we could forget your Sorrows
to us. or any way neglect to love & remember with affection
even the hem of your garment. we indeed presume on your
kindness in neglecting to have called on you Since my Husbands
first return from Felpham. We have been incessantly busy in
our great removal but can never think of going without first
paying our proper duty to you & Mr Flaxman. We intend
to call on Sunday afternoon in Hampstead to take farewell
All things being now nearly completed for our setting forth
on Tuesday Morning. It is only Sixty Miles & Lambeth
was One Hundred for the terrible Desart of London was between
my husband has been obliged to finish several things necessary
to be finishd before our migration the Swallows call us
fleeting past our window at this moment. O how we
delight in talking of the pleasure we shall have in pre
paring you a Summer bower at Felpham. & we not
only talk but behold the Angels of our journey have
inspird a Song to you

To

To my dear Friend Mrs Anna Flaxman

This Song to the flower of Flaxmans joy
To the Blossom of hope for a Sweet decoy
Do all that you can or all that you may
To entice him to Felpham & far away

Away to Sweet Felpham for Heaven is there
The Ladder of Angels descends thro the air
On the Turret its spiral does softly descend
Thro the village then winds at my Cot it does end

You stand in the Village & look up to heaven
The precious stones glitter on flights Seventy Seven
And My Brother is there & My Friend & Thine
Descend & Ascend with the Bread & the Wine

The Bread of sweet Thought & the Wine of Delight
Feeds the Village of Felpham by day & by night
And at his own door the blessd Hermit does Stand
Dispensing Unceasing to all the whole Land

WBlake

Receive my & my husbands love & affection &
believe me to be Yours affectionately

* H.B. Lambeth
14 Septr 1800

Catherine Blake

* Hercules Buildings, Lambeth

227 Oberon, Titania and Puck with Fairies Dancing *c.1785*

Pencil and watercolour on paper 47.5 × 62.5
(18¾ × 24⅝) (irreg.)

Tate; presented by Alfred A. de Pass in memory
of his wife Ethel 1910

Lit: Butlin 1981, no. 161; Butlin 1990, no. 5

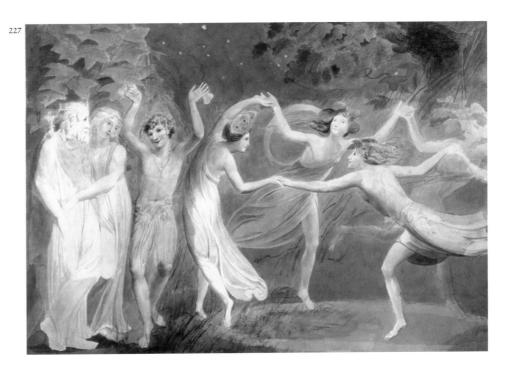

Shakespeare was an important early influence
on Blake. For example, the language and subject
of the fragment 'King Edward the Third' in
Poetical Sketches (see no.17) are inspired by the
history plays, and the figure of Tiriel (nos.19–28)
owes a partial debt to King Lear. In terms of
greatness Blake brackets him with Dante and
Milton as well as with Michelangelo and
Raphael. However, he produced relatively few
works directly illustrating or inspired by
Shakespeare; the best known is *Pity* (no.241). The
two works shown here illustrate the contrasting
ways in which Blake responded to him.

No.227 illustrates the final scene of
A Midsummer Night's Dream. Oberon and Titania,
king and queen of the fairies, look on as their
train sing a song 'and dance it trippingly …
hand in hand with fairy grace'. Blake's close
reading of the play is evident in some of the
details he picks out. Thus he shows one of the
fairies with butterfly wings adorning her hair – a
reference to Titania's instruction that butterfly
wings should be plucked and used by a fairy to
shield Bottom's eyes from moonbeams (III. ii.
164–5). And he shows Puck rhythmically
clicking bones as an accompaniment to the
dancing – a reference to the making of 'rural
music' in act 4, scene 4. By taking an ancient
Roman statue of the Dancing Faun as a model
for his Puck, he has followed advice given him as
a student (E.544) though, of course, the play is
set in Greece.

This watercolour shows Blake responding
to Shakespeare rather as most other Shakespeare
illustrators of the time would have done,
possibly because he meant it to be engraved and
sold as a print by the print-selling business he
had set up with James Parker in 1784. RH

228 As if an Angel Dropped down from the Clouds 1809

Pen and ink and watercolour 23.2×17.4
(9⅛×6⅞)(framing line) on paper 30.8×19.2
(12⅛×7½)
Inscr. in ink 'WBlake 1809' b.r.
The British Museum, London
Lit: Grant 1972; Butlin 1981, no.547.6

This is a very different and more complex work than *Oberon*. Its title comes from a line in 'King Henry IV, part 1' that describes the wanton and rebellious Prince Harry vaulting onto his horse armed and ready for battle 'As if an angel dropped down from the clouds / To turn and wind a fiery Pegasus … ' But rather than just depicting the virile prince impressive in his armour, Blake focuses on other parts of the description as a way of capturing the whole of Shakespeare's image of him with all its anticipation of Harry as the future glorious King Henry V: the idea of 'wind', 'glittering … gorgeous sun', Harry as Mercury (the messenger of the gods) and most noticeably the mention of the mythological horse Pegasus (though here wingless), the mount of the Greek hero Bellerophon – all recorded by a heavenly scribe. Blake's first treatment of this subject was titled 'A Spirit vaulting from a cloud …'(see p.194) and showed 'the Horse of Intellect … leaping from the cliffs of Memory and Reasoning; it is a barren Rock: it is also called the Barren Waste of Locke and Newton'(E.546). When Pegasus stamped on the ground the Hippocrene Fountain, sacred to the Muses, flowed. Anyone who drank its water would be inspired to write poetry. Blake here pays homage to Shakespeare but also celebrates the Poetic Genius as 'the extent of the human mind' (E.544) in an image to be seen alongside the fixed, reasoning Newton on his 'Rock' (nos.248-9). RH

229 ?J.D. LEUCHTER (C.1685–C.1760) AFTER DIONYSIUS ANDREAS FREHER (1649–1728)
The Second Table
Engraving and etching? 33 × 48 (13 × 18⅞)
on paper
From vol.3 of Jacob Boehme (also known as Behmen, 1575–1624), *The Works of Jacob Behmen: The Teutonic Philosopher*
4 vols, London 1761–81, vol.3 (1772)
Approx. 27 x 19 (10⅝ x 7½)
The British Library Board

230 ?DIONYSIUS ANDREAS FREHER

The Third Table

Pen and ink and grey wash on four leaves of laid
paper, leaf 1 verso displayed, approx. 33.5×48.5
(13¼×19⅛)

Trustees of Dr Williams's Library

Lit: Damon 1965; Muses 1951; Bindman 1982, pp.68–9

231 ?DIONYSIUS ANDREAS FREHER

The Third Table

Pen and ink and grey wash on four leaves of laid
paper, leaves 2 and 3 recto displayed, approx.
33.5×48.5 (13¼×19⅛)

Trustees of Dr Williams's Library

232 EMANUEL SWEDENBORG (1668–1772)

**The Wisdom of Angels, Concerning Divine
Love and Divine Wisdom**

London 1788

William Blake's copy with his annotations

Open at pp.10–11

The British Library Board

Lit: E.602–11; Bellin and Ruhl 1985

230
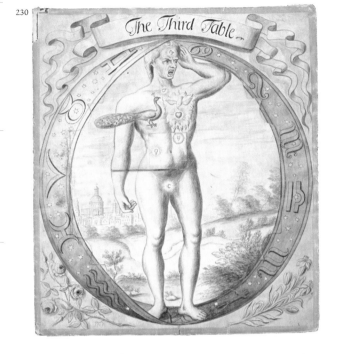

231
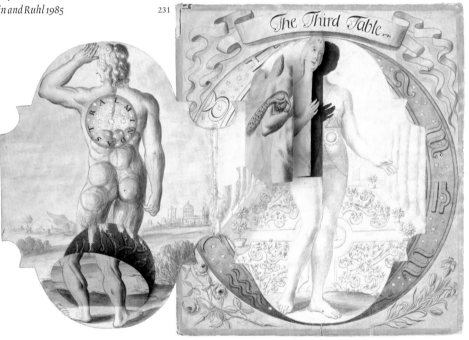

233 JOSHUA REYNOLDS (1723–1792)
The Works of Sir Joshua Reynolds, Knight
Edited by Edmund Malone, 3 vols,
London 1798, vol.1
Open at frontispiece and title-page
William Blake's copy with his annotations
The British Library Board
Lit: Damon 1965; E.635–62

Blake was always an avid and knowledgeable
reader, with the Bible, Shakespeare and Milton
no doubt among the very first books he looked
at. When 'very Young', he read the philosophers
John Locke (see no.108), Francis Bacon and
Edmund Burke. Blake did not learn any
languages when he was a child but he remedied
this deficiency with energy and enthusiasm in
later years. When he was living in Felpham he
learnt Latin, Greek and Hebrew and then, when
he was working on the Dante illustrations
(nos.68–96), he seems to have studied Italian so
he could read the text in the original language.
His library contained books in all these
languages as well as in French. Most serious
artists, notably Sir Joshua Reynolds and, within
Blake's own circle, Henry Fuseli, John Flaxman
and Richard Cosway, owned substantial
libraries, which they saw as a natural adjunct to
their place in the world of learning as well as
having to hand sources for their art in ancient
and modern literature. More unusually, Blake
also had a large collection of works by 'the
mystical writers, Jacob Behmen, Swedenborg,
and others' (BR.41), an interest that he shared
particularly with Richard Cosway. Only about
fifty titles in Blake's library, including some of
the volumes actually owned and revealingly
annotated by Blake, are now known to us.
Together with the old prints that he also bought
Blake's collecting and reading stimulated his
thinking and fed his art and writing in a wholly
original way.

Blake's reading is highly individual when
compared to that of other artists and writers of
his day. This is most apparent in his interest in
the writings of mystics, visionaries and
occultists such as the alchemist Theophrast
Bombast von Hohenheim (1493–1541), known as
Paracelsus, and the mystic Jacob Boehme
(1575–1624) (*Marriage of Heaven and Hell*, pl.22;
no.127). Among thinkers of his own times he
studied Emanuel Swedenborg (no.232) and the
modern mythologist Jacob Bryant (1715–1804),
with the latter supplying him with ideas about
the universal and enduring significance of
myth. Blake and Cosway were not alone among
artists in being interested in these sorts of

subjects. Flaxman was a Swedenborgian, P. J.
De Loutherbourg (see no.135) was interested in
mesmerism and John Varley in astrology – just
some small indication of the world of secret
societies, religious sects and prophets, often
touching on both established and non-
conformist circles, which had always flourished
in England: Freher and Leuchter, the scribes and
translators of Boehme's words, and originators
of the illustrations and diagrams for the edition
shown here, belonged to a largely unknown
group of disciples based in the City of London
and dedicated to promoting his mystic beliefs.

Blake's apprenticeship to Basire introduced
him to just such a world of secrets, often linked
with freemasonry since many engravers and
artists were masons. And because engravers
were concerned with metal (particularly copper)
and acids as part of a process of transformation,
it is not too difficult to make a connection
between their work and that of alchemists in
search of the philosopher's stone. It is possible,
but not always fruitful, to find all sorts of
connections between Blake and alchemy –
whether it is in some of his imagery (such as the
globe of creation seen in *Urizen*, pl.17(15), no.296,
and the Frontispiece to *The Song of Los*, no.301) or
in the use of invented names for the characters
who feature in his writings. But we can easily
ally him to a tradition of experimentation with
metal and chemicals that in his case might have
contributed to the development of relief etching
(see p.104ff.). He could have found in Paracelsus
(or in the writings of other alchemists) one key
to a visionary and philosophical framework that
made the process of his illuminated writing an
intellectually consistent whole, with the word
possessing an existence beyond its sound and
shape. So Paracelsus saw any metal in its original
state as having a 'life' both derived from its own
'star' and also its 'secret fatnesse', which can be
seen when it is molten (Paracelsus, *Of the Nature
of Things…* , London 1650, Book IV, p.31; Book IX,
p.133): the revealing of this life is comparable to
the 'infernal method' of printing described on
plate 14 of *Marriage* where corrosives (acid) melt
(dissolve) the metal and show a previously
hidden 'infinite' in the form of relief lettering
(see pp.105–6).

The early importance of Behmen to Blake is
much clearer. He described him as a 'divinely
inspired man' and from him he learnt the
importance of the imagination: 'The
understanding born of God' (i.e. poetic genius)
that is 'not the product of the schools in which
human science is taught' (in other words reason)

(Boehme, *Forty Questions*, xxxvii. 20). Blake also
said that the tables (see nos.229–31) in his
'Works' were 'very beautiful' and Michelangelo
could not 'have done better' (BR.313). Included
in the volume published in 1772, the figure in
The Second Table finds an echo in Blake's early
Joseph of Arimathea of 1773 (no.273) that suggests
that Behmen must have been a particular
discovery of his years with Basire. The three
illustrations, of which two are reproduced here,
show man in his threefold state before, after and
rising from the Fall. The *Second* (no.229) depicts
him after his Fall, 'in Pollution and Perdition',
and the *Third* (no.230–1) with him 'rising from
the Fall' on the way to 'Regeneration'. The flaps
of paper enable the reader to let in light on
'buried' images and gradually reveal in turn,
according to Behmen's scheme, man's body, soul
and spirit – a process that in its movement from
the male to the female form anticipates Blake's
belief in the bisexual male and the concept of the
female Emanation (nos.280–1), and is
simultaneously an act of revealing the 'Spiritual
body' that Blake uses later (for example, in
Enitharmon's uncovering of Orc in plate 6(4) of
Europe – see no.271).

With this sort of contact with much earlier
visionaries and mystics it was probably
inevitable that Blake would gravitate to similar
but more current ways of thought, such as those
found in the writings of a much older
contemporary, the scientist and visionary
Emanuel Swedenborg, who died in London in
1772. Blake was perhaps introduced to his work
by John Flaxman in about 1787, maybe in the
grief-stricken aftermath of Robert Blake's death.
He was later to describe Swedenborg as 'a divine
teacher' (BR.312), words that suggest that the
first impact of Swedenborg's teachings was truly
revelatory in a way that his later parodying of
them (see, for example, *The Marriage of Heaven
and Hell*, no.127 pl.21) could not obscure. William
and Catherine signed the Minute Book of the
General Conference of the Swedenborgian
New Jerusalem Church in April 1789, and
though they never joined the Church (nor ever
associated themselves with any other
organization), they were none the less
acknowledging its guiding principles including
a conscious rejection of the 'Old' Protestant
and Catholic Churches and their 'destructive
faith' (Resolution 4; Bellin p.127) – a sentiment
that often recurs in Blake's rejection of
organized religion.

The sort of proposition taken from
Swedenborg's *True Christian Religion* and

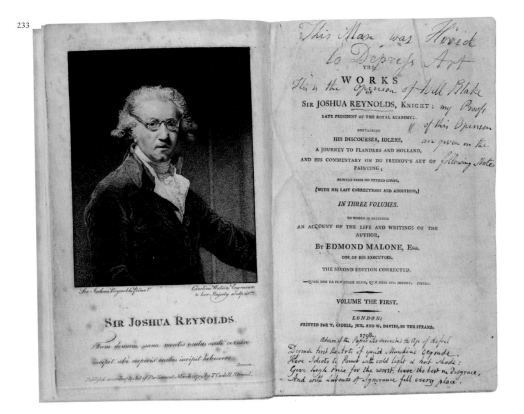

considered by the Church in 1788, 'That Now it is allowable to enter intellectually into the Mysteries of Faith' contrary to the Old Church's rule that 'Understanding is to be kept bound under Obedience to Faith' (Bellin and Ruhl, p.124), undoubtedly matched Blake's own independent thinking at this time and finds an echo in the 'Thou shalt not' over the door of the chapel in 'The Garden of Love' (no.159). Indeed, it could even have been the presence of a group of Swedenborgians in Lambeth (T.S. Duché being one, see no.146) that drew him to Hercules Buildings in 1790. In the poem 'The Little Black Boy' for *Songs of Innocence* (no.298, pls.9, 10), and also in his involvement with Stedman's *Narrative* (no.234), we can see Blake signalling the same opposition to slavery that Swedenborgians had. Blake also took from Swedenborg's writings the idea of 'correspondences' – the way in which the spiritual and natural worlds were joined together.

Blake's knowledge of these mystics and visionaries reinforced the fearless way in which he expressed his own visionary experiences. A sense of their rightness and their use to him was driven further by his sometimes exaggerated view of the hypocrisy and materialism of the art world in which he moved – the subject of a sustained, albeit private, attack on that world's figurehead, Sir Joshua Reynolds, President of the Royal Academy, 1768–92. This is found in the angry comments he wrote in his copy of Reynolds's *Discourses* and can be succinctly summed up in the title-page annotation in vol.1: 'This Man was Hired to Depress Art ... ' (no.233). These and other attacks had their origins partly in Reynolds's criticism of Blake's own work and the idea that the President '& his Gang of Cunning Hired Knaves' had conspired to deprive him of employment – possibly a reference to the fact that his work was not always selected for exhibition in the Academy (E.636) – which was bitterly elucidated in Blake's attack on Reynolds for his belief in the cultivation of patronage rather than the acknowledgement of genius (E.515). Blake believed in the centrality of the imagination ('the Poetic Genius is the True Man', see no.109b). His response to Reynolds's idea that through the teachings of the Academy genius was susceptible to the 'utmost improvement' (*Discourse* 1) helps reinforce our idea of his extraordinary self-belief: 'Genius is Always Above The Age' (E.649) – the subject of one of his annotations in the Swedenborg book shown here: 'He who feels love descend into him & if he has wisdom may percieve it is from the Poetic Genius which is the Lord.' RH

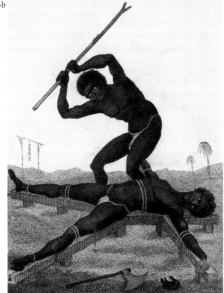

234 WILLIAM BLAKE AFTER JOHN GABRIEL STEDMAN

(1744–1797)

Illustrations to John Gabriel Stedman,

Narrative, of a Five Years' Expedition, against the Revolted Negroes of Surinam

2 vols, London 1796

The British Library Board

Lit: Thompson 1962, pp.182–3; Essick 1991, no. XXXIII

a) Vol.1, facing p.110

A Negro hung alive by the Ribs to a Gallows 1791/1792

Etching and line engraving finished with watercolour 18 × 13 (7⅛ × 5⅛) (framing lines)

Engraved signature 'Blake Sculp.' b.r., and title and imprint 'London, Published Dec.¹ 1ˢᵗ 1792, by J. Johnson, Sᵗ Paul's Church Yard./11' b.c.

b) Vol.2, facing p.296

The Execution of Breaking on the Rack 1793

Etching and line engraving finished with watercolour 17.7 × 12.9 (7 × 5⅛) (framing lines) on paper

Engraved title and imprint 'London, Published Dec.ᶜ 2ᵈ 1793, by J. Johnson, Sᵗ Paul's Church Yard./71' b.c.

J.G. Stedman was an officer in the Scots Brigade, which in 1772 was sent to the Dutch colony of Surinam in South America to put down a revolt by Negro slaves against the plantation owners. Stedman's journal recorded the shocking cruelty of the slave owners; when he returned to England in 1784, wishing 'to deter others from similar inhuman practices, and to teach them virtue', he revealed how Surinam was 'reeking and dyed with the blood of the African negroes'. The *Narrative*, published by William Blake's friend the radical publisher Joseph Johnson, was the result. Its appearance coincided with the increasingly vociferous denunciation of the slave trade, led in England by William Wilberforce.

Blake engraved thirteen of the illustrations for the *Narrative*. As a group they provided for the first time graphic evidence of the horrors Christian Europeans were inflicting on innocent Africans. This copy of the Narrative comes from George III's library and the dramatic use of red watercolour on the engravings (not applied by Blake) heightens the horror. By the time Blake had begun engraving Stedman's drawings his own views on slavery had already found expression in *The Little Black Boy* (no.298, pls.9, 10) and they were to be developed further in *Visions of the Daughters of Albion* (no.125). Stedman described the episode shown in no.234b in the *Narrative* (pp.295–7): A negro called Neptune was sentenced to be broken alive on a rack for shooting a plantation overseer. He was tied down. The executioner amputated his left hand and then 'broke his bones to shivers till the marrow, blood, and splinters, flew about the field – but the sufferer never uttered a groan nor a sigh.' This extraordinary image of primitive violence with its overtones of Christian martyrdom might have informed Blake's description of one of the inmates of the Bastille who was described in his poem *The French Revolution* (1791) as having his 'feet and hands cut off' (E.288). The chained figure of Orc on plate 3 of *America* (no.124) and in the related watercolour (no.292) might also owe something to Stedman. RH

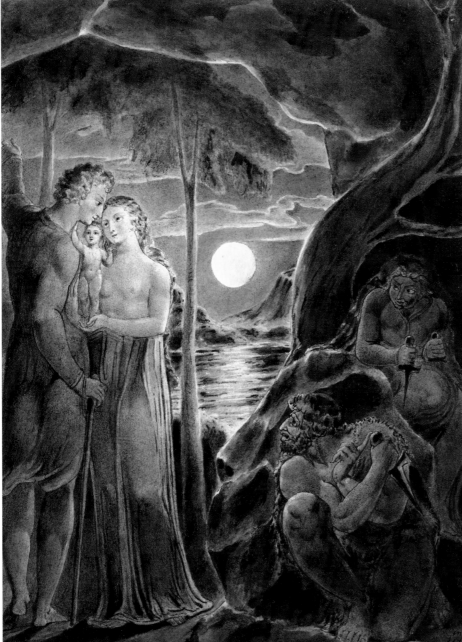

235 **Malevolence 1799**

Pen and ink and watercolour on paper approx.
30 × 22.5 (11⅞ × 8⅞)
Philadelphia Museum of Art; gift of
Mrs William T. Tonner
Lit: Butlin 1981, no.341; E.701–4

In July 1799 Blake was asked by the Revd John
Trusler to produce ideas for at least four 'moral'
pictures on the themes of 'Malevolence',
'Benevolence', 'Pride' and 'Humility', which, it
seems, Blake was eventually to engrave. Trusler,
was a prodigious compiler of indifferent
moralising publications, one of which, *Hogarth
Moralised* (1768), was 'calculated to improve the
Minds of youth and Convey Instruction, under
the Mask of entertainment'.

The two letters that Blake wrote to Trusler
about *Malevolence*, along with another to George
Cumberland, contain some of the artist's most
revealing thoughts about his art (E.701–4). It is
also clear from them (though one only has to
contrast *Songs of Innocence* with *Hogarth Moralised*)
that there was no way that Blake and his art were
right for Trusler's purposes. Trusler wanted his
themes treated in a realistic manner, verging
towards caricature, as in Hogarth, seventeenth-
century Dutch genre pictures or even Thomas
Rowlandson. Blake spent two weeks wrestling
with this problem before finally being 'compelld
by my genius or Angel to follow where he led …'

The end result (based on an earlier design
for *Europe*, see no.299 pl.3) Blake described as
'A Father taking leave of his Wife & Child. Is
watched by Two Fiends incarnate. with
intention that when his back is turned they will
murder the mother & her infant – If this is not
Malevolence with a vengeance I have never seen
it on Earth.' Blake's treatment was elevated far
above Trusler's wish for modern-life
ordinariness. The first of the murderers
possesses a Michelangeloesque energy; the
family radiates a sense of innocence but with a
need for pity imminent (see also no.241), while
the presence of the moon with its gentle light
recalls the words of Psalm 72: 'In his days shall
the righteous flourish; and abundance of peace
so long as the moon endureth.' Such allusions
suggest a sense of timelessness, appropriate to
the moral purpose of the image, guided, as Blake
had to point out to Trusler, by 'Visions of Fancy'
– in other words 'Imagination' or 'Spiritual
Sensation'. This was incomprehensible to
Trusler and Blake's commission went no further
than this watercolour. RH

236 Mirth *c.*1820–7

Line engraving with some stipple 16.1×12.2
(6⅜×4¾) on paper 21.7×17.5 (8½×6⅞)
Inscr. below the image 'Solomon says Vanity
of Vanities all is Vanity & what can be Foolisher
than this'
The British Museum, London
*Lit: Bindman 1978, no.601b; Butlin 1981, no.543.1;
Essick 1983, no.XVIII: 2B; E.702*

The seriousness of Blake's art, its purpose and
seeming complexity make it very easy to forget
that the artist could be happy and, in fact, was a
discerning lover of pleasure. As the forcefulness
of his own words reveal, it was central to his
being. In an annotation to his copy of Johann
Lavater's *Aphorisms on Man* (1788) he wrote 'I hate
scarce smiles I love laughing' (E.585). A few years
later he wrote to the patron who had
commissioned *Malevolence* (no.235): 'Fun I love
but too much Fun is of all things the most
loathsom[e]. Mirth is better than Fun &
Happiness is better than Mirth – I feel that a
Man may be happy in This World. And I know
that This World Is a World of Imagination
& Vision … ' (E.702).

This is the second state of a print that still
shows some of the stipple engraving technique
used extensively in the first state. Stipple was
often used for pretty or sentimental prints
intended for the popular market (e.g. Wheatley
132, 133) and here it shows just how aware Blake
was of using a technique appropriate to the
subject – just as he had evolved relief-etching
techniques for his prophetic works.

Mirth was inspired by John Milton's poem
'L'Allegro', an idyll in which the poet (the 'happy
man' of the title) seeks the company and delights
of the goddess, 'Heart easing' Mirth (see
nos.269–70). Here, in a way that enlarges the
sense of Mirth, as he had once done by
associating her with imagination, Blake shows
Mirth leading, with her right hand, the nymph
'Sweet Liberty'. RH

237 The Head of a Ghost of a Flea *c.*1819

Pencil on paper 18.9×15.3 (7½×6)
Tate; bequeathed by Miss Alice G.E.
Carthew 1940

238 The Ghost of a Flea *c.*1819–20

Tempera heightened with gold leaf
on mahogany
21.4×16.2 (8½×6⅜)
Signed 'WBlake Fresco' b.r.
Tate; bequeathed by W. Graham Robertson 1949
*Lit: Keynes 1960; Butlin 1981, nos. 692.98, 750; Butlin
1990, nos.63, 64*

This subject is one of the 'visionary heads'
seen and drawn by Blake in the company of
his friend, the artist and amateur astrologer
John Varley.

The origin of no.237 was recounted
by Varley:

> This spirit visited his imagination in such
> a figure as he never anticipated in an
> insect. As I was anxious to make the most
> correct investigation in my power, of the
> truth of these visions, on hearing of this
> spiritual apparition of a Flea, I asked him
> if he would draw for me the resemblance
> of what he saw; he instantly said, 'I see
> him now before me.'

Varley gave Blake pencil and paper and he set
about drawing the head of the flea and a detail
of its open mouth. While he was drawing, Blake
was told by the flea 'that all fleas were inhabited

by the souls of such men, as were by nature
bloodthirsty to excess, and were therefore
providentially confined to the size and form of
insects: otherwise, were he himself for instance
the size of a horse, he would depopulate a great
portion of the country'. Blake turns his flea's
observation into a reality by making him a giant
striding form against his original, which can be
seen on the floor beyond, and then shows him
with his tongue whisking out of his mouth and
in his hand a bowl that holds the blood off which
he feeds. In a drawing made in a sketchbook
during a later session with Varley Blake shows
the flea full length and with bat-like wings – a
feature that might perhaps link the predatory
ghost in Blake's mind with the Spectre and its
'ravening devouring lust continually craving
and devouring' (see nos.293, 294). Thus, while
undoubtedly humouring Varley, who in his
Treatise on Zodiacal Physiognomy described Blake's
flea as having characteristics of people born
under the Gemini star sign, Blake made the
subject very much his own. In this tempera a
flattering aside to Varley (who was to own the
work) and his astrological interests can be seen
in the stars and the comet in the background.

As can be found elsewhere in Blake's work,
his imagination was fed significantly by his
knowledge of old engravings: no.237 owes a
debt to an engraving of a flea seen under a
microscope and first published in Robert
Hooke's *Micrographia* of 1665, which Blake
could also have seen in books published in 1745
and 1780. RH

236

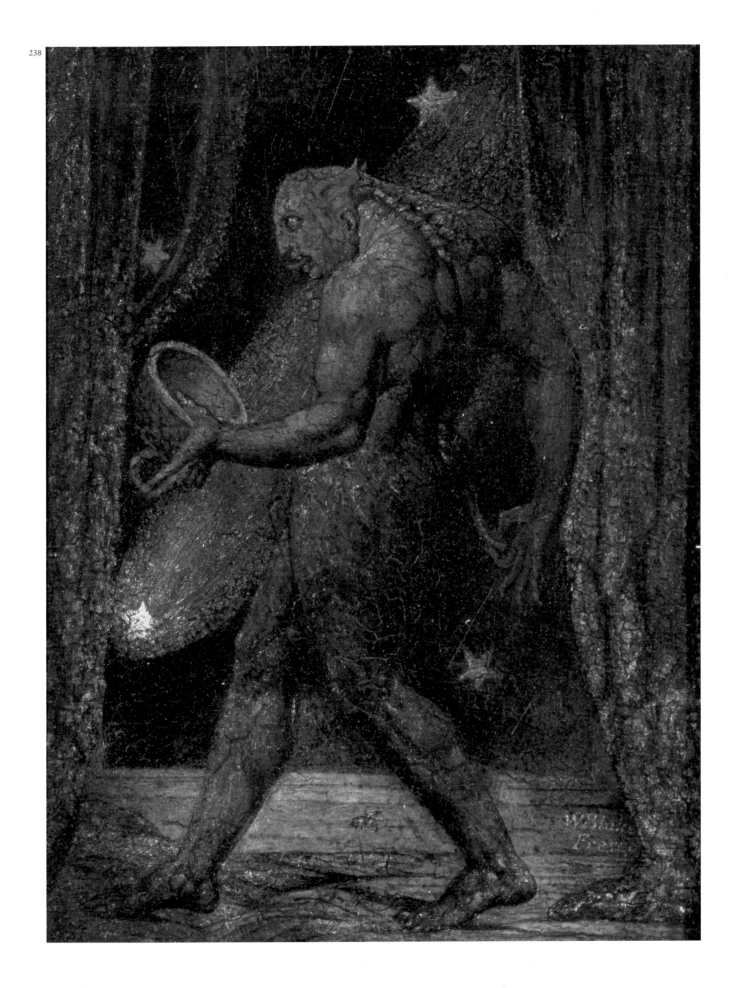

239 The Man Sweeping the Interpreter's Parlour *c.*1822

White-line metal cut printed in black ink 8 × 16 (3⅛ × 6¼) on paper 34.5 × 24.6 (13⅝ × 9⅝)
Signed 'WB in & s' (monogram) b.l.
Lent by the Syndics of the Fitzwilliam Museum, Cambridge
Lit: Essick 1983, no. XX:2H

This illustrates a passage from one of the greatest religious books in the English language, John Bunyan's *The Pilgrim's Progress* of 1678. It is the story of a man called Christian, who, after a number of trials in his search for eternal life, arrives at the House of the Interpreter. The Interpreter lets him in and shows him the rooms in the House. Each contains 'excellent things' that would help Christian on his journey. One room was 'a very large Parlour that was full of dust, because never swept'. When the Interpreter asks a man in to sweep it, the dust he stirs up almost chokes Christian until the Interpreter calls in a Damsel, who sprinkles water around the room to lay the dust. The room can then be swept properly. Christian is told the meaning of all this by the Intepreter. The Parlour represents the heart of a man who is ignorant of the Gospels and the dust is his original sin and other corruptions. The man who swept was the Law and the Damsel who brought the water, the Gospel. The lesson for Christian is that the Law alone cannot purify the heart of sin because it cannot conquer it. However, the 'sweet' influence of the Gospel can cleanse souls by conquering sin.

Bunyan's lesson is that the moral law is shown to be powerless against the cleansing power of the gospel of forgiveness preached by Christ. This echoes one of Blake's central beliefs as can be seen, for example, on the pages of *Jerusalem* (no.303), when he refers to the 'Wastes of Moral Law' (pl.24), or on plate 52, 'The Glory of Christianity is, To Conquer by Forgiveness'.

A much broader point about Blake's art is also highlighted by this illustration to a story that describes the trials of the human soul in the form of a journey – just like Dante's (nos.68–96). Bunyan's *Pilgrim's Progress* is an allegory, a literary form described by the poet Samuel Taylor Coleridge as the use of 'a set of agents and images to convey in disguise a moral meaning [and forming] a homogeneous whole'. An awareness of Blake's sympathy with this idea of allegory helps us understand his use of the same form in his own writings, as well as place them in literary history. Blake referred to *Milton* (no.272) as 'a Sublime Allegory' (E.730).

Blake's young artist followers, 'the Ancients' called his last home 'The House of the Interpreter'. RH

240 The Sea of Time and Space 1821

Pen and ink, watercolour and gouache on gesso ground on paper 40 × 49.5 (15¾ × 19½)
Signed 'W Blake inventor 1821' b.l.
Arlington Court, The Chichester Collection (The National Trust)
Lit: Butlin 1981, no.803; Heppner 1996, pp.237–77

Although the precise meaning of this mysterious work has long been uncertain, a convincing interpretation has recently been put forward by Christopher Heppner. According to Heppner, the kneeling male figure in red to the left of centre is the prophet Isaiah, whose gesture signals a prophetic yearning. He is placed deliberately in a classical setting, to expose the improbable and deceptive aspects of Pythagorean and Platonic Philosophy, as expressed in Ovid's *Metamorphoses*, and to denote the tension between classical and divine inspiration. The veiled female figure to the right of Isaiah, although quite discrete, is the personification of Ovidian and Pythagorean Nature, who governs change and transformation between the elements and the cycles of time. As Heppner states, Isaiah and Nature stand in 'apposition', invisible to one another, representing alternative and incompatible views of the world. Nature gestures towards the present world, above and below, while Isaiah, conversely, points to a world of the imagination beyond the picture plane. At the top left of the composition sits Apollo. On his right arm are the Muses who sing of the elements, on his left the Hours, who tend his horses and represent the seasons. Below, in the sea, is Aurora, goddess of the dawn, Blake thus presenting 'an allegory of time and space, in which dawn and sunset can be shown simultaneously' (Heppner, p.256). Beneath the ground occupied by Isaiah and Nature is a figure identified by Heppner as 'Jupiter Hammon' or possibly Pan or Bacchus. From his right hand a great coil of thread unwinds through the hands of the three Fates, while his left pours out a burning river of flame, revealing his role as the source of natural life and fire. At the extreme right is the cave of the weavers, with figures collectively representing the processes that give form to the material world, and continually renew the human life cycle. MJP

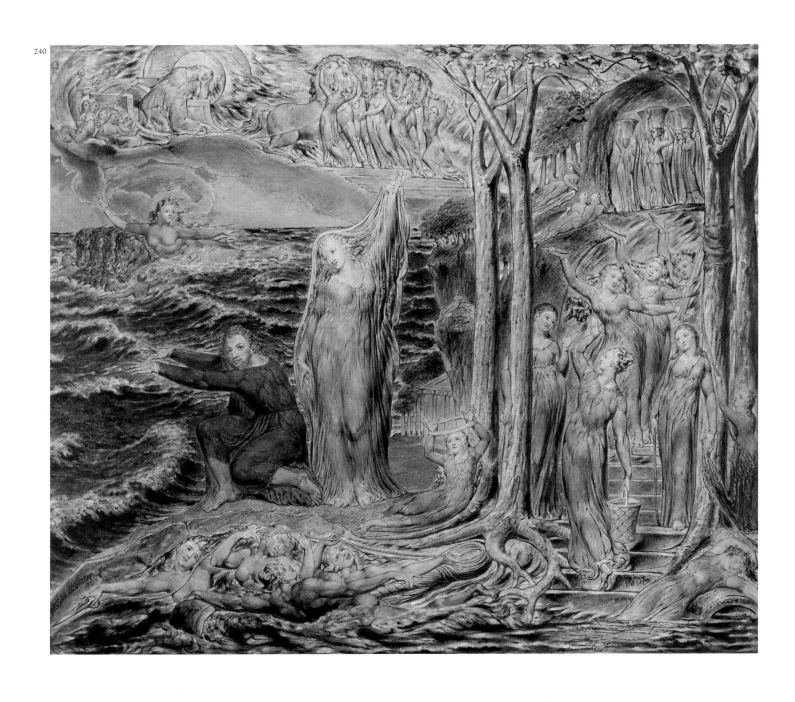

The twelve large colour prints, 1795/1805

The large colour prints dating from 1795 developed out of the colour printing of books that began the previous year (see p.118ff.). A link between the two forms can be found in the use of an initial relief-etched copper plate, as used for the illuminated books, in the large print *God Judging Adam* (no.244) and the way in which some illuminated book designs were based on outlines etched into the copper plate with pigments then being applied to the metal surface within these outlines for printing (such as the Frontispieces to *The Book of Ahania* and *The Song of Los* (no.301) and the Title-Page to *The Book of Los*, no.302). Another connection with the colour-printed books can be seen in the vertical page format for both the first design for *Pity* (no.241a) and another design, described by Blake as 'one of the first' of his frescoes (E.546), *A Spirit vaulting from a cloud …* , a subject later reworked for *As if an Angel* (no.228).

Blake's description of these works as 'fresco' gives an idea of how important he thought they were. The word is inscribed on four out of the total of twenty-eight impressions of the twelve designs that are known to exist, including *Naomi entreating Ruth* (no.246), dateable to 1795. Its use in 1795 on some of the largest works he had produced to date and the technical experimentation that preceded them (see *Pity*, 241c) suggest that these prints were intended for general public exhibition. Blake would have linked fresco with didactic narrative schemes for public display, like those created by Raphael for the Vatican Loggia (see no.142), a feature characteristic of the twelve large prints. In addition, 'frescos' using watercolour would in Blake's view have 'colours … as pure and as permanent as precious stones' (E.527–8, 531). So Blake's interest in 'fresco' had a great deal to do with his perception of how he might fix his reputation for posterity. The existence of two complementary Shakespeare subjects, *Pity*, and *A Spirit vaulting,* at the inception of the colour-print project helps support the well-established way of looking at the colour-printed subjects in pairs; perhaps Blake had in mind at one point the creation of a Shakespeare cycle to rival John Boydell's Shakespeare Gallery, or even one such as Henry Fuseli had much earlier conceived.

Blake's exact technique in these prints remains the subject of some speculation. Frederick Tatham, who must have heard it from Mrs Blake, reported that Blake

> … took a common thick millboard and drew, in some strong ink or colour, his design upon it strong and thick. He then painted upon that in such oil colours and in such a state of fusion that they would blur well. He painted roughly and quickly, so that no colour would have time to dry. He then took a print of that on paper, and this impression he coloured up in watercolours, repainting his outline on the millboard when he wanted to take another print.

Tatham added that Blake used this method because it allowed him to make each print slightly different, this being further aided by accidental effects in the pigments brought about by the printing process itself (Gilchrist 1863, I, pp.375–6). Tatham's account omits some essential preliminaries to all this: the background in the production of illuminated books; the re-working of existing designs from the books, for example *Nebuchadnezzar* (no.247) and *Good and Evil Angels* (no.252); the making of preparatory drawings for some of the designs, such as *Satan* (no.243), *Pity* (no.241), *Newton* (no.249) and *The Night of Enitharmon's Joy* (no.250); and then a trial proof stage for such drawings as in the case of *Pity* (no.241c). Nor does Tatham mention the use of pen and ink to reinforce the images and the number of impressions of each design pulled – up to about three – these, in a few cases, being run off without pigments having been reapplied to the plate (see *Pity* 241d, e).

Although revolutionary in their scale as monoprints and the extent to which Blake allowed chance printing effects to dominate the finished work, the materials he used were easily available. The supports, either copper plate or millboard (which was very much cheaper and easier to handle), were standard artists' materials as were the limited range of pigments which he used, some of which he would

probably have ground himself. Similarly, Blake modified his colours in just the same way as any other painter would: to achieve flesh colours in both printed and painted areas, for example, he would mix vermilion with lead white. Despite Blake's objections to oil paint, tests suggest its possible use in some areas of some prints. Importantly, because it largely explains Blake's use of the word 'fresco' by relating it directly to the pure fresco technique of painting in watercolour on wet plaster, he mixed chalk with some of his pigments in order to lighten their colours, give bulk to the consistency of the paint, and emulate the matt appearance of true fresco. It remains the case, however, that in describing his process in these prints as 'fresco' he was more concerned with simulating appearance than imitating fresco techniques. The 1795 prints anticipate the idea of 'portable fresco' for ornamenting public buildings put forward by Blake in 1809 though the difficulty his fellow artists had in trying to relate them to contemporary painting and print-making practice is suggested by Blake's comment at the same time that '[they] are regularly refused to be exhibited by the *Royal Academy* and the *British Institution*' (E.527). RH, NCM

Lit: *Essick 1980, pp.130–5; Butlin 1981, vol.I, pp.156–77; Heppner 1981; Maheux 1984; Butlin 1989, pp.1–17; Lindsay 1989, pp.19–41; Butlin 1990, no.30; Bindman 1983*

Opposite: 'Elohim Creating Adam' 1795/c.1805 (detail)

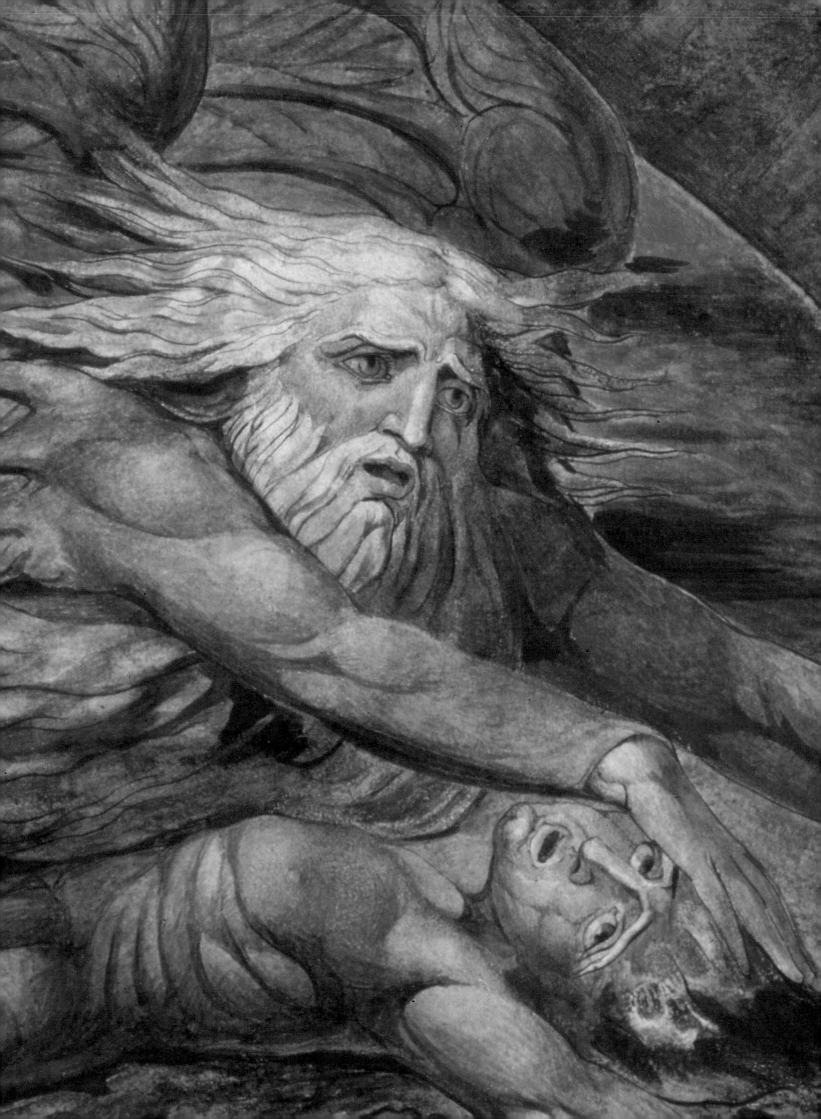

241 Pity c.1795

a) Preliminary sketch c.1795

Pencil and graphite approx. 29.4 × 28 (11⅝ × 11)
on paper (trimmed) 41.8 × 28.4 (16½ × 11⅛)
Inscr. (by Frederick Tatham) 'Shakespeares Pity /
And pity like a naked new born Babe/
&c &c / F.Tatham –'
The British Museum, London

b) Preliminary sketch c.1795

Pencil on paper 27.2 × 42.2 (10¾ × 16⅝)
The British Museum, London

c) Trial proof c.1795

Watercolour line drawing and washes with
colour printing 19.6 × 27.4 (7¾ × 10¾) on paper
27.6 × 35.9 (10⅞ × 14⅛)
The British Museum, London

d) First impression c.1795

Colour print finished with pen and ink and
watercolour (irreg.) 42.5 × 53.9 (16¾ × 21¼) on
paper approx. 54.5 × 77.5 (21½ × 30½)
Signed 'Blake' incised b.r.
Tate; presented by W. Graham Robertson 1939

e) Second impression c.1795

Colour print finished with pen and ink and
watercolour on paper (trimmed) 42.1 × 52.8
(16⅝ × 20¾)
Inscr. b.r 'WBlake inv.'
Metropolitan Museum; gift of Mrs Robert
W. Goelet, 1958
*Lit: Butlin 1981, nos.310–11, 313–15; Heppner 1981;
Butlin 1990, no.30*

Although not given a title by Blake it is accepted
that *Pity* was inspired by lines from act 1, scene 7
of Shakespeare's play *Macbeth*, as originally
identified by Frederick Tatham (no.241a):

> And Pity, like a naked new-born babe,
> Striding the blast, or heaven's cherubin
> hors'd
> Upon the sightless couriers of the air,
> Shall blow the horrid deed in every eye,
> That tears shall drown the wind

At this moment Macbeth is anticipating the
outcome of his murder of Duncan the King.
Blake's image unites the vulnerable and
vengeful, human and supernatural elements
of Shakespeare's double simile. His image
characterises the 'sightless', or invisible, winds

as horses, a reference to a portent of Duncan's
death described later in the play when his
'beauteous and swift' horses unexpectedly
become 'wild'.

There are five known preparatory studies for
this print, three of which (nos.241a, b, c) are
shown here. In their energetic and allusive
pencil work, the two drawings can be compared
with other sketches Blake made for printed
images (such as nos.113, 114). The vertical format
of no.241a, shifting to the horizontal format
of no.241b that was eventually used in all
the finished colour prints, combined with the
existence of the unique proof print no.241c,
suggest that *Pity* might have been the first of
the large colour prints to be produced, but *God
Judging Adam* (no.244) could equally well claim
this place. The colour proof follows no.241b but
in reverse and with the two female figures now
clad, the lower one no longer in the agony of
childbirth. It was produced using drawing and
painting in watercolour and printing, but it is
difficult to determine the drawing and printing
sequence. It appears that the line drawing and
washes were applied to the paper first (as the
relief-etched line was in *God Judging Adam*)
followed by the areas of colour printing with
some black lines then applied over printed
surfaces. The most significant subsequent
change in the design concerns the rendering of
the earthly 'blast' of Shakespeare's text, which is
shown by the grass or rushes bent over the
prostrate female (and which might be compared
with an image on *America*, pl.11, no.124). This
remains up to the trial proof stage. In the
finished work this goes and it is Pity,
not as the 'babe' but as the 'cherubin hors'd',
whose forward motion symbolises the troubled
heavenly wind, the 'deep damnation' feared
by Macbeth, that will 'blow the horrid deed
in every eye'.

Three impressions of *Pity* are known. Two
are shown here. The richness of the printing in
no.241d compared with that in no.241e suggests
that it was the first to be pulled by Blake.
RH, EEB, NCM

241a

241b

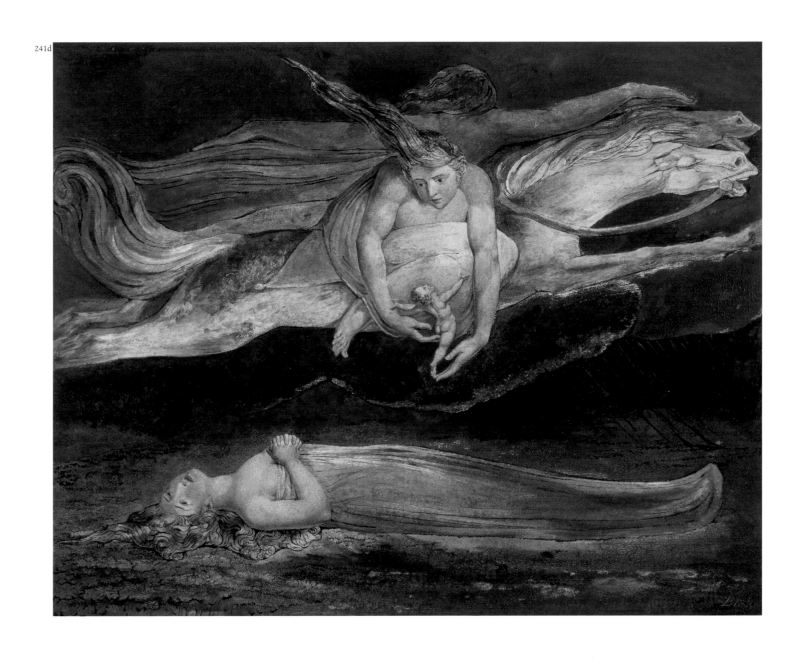

242 Elohim Creating Adam 1795/c.1805

Colour print finished in pen and ink and
watercolour 43.1×53.6 (17×21⅛) on paper
approx. 51.5×59.5 (20¼×23½)
Signed '1795 WB inv (in monogram)' b.c and
inscribed 'Elohim creating Adam' below design
Tate; presented by W. Graham Robertson 1939
Lit: Butlin 1981, no.289; Butlin 1990, no.25

An illustration of verse 7 of chapter 2 of the Book
of Genesis: 'And the Lord God formed man of the
dust of the ground, and breathed into his
nostrils the breath of life; and man became a
living soul.' Adam is shown with his head, feet
and his left hand growing out of the earth, a
piece of which Elohim is gathering up with his
left hand. The idea that this is the culminating
moment in the creation of the world is conveyed
by the presence of the sun behind Elohim and to
the left a globe of blackness, references to God
making day and night on the first day.

God's intention that man would have
'dominion over all the earth' is symbolised in
the way Adam's body stretches across the curved
portion of land. A worm, a symbol of mortality,
coils around Adam's body and, shown without
a head, also appears to grow out of it, thus
anticipating the creation of Eve out of Adam's
flesh and then the Fall (see nos.256, 266).

Elohim is a Hebrew word for God and also
means 'Judge'. Blake's choice of it in this title
for this work, combined with the image of the
Creator as a Urizen-like figure is calculated: it
reflects his pessimistic view of a Creator as a
begetter of tyrannical laws and thus anticipates
God Judging Adam (no.244). RH

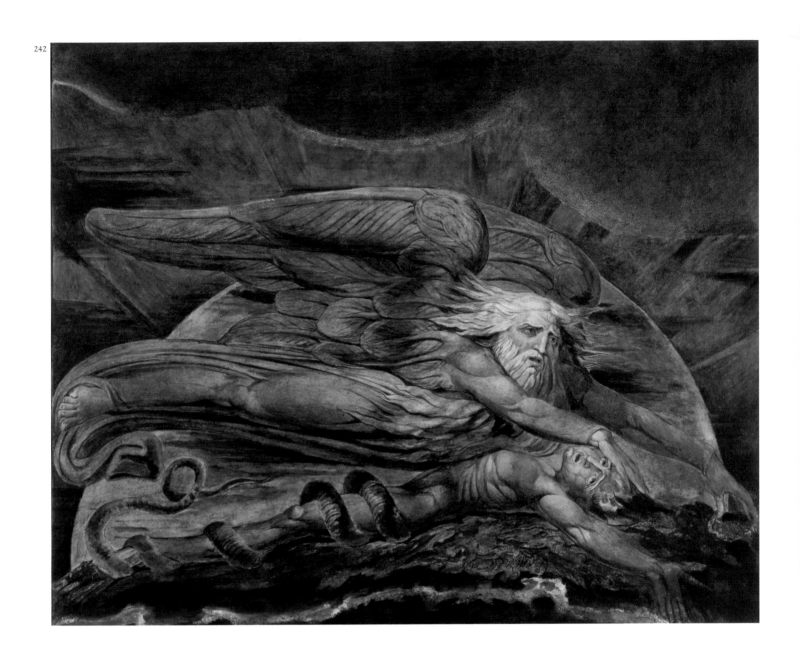

243 Satan Exulting over Eve *c.*1795?

Colour print finished in pen and ink and
watercolour 42.8 × 53.2 (16⅞ × 21)(ruled margin)
on paper 43.8 × 54.2 (17¼ × 21⅜)
Signed 'Blake'(incised) b.l.
Tate; purchased with assistance from the
National Heritage Memorial Fund, the Friends
of the Tate Gallery, the Essick Foundation,
Edwin C. Cohen and other benefactors
honouring Martin Butlin, Keeper of the British
Collection 1967–89, 1996
Lit: Butlin 1981, no.291

This subject originates in Genesis though Blake
also looked to Milton's *Paradise Lost* for
inspiration. In Book 5, lines 28–92, of the poem
Eve tells Adam of her dream where she found
herself by the Tree of Forbidden Knowledge
beside which stood Satan, 'shap'd and wingd'
like other angels. He took one of the fruits and
gave it to Eve, who tasted it. She was swept up
into the clouds along with Satan who equally
suddenly disappeared and Eve 'sunk down, / and
fell asleep'. The dream anticipates the moment
when Eve and then Adam actually eat the
forbidden fruit, led into doing so by Satan in the
form of a serpent. In other Milton illustrations
showing Satan as an angel Blake usually shows
him with the serpent coiled round him (see
no.261) but here we see him in a divided form –
as the exultant flying angel of the dream, who
has successfully tempted Eve, and also,
anticipating the temptation, as the serpent
coiled around the sleeping Eve, who holds the
fateful fruit. RH

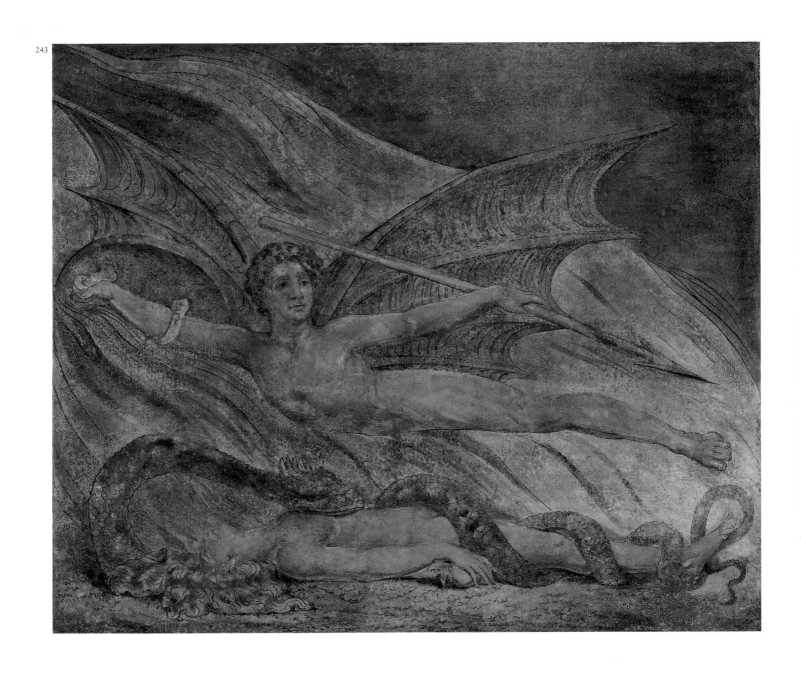

244 God Judging Adam 1795

Colour-printed relief etching finished in pen and ink and watercolour 43.2 × 53.5 (17 × 21⅛) on paper approx. 54.5 × 77 (21½ × 30¼) Signed 'WB inv [in monogram] 1795' b.l. and inscr. 'God speaking to Adam' below design Tate; presented by W. Graham Robertson 1939
Lit: Butlin 1981, no.294; Butlin 1990, no.26

Blake's first title for this work, in the pencil inscription under the image, together with the solitary, naked figure of Adam before the figure of God in his chariot, suggests that it illustrates verse 17 of chapter 2 of Genesis when God, speaking of 'the tree of the knowledge of good and evil', says to Adam 'thou shalt not eat of it': Adam is at this moment naked and Eve has yet to be created. In Genesis, however, when judged by God after eating the forbidden fruit Adam and Eve are together, and in illustrations of this scene they are usually shown wearing their 'aprons' of fig leaves, as Blake shows them on the General Title-Page for *Songs of Innocence and of Experience* (nos.144, 298).

As with Elohim the creator in no.242, Blake has made the figure of God sitting in judgement look like his own character of Urizen (see nos.295–7), though the imagery can still be traced back to the biblical sources that he drew upon in creating Urizen, in particular, the portrayal of the Ancient of Days found in chapter 8 of the Book of Daniel: his 'garment was white as snow, and the hair of his head like the pure wool: his throne was like the fiery flame, and his wheels as burning fire'. Before him 'the judgement was set, and the books were opened'. In no.244 God seems to be holding a sceptre in his right hand, the symbol of his omnipotence, with the action illustrating words from Deuteronomy 'from his right hand went a fiery law' (33: 2). In Blake's own writings of the same date as this print, *The Song of Los*, a reference that parallels this subject can also be found: 'Adam stood in the garden of Eden: /… [and] saw Urizen give his Laws to the Nations' (no.301 pl.3; E.67).

The figure of Adam commands our attention for he is in God's – Urizen's – own image. Blake's transformation of Adam's created form from that in *Elohim Creating Adam* (no.242) to that which he possesses here after his Fall, is comparable to the way in which Michelangelo depicts Eve before and after the Fall in one of the Sistine Chapel frescoes, indicating the burden of shame and guilt that she bears: beautiful in the Garden of Eden, her features age after the Expulsion. But, far more significantly, Blake's own transformation of man in *God Judging Adam* marks the culminating point in a cycle of events that can be traced through Blake's mythology. It begins with Urizen's own creation on the First Day when God created light, eventually becoming 'Creator of men', who were ruled by Urizen's law 'One King, one God, one Law' (*Urizen* pl.4; E.72). Urizen's 'web', or the 'Net of Religion', 'dark & cold' like him, has almost taken on a visible form in Adam – 'bound down by … narrowing perceptions' (*Urizen*, pl.25(23), nos.120, 296): like Newton (see no.249), Adam looks fixedly down. The absence of Eve from this judgement scene can be explained in Blake's description of the web that has produced this as 'a Female in embrio' (*Urizen*, pl.25(23), no.296). The inhibiting laws of moral virtue promulgated by Urizen have their root in the tyrannical laws of organised religion, which are embodied in the biblical injunction from a repressive creator to man never to eat the forbidden fruit. RH

244

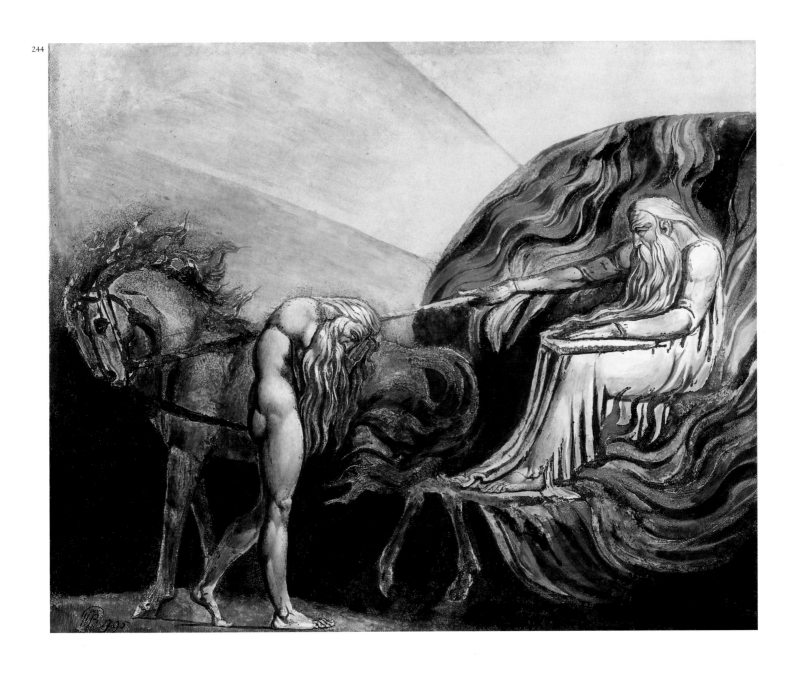

245 Lamech and his Two Wives 1795

Colour print finished in pen and ink and
watercolour 43.1×60.8 (17×23⅞) on paper
approx. 54.5×75.5 (21½×29¾) (corners
cut diagonally)
Signed 'WB inv [in monogram] 1795' and inscr.
'Lamech and his two Wives' below design
Tate; presented by W. Graham Robertson 1939
Lit: Butlin 1981, no.297; Butlin 1990, no.27

The subject of this print comes from the song
of Lamech contained in Genesis 4, verses 23–4.
Lamech, husband of Adah and Zillah, tells how
he has killed a man for wounding him and a
boy for just hurting him. One of the victims is
shown stretched out at Lamech's feet while
the two wives stand horrified in front of their
tent. Lamech's story illustrates how sin is
increased through Man's growing pride and
vengeance. RH

245

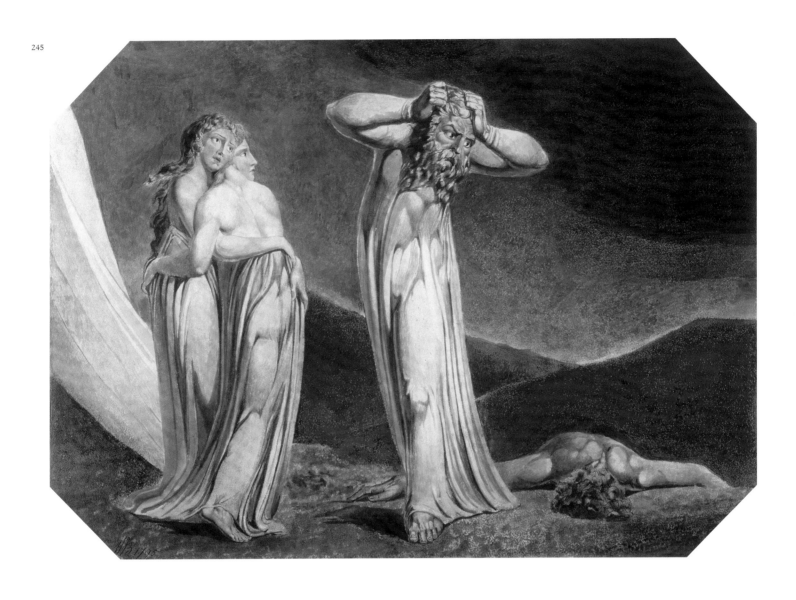

246 Naomi Entreating Ruth and Orpah to Return to the Land of Moab *c.*1795
Colour print finished in pen and ink, shell gold and chinese white, sight size 42.8 × 58 (16⅞ × 22⅞) (corners cut diagonally)
Signed 'Fresco W Blake inv' b.l.
The Victoria & Albert Museum
Lit: Butlin 1981, no.299

The story of Naomi and her Moabite daughters-in-law Ruth and Orpah, is told in the Old Testament Book of Ruth. After all three women are widowed Naomi resolves to leave the country of Moab and return to her own country Judah. She tries to persuade Ruth and Orpah to remain in their homeland. Orpah decides to stay but Ruth declares her devotion to Naomi and they both travel to Bethlehem. Blake shows Ruth embracing Naomi while a distraught Orpah goes back to her people.

The format of *Lamech* (no.245) and *Naomi*, both with chamfered corners, and with their similar treatment of complementary subjects, provide a clear sign that Blake saw them as a pair: *Lamech* deals with the sins of violence and vengeance and thus looks back to the legacy of Cain, the first murderer, from whom Lamech was descended. In 'The Everlasting Gospel' Blake wrote that 'if you Avenge you Murder the Divine Image & he cannot dwell among you … because you Murder him' (E.875). By contrast, *Naomi* is concerned with gentleness and devotion that transcends self-interest. Furthermore, through Naomi's and Ruth's protectiveness towards each other, and the place of Ruth (who was the great grandmother of David) as an ancestor of Christ, the story looks forward to the idea of resurrection and salvation through Christ. Blake shows Naomi with a halo as a sign of her special place in the genealogy of Jesus Christ. RH

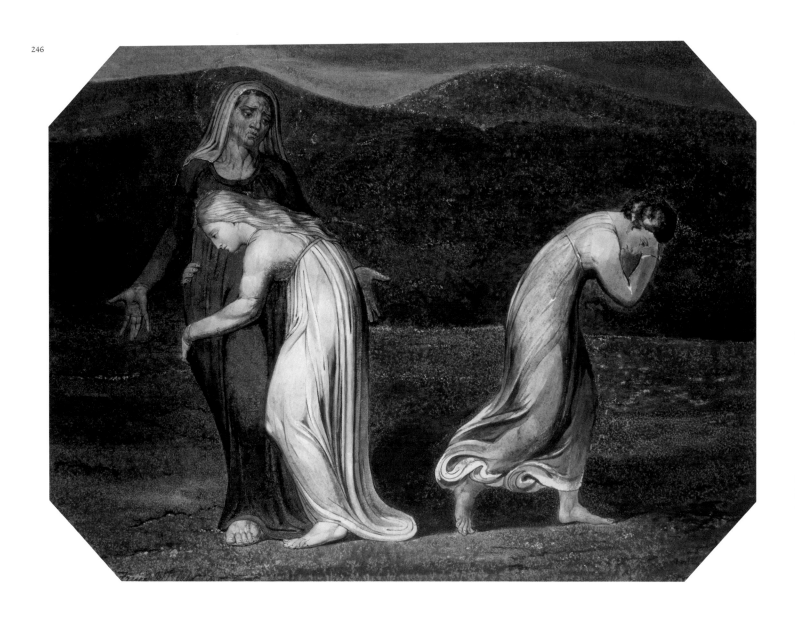

247 Nebuchadnezzar 1795/c.1805

Colour print finished in pen and ink and
watercolour 44.6×62 (17⅝×24⅜)(irreg.) on
paper approx. 54.5×72.5 (21½×28½)
Signed '1795 WB inv (in monogram)' b.r. and
inscribed 'Nebuchadnezzar' below design
Tate; presented by W. Graham Robertson 1939
Lit: Butlin 1981, no.301; Butlin 1990, no.28

The story of King Nebuchadnezzar from the Old
Testament Book of Daniel is a warning to the
proud – that 'those that walk in pride [the Lord]
is able to abase'. Nebuchadnezzar built Babylon
to celebrate his own power and majesty despite a
dream in which he was warned that he would be
punished for setting himself above his God.
When Babylon was built the prophecy was
fulfilled. His reason lost, Nebuchadnezzar's
humbling consisted of his kingdom being taken
from him and then, driven into the fields, he
had to eat grass just as oxen did. He became
like an animal as his hair grew like eagle's
feathers and his nails became like birds' claws.
His reason returned to him when he looked
heavenwards and finally recognised the all-
powerful King of Heaven.

The subject of Nebuchadnezzar is rarely
treated in art though Blake would have known
a 1781 etching *Nebuchadnezzar Recovering his
Reason*, taken from a drawing by John Hamilton
Mortimer (1740–79), an artist he much admired.
However, Blake's actual source for the figure
of Nebuchadnezzar can be found in a print
by Albrecht Dürer, *The Penance of St John
Chrysostomos*. The pose of the tiny figure of the
saint in the Dürer was borrowed by Blake first
for plate b.11 of *There is No Natural Religion*
(no.107). As is so often the case with Blake, this
kind of association between separate works is
illuminating. Here, the Nebuchadnezzar of this
colour print is one who, unable to see God, saw
only himself – just as with Newton (nos.248–9) –
which suggests that the two prints should be
seen as a pair.

Blake's interest in the subject of
Nebuchadnezzar spanned a number of years
from around 1790 until about 1805, ranging
from slight sketches in the *Notebook*, through a
design for *The Marriage of Heaven and Hell* (no.127)
and an illustration in Young's *Night Thoughts*
(see nos.29–36), to finally this large colour print
pulled for his patron Thomas Butts in about
1804–5. Such a preoccupation with the theme
of a proud king who lost his reason and was
humbled was not altogether surprising during
this period, since an obvious parallel was to
be found, and indeed was once made in a
caricature, with King George III. In *The Rights of
Man* (no.166) Paine possibly alludes to the story
when, in writing of the tyranny of hereditary
government, he notes that 'Kings succeed each
other … as animals', and ironically their
subjects are 'like beasts in the field'. RH

Opposite: 'Nebuchadnezzar' 1795/c.1805 (no. 247, detail)

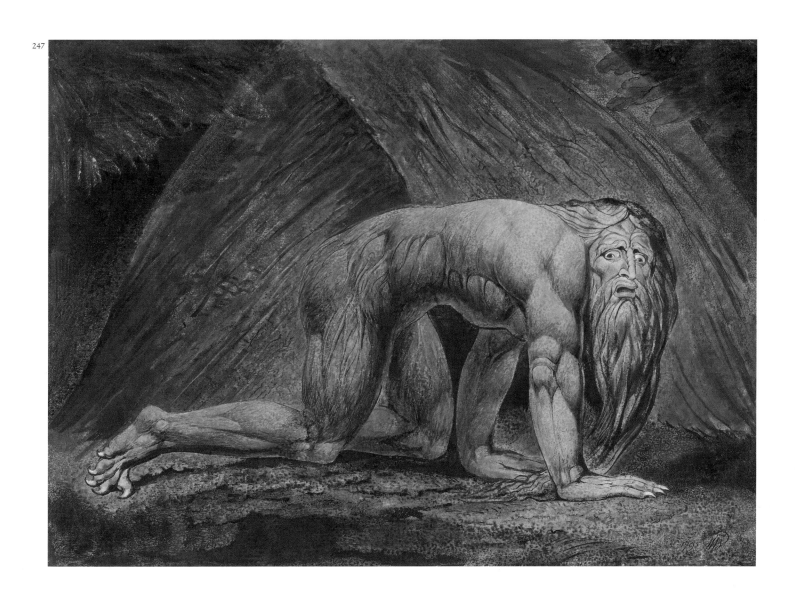

248 Sketch for Newton c.1795
Pencil on paper 20.4 × 26.2 (8 × 10⅜) (irreg.)
Keynes Family Trust on loan to the Fitzwilliam
Museum, Cambridge

249 Newton 1795/c.1805
Colour print finished in pen and ink and
watercolour 46 × 60 (18⅛ × 23⅝) on paper
approx. 54.5 × 76 (21½ × 30)
Signed '1795 WB inv [in monogram]' b.r., inscr.
'Newton' below design
Tate; presented by W. Graham Robertson 1939
*Lit: Essick 1971; Butlin 1981, nos.306, 308; Butlin 1990,
no.29; Eaves, Essick, Viscomi 1993; White 1997*

Sir Isaac Newton (1642-1727) was a philosopher,
mathematician, alchemist and biblical scholar
best known for his law of universal gravitation.
He was considered a towering genius of British
science and rationalism. He first emerged as a
major figure in Blake's work in *Europe* in 1794,
where he appeared as 'A mighty Spirit' leaping
from the 'land of Albion' and sounding an
'enormous blast' on a trumpet (pl.16(13), no.299).
Newton's trumpet call was the fourth, and
successful, attempt to 'awake the dead to
judgement'. The episode recalls that in the Book
of Revelation when the angels give the seven
trumpet blasts that signal the Last Judgement:
after the fourth blast, darkness and plagues
descend upon the world. Far from celebrating
Newton, Blake's *Europe* satirises him as an angel
who brings about darkness.

As in *Europe*, this print by Blake presents an
unconventionally negative image of the
scientist. Blake shows Newton the rationalist,
preoccupied with his calculations. When
Newton's supreme achievement, *Mathematical
Principles of Natural Philosophy* was first published
in English in 1729, it had a frontispiece showing
the author enthroned in Heaven with Truth
holding her compasses beside him. Here,
Newton's compasses are the same as the
instrument used by God the Divine Geometer in
creating the world and later appropriated by the
oppressive Urizen, who can be seen holding
them in *The Ancient of Days* (see nos.297, 299 pl.1).
His muscularity is suggestive of the physical
energy given him in *Europe* and somehow equal
to the task of reshaping man's universe; and his
intense powers of concentration are captured
in the way his eye is on exactly the same diagonal
as one of the compass arms. This sense of a
supreme strength at work is further heightened
when we realise that his pose is based on the
figure of Abias, one of the Ancestors of Christ
depicted by Michelangelo in the Sistine Chapel,
and that the emphasis given to Newton's right
forefinger is an echo of God's action in
Michelangelo's *God Creating Adam*, also in the
Sistine. It is as though for Blake's purposes
Newton becomes one with the Holy Trinity,
and he is shown measuring the deceptively
simple symbol of the Trinity, the triangle, on
the scroll at his feet.

Blake brings Newton down to earth.
A comparison with *Albion rose* (nos.176, 279), *As
if an Angel* (no.228), or plate 50 of *Jerusalem*
(nos.276, 303) suggests that the rock on which
Newton sits is the rock of Albion from which, as
in *Europe*, he might soon leap up. That he is
shown sitting underwater suggests a further
layer of references: to Newton's work on gravity
and theory of tides; to the Newton monument in
Westminster Abbey (well known to Blake from
the 1770s and in which the figure of the scientist
is inspired by a classical figure of the river god
Tiber); and to Blake's own motif of water as a sign
of materialism (see no.296 pl.12(11)). Blake's
thinking behind this image becomes clearer if we
return to the Newton of *Europe*, plate 13, when in
response to the sound of his trumpet, 'Yellow as
leaves of Autumn the myriads of Angelic hosts,
Fell thro' the wintry skies seeking their graves.'
In depriving these angels of life, Newton pits
himself against God and, the text suggests,
becomes a party to quelling the revolutionary
spirit of Orc.

For Blake, who saw the imagination as God
in Man, Newton's vision was 'Single' (to Butts, 22
Nov. 1802; E.722), and this is summed up in the
curtailed straight line of his gaze in this print.
A direct comparison can be made with a plate
from *There is No Natural Religion* (no.197).
However, while being critical, Blake also suggests
that Newton is not perhaps beyond redemption:
almost completely naked, his white mantle of
mortality (like Albion's in plate 95 of *Jerusalem*) is
about to be cast off, signalling salvation. RH

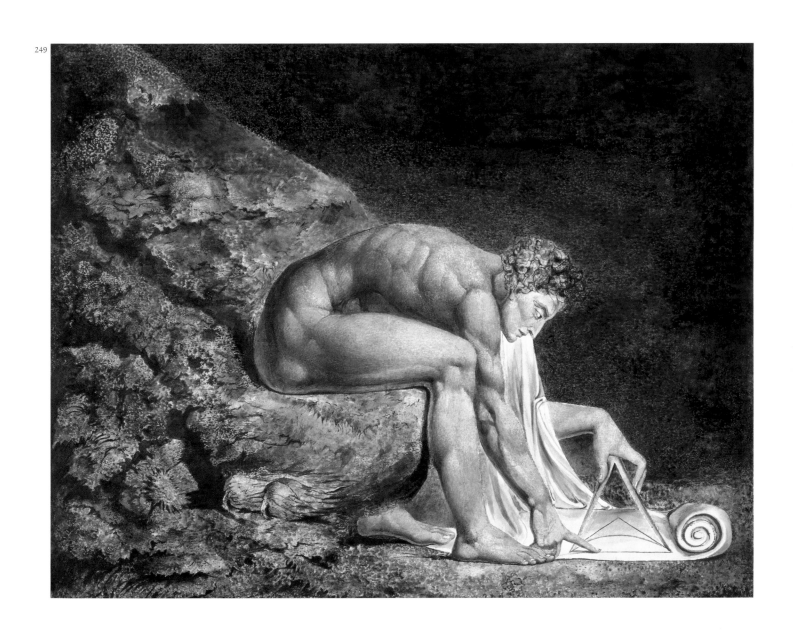

250 The Night of Enitharmon's Joy (formerly called *Hecate*) *c*.1795

Colour print finished in pen and ink and watercolour 43.9×58.1 (17½×22⅞) on paper approx. 54.5×77 (21½×30¼)

Signed 'Blake' incised b.l.

Tate; presented by W. Graham Robertson 1939

Lit: Butlin 1981, no.316; Heppner 1981; Lindsay 1989, pp.29–30; Butlin 1990, no.31; Schiff 1990; Dörrbecker 1995, pp.145–6

The title *Hecate* originally given to this print came not from Blake but from W. M. Rossetti's list of Blake's works in the 1863 edition of Gilchrist's biography. The female figure is not Hecate, the classical goddess of the moon and witchcraft whose three heads all look outwards, nor the 'Pale Hecat' of Shakespeare's *Macbeth*. However, she is clearly a divisive figure with the power to induce guilt as her position between male and female figures, who both look down in shame, suggests. She is also pointing to a book and in Blakean terms this immediately suggests Urizen's 'Book of brass' containing his repressive laws.

This reminder of Urizen's Book indicates that a source for the subject might be found somewhere in Blake's writings that predate 1795, the year of the print's conception. Since other large colour prints derive directly from an illuminated book (nos.247, 252) this is a reasonable assumption. The night-time setting and the image of a woman who dominates it, signalled obviously by her pointing to a book of laws but also by the way she separates the two figures behind her, lead us to the figure of Enitharmon who comes to the fore in Blake's mythology in two books of 1794, *The First Book of Urizen* (no.296) and *Europe* (no.299). It is lines in *Europe*, plate 8(5)(no.299), that Blake is illustrating here. They describe Enitharmon's 'night of … joy' as she sets out her false religion, comparable to Urizen's, that 'Woman, lovely Woman! May have dominion': the 'human race' is told that 'Womans love is Sin'. Enitharmon's advice in lines 8–9 to 'the little female [to] Spread nets in every secret path'– the net is a symbol of the ensnaring power of sex – is matched by her glance towards the female and the simultaneous pointing of her finger towards her book in which the injunction is set out. The image of Enitharmon separating the youthful male and female is the joyless separating of the sexes through sexual repression. RH

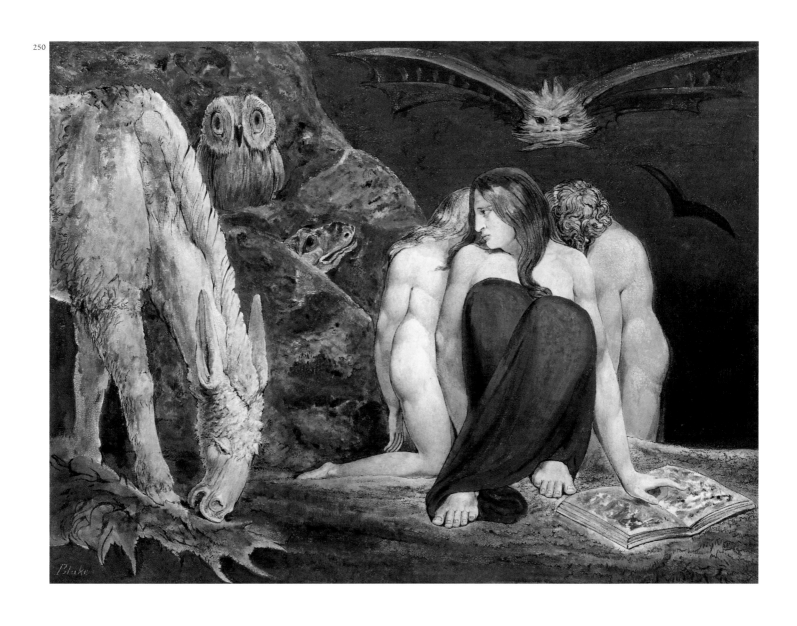

251 The House of Death 1795/c.1805

Colour print finished in pen and ink and watercolour 48.5×61 (19⅛×24) on paper approx. 54.5×77 (21½×30½)

Signed 'WB 1795' b.l., inscr. 'The House of Death Milton' below design

Tate; presented by W. Graham Robertson 1939

Lit: Butlin 1981, no.320; Butlin 1990, no.32

Since John Milton was of such significance to Blake (see nos.254–272) it was inevitable that his most important colour-printing project should include subjects inspired by his writings (see also *Satan Exulting*, no.243). This print illustrates lines from Book XI of *Paradise Lost* in which the Archangel Michael shows Adam the misery that will be inflicted on Man now he has eaten the Forbidden Fruit. In a vision of Death's 'grim Cave' Adam sees a 'monstrous crew' of men afflicted by 'Diseases dire'. They writhe and groan in the 'sad, noisom, dark place'. The figures to the left and right beneath hovering Death might be seen as Milton's 'Daemoniac Phrenzie' and 'moping Melancholie'. The figure of 'despair' that waits on the tormented stands on the right. He holds a dagger but as the agent of 'triumphant Death' who does not exercise his final power despite pleas to do so, he is powerless to use it.

Blake's overarching figure of Death recalls his own idea for the winged and bearded monsoon god who inundates the plain of the Nile that he worked up for his engraving of Fuseli's *The Fertilization of Egypt* (see nos.215, 216). The borrowing is apt since Adam is being shown visions of the world before the Flood that God created to punish man's wickedness. More obviously, as a comparison with the Title-Page to *The First Book of Urizen* (no.296) or *The Ancient of Days* (no.297) shows, Blake also makes his figure of Death synonymous with Urizen – whose history takes much from the Satan of *Paradise Lost*. The equivalent of Milton's Death, who holds, in Blake's later words, Satan's 'infernal scroll, / Of Moral laws and cruel punishments' (*Milton*, pl.7, no.272), can be seen in the Title-Page of *Urizen* . Given the date of *The House of Death*, it is possible to see in it Blake's response to events at the time in France, which was in the grip of a Urizenic rationalism involving militarised terror as well as great hardship. RH

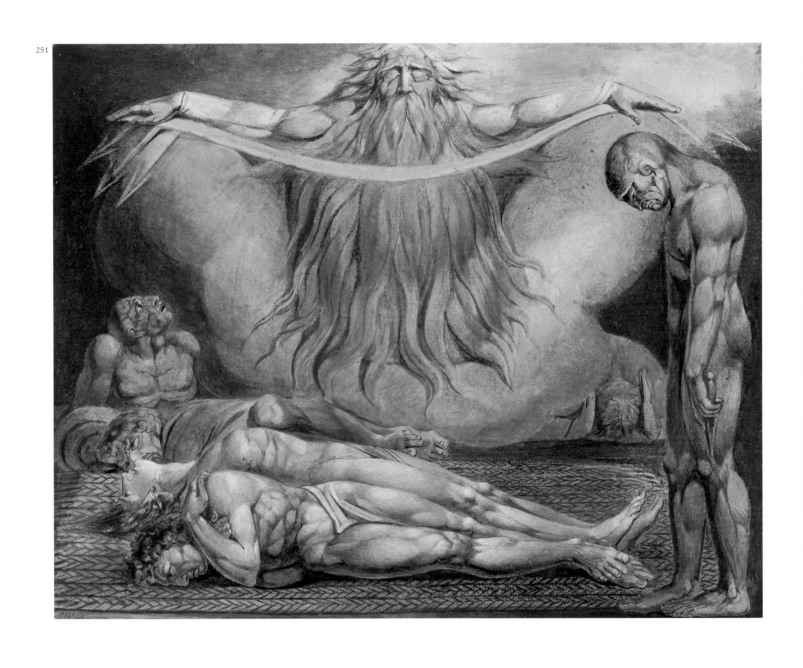

252 The Good and Evil Angels 1795/?c.1805
Colour print finished in pen and ink and
watercolour 44.5×59.4 (17½×23⅜) on paper
approx. 54.5×76 (21½×30)
Signed 'WB inv [in monogram] 1795' b.l., inscr
'The Good and Evil Angels' below design
Tate; presented by W. Graham Robertson 1939
Lit: Butlin 1981, no.323; Butlin 1990, no.33

Like *Nebuchadnezzar* (no.247), this work is a
version in reverse of a design on one of the plates
in *The Marriage of Heaven and Hell* (no.127 pl.4)
and, like *Nebuchadnezzar*, also deals with the
aspect of Reason in Man. In plate 14 of *Marriage*
Blake claims that it is his intention to 'expunge'
the 'notion that man has a body distinct from his
soul' through his illuminated books – both by
means of the printing method itself and, it is
implied, through those personifications of the
divided man that feature in his writings. One
reason for reworking the design on plate 4 of
Marriage as a large colour print might well have
arisen out of Blake's colour printing of copies
of the book in about 1794 (Viscomi 1993, p.289).
The large scale of the colour print can also
be seen as a more powerful visual means of
'expunging the notion' set out on plate 14
of *Marriage*.

According to the text on the *Marriage* plate,
the figures in this print can be interpreted as
representative of the errors brought about by
'All Bibles or sacred codes'. Energy, mistakenly
seen by such 'codes' as evil and originating in
the body, is shown as the Evil Angel on the left;
Reason, mistakenly seen as good and
originating from the soul, is shown as the Good
Angel on the right. Blake illustrates the
perceived division between body and soul that
such errors produce by setting Body/Energy and
Soul/Reason apart from each other and then
emphasising their separateness through the
contraries of dark and light flesh tones. The
separation brings us immediately to the first
of Blake's 'Contrary' truths listed in *Marriage*,
that such a division in man does not exist 'for
that calld Body is a portion of Soul discernd by
the five Senses' (E.34) – sight, hearing, smell,
taste and touch – which for Blake gave man
unlimited ways to perception including,
through touch, sex. The Angels' senses are
incomplete: the Evil Angel is sightless, the
closed mouth suggests that he cannot be heard
and the sensation of touch must remain
unknown to him because he is chained –
the Good Angel is just out of reach.
The androgynous forms of both Angels also
imply that touch, through sex, is impossible.

As shown here, the erroneous division of the
body from the soul brings torment and fear.
The hellfire from which Energy unsuccessfully
struggles to escape is an illustration of Error '3' –
'That God will torment Man in Eternity for
following his Energies' – with Blake's
'Contraries' (2, 3) to this state of obvious pain
being that body and soul as one bring 'Energy
[which] is Eternal Delight'. RH

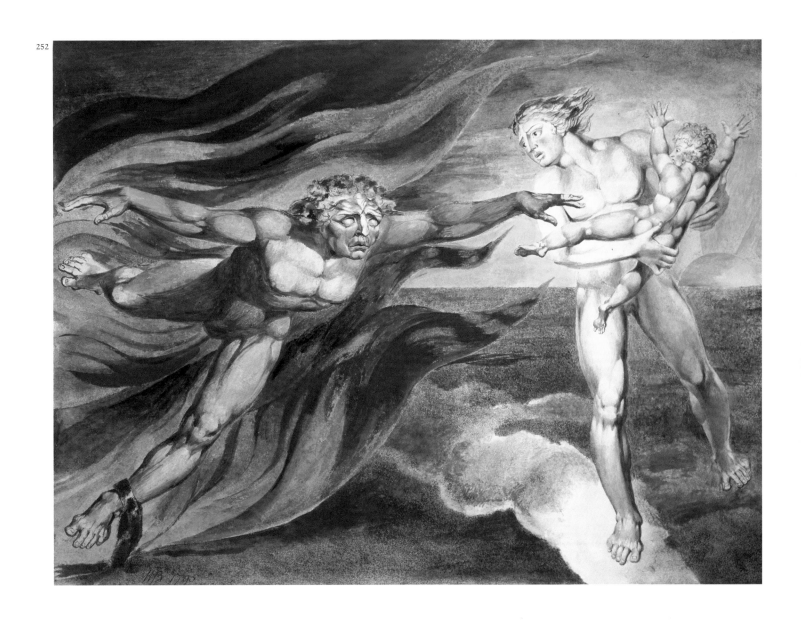

253 Christ Appearing to the Apostles after the Resurrection *c.*1795

Colour print finished in ink and watercolour
and varnish on paper 40.6 × 49.9 (16 × 19⅝)
Tate; bequeathed by W. Graham Robertson 1948
Lit: Butlin 1981, no.327; Butlin 1990, no.34

This print illustrates verses 36–40 of chapter 24
of St Luke's Gospel describing Christ appearing
to his disciples after the Resurrection and
showing them the wounds of his crucifixion:

> … they were terrified and affrighted, and
> supposed that they had seen a spirit. And
> he said unto them, Why are ye troubled?
> And why do thoughts arise in your hearts?
> Behold my hands and my feet, that it is I
> myself: handle me, and see; for a spirit
> hath not flesh and bones, as ye see me
> have. And when he had thus spoken, he
> shewed them his hands and his feet.

Along with the Old Testament subject of *Naomi
Entreating Ruth and Orpah to Return to the Land of
Moab* (no.246), *Christ Appearing*, with its theme
of resurrection and salvation, is one of the most
positive of the large colour print subjects. If the
idea of Blake conceiving his subjects in pairs
is followed, then compositionally and
thematically *Christ Appearing* can be seen as
paired with the *The House of Death* (no.251).

There are three known impressions of
the print. This one was varnished in the
nineteenth century and the image has become
obscured. However, the pigments on the paper
are quite thin and this is an indication that the
impression was probably the last of the three
to be made by Blake. RH

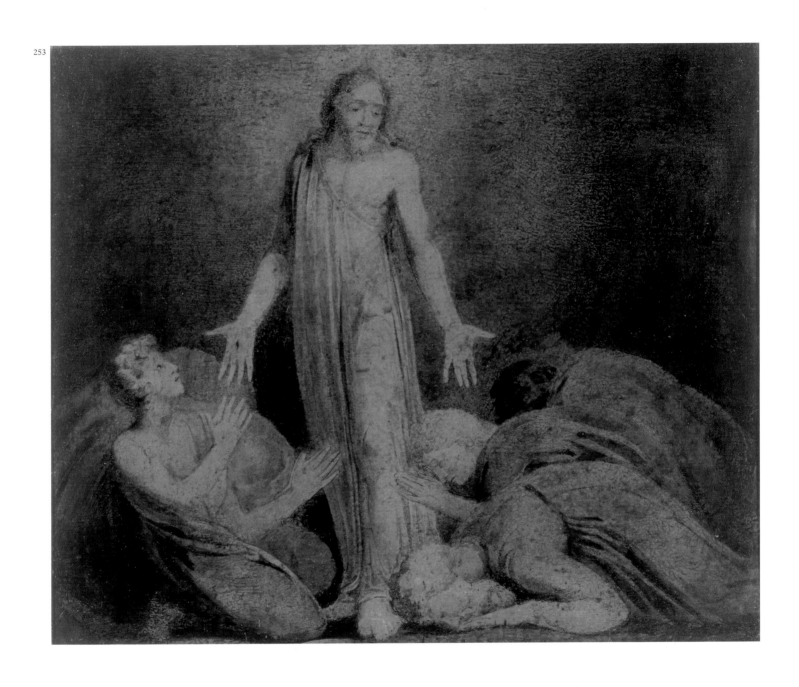

The inspiration of Milton

254 Milton c.1800–3
Pen and ink and tempera on canvas 40.1 × 90.9
(15¾ × 35¾)
Manchester City Art Galleries
Lit: Wells and Johnston 1969; Butlin 1981, no.343 11

This is one of eighteen heads of poets
commissioned by William Hayley as decorative
panels for his library at Felpham. The series,
began around November 1800 and completed in
1803, also included Homer, Demosthenes,
Cicero, Dante (no.64), Chaucer, Camões,
Ercilla, Tasso, Spenser, Shakespeare, Voltaire,
Dryden, Otway, Pope, Klopstock, Cowper and
Thomas Alphonso Hayley, the illegitimate son
of William Hayley who had died in 1800 aged
nineteen. Milton's head is presented as a fictive
carved medallion, surrounded by a wreath of
oak leaves, its stony countenance recalling
Blake's early drawings of effigies in Westminster
Abbey. It is framed on the left by a harp
decorated with an angel and on the right by pan-
pipes, respective emblems of epic and pastoral
poetry. Entwined around the medallion is a
serpent with an apple, a reference to the Fall of
Man in the Garden of Eden and to *Paradise Lost*.
MJP

**255 Sketch for Milton, Plate 41: Milton and
Ololon c.1804–6**
Pencil on paper 16.5 × 11.1 (6½ × 4⅜)
The Victoria & Albert Museum
Lit: Butlin 1981, no.560

The identity of the protagonists in plate 41 of
Milton, for which the present drawing is a study,
is by no means certain, since there is no clear
reference to the episode in Blake's text. The
standing figure has been identified as Milton,
the slumped figure as his Emanation, Ololon.
That being so, the plate may refer to the first
lines on plate 42: 'Before Ololon Milton stood
& percieved the Eternal Form / Of that mild
Vision'. However, the slumped figure is perhaps
Urizen, the plate referring then to Ololon's
words spoken to Milton a little later: 'I see thee
strive upon the Brooks of Arnon. there a dread /
And awful Man I see, oercoverd with the mantle
of years. / I behold Los & Urizen' (plate 42, lines
4–6). In the pencil sketch the slumped figure,
which is only partially clothed, appears less akin
to Urizen than in the final plate, although its
identity remains elusive. MJP

**256 Milton Rising up from the Heavens
of Albion**
Milton: **plate 13 (second state)**
Colour-printed relief etching 16 × 11.1 (6¼ × 4⅜)
on paper 21.3 × 15.4 (8⅜ × 6)
Philadelphia Museum of Art; gift of
Carl Zigrosser
Lit: Essick and Viscomi 1993

> Then Milton rose up from the heavens
> of Albion ardorous!
> The whole Assembly wept prophetic,
> seeing in Miltons face
> and in his lineaments divine the shades
> of Death & Ulro
> He took off the robe of the promise,
> & ungirded himself from
> the oath of God
> (*Milton*, Book 1, pl.12, lines 10–14)

This impression of plate 13 of *Milton* indicates
the appearance of the plate before hand
colouring by the artist (compare fig.3, p.21). In
this plate, in the Title-Page and in plates 38 and
41, Blake employed a new etching process that
he described as 'Woodcut on Copper'. This
process, which was a form of white-line relief
etching, produced the effect of a white line
drawn upon a sheet of black paper. In its finished
state the technique results in a heavy, rough-
hewn image with sharp contrasts between dark
and light, a contrast that reflects the stark and
sublime world inhabited by his protagonist.

Milton's removal of clothing represents his
rejection of the rational and materialistic code
that has hampered his art and his imagination.
More specifically, in his reference to 'the robe of
the promise' and 'the oath of God' Blake has
Milton renounce the thirty-nine articles of the
Anglican Church to which he had subscribed as a
graduate at Cambridge. In assuming a Christ-
like aspect Milton confirms his rejection of the
old order, the punitive creed of the Old
Testament. His stance and aura also confirm his
allegiance to the spirit of Los, and to the world of
the imagination. MJP

254

255

Milton when Young

257 John Milton when Young *c.*1819
Pencil on paper 25.4 × 20.3 (10 × 8)
Inscr. 'Milton when Young' l.c. and 'Milton' l.r.
From *The Larger Blake-Varley Sketchbook* p. 46 verso
Private Collection

The head of Milton when young is one of a series
of 'visionary heads' made in 1819 at the behest of
the watercolourist John Varley, whom John
Linnell had introduced to Blake the previous
year. The appearance of Milton in such a session
must have owed a lot to Blake's identification
with him as a lover of liberty – notably during
Oliver Cromwell's Commonwealth – and
Milton's belief in a people's right to pass
judgement on monarchs and ministers. Varley
commissioned him to make portrait drawings of
the heads of spirits he arbitrarily conjured up in
connection with Varley's *Treatise on Zodiacal
Physiognomy*. These drawings, many of them
made in the small hours at Varley's home, were
apparently taken at face value by Blake's host –
Linnell recalled that 'Varley believed in the
reality of Blake's visions more than even Blake
himself' (Butlin 1978, p. 8). Aside from Milton,
the products of these sessions included *The Ghost
of a Flea* (nos. 237, 238). Varley, who cherished
the drawings, used a number of them as
illustrations to his *Treatise*, complete with
designated star signs. Although the drawings
are quite atypical of Blake, Victorian critics
believed they represented significant evidence
of his mental instability. MJP

Illustrations to
Paradise Lost, 1808

Although he is little read today outside academic circles, Milton was in the eighteenth and early nineteenth centuries still recognised as England's great epic poet and *Paradise Lost* as his epic masterpiece. Blake had regarded him since childhood with reverence, giving rise to his celebrated observation that the 'reason Milton wrote in fetters when he wrote of Angels & God, and at liberty when of Devils & Hell, is because he was a true Poet and of the Devils Party without knowing it'. For artists as well as writers Milton represented the apogee of native epic poetry. In his celebrated self-portrait (Tate) Hogarth had quite literally rested his reputation as a painter of High Art upon Milton, propping his *trompe-l'oeil* canvas on a volume of his works. Later in the century a host of artists including James Barry, Henry Fuseli and Thomas Lawrence fostered their ambitions as history painters through illustrations of Milton. Blake, too, received numerous commissions for illustrations to Milton, including two series based on *Paradise Lost*, the first in 1807 and the second, which is illustrated here, in 1808. MJP

258 Satan Arousing the Rebel Angels
Pen and watercolour, irreg. 51.8 × 39.3
(20⅜ × 15½)
Signed 'WBlake 1808' b.l.
The Victoria & Albert Museum
Lit: Dunbar 1980, pp.43–7; Butlin 1981, no.536 1
Paradise Lost I, lines 300–334

> They heard, and were abasht, and
> up they sprung
> Upon the wing, as when men wont
> to watch
> On duty, sleeping found by whom
> they dread,
> Rouse and bestir themselves ere
> well awake.
> (I, 331–4)

Satan calls to conference the fallen rebel angels, including Beelzebub, who reclines upon a rock, and the bearded figure of Death, spread-eagled in the centre foreground. Collectively, their heroic nudity and expressive attitudes reveal Blake's fascination with the Antique mediated through the example of Michelangelo, notably the Last Judgement fresco from the Sistine Chapel. The present watercolour originally belonged to Thomas Butts, but was separated from the main body of the series in the mid-nineteenth century. It is one of four versions of the subject, which include two tempera versions and one other watercolour (The Huntington Art Collections), made for the 1807 series and commissioned by the Revd Joseph Thomas. MJP

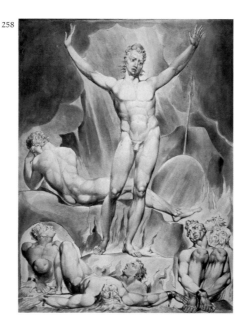

258

259 Satan, Sin and Death: Satan Comes to the Gates of Hell *c.*1806
Pen, gold and watercolour 49.5 × 40.3
(19½ × 15⅞)
Signed 'WB inv' in monogram b.l.
The Huntington Library, Art Collections and Botanical Gardens
Lit: Dunbar 1980, pp.48–53; Butlin 1981, no.536 2
Paradise Lost II, lines 645–734

> … and now great deeds
> Had been achiev'd, whereof all Hell
> had rung,
> Had not the Snakie Sorceress that sat
> Fast by Hell Gate, and kept the fatal Key,
> Ris'n, and with hideous outcry rusht
> between.
> (II, 722–6)

'Satan, Sin and Death' was one of the most popular Miltonian subjects in British eighteenth-century art, notable precursors including Hogarth, Mortimer, Fuseli, Gillray and James Barry, whose etching of *c.*1792–5 anticipates Blake's own heroic treatment of the protagonists. Now kept with the first series of illustrations to *Paradise Lost* made in 1807 for the Revd Joseph Thomas of Epsom, the present version of *Satan, Sin and Death* appears to be one of the 'lost' plates from the second series made for Thomas Butts. These illustrations are larger, and the figures more physically robust and strongly defined than in the first set. Blake's attentive response to Milton's text is apparent in the transparent figure of Death to the right, recalling Milton's description of Death as the 'shaddow … that shape had none' (II, 667–9). MJP

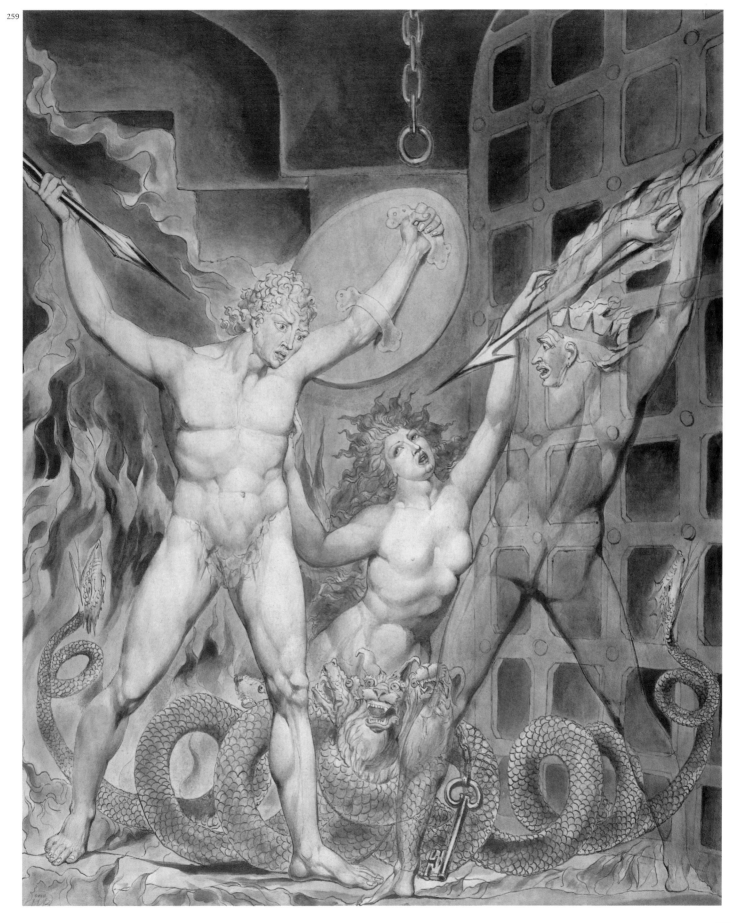

260 Christ Offers to Redeem Man

Pen and watercolour 49.6 × 39.3 (19½ × 15½)
Signed 'WBlake 1808' b.l.
Museum of Fine Arts, Boston; gift by
subscription, 1890
Lit: Dunbar 1980, pp.53–6; Butlin 1980, no.536 3
Paradise Lost III, lines 222–352

> … I for his sake will leave
> Thy bosom, and this glorie next to thee
> Freely put off, and for him lastly die
> Well pleas'd, on me let Death wreck all
> his rage
> (III, 238–41)

Blake's account of Christ's offer to sacrifice his
own life to redeem mankind departs from
Milton's intention in the contrast he draws
between the vital, beatific presence of the Son
and the slumped, Urizenic figure of the Father,
portrayed as a faceless, repressive and
hypocritical Jehovah of the Old Testament.
Flanking Christ are four symmetrically
disposed angels, who bear Christ down towards
earth. They offer up crowns in adoration, a
reference presumably to the 'Fourfold' aspect
of man found in Blake's *Jerusalem* (plate 98).
Below lies Satan, 'Coasting the wall of heav'n
on this side Night / In the dun Air sublime'
(III, 71–2). Now wearing his familiar bat-wings
(as in no.243), he is isolated physically and
spiritually from the other figures by a band of
cloud. MJP

**261 Satan Watching the Endearments of Adam
and Eve**

Pen and watercolour 50.7 × 38.2 (20 × 15)
Signed 'WBlake 1808' (twice) b.r.
Museum of Fine Arts, Boston; gift by
subscription, 1890
Lit: Dunbar 1980, pp.56–61; Butlin 1981, no.536 4
Paradise Lost IV, lines 325–534, 495–8, 501–4

> Under a tuft of shade that on a green
> Stood whispering soft, by a fresh
> Fountain side
> They sat them down, and after no
> more toil
> Of thir sweet Gardning labor
> than suffic'd
> To recommend cool *Zephyr*, and
> made ease
> More easie, wholsom thirst and appetite
> More grateful, to thir Supper Fruits
> they fell,
> Nectarine Fruits which the compliant
> boughes
> Yielded them, side-long as they sat recline
> On the soft downie bank damaskt
> with flowrs.
> (IV, 325–34)

Blake collates several passages from Milton's
text, characteristically adding his own
embellishments and 'corrections'. In a reaction
against Milton's puritanical prudishness Eve's
'loose tresses' no longer cover her breasts. Adam
and Eve pluck flowers, he a thrusting lily and she
a wilting rose – respective symbols of the
immortal beauty of the soul and the transient
beauty of the body, and an indication in turn of
Eve's role on precipitating the Fall. Flanking the
figures are palm fronds, symbolising Christ's
entry into Jerusalem on Palm Sunday. Above,
Satan hovers, a serpent coiled around his loins.
As Satan's worried and quizzical expression
indicates, it is the serpent's scheme to lure Eve
into temptation. Thus, Satan is represented not
as fundamentally evil but divided, ensnared by
his own fallibility. MJP

262 Adam and Eve Asleep

Pen and watercolour 49.2 × 38.8 (19⅜ × 15¼)
Signed 'WBlake 1808'
Museum of Fine Arts, Boston; gift by
subscription, 1890
Lit: Dunbar 1980, pp.61–2; Butlin 1981, no.536 5
Paradise Lost IV, lines 771–809

> … him there they found
> Squat like a Toad, close at the ear of *Eve*,
> Assaying by his Devilish art to reach
> The Organs of her Fancie, and with
> them forge
> Illusions as he list, Fantasms
> and Dreams
> (IV, 799–803)

Having made love, Adam and Eve, 'lulld by
nightingales', fall into a sleep. Night descends
and Cherubim are dispatched to patrol the
heavens 'in warlike Parade'. To the Garden of
Eden Gabriel sends the angels, Ithuriel and
Zephon, 'two strong and suttle spirits', who
find Satan beside Eve's ear, disguised as a toad.
Blake's depiction of Satan as a toad in the ear
of Eve appears only in the second series of
illustrations for Thomas Butts, replacing
'Raphael's Descent into Paradise', the intention
being to emphasise the role of Satan in the Fall
and Eve's specific vulnerability and frailty. Eve,
open to suggestion and physically detached
from Adam, inhabits the Blakean state of
Beulah, a necessary stage of her journey towards
spiritual redemption and reunion with her
male counterpart. MJP

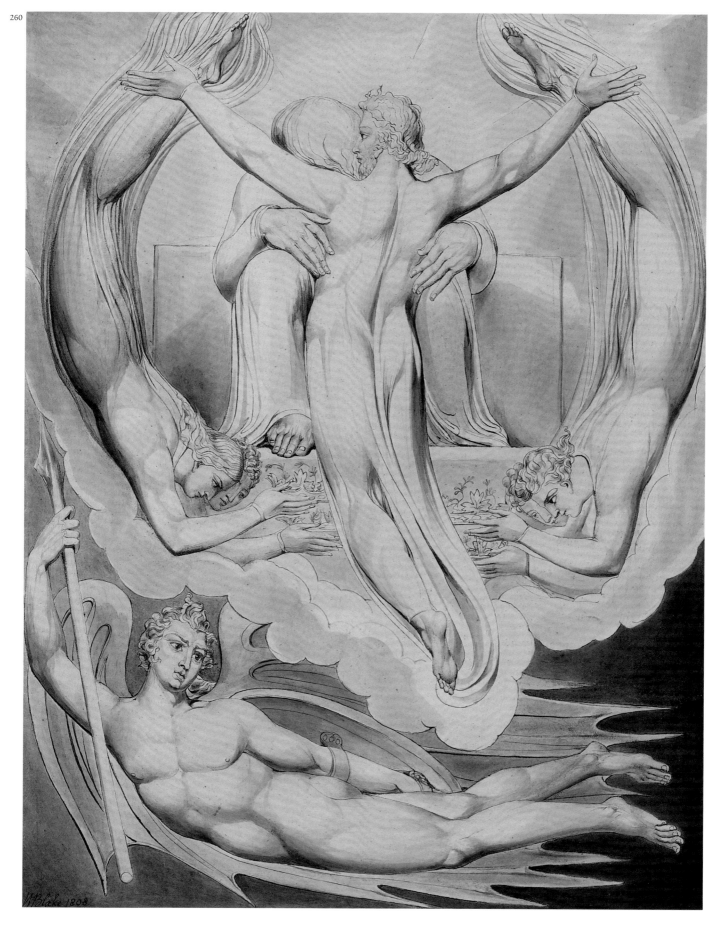

260

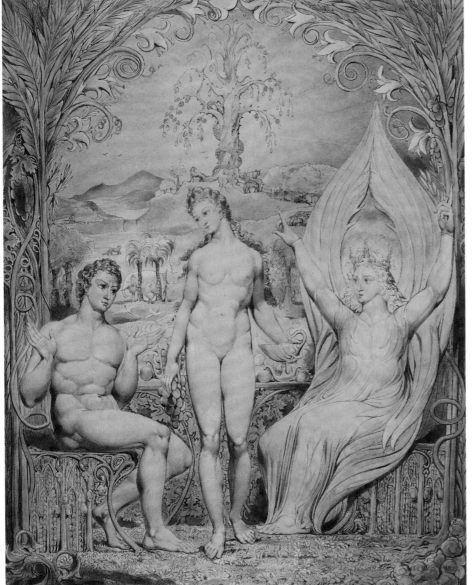

Raphael Warns Adam and Eve
Pen and watercolour 49.7 × 39.7 (19⅝ × 15⅝)
Signed 'WBlake 1808' b.r.
Museum of Fine Arts, Boston; gift by
subscription, 1890
Lit: Dunbar 1980, pp.68–72; Butlin 1981, no.536 6
Paradise Lost V, lines 377–85, 443–50, 512–28

> They came, that like *Pomona*'s Arbour
> smil'd
> With flowrets deckt and fragrant smells,
> but *Eve*
> Undeckt, save with her self ...
> Stood to entertain her guest from Heav'n
> (V, 378–80, 383)

Eve ministers to Adam, seated at the left, and
Gabriel on the right. Adam, who has been
warned not to eat the fruit of the Tree of
Knowledge, listens to Gabriel's warning of the
sin of disobedience: 'Son of Heav'n and Earth, /
Attend: That thou art happie, ow to God; / That
thou continu'st such, owe to thy self, / That is, to
thy obedience; therein stand' (V, 519–22). Behind
them, framed by the fronds of the bower is the
Tree of Knowledge, the serpent coiled around its
thorn-covered trunk. Underlining the
consequences of disobedience, Raphael points
with his right hand to the Tree, and with his left
to the bower, presently their home. The central
position of Eve and her apparent inattention to
Gabriel's warning emphasises her own
culpability. MJP

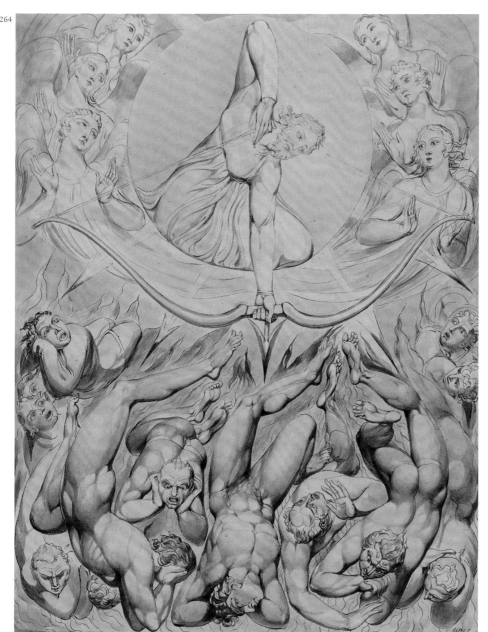

264

264 The Rout of the Rebel Angels

Pen and watercolour 49.1×38.2 (19⅜×15)
Signed 'WBlake 1808' b.r.
Museum of Fine Arts, Boston; gift by
subscription, 1890
Lit: Dunbar 1980, pp. 64–8; Butlin 1981, no. 536 7
Paradise Lost VI, lines 835–66

Raphael describes the rout of the rebel angels by
the Messiah to Adam and Eve: 'Nor less on either
side tempestuous fell / His arrows, from the
fourfold-visag'd Four' (VI, 844–5). At that point
the crystal wall of heaven opens:

> … the monstrous sight
> Strook them with horror backward, but
> far worse
> Urg'd them behind; headlong themselves
> they threw
> Down from the verge of Heav'n, Eternal
> wrauth
> Burnd after them to the bottomless pit.
> (VI, 862–6)

In the upper half of his diagrammatic
composition Blake positions the Messiah, bow
in hand; below the rebel angels tumble into the
pit, their howling visages and naked, tangled
limbs reminiscent of the damned souls in
Michelangelo's *Last Judgement*. Blake contains
the kneeling figure of Christ within a circle,
creating a formal association between the Son of
God and the Sun. Blake also makes this equation
with Los, who is in turn regarded by Blake
as an incarnation of Christ and a cipher for
redemption, routing 'error' through the
power of the artistic imagination. The 'Bow
of burning gold' and 'Arrows of desire' figure
metaphorically in the Preface to Blake's *Milton*
as weapons in the fight for artistic and spiritual
regeneration. Here, too, as indicated by Christ's
beatific expression, the rout of Satan is not a
victory over an external enemy but a struggle
to cast out the devils that exist in the mind and
divide the self. MJP

265 The Creation of Eve

Pen and watercolour 50.3 × 40 (19¾ × 15¾)
Signed 'WBlake 1808' b.r.
Museum of Fine Arts, Boston; gift by
subscription, 1890
Lit: Dunbar 1980, pp.72–5; Butlin 1981, no.536 8
Paradise Lost VIII, lines 452–77

> Under his forming hands a Creature grew,
> Manlike, but different Sex, so lovely faire
> That what seemd fair in all the World,
> seemed now
> Mean, or in her summd up, in her
> containd
> And in her looks, which from that time
> infus'd
> Sweetness into my heart, unfelt before,
> And into all things from her Air inspir'd
> The spirit of love and amorous delight
> (VIII, 470–77)

In *Paradise Lost* the creation of Eve is related
retrospectively to Raphael by Adam, who
observes the act through his 'internal sight'
while sleeping, his body inert upon the earth.
Earlier (c.1803), in his illustration of the creation
of Eve based upon the account in Genesis (2:2),
'The Angel of the Divine Presence Bringing Eve
to Adam', Blake had depicted the act as the
repressive division of man from his female
Emanation by the Urizen-like Jehovah of the
Old Testament. Here Blake replaces Jehovah
with the benign presence of Christ, who stands
in profile with his right arm raised above Eve's
head in an uplifting gesture to indicate that her
creation is a necessary step on the path to the
spiritual redemption. MJP

266 The Temptation and Fall of Eve

Pen and watercolour 49.7 × 38.7 (19⅝ × 15¼)
Signed 'WBlake 1808' b.l.
Museum of Fine Arts, Boston; gift by
subscription, 1890
Lit: Dunbar 1980, pp.75–8; Butlin 1981, no.536 9
Paradise Lost IX, lines 780–4

Finding Eve alone, the Serpent tells Eve that his
powers of speech and reason were gained
through eating fruit from the Tree of
Knowledge, and succeeds in persuading her to
partake:

> … her rash hand in evil hour
> Forth reaching to the Fruit, she pluckd,
> she eat:
> Earth felt the wound, and Nature from
> her seate
> Sighing through all her Works gave signs
> of woe,
> That all was lost
> (IX, 780–4)

The sensual aspect of the Temptation is given
full rein by Blake who depicts the giant Serpent
coiled around the naked body of Eve, who
guides its path with open hands. The Serpent's
phallic status is further emphasised by the
vibrant use of colour, its track across her
pudenda, and the oral transfer of the forbidden
fruit from its jaws to her open mouth. Eve's
complicity with the Serpent, and the intimate
nature of the act is underlined by the remoteness
of Adam, whose back is turned and whose
attention is focused upon the impending storm,
a portent of Adam's own Fall. MJP

267 Michael Foretells the Crucifixion

Pen and watercolour 50.1 × 38.1 (19¾ × 15)
Museum of Fine Arts, Boston; gift by
subscription, 1890
Lit: Dunbar 1980, pp.83–6; Butlin 1981, no.536 11
Paradise Lost XII, lines 411–19, 427–31

Before Adam is expelled from Paradise,
the future of the world from the Flood to the
incarnation, death and resurrection of Christ
is revealed to him by the Archangel Michael:

> … he shall live hated, be blasphem'd,
> Seiz'd on by force, judg'd, and to death
> condemnd
> A shameful and accurst, naild to
> the Cross
> By his own Nation
> (XII, 411–14)

Exceptionally, Blake chose to illustrate two
episodes from Book 12 of *Paradise Lost*, the first
being Michael's account of the Crucifixion.
To the left of the cross stands the winged figure
of Michael, to the right Adam who gazes up
towards the face of Christ. The Serpent's head
is nailed to the cross beneath Christ's feet,
immediately below him the slumped bodies
of Sin and Death. Eve, who was not privy to
Michael's prophecy, lies cocooned in the
foreground, her attitude recalling that of Adam
during her own creation. MJP

265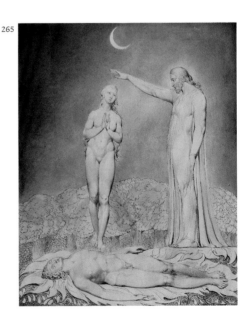

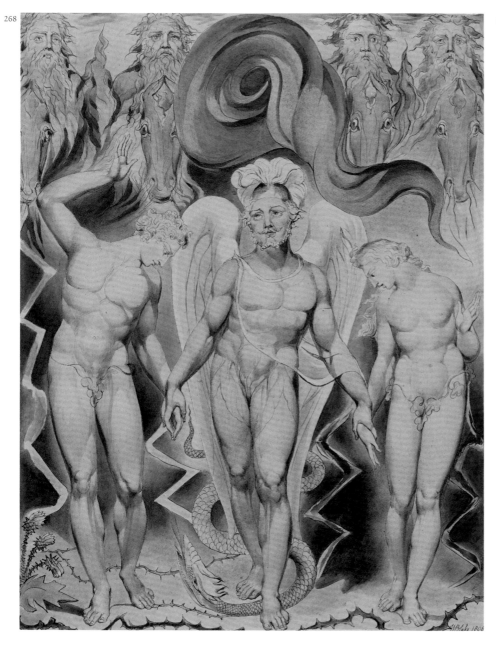

268

The Expulsion of Adam and Eve from the Garden of Eden

Pen and watercolour 50 × 38.8 (19⅝ × 15¼)
Signed 'WBlake 1808' b.r.
Museum of Fine Arts, Boston; gift by subscription, 1890
Lit: Dunbar 1980, pp.86–90; Butlin 1981, no.536 12
Paradise Lost XII, lines 637–44

> In either hand the hastning Angel caught
> Our lingring Parents, and to th'
> Eastern Gate
> Led them direct, and down the Cliff as fast
> To the subjected Plain; then disappear'd.
> (XII, 637–40)

The Archangel Michael leads Adam and Eve by hand out of the eastern gate of Paradise. At their feet are thorns and thistles, emblematic of the pain and hardship that await them in the outside world, and of Christ's crown of thorns, which lead ultimately to redemption. Accompanying them also is the Serpent, snapping at the heels of Adam, who retaliates by raising his hand in anger towards it. Above Michael's head is a huge coiled flame, the 'brandisht Sword of God' which 'before them blaz'd / Fierce as a Comet' (XII, 633–4). Ranged at either side of the coiled flame, and guarding the gate, are four Urizen-like 'dreadful faces' of 'flaming Warriors' (XI, 101). These mounted figures, while they may possibly allude to the four horsemen of the Book of Revelation, are also the constituent parts of the divided, fourfold aspect of mankind (the Four Zoas) found in *Jerusalem*: 'One to the West One to the East One to the South One to the North, the Horses Fourfold' (no.303 pl.98,). MJP

Illustrations to 'L'Allegro' and 'Il Penseroso', c.1816–20

269 **'L'Allegro' III: The Sun at his Eastern Gate**
Pen and watercolour 16 × 12.2 (6⅜ × 4⅞)
Signed 'WBlake inv' b.l.
The Pierpont Morgan Library, New York
Lit: Dunbar 1980, pp.129–33; Butlin 1981, no.5433
'L'Allegro', lines 57–68

> Som time walking not unseen
> By Hedge-row elms, on Hillocks green,
> Right against the Eastern gate,
> Where the great Sun begins his state,
> Rob'd in flames and Amber light,
> The clouds in thousand Liveries dight;
> ('L'Allegro', 57–62)

Blake's twelve illustrations to Milton's
'L'Allegro' and 'Il Penseroso' were purchased by
Thomas Butts. In these poems Milton captured a
series of moods ranging from mirth (see no.236)
to melancholy experienced by a gentleman in
the course of his daily round. Although Milton
did not specify any autobiographical intent,
Blake used the series to pursue his own legend
concerning the evolution of Milton's poetic
genius and his spiritual regeneration. In the
third illustration to 'L'Allegro' a youthful sun-
god stands within a large mandorla of flame.
He is also Los, like Blake the redeeming spirit of
poetry and the imagination. In his note which
accompanied the illustration Blake wrote:

> The Great Sun is represented clothed in
> Flames Surrounded by the Clouds in their
> Liveries, in their various Offices at the
> Eastern Gate. beneath in Small Figures
> Milton walking by Elms on Hillocks
> green The Plowman. The Milkmaid The
> Mower whetting his Scythe. & The
> Shepherd & his Lass under a Hawthorne
> in the Dale.

MJP

269

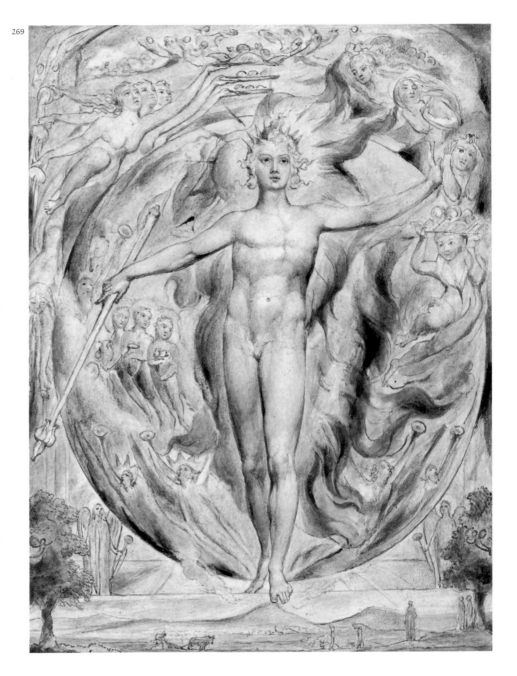

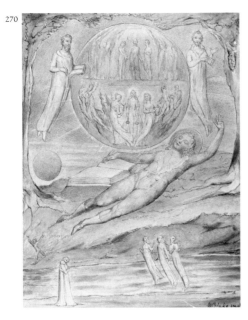

270 'L'Allegro' VI: The Youthful Poet's Dream
Pen and watercolour 16.1×12 (6⅜×4¾)
Signed 'WBlake inv' b.r.
The Pierpont Morgan Library, New York
Lit: Dunbar 1980, pp.139–43; Butlin 1981, no.543 6
'L'Allegro', lines 125–6, 128–34

> There let *Hymen* oft appear
> In Saffron robe, with Taper clear,
> And pomp, and feast, and revelry,
> With mask and antique Pageantry,
> Such sights as youthful Poets dream
> On Summer eves by haunted stream.
> ('L'Allegro', 125–30)

Milton lies beneath a large globe that contains his dream, mediated by spirits of Shakespeare and Ben Jonson who stand on either side of the globe. Milton, in the garb of a romantic youth, is recumbent upon a bank, airily waving his hand to conjure up the vision that is to be committed to the large book under his right arm. His closed eyes indicate that his inspiration is not the natural world about him but his inner vision. The sun of the natural world is thus shown as pale and inconsequential compared to the great globe of vision suspended above the poet. The globe itself is divided into two hemispheres, the figures appearing to move from the lower to the upper part, from the material to spiritual world. In the lower left a demon flees – one of the 'eating cares' expelled by Mirth. In the left foreground the figures of Orpheus and Eurydice embrace, a symbolic union of the male and his female Emanation. Beyond, to the right, are the three Fates who measure out Time Past, Time Present and Time Future. MJP

271 'Il Penseroso' V: Milton's Mysterious Dream
Pen and watercolour 16.3×12.4 (6⅞×4⅞)
Signed 'WBlake inv' b.l.
The Pierpont Morgan Library, New York
Lit: Dunbar 1980, pp.157–9; Butlin 1981, no.543 11
'Il Penseroso' lines 139–40, 145–54

> And the Waters murmuring,
> With such consort as they keep,
> Entice the dewy-featherd Sleep;
> And let som strange mysterious dream
> Wave at his Wings in Airy stream
> Of lively portraiture displayd,
> Softly on my eye-lids laid.
> ('Il Penseroso', 144–50)

Blake noted:

> Milton Sleeping on a Bank; sleep descending, with a Strange Mysterious dream upon his Wings of Scrolls & Nets & Webs unfolded by Spirits in the Air & in the Brook around Milton are Six Spirits of Fairies hovering on the air, with Instruments of Music.

At this point in his life Milton remains in a state of Error bound by the material world. His debased sexuality is released only in slumber, as the crossed hands upon his lap indicate. The 'globe of vision' above his head is a two-dimensional disc. Contained within it are three unhappy figures representing the Arts. Painting covers his eyes, Music closes his ears, Poetry alone looks up to heaven in search of redemption. Between Painting and Poetry is the repressive figure of Jehovah, who controls the Arts. Milton, who lies in a cocoon-like state, awaits transformation, guarded by the six female spirits that surround him, the 'Six Fold Emanation', that simultaneously represents Milton's wives and daughters with whom he will be spiritually reunited. MJP

272 Milton a Poem / in 12 Books 1804/1811
'The Author / & Printer W Blake / 1804 / To
Justify the Ways of God to Men'
Copy A 1811
19 plates (1–4, 8, 15–17, 20–1, 29, 30, 32–3, 36–7, 41,
43–5) out of 45
Relief etching and white line engraving printed
in black ink finished with watercolour and grey
wash approx. 16×11.5 (6¼×4½) on paper
approx. 23.7×17.6 (9⅜×6⅞)
The British Museum, London
Lit: E.95–144; Essick and Viscomi 1993 (facsimile Copy
C); Viscomi 1993, pp.315–29

> And did those feet in ancient time,
> Walk upon Englands mountains green:
> And was the holy Lamb of God,
> On Englands pleasant pastures seen!

These lines are familiar as the opening stanza
of 'Jerusalem', the great unison choral song
composed by Sir Hubert Parry during the First
World War to words by William Blake. During
the twentieth century 'Jerusalem' gained the
status of a sacred national anthem. Yet it
generally comes as some surprise to learn that
they are not taken from Blake's own prophetic
book *Jerusalem* but from the Preface (pl.2) to his
less well-known *Milton*, the most personal and
autobiographical of his illuminated books.
Milton, like Parry's subsequent anthem, was
written at a time of war, when the ideal of
England's 'green and pleasant land' was
threatened by international conflict and
disorder. Blake's struggle, however, was not
against the threat of French imperial might
or the 'dark Satanic Mills' spawned by the
Industrial Revolution, but a 'mental fight' to
recover the poetic Christian soul of the English
artist. To this effect he vainly sought to rally a
whole new generation of artists, 'Young Men
of the New Age', to reject the materialist,
secular, classical culture of the eighteenth
century, in which art had become a service
industry, in favour of an independent,
emotional and imaginative art, which drew
on ancient native traditions.

Blake's poem was an attempt to liberate
and spiritually rehabilitate Milton, while at the
same time exploring the potential of his own
prophetic voice. Rejecting conventional
perceptions of Milton as a moral preceptor, he
challenged his reading of the creation myth in
Paradise Lost as a battle between God and Satan,
in which the world was divided between good
and evil, the spiritual and the material.
According to Blake's cosmology, Satan was not

fundamentally evil, but a source of misdirected
creative energy. It was the repression and
subversion of energy and desire that Blake
regarded as the principal subjugation of true
artistic endeavour. In his animadversion on
Milton's *Paradise Lost* Blake chose, therefore,
to relive with him the journey of his mental
battles, and achieve a catharsis whereby Milton
recognises his errors and erases his own selfhood
in order to achieve spiritual regeneration.

Milton was conceived, in great measure, as a
reaction to the spiritual and intellectual mid-life
crisis that Blake underwent in the years
immediately after 1800, when he left Lambeth
(see pl.4) to live at Felpham on the Sussex coast
(pl.36). Blake was at first invigorated by the
peace and beauty of his new surroundings.
'Heaven', he wrote, 'opens here on all sides her
golden Gates her windows are not obstructed
by vapours … voices of Celestial inhabitants are
more distinctly heard & their forms more
distinctly seen & my Cottage is also a Shadow of
their houses' (to Flaxman 21 Sept. 1900; E.710).
Inspired to write, Blake began to compose an
epic prophetic poem, which he described to
Thomas Butts on 25 April 1803 as 'the Spiritual
Acts of my three years Slumber on the banks
of the Ocean' (E.728). This unnamed poem was
probably *The Four Zoas* (or *Vala*), begun around
1797. At the same time Blake was enervated by
the menial tasks set him by his patron Hayley,
a man without a shred of self-doubt, who cast
himself in the role of Blake's mentor. In the
summer of 1803, as he was preparing to return to
London, Blake's conviction that dark forces were
conspiring to fetter his vision appeared to be
confirmed when he was charged with sedition
after frog-marching a drunken soldier out of his
garden (*Milton*, pl.17: 'Scofield is bound in iron
armour before Reubens Gate!'). The ensuing
trial in January 1804 (see nos.208–11), which
resulted in Blake's acquittal, left him both
exhausted and elated, and quite determined
that the events, sensations and nightmares of
the past three years should serve as grist to his
'dark Satanic Mill'.

Blake appears to have begun to etch *Milton*
in 1804, the date on the Title-Page of the poem
(pl.1). Altogether he printed and hand-coloured
four copies of this illuminated book, each of
between forty-five and fifty pages. Blake claimed
on the Title-Page that the poem encompassed
twelve volumes, although only two
materialised. As Joseph Viscomi has shown,
through a painstaking reconstruction of Blake's
printing technique and methods, the

illuminated book was almost certainly not
transcribed from a pre-existing text but evolved
organically, page by page. The first three (known
as Copies A, B and C) were completed and
printed in the same run around 1810–11, a fourth
(Copy D) appearing by 1818. Blake set his own
timetable and deadlines for production, the sale
price of ten guineas bearing no economic
relation to the mental and physical effort that
went into them. And while he sold the first two
copies, Blake retained the third, restructuring it
over and again, removing and adding plates, as
he reshaped his own vision and the memories of
those events and the inner turmoil that had
precipitated them.

The basic narrative structure of *Milton* can
be summarised as follows. In Book One Milton
descends from the heavens in the form of a
comet and enters Blake's left foot (pl.29).
Conjoined with Blake, Milton is shown that
his failure to annihilate his selfhood and his
reliance on reason and intellect have perverted
his poetic vision and corrupted his relations
with wives and daughters, who respond with
confused signals of desire and denial (pl.16).
Blake, infused with the spirit of Milton, gains
a renewed vision of the beauty that exists in the
material world (and that he had so appreciated
during his sojourn at Felpham). As Blake is
enlightened, Milton recognises his own Error,
reaching out to sculpt the form of, and struggle
with, Blake's age-old enemy Urizen, destroying
this false prophet and simultaneously
annihilating his own selfhood (pl.15). At this
stage Milton, however, remains separated from
his female Emanation (Ololon), divided and
unredeemed. Book Two, which opens with a
description of Beulah (pl.30), announces the
arrival of Ololon, who follows Milton back to
earth to consummate their spiritual union.
Before her Milton recants, declaring his
intention (pl.43):

> To cast off Rational Demonstration by
> Faith in the Saviour
> To cast off the rotten rags of Memory by
> Inspiration
> To cast off Bacon, Locke & Newton from
> Albions covering
> To take off his filthy garments, & clothe
> him with Imagination
> To cast aside from Poetry, all that is not
> Inspiration

Ololon, in response, sacrifices her own selfhood
and is united with Milton's shadow. Thus,

through the agency of Blake, Milton's false edifice of the created world is destroyed, Milton himself is united with Jesus Christ, and 'All Animals upon the Earth, are prepard in all their strength / To go forth to the Great Harvest and Vintage of the Nations' (pls.44, 45).

Blake's *Milton*, involving the protagonist's recognition of Error followed by redemption, would appear, from the précis offered here, linear in construction and quite comprehensible in form. However, the underlying intricacies of multiple and shifting identity, the contorted complexities of time, space and scale are not at all easy to grasp. Among the most perplexing and alluring aspects of *Milton* is its conception of space (pl.17):

> Four Universes round the Mundane Egg remain Chaotic
> One to the North, named Urthona: One to the South, named Urizen:
> One to the East, named Luvah: One to the West, named Tharmas
> They are the four Zoa's that stood around the Throne Divine!

'Milton's track' (pl.32) bisects the overlapping spheres of Luvah and Urizen – the zones of desire and reason, moving on through the realm of Satan (the selfhood that Milton is to annihilate) to Adam, from which redemption can begin. The world through which Milton journeys, the 'Mundane Egg' (or 'Shell'), is apparently vast – 'an immense / Hardend shadow of all things upon our Vegetated Earth' (pl.16) – yet immeasurable by conventional means. Taken as a whole, *Milton* is as bewildering as it is beautiful. Yet, today, Blake's idiosyncratic annihilation of an accepted world order appears far less eccentric than ever before, as concepts of godhead, space, time and gender appear to be increasingly mutable. MJP

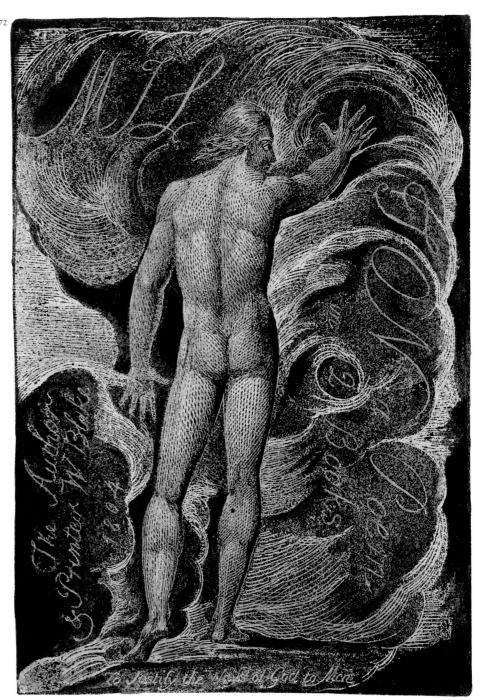

272

PLATE 1

272

PLATE 2

272

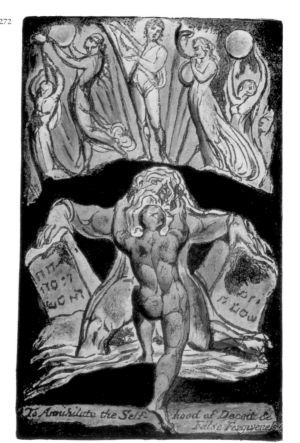

PLATE 15

272

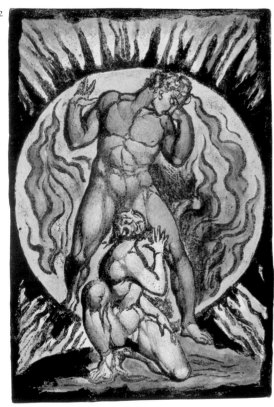

PLATE 21

272

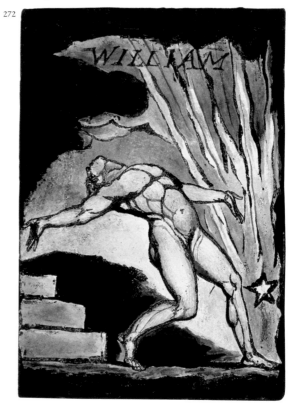

PLATE 29

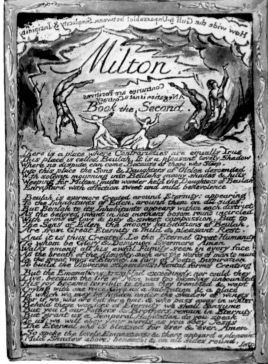

272

PLATE 30

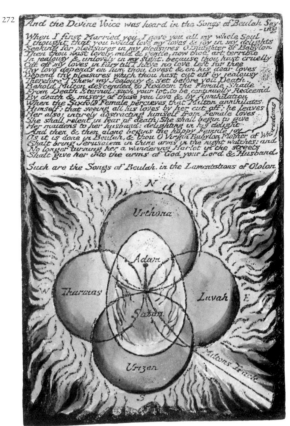

272

PLATE 32

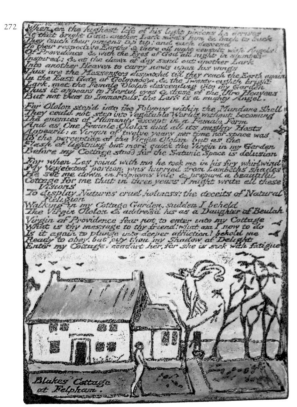

272

PLATE 36

Some aspects of Blake's mythology

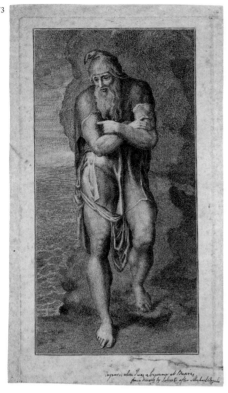

Albion The Land

'All things Begin & End in Albions Ancient Druid Rocky Shore' (*Jerusalem*, pl.27)
Lit: Damon 1965

273 Joseph of Arimathea Among the Rocks of Albion *c.*1773–9
Engraving in brown ink 22.8×11.9 (9×4⅝) (framing lines) on paper 26.6×15.6 (10½×6⅛)
Inscr. in black ink b.r. 'Engraved when I was a beginner at Basires / from a drawing by Salviati after Michael Angelo'
Lent by the Syndics of the Fitzwilliam Museum, Cambridge
Lit: Essick 1983, I:1A

274 Lear and Cordelia *c.*1779
Pen and ink and watercolour 12.3×17.5 (4⅞×6⅞) on paper 13.2×18.2 (5¼×7⅛)
Tate; bequeathed by Miss Alice G. E. Carthew 1940
Lit: Bindman 1973; Butlin 1981, no.43; Butlin 1990, no.1

275 Joseph of Arimathea Preaching to the Inhabitants of Britain 1794
Colour-printed relief etching 7.6×10.8 (3×4¼) on paper 32×24.1 (12⅝×9½)
National Gallery of Art, Washington Rosenwald Collection 1943
Lit: Butlin 1981 no.286; Essick 1983, no.XI; 1B

276 The Cliffs of Albion with Newton, Bacon and Locke Emerging from the Giant Hand
Jerusalem (copy A), pl.50
Relief etching and white line engraving printed in black approx. 22×16 (8⅝×6¼) on paper approx. 26.5×32.7 (10⅜×12⅞)
The British Museum, London
Lit: Damon 1965; Paley 1991

Albion is the ancient name for Great Britain and was called this, according to legend, because the giant Albion, one of Neptune's sons, was its king. The Romans also called Britain Albion because the Latin word 'Albus' means white – the colour of the cliffs that they saw when they first landed. Blake's frequent references to Britain as Albion show him drawing on this history, while recognising too that his country was now a great world power. He also locates himself and his readers in the landscape of the presiding giant, notably during the three years he spent at Felpham when *Jerusalem* was taking shape in his mind (no.303 pl.3).

Early on, Blake illustrated episodes from the legendary history of the island, such as *Joseph of Arimathea* (nos.273, 275; see also no.2). In about 1779 he produced a series of watercolours, later the basis for an engraved *History of England* planned in 1793, that included subjects showing the landing of Brutus (son of the Trojan Aeneas, who named the island Britain after himself) and of King Lear (Brutus's direct descendant) with his daughter Cordelia (no.275). Albion appears in the play-fragment *King Edward the Third*, printed in the *Poetical Sketches* of 1783, when a minstrel sings of the King's soldiers whose Trojan ancestors arrived 'upon the rocks Of Albion [and] kiss'd the rocky shore' saying 'Be thou our mother, and our nurse' (E.437). In words anticipating the subject of *Albion rose* (no.279), Brutus proclaims 'Liberty shall stand upon the cliffs of Albion' (E.438).

For Blake, the land of Albion has at first a Garden of Eden quality, with its mountains, vales, forests and groves. The land is covered by existing counties, rivers, villages, towns and cities, real geographical details that link the idea of the ancient Albion with a modern one. It is also a land of 'rocks and precipices' and 'caves of solitude & dark despair' (*Jerusalem*, no.303 pl.31). This makes sense of Blake's own city of 'Art and Manufacture' Golgonooza, built by Los on the bank of the Thames (*Milton*, pl.23, line 50, E.120; *Jerusalem*, no. 303, pl.53, line 15, E.203). This is the city that Los and Enitharmon leave to bind Orc – the anti-revolutionary act that symbolises what Blake saw as the fallen state of the modern-day Albion. For Blake, Albion, like other countries in Europe, had fallen into a state of decay, suffering under war and the 'terrors' of reasoning philosophers like Bacon, Newton and Locke (no.276). Los's search through the land in *Jerusalem* (no.289) reveals Blake's view of what the now 'awful Parent Land' of Albion had become, with 'barren mountains of Moral Virtue: and every Minute Particular hardened into grains of sand: And all the tendernesses of the soul cast forth as filth & mire' (plate 31, lines 19-21; E.194). The end of all this desolation is marked by the appearance of the sun of 'Eternal Day' over the hills of Albion (no.277, pl.95), the final transforming effect of which is seen in *Albion rose* (no.279). RH

ALBION The Giant

'Albion the Ancient Man' (*Vala* or *The Four Zoas*
Title-Page)
Lit: Damon 1965

277 Jerusalem 1820
Copy A 1820
Plate 14: Albion and his Emanation, Jerusalem
Plate 19: Albion Fallen
Plate 25: Albion and his Tormentors
Plate 37: Albion sunk down *and* the Spectre over
Jerusalem
Plate 41: Albion Brooding
Plate 94: Albion cold lays
Plate 95: Albion Rising
Relief etchings printed in black ink finished
with grey-black wash approx. 21.1×15 (8¼×5⅞)
on paper 32.7×26.5 (12⅞×10⅜)
The British Museum, London

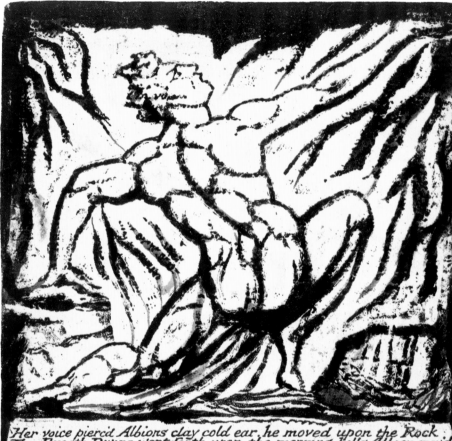

PLATE 95

277

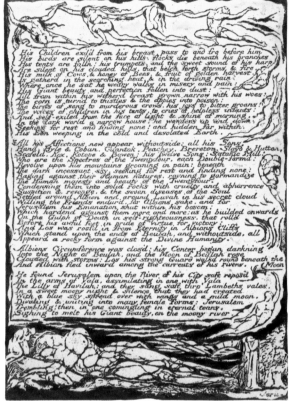

PLATE 19

277

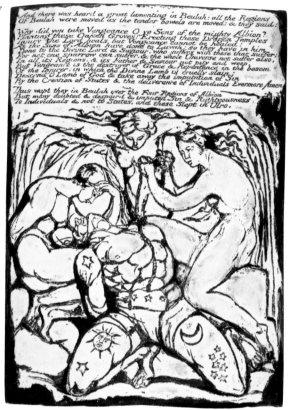

PLATE 25

277

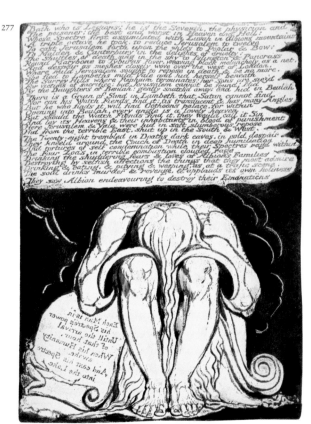

PLATE 41

278 Albion on the Rock *c.*1807–9
Milton, plate 38
Relief etching with white line engraving, printed in black with some grey wash 13.5 × 10.5 (5⅜ × 4⅛) on paper 23.2 × 15.7 (9⅛ × 6⅛)
Collection of Robert N. Essick

279 Albion rose *c.*1793/*c.*1796
Colour-printed engraving finished with pen and ink and watercolour 27.2 × 19.9 (10¾ × 7⅞) on paper 36.8 × 26.3 (14½ × 10⅜)
The Huntington Library, Art Collections and Botanical Gardens
*Lit: Essick 1983, no.*VII: *1B*

The land of Albion and the figure of the giant Albion, the Ancient Man, are inextricably bound up together. But for Blake it is around the universality of the Man that he poses the question of the greatest relevance to his own time: 'When shall the Man of future times become as in days of old' (*Vala*, p.120, line 5; E.389).

It is not until the mid-1790s that we find the concept of an Albion inhabited by giants entering Blake's work. It is seen in two of the subjects for his engravings illustrating the History of England planned in 1793 (E.672) and then most obviously in the colour print of *Albion rose* of about 1794–6 (no.279) taken from an earlier copperplate (no.176). These were the years of the ending of the Terror and of the treason trials at home in 1794 and the rise of Napoleon. The emergence of this image of British liberty as a giant form was the outcome of Blake's desire to create an Albion for his own times but also rooted in ancient mythology. He sees him as a Titan and connects him with King Arthur. In looking back to the founder (the Ancient Man) of a line of kings, Blake was undoubtedly setting up a deliberate antithesis not only to the popular image of John Bull but also to a usurper in that line, 'Albions wrathful

prince', George III (*America*, pl.3, line 14; E.52).

Blake's Albion is conceived on a colossal scale appropriate to his role as a personification of an island, but this is rarely captured in visual form (see no.277, pl.19). The best sense of the giant's scale is found in *Milton* where Albion's throne is described as having four pillars, one each located in London, Bath, a former Roman town near the Welsh border, and Edinburgh, and London lies between his knees (pl.40, lines 35–45; E.140). Like many of Blake's heroic figures, Albion is always shown naked or partly clothed. In this case, the artist's specific purpose was to convey the difference between the always naked Man from ancient, happier times, and Man from the modern period who 'stripped from his load of cloathing … is like a dead corpse' (*Descriptive Catalogue*, E.545).

In the Giant Albion are to be found the 'Four Eternal Senses', or 'Four Zoas' (see also *Milton*, pl.32) which are his body (Tharmas), his reason (Urizen), his emotions (Luvah) and his imagination (Urthona – whose Spectre is Los). When these senses and their Emanations struggle for supremacy, the resulting loss of unity within the self brings about Albion's fall. 'Weary', Albion hands over his power to Urizen, who sets about building the Mundane Shell around the rock where he lies (*Vala*, pp.23–24; E.313-4).

Blake's identification with the figure of Albion is complete. Although the fallen Albion lies on a rock (no.278) he is also depicted lying in Blake's own 'mild Lambeth's vale', a potent symbol of the artist's experience of Urizenic repression in the 1790s (*Jerusalem*, no.303 pl.20, line 1; E.165; no.277 pl.19). Similarly, of Albion's twenty-four children all twelve sons have names based on Blake's enemies: Hyle is William Hayley; Hand was inspired by the Hunt brothers who attacked Blake and his 1809 exhibition in their journal *The Examiner*. These are the kind of

men who are responsible for the nation's sleep, exemplified in the sleep of Albion.

In *Jerusalem* a guilty Albion establishes laws of Moral Virtue, just as Urizen has always done. The ensuing loss of liberty in the land is anticipated in the image of Albion, flanked by the females Rahab and Tirza, being tormented (no.277, pl.25). Rahab and Tirza were associated by Blake with the French rationalists Voltaire and Rousseau, and thus with the French Revolution, which resulted in repression in Britain in the 1790s. Los, symbol of Imagination, is unrelenting in his efforts to save Albion and eventually sees the possibility of him rising because the evils of the divided self will no longer exist. The apocalyptic moment when Albion rises from his rock and sees the vision of the land as Jerusalem comes about when he subdues Urizen, Tharmas and Luvah (no.277, pl.95, lines 16–17; E.255). With all four Zoas now re-united, Albion's Emanation, Jerusalem, awakes. The significance Blake attached to this moment, linked as it was to the ideas of 'all things' beginning and ending on Albion's shore and Albion as the 'Universal Man' is voiced by the giant himself when he calls on 'Jerusalem! O lovely Emanation of Albion' to 'Awake and overspread all Nations as in Ancient Times' (no.303, pl.97, lines 1–2; E.256). When finally 'All Human Forms' assume 'Immortality' and with their Emanations named Jerusalem, Albion is saved (no.303, pl.99, lines 1–5; E.258–9). *Albion rose* (no.279), like the sunrise of no.269, is the most perfect realisation of this idea of liberty for all individuals. RH

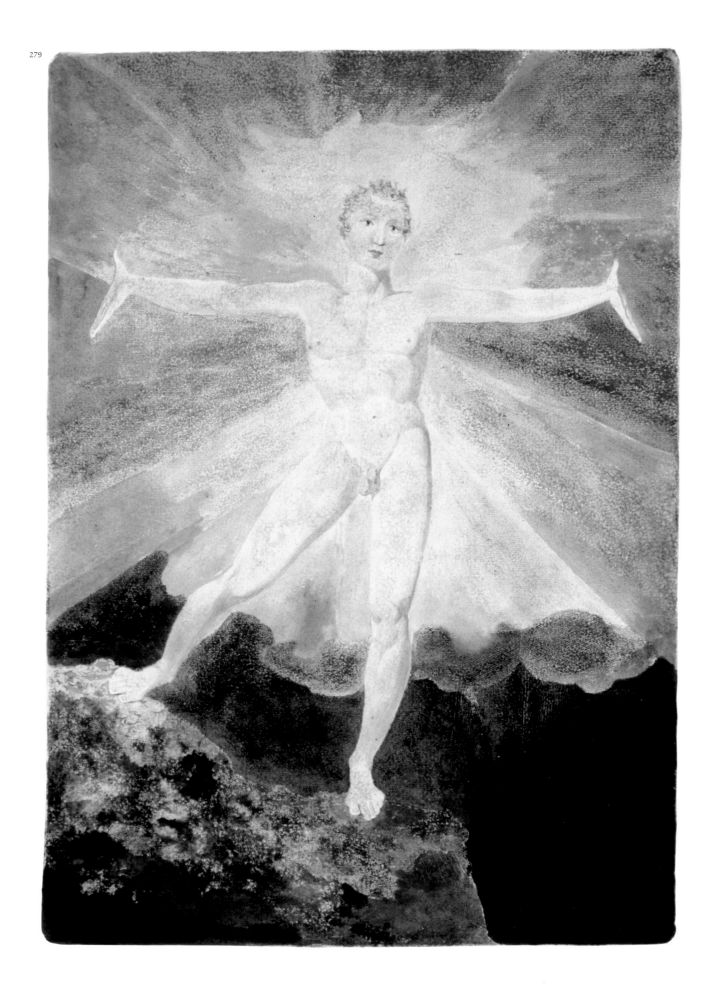

Emanations

For Man cannot unite with Man but by their
Emanations
Which stand both Male & Female at the Gates
of each Humanity
(*Jerusalem* no.303, pl.88, lines 10–11)

280 Albion and his Emanation
Sketch for *Jerusalem*, pl.14
Pencil on paper 11.6×16.5 (4⅝×6½)
The Victoria & Albert Museum
Lit: Butlin 1981, no.563

281 Urizen and his Emanation Ahania
From *The Book of Ahania* (copy A)
Colour printed intaglio etching 13.6×10 (5⅜×4)
on paper 28.2×23.3 (11⅛×9⅛)
Lent by the Syndics of the Fitzwilliam Museum,
Cambridge
Lit: Damon 1965; Worrall 1995 (facsimile Copy A)
The word 'emanation' first appears in Blake's
writing at the very beginning of *Vala* or *The Four
Zoas* when Urthona (see Los) 'his Emanations
propagated', and then when Tharmas addresses
his Emanation, or counterpart, the female,
Enion (p.4, lines 2,7; E.301). Emanations, as their
having names implies, are real and not abstract
like nameless Spectres. So, Tharmas could sleep
with his Emanation Enion, their coupling,
resulting in two infants, born with 'fierce pain'
(*Vala*, p.8, E.304), Los and Enitharmon. When
one of Urizen's sons, Fuzon, revolts, Urizen's
soul is divided into male and female portions,

the female being Ahania (no.281 depicts a
moment in the division). Emanations can find
a place of temporary rest and protection before
they return to their counterparts in Beulah, a
pleasant land created by Blake which has an
existence between Eden (or Eternity) and Ulro,
the chaotic material world. For example, Los
and his twin and Emanation Enitharmon are
eventually rejoined.

The term 'emanation' was used in
eighteenth-century philosophical writings
to describe an abstract, or spiritual, almost
vaporous essence of man's being. But Blake's
Emanations take on a real form, almost always
female, and sometimes as the repressed
'feminine' counterparts of the male. Their
separation from the male is comparable to the
creation of Eve out of Adam (a moment which
anticipates the Fall) and they therefore become
linked with a destructive separation from
eternity which signals a division in Man's
personality and his fall into chaos. The
Emanation gone, Man's Spectre, his rational
power seeking domination, takes over. Los's
Emanation about to enter him is shown in
Jerusalem, pl.30 (nos.294, 303). Importantly,
because the idea is central to Blake's greatest
work, *Jerusalem*, nations have their Emanations
too. Jerusalem is the Emanation of Albion: with
her wings and ethereal beauty, she symbolises
liberty or feminine wisdom (no.280). RH

Enitharmon

Loveliest delight of Men
(*Vala*, Night 7, p.82, line 28, E.358)
Lit: Damon 1965

282 Enitharmon and her Son Orc 1794/?1796
The First Book of Urizen, pl.2
Colour-printed relief etching finished in pen
and ink and watercolour 10.9×10.2 (4¼×4)
on paper 20.8×18.7 (8⅛×7⅜)
Inscr. 'Teach these Souls to Fly' below image
Tate; purchased from Mrs John Richmond
(Grant-in-Aid) 1922
Lit: Butlin 1981, no.261.5; Butlin 1990, no.23

283 Enitharmon Descending over Orc
Europe (Copy a) 1794
Plate 7
Relief etching printed in dark green ink
23.1×16.4 (9⅛×6½)
on paper 33.5×26 (13¼×10¼)
The British Museum, London

284 Enitharmon
Jerusalem (copy A)
Plate 93
Relief etching printed in black ink finished with
grey-black wash 20.8×14.9 (8¼×5⅞) on paper
32.7×26.5 (12⅞×10⅜)
The British Museum, London

280

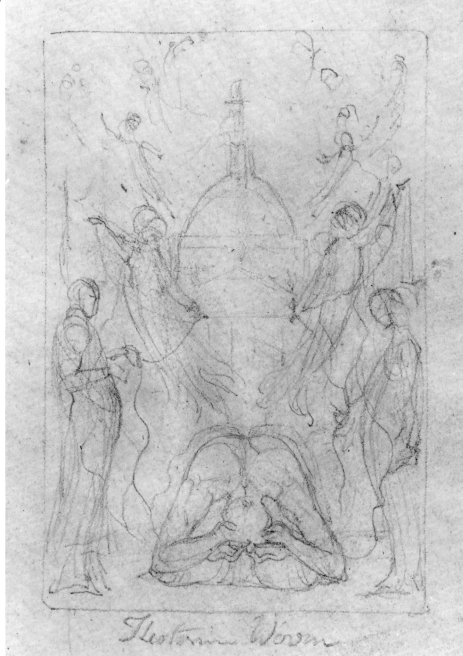

285 Theotormon Woven: Cathedron beyond

Pencil within pencil margin approx. 11 × 7.5
(4⅜ × 3) on paper 19.7 × 11.7 (7¾ × 4⅝)
Inscr. 'Theotormon Woven' below image
The Victoria & Albert Museum
Lit: Butlin 1981, no.573

Enitharmon is first mentioned by name in
America (nos.115, 124, pl.7) and in all appears
in six of Blake's illuminated books and in *Vala*
or *The Four Zoas* (no.300). She is the daughter of
Enion and her brother is Los, of whom she is the
separated half and Emanation. Her birth begins
with a bloody globe separating from Los, which
becomes 'the first separate female form' (*Urizen*,
pl.18(16); no.296). Los takes pity on her and after
a pursuit their child Orc is conceived. Many
more sons and daughters follow, thirty-eight of
whom are named. She is shown with Orc and six
of her other children in 283.

As many of the descriptions of her suggest,
Enitharmon symbolises beauty, and as Los's
Emanation she is his muse. She also represents
Pity – the similarity between the image in
no.282 and the colour print *Pity* (no.241d)
suggests this. In her fallen form, she is
identifiable as Eve, although she creates a false
and repressive religion lasting eighteen
hundred years (the Christian era up to Blake's
time) based on dominion over Man. This is most
fully described in *Europe* (no.299) and in the
colour print *The Night of Enitharmon's Joy*
(no.250). In *Vala*, Los sets out to challenge
the jealous dominion of the female will as part
of saving Albion, and in *Milton* and *Jerusalem*
her looms, used when she is in the city of
Golgonooza (or 'Cathedron', no.285), turn lost
souls into saved mortals.

Just as Blake identifies with Los, so
Enitharmon, as Los's muse, can be linked to
Catherine. The quarrels and sexual jealousies
described as part of Los and Enitharmon's
experience might be a reflection of Blake and
Catherine's marriage, and in *Vala* or *The Four Zoas*
there are lines touching upon a parallel artistic
collaboration: 'And first [Los] drew a line upon
the walls of shining heaven And Enitharmon
tincturd it with beams of blushing love' (p.90,
lines 35–6, E.370). RH

Los

I must Create a System, or be enslav'd by
another Mans
I will not Reason & Compare: my business
is to Create
(*Jerusalem*, pl.10, lines 20–1)
Lit: Damon 1965

286 Oh! Flames of Furious Desires 1794/1796
Urizen, pl.3
Colour-printed relief etching finished with
pen and ink and watercolour 6×10 (2⅜×4)
on paper 10×15 (4×6)
Keynes Family Trust, on loan to the Fitzwilliam
Museum, Cambridge
Lit: Butlin 1981, no.261.4

287 Los and his Spectre 1804–20
Jerusalem (Copy A) pl.6
Relief etching printed in black ink finished with
grey/black wash 22.1×16.2 (8¾×6⅜) on paper
32.7×26.5 (12⅞×10⅜)
The British Museum, London

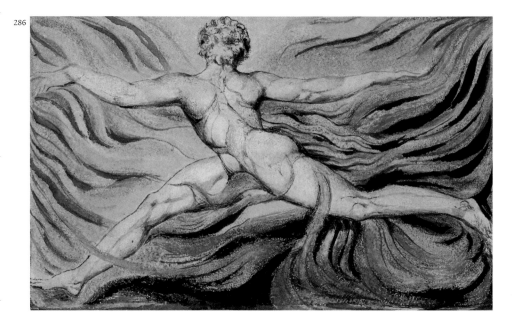

286

His Spectre driv'n by the Starry Wheels of Albions sons, black and
Opake divided from his back; he labours and he mourns!

For as his Emanation divided, his Spectre also divided
In terror of those starry wheels: and the Spectre stood over Los
Howling in pain: a blackning Shadow, blackning dark & opake
Cursing the terrible Los: bitterly cursing him for his friendship
To Albion, suggesting murderous thoughts against Albion.

Los rag'd and stamp'd the earth in his might & terrible wrath!
He stood and stamp'd the earth; then he threw down his hammer in rage &
In fury: then he sat down and wept, terrified! Then arose
And chaunted his song, labouring with the tongs and hammer:
But still the Spectre divided, and still his pain increas'd!

In pain the Spectre divided: in pain of hunger and thirst:
To devour Los's Human Perfection, but when he saw that Los

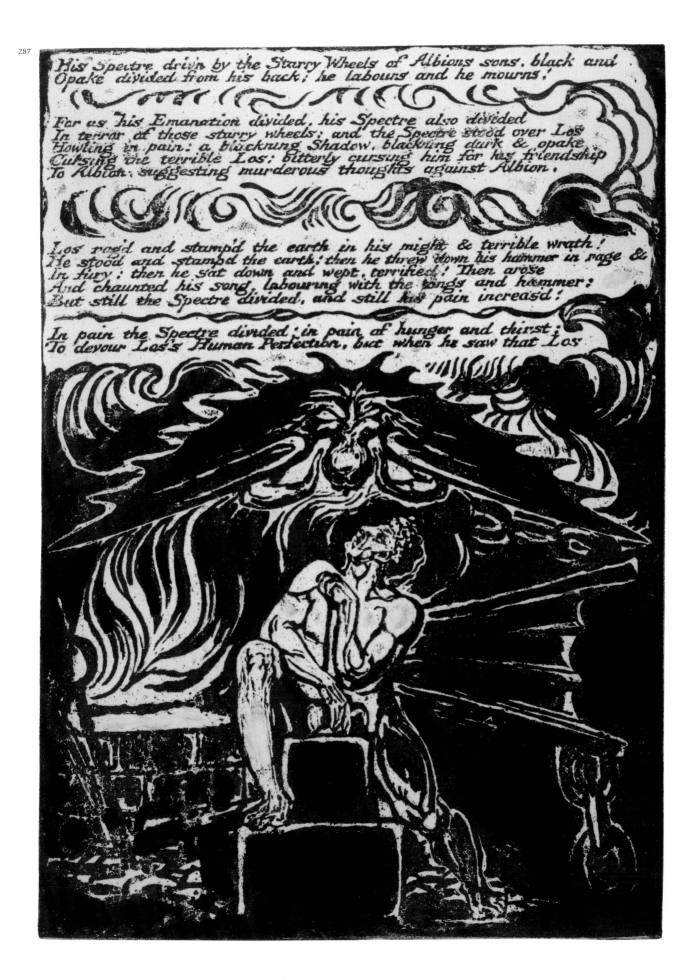

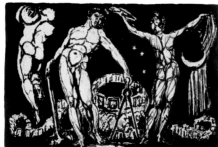
288

288 Los, his Spectre and Enitharmon before a Druid Temple
Jerusalem (copy A), pl.100
Relief etching printed in black ink finished with grey-black wash 14.7 × 22.3 (5 ¾ × 8 ¾) on paper 26.5 × 32.7 (10⅜ × 12⅞)
The British Museum, London

289 Los as he Entered the Door of Death
1804–*c*.1807
Jerusalem pl.1 (proof)
Relief etching and white line etching printed in orange-brown ink 22.1 × 16.1 (8¾ × 6⅜) on paper 25.6 × 19.3 (10¼ × 7⅝)
Keynes Family Trust on loan to the Fitzwilliam Museum, Cambridge

Los is first mentioned by name in two illuminated books of 1794, *Europe* (no.299) and *The First Book of Urizen* (no.296) and he was the subject of two books of 1795, *The Song of Los* (no.301) and *The Book of Los* (no.302). In all, he appears in eight of Blake's books.

He is one of two children (the other being Enitharmon) born out of the union of the female Enion and the male Tharmas. He grows into a physically powerful and obdurate figure with a 'mighty stature' (*Vala*, p.96, line 19; E.361). He has a 'furious head' (*Vala*, p.48, line 25; E.332), 'furious limbs' *Urizen*, no.296, pl.8(7), line 6) and 'immortal' hands (*Vala*, p.60, line 24; E.341). As the sound of hammers at his birth foretells, Los becomes a blacksmith and is shown as such in nos.287 and 301 (pl.8). Los is an aspect of Urthona, the northern Zoa (see no.272 pl.32), in the fallen world. His Emanation is Enitharmon, and their first child is Orc: at the moment of Orc's birth 'sweat & blood stood … in globes' on Los's limbs (*Vala*, p.60, line 21; E.340) as he becomes jealous of the boy's potential for revolt (see no.290). Los's main task in Blake's writings is to save Albion. Some of his battles are dealt with in chapter 3 of *Jerusalem* (no.303 pls.53–76).

The name Los is probably an inversion of 'sol' (meaning sun). In classical mythology the sun is a deity Helios (or 'Sol'), also Apollo, the god of the arts. Blake's character appears in *Europe* as 'possessor of the moon' (no.299 pl.6(3)), which can be taken as a reference to the reflected light of the sun. In *Milton* he is described as 'a terrible flaming Sun' (pl.20). Los's physical strength and creativity are qualities he needs as the watchman or guardian for those spirits who need to escape from the chaos of the fallen world (Ulro) as well as those needed to build Golgonooza, the great city of 'Art and Manufacture' built on the banks of the Thames. The precise location of Golgonooza is suggestive of Blake's own residence in Lambeth, and helps identify the artist with the figure of Los. Blake shows Los dressed like a London nightwatchman (no.289) as he searches out the 'tempters' in 'the interiors of Albions Bosom …' and so confronts the 'solitude & dark despair' (*Jerusalem*, pl.31, no.303) that Blake knew in Lambeth and epitomised, for example, in 'London' (nos.129, 161, 162). The description and image of Los labouring at his anvil in *Jerusalem*, plate 73, has strong overtones of Blake at work in his studio. Also, the jealous binding of Orc by Los is later justified when Orc becomes a serpent to escape, paralleling Blake's attacks on the perversion of revolutionary energy that was the Terror in France. Blake's absorption of his own character into Los is summed up in *Milton* when he writes 'Los had enterd into my soul', becoming 'One Man with him' (plate 20, lines 12–13; E.117). RH

289

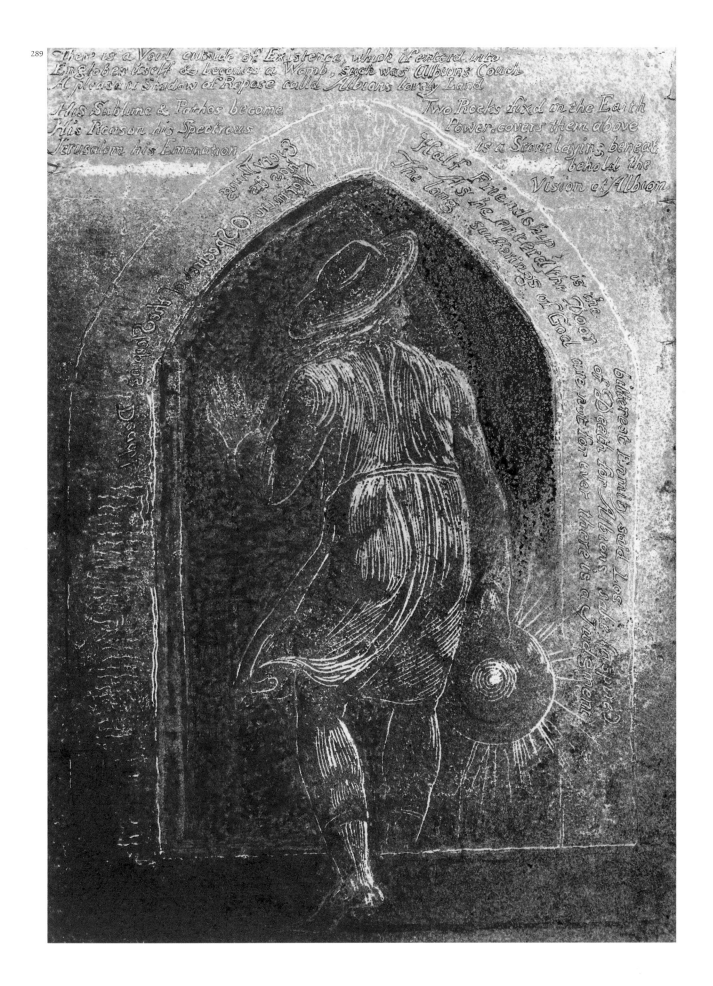

249

Orc

'the thick-flaming, thought-creating
fires of Orc'
(*The Song of Los*, pl.6, line 6)
Lit: Damon 1965

290 Los, Enitharmon and Orc *c.*1795
First Book of Urizen pl.21
Colour-printed relief etching 16.6 × 10.2 (6½ × 4)
on paper 31.3 × 25 (12⅜ × 9⅞)
National Gallery of Victoria, Australia. Felton
Bequest, 1920
Lit: Butlin 1981, no.281; Butlin and Gott 1989, no.43

291 The Chaining of Orc *c.*1812
Urizen, pl.21(23)
Pencil 11 × 7.5 (4⅜ × 3) on paper 16.8 × 12.7
(6⅝ × 5)
The British Museum, London
Lit: Butlin 1981, no.584; Bindman 1978, no.479

292 Los and Orc: Orc Chained *c.*1792
Pen and ink and watercolour on paper 21.7 × 29.5
(8½ × 11⅝)
Signed 'W. Blake' b.l.
Tate; presented by Mrs Howard Samuel in
memory of her husband 1962
Lit: Butlin 1981, no.255, pl.305; Butlin 1990, no.13

Orc is referred to by name in six of Blake's books.
He is first mentioned in the 'Preludium' to
America in 1793 where he is described as
'red'(no.124, pl.3). He is the first born of the
female Enitharmon and Los.

In *Urizen* (no.296, pl.19(17)), Orc is described
as 'the Child with fierce flames' who issued from
his mother. In *Vala* or *The Four Zoas* he is the
'terrible child' described as emerging from his
mother 'In thunder smoke & sullen flames &
howlings & fury & blood'. Although Blake never
specifically illustrates the moment of birth, the
image on plate 3 of *The Marriage of Heaven and Hell*

(no.127), combined with the words above it, 'Evil
is the active springing from Energy', seems to
allude to one aspect of Orc's potential as a man.
In plate 25 of *Marriage* the words 'the new born
terror' anticipate Orc's later appearance as the
spirit of revolution. Blake frequently mentions
him in the context of 'flames', 'fires' and 'fury'.
In *The Song of Los* (no.301, plate 6) Orc's fires are
described as 'thought creating'. In classical
mythology, Orcus is one of the names of Pluto,
the god of Hell, as well as a name for the infernal
regions. By describing him as red, or with 'red
eyes', Blake associated Orc with passion, terror
and war, all attributes found in Hell. But Orc's
name is also an anagram of 'cor' because he was
born out of Enitharmon's heart.

When Orc was fourteen years old, his father
Los saw him embracing his mother Enitharmon
and so believed that Orc was plotting his death
(no.290). As a result, he tied down Orc, howling,
on a mountain (Mount Atlas in Africa according
to *The Song of Los* (no.301, pl.3). Eventually,
remorse drove Los and Enitharmon back to the
mountain to release him, but they found that his
limbs and chains had become welded to the rock
by 'fibres' from the 'Chain of Jealousy'. Orc rages
against his enemy Urizen, who is trying to cool
his creative 'flames' with snow and storms, and
turns into a worm or serpent to escape.

Orc's chaining symbolises the suppression
of energy and is a way of eliminating the threat
that he posed to the power of Reason. In no.292,
the shadow that curves across the valley beyond
Orc can be compared with the threatening
shadow seen in Robert Blake's drawing and
Blake's print after it, *The Approach of Doom*
(nos.164, 165). Blake's Orc is the essence of
revolutionary passion and energy, the antithesis
of Reason represented by Urizen. As such,
these two characters epitomise Blake's idea
of 'Contraries' without which nothing can
progress. RH

290

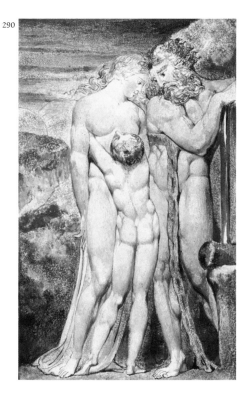

Spectres

'Each Man is in his Spectre's power'
(*Jerusalem*, pl.41 (*reverse writing*))
Lit: Damon 1965

293 Los and his Spectre *c.*1804–7
Sketch for *Jerusalem*, pl.6
Pencil 15.7 × 9.5 (6⅛ × 3¾) on paper (irreg.)
20.3 × 15.9 (8 × 6¼)
National Gallery of Art, Washington DC
(Lessing J. Rosenwald Collection)
Lit: Butlin 1981, no.561 verso

294 Los, his Emanation and Spectre
Jerusalem (copy A)
Pl.30
Relief etching printed in black ink finished with
grey-black wash 21.1 × 15 (8 ¼ × 5 ⅞) on paper
32.7 × 26.5 (12⅞ × 10⅜)
The British Museum, London

Blake first used the word 'spectre' in his 1791
poem *The French Revolution* when he refers to 'a dark
shadowy man' in the form of King Henry the Fourth
as the King's 'spectre' (p.9, lines 164–5, 171; E.293).
The idea of a spectre has its origins in the use of the
word to describe a phantom or a ghost, particularly
one that is terrifying. This use of the word was
common in Gothic literature of the time, and it
informs Blake's own concept of the Spectre. Without
the 'counterpart' of a 'Created body' a Spectre has no
life, and, unlike Emanations, they have no names.
Blake's descriptions of the appearances of Spectres
convey a sense of the dark, destructive side of man's
nature. Likewise, and possibly influenced by an
engraving of a bat in J.G. Stedman's *Narrative* (see
no.234), he depicts them as bat-winged creatures
associated with the night, vampirism and ugliness.
The bat in Dürer's *Melencolia* (no.214) could also have
helped shape Blake's imagery. This image amplifies
the words Blake uses in *Jerusalem* (no.303, pl.74),
where he describes the Spectre as

> the Reasoning Power in Man; & when
> separated
> From Imagination, and closing itself as in
> steel, in a Ratio
> Of the Things of Memory. It thence frames
> Laws & Moralities
> To Destroy Imagination! the Divine Body,
> by Martyrdoms & Wars

The Spectre's wayward power and unpredictability
is summed up in the words that it 'is in Every
Man insane, brutish Deformd' (*Vala*, p.84, lines
36–7; E.360). RH

Urizen

'I am God the terrible destroyer'
(*Vala*, Night 1, p.12, line 26)
Lit: Damon 1965

295 Moses Receiving the Law *c.*1780
Pen and ink and wash over pencil on paper
65.9 × 31.1 (26 × 12¼)
Paul Mellon Collection, Yale Center for
British Art
Lit: Butlin 1981, no.111

295

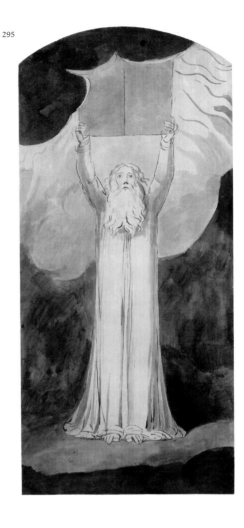

296 The First Book of Urizen 1794
'Lambeth. Printed by Will Blake 1794'
Copy D 1794
26 relief etchings printed in orange-brown
ink, colour printed and finished with pen and
ink and watercolour 15×10.5 (5⅞×4⅛) on
paper 25.4×18.1 (10×7⅛)
The British Museum, London
Lit: Worrall 1995 (facsimile Copy D)

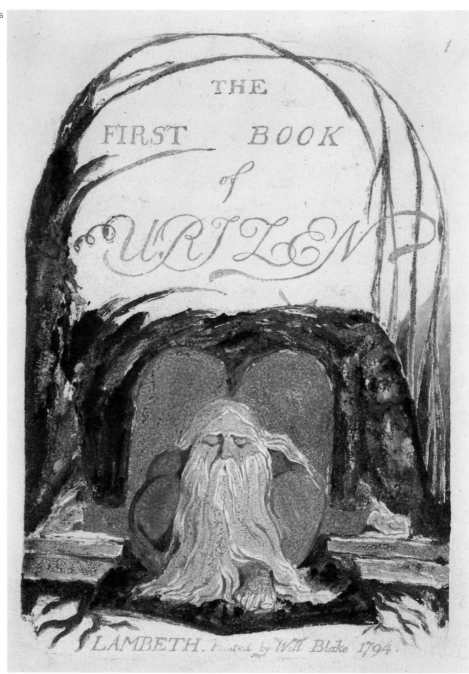

PLATE 1

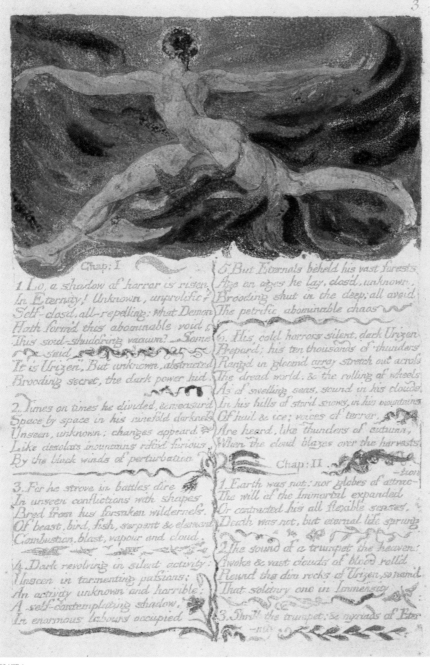

Chap: I

1 Lo, a shadow of horror is risen
In Eternity! Unknown, unprolific!
Self-clos'd, all-repelling: what Demon
Hath form'd this abominable void
This soul-shudd'ring vacuum?—Some
said
It is Urizen. But unknown, abstracted
Brooding secret, the dark power hid.

2. Times on times he divided, & measur'd
Space by space in his ninefold darkness
Unseen, unknown: changes appeard
Like desolate mountains rifted furious
By the black winds of perturbation

3. For he strove in battles dire
In unseen conflictions with shapes
Bred from his forsaken wilderness,
Of beast, bird, fish, serpent & element
Combustion, blast, vapour and cloud.

4. Dark revolving in silent activity:
Unseen in tormenting passions;
An activity unknown and horrible;
A self-contemplating shadow,
In enormous labours occupied

5. But Eternals beheld his vast forests
Age on ages he lay, clos'd, unknown
Brooding shut in the deep; all avoid
The petrific abominable chaos

6. His cold horrors silent, dark Urizen
Prepar'd; his ten thousands of thunders
Rang'd in gloom'd array stretch out across
The dread world, & the rolling of wheels
As of swelling seas, sound in his clouds
In his hills of stor'd snows, in his mountains
Of hail & ice; voices of terror,
Are heard, like thunders of autumn,
When the cloud blazes over the harvests

Chap: II

1. Earth was not: nor globes of attrac-
tion
The will of the Immortal expanded
Or contracted his all flexible senses.
Death was not, but eternal life sprung

2. the sound of a trumpet the heavens
Awoke & vast clouds of blood roll'd
Round the dim rocks of Urizen, so nam'd
That solitary one in Immensity

3. Shrill the trumpet: & myriads of Eter
-nity

PLATE 3

296

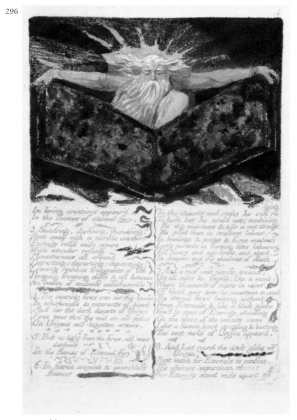

PLATE 5 (4)

296

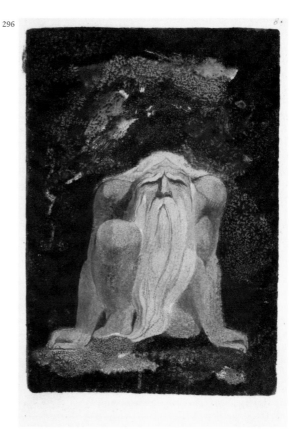

PLATE 9 (8)

296

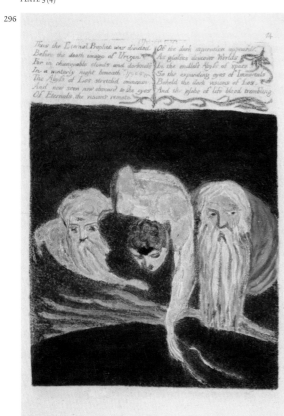

PLATE 15 (14)

296

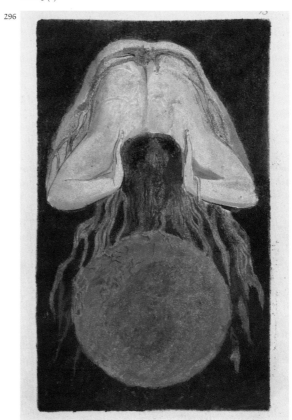

PLATE 17 (15)

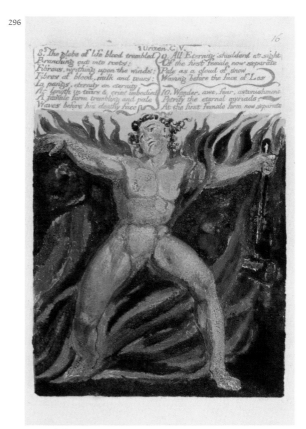

PLATE 18(16)

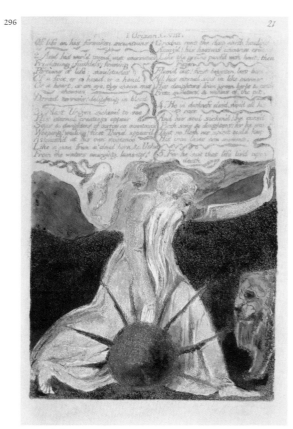

PLATE 23(21)

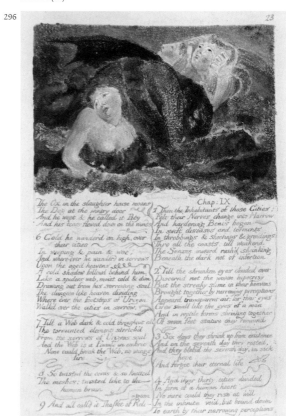

PLATE 25(23)

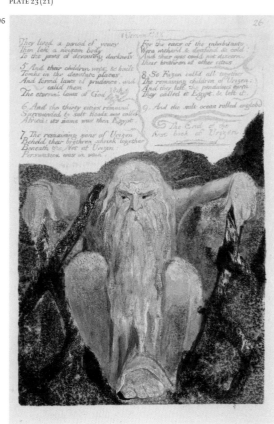

PLATE 28(26)

297 The Ancient of Days 1824?
Relief etching finished in gold, watercolour
and gouache on paper 23.4×16.8 (9¼×6⅝)
Signed 'Blake 1824' c.r.
The Whitworth Art Gallery, The University
of Manchester
Lit: Butlin 1981, no.271

Urizen appears in eight of Blake's books. He first
appears, by name, in *Visions of the Daughters of
Albion* (1793) as 'Creator of men! mistaken
Demon of heaven' (no.125, pl.5), and what might
be an image of him can be seen above the leaping
figure on the Title-Page of the book (no.125,
pl.2). Urizen's importance for Blake is clear from
the fact that he was the first of the characters in
his mythology to have a book devoted to him,
The First Book of Urizen (1794, no.296).

Urizen was born of Vala, the goddess of
nature, as recorded in *Vala* or *The Four Zoas* where
he is described as 'Prince of Light / First born of
Generation' (p.83 lines 12–13; E.358). His father
was Albion, and he grew up in the pleasant land
of Beulah where he began his enduring task of
creating a 'Direful Web of [deceitful] Religion'
(*Vala*, p.103, line 26; E.375). Urizen is a brooding
and wrathful figure. Hair 'white as snow coverd
him in flaky locks terrific' (*Vala*, p.73, line 28;
E.350). He wears white robes and is sometimes
covered in snow. His place in his heaven is alone
in a cave or on a rock. In his solitude Urizen
continually writes out his laws in metal books
with an iron pen (no.296 pl.1). These books are of
brass (the most important), iron, silver and gold.
Urizen's Emanation is Ahania (see no.281).

The name Urizen is probably a punning
reference to 'your reason'. He is the southern Zoa
who stands for Reason (see *Milton*, no.272 pl.32).
For Blake, this means that he makes laws that
limit energy and repress the imagination. From
the outset, Blake's references to Urizen as
'Creator of Men' establishes the figure as a god of
immense power, comparable to the Christian
God, though very much of this material world.
The First Book of Urizen, with its interspersed
images showing the four elements places him
firmly in this context. Blake's most powerful
image of him as such a god is *The Ancient of Days*
(no.297). This shows Urizen, having made 'gold
silver & iron and brass … vast instruments to
measure out the immense' using one of them,
the compasses, to 'fix The whole into another
world better suited to obey His Will'(*Vala*, p.73;
E.350). The repressive, 'direful web' of organised
religion based on reason which is the result is
seen in 'A Song of Liberty' (no.192), *Urizen*, plate
28(26) and also in *Songs of Experience* (no.298
pl.47).

Urizen's prototypes in appearance and
action are the vengeful God of the Old
Testament and the prophet Moses (no.295).
Both are usually shown in art with flowing
white beards, like Urizen, and Blake's character
is sometimes shown with an open book before
him, just as Moses might be shown holding
the stone tablets of the Ten Commandments
(nos.295, 296 pl.1). Urizen's books of his laws
also have obvious Biblical connotations.
In the case of the 'Book of Brass', in biblical
terms brass is a strong and durable metal but
also the material out of which false idols are
made – an allusion we need to be aware of in
order to realise that what Urizen writes is false.
There is also an implied contrast here between
the soft and malleable copper out of which Blake
made his own books and the hard brass on
which Urizen wrote his texts. RH

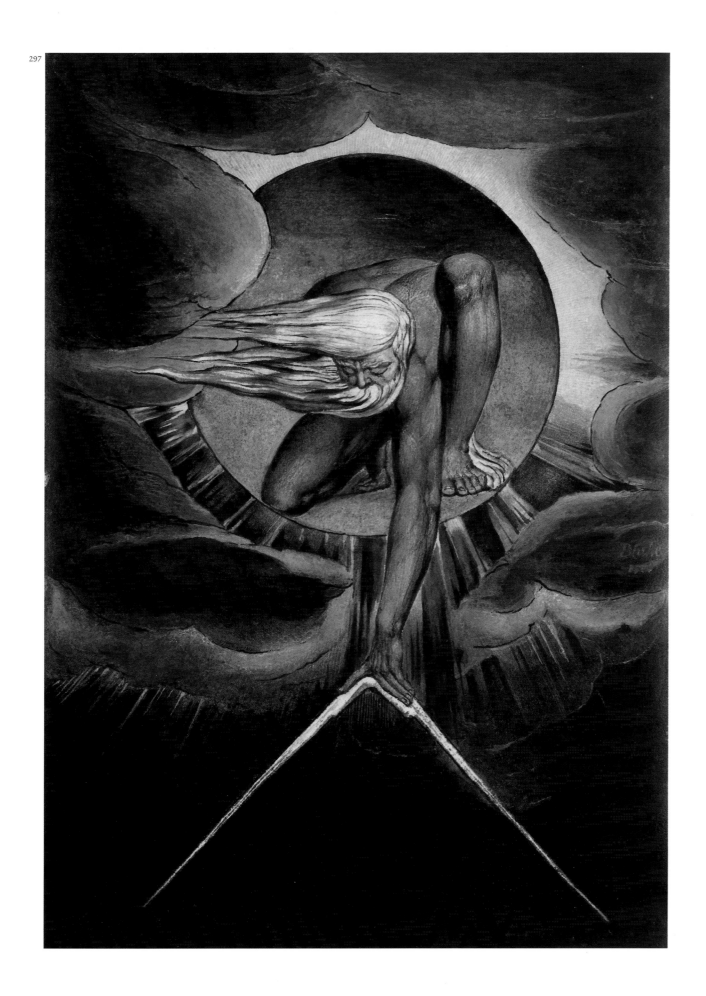

'Many Formidable Works'

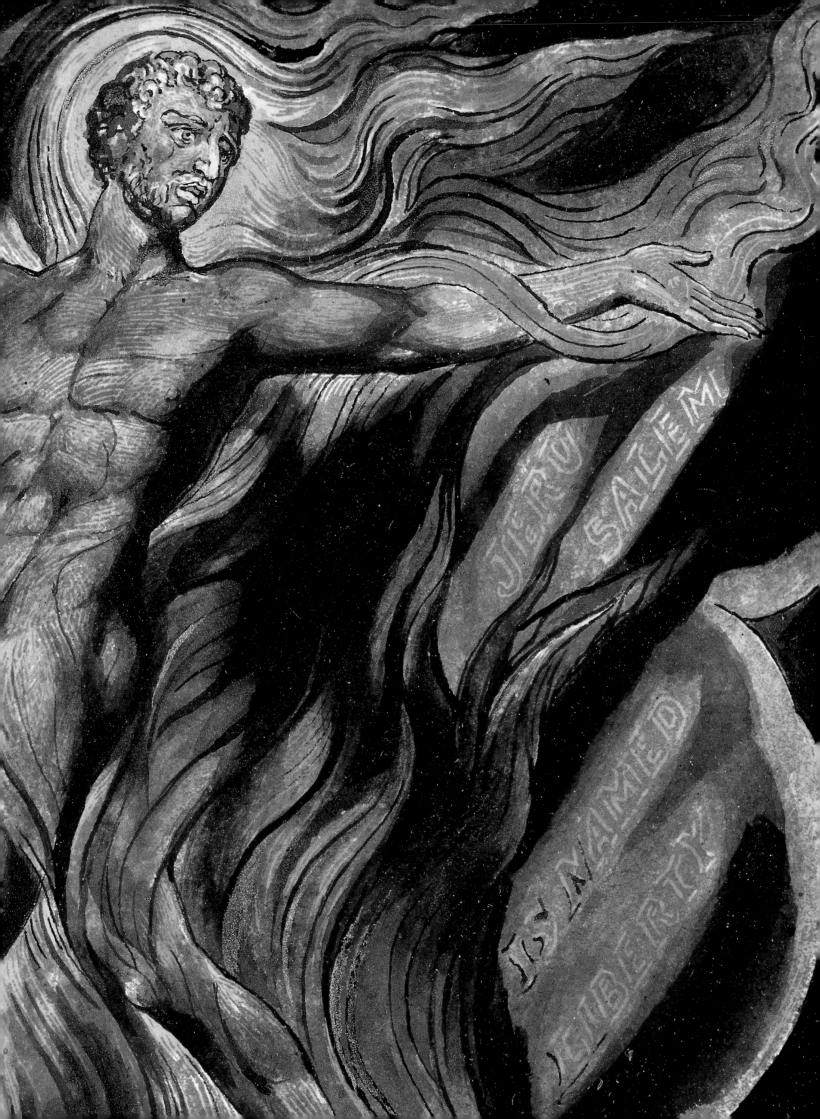

Because Blake's writing and his painting and drawing are so inextricably entwined it is difficult to see at first whether he gave greater emphasis to the former rather than the latter. But a comparison of rather crude calculations can be revealing. Thus, the catalogue of his drawings and paintings contains about 2,000 works while the number of printed illuminated book leaves he produced amounts to about 3,500. On the face of it, then, the word and the book emerge as the main focus of all Blake's endeavours and it is evident from what Blake himself said that this was indeed where his main ambitions lay from the very beginning. The most challenging of all Blake's works is a book about himself and a poet – John Milton – and is titled accordingly (no.272). But other instances of such ambition stand out in particular: his (hopelessly optimistic) aim, expressed in the mid-1780s in *An Island in the Moon* (see no.106), of running off 2,000 copies of a three-volume work printed from engraved writing; he never boasts about his output of pictures in quite the same way as he does about his writing when right at the end of his life he says 'I have written more than Voltaire or Rousseau – Six or Seven Epic poems as long as Homer and 20 Tragedies as long as Macbeth' (BR.322) – though it should be noted that there is no evidence to substantiate this claim. And, most tellingly of all, when writing about the impressions of images for the Large and Small Books of Designs printed independently of the text, the emphasis is clear: 'without [the] Poems they never could have been Executed' (E.771).

From his youth onwards Blake's careers as a writer and artist (which includes his printmaking) developed more or less in parallel. When he was ten, he went to a drawing academy and when he was eleven, as we know from the 'Advertisement' to *Poetical Sketches* (no.17), he had certainly begun writing poetry. Brought up in a dissenting household, where we can safely assume that reading was a central activity, it was the word, either printed or read out aloud, which was undoubtedly the first great stimulus to Blake's imagination and, as we can deduce from comments he made, it remained supreme. As far as art was concerned, in speaking to Malkin Blake certainly mentioned his early collecting of old prints and making copies from them also when about ten years old. However, when later on Blake set out in any sort of order either significant influences on him, or the place of his own art of design among the other arts, it is striking just how central books and the printed word were to his being. Consistently it is

writers and the idea of the writer and not painters and draughtsmen who sprang to his mind first. Thus, most forcibly, 'Milton lovd me in childhood & shewd me his face Ezra came with Isaiah the Prophet ...' (to Flaxman 12 Sept. 1800; E.707). But the same emphasis occurs elsewhere as in the later *Descriptive Catalogue*. When Blake refers to those 'remains' from antiquity along with modern works which he had set out to emulate, they come in the following order: 'Poetry ... Music ... Painting and Sculpture ... Milton, Shakspeare, Michael Angelo, Rafael ...' (E.544). Or, in *Laocöon* (no.3), it is 'A Poet a Painter a Musician an Architect' (E.274) or in plate 3 of *Jerusalem* 'Poetry Painting and Music' (no.303).

We cannot date the moment when Milton first 'lovd' Blake (possibly as early as eleven years old) though its lasting impact is vividly illustrated in one of the *Milton* plates (no.272 pl.29). Nor is the reason for the transition from Milton specifically to Ezra and then to Isaiah, which comes in the same breath, immediately obvious. But if we think about this sequence of names as representative of a continuing process for Blake rather than a series of isolated incidents, then its significance becomes much clearer because parallels can be found elsewhere in Blake's writings. One is found in *An Island in the Moon*, already referred to above. This is a burlesque on several conversazioni based on Blake's own experiences. These conversazioni are punctuated by singing, notably the extempore singing of three songs which we know were Blake's own because they eventually found their way into *Songs of Innocence* (pls.13, 19, 24; see nos.118, 128, 298 pl.4). *An Island* is thus a record of conversations and banter together with songs that we know from later evidence the author had felt worth preserving, though the conversazioni were mostly uncapturable air. The burlesque is also unfinished but its 'end' significantly has one of the characters, Quid, who is Blake, talking about the possibilities of engraved writing on copper plates being used to print books that would reach a wide audience and, incidentally, make the author rich. This quite explicit idea of a complete sung or spoken word- to-writing-to-printing-to-reading cycle, masterminded by the author himself, is stated more clearly in the 'Introduction' to *Songs of Innocence* (nos.128, 298 pl.4). Here Blake outlines the origins of the book in a way which echoes the moment described in *An Island* though this time it is a laughing child, or muse, who urges the author and singer (that is Blake) to '... sit thee down and write / In a book that all may read', the result being that the author made a pen and wrote his

'happy songs, / Every child may joy to hear'.

If this gives a general sense of Blake's instinct for the word and writing we can fairly easily establish from what he said the weight and significance he himself attached to his own words and then in what form – the illuminated book – he believed they were best expressed. It is apparent from the initially puzzling linking of Milton (the modern poet who, in *Paradise Lost* and *Paradise Regained*, wrote a great religious epic) with Ezra (the 'ready scribe in the law of Moses' of the Old Testament) and then Isaiah (the foremost prophet). Once actually described, these men fall into place as crucial pieces of evidence for the way we should regard Blake's idea of the primacy of the book. Milton 'showing' his face to Blake suggests first and foremost a visionary experience, the counterpoint to which would be the 'hearing' of a voice (or conceivably Milton's words spoken by someone else: along with the Bible, *Paradise Lost* and *Paradise Regained* would commonly have been read aloud in homes) perhaps comparable to the moment in Milton when the Bard – 'I am Inspired! I know it is Truth!' – takes 'refuge in Milton's bosom' (no.272 pls.11-12).

What is immediately noticeable here is the biblical frame of reference that Blake sets up for himself as a writer and for his writings. It is important that we recognise the thoroughgoing nature of this, as well as its weightiness, in order to understand the reason for placing such an emphasis on Blake's illuminated books. After all, Blake was 'not afraid to say' that his 'works [were] of equal magnitude and consequence with the productions of any age or country' (see p.122). In one way the biblical allusions are obvious. We have only to think of Urizen as a 'first book', comparable to one of Moses' and, moreover, printed in two columns just like the Authorised Version of the Bible; or Blake's use of words like 'Prophecy' and 'Songs' in his titles. But what we should not lose sight of is the biblical sense of the 'voice', the 'secret' inspiration or genius of the prophet, which is likewise a recurring motif in the Bible. And, of course, Blake experiences it in the same way: he is 'under the direction of Messengers from Heaven, Daily & Nightly' (10 Jan. 1803; E.724); he writes 'from immediate Dictation, twelve or sometimes twenty or thirty lines at a time … ' (25 Apr. 1803; E.728–9); such 'voices of Celestial inhabitants' were heard more clearly in peaceful Sussex (21 Sept. 1800; E.710) where, just as in the Bible any sound or noise becomes a 'voice', he can write of 'the voices of winds trees & birds' (23 Sept. 1800; E.711). So we can discern the one vital principle revealed early on to

Blake through his hearing and reading – namely the prophet's (for which we can read the speaker's, the poet's and the bard's) dependency upon the written or, better, the printed word as the only means whereby his work can endure: Ezra the scribe was crucial to Isaiah and Moses; and Blake as his scribe and corrector of his errors, becomes crucial to Milton. There is an extraordinary completeness about this circle of names that Blake has created. Its very integrity leads us to find other interlinked aspects of his printed work. The act of scribing or writing was, as we have seen (p.104) the first step in his relief-etching process which was revealed to him through a 'voice', that of his brother Robert, 'in [a] consolatory dream' Blake had after he had died (Gilchrist 1863, I, p.68). The sense of the elemental life of the copper plate, which Blake might have brought to his understanding of the metal from Paracelsus (see p.186), whereby his writing was directly transposed into the printed word and from which each page of each book was printed, was realised. The fact that the 'voices' dictating the words for writing which could then be printed was part of a continuum and made Blake both a scribe and prophet of a kind never before known.

Concluding an exhibition with this group of illuminated books is profoundly symbolic: they naturally assume the place the author gave them in his total output, and then go on to test and either underpin or, for some, maybe even undermine his hopes about posterity's judgement on them. He lavished more care on *Jerusalem* (no.303) than on any other single work. On plate 3 of this book, addressed 'To the Public', the author wrote the following justification for its being written:

> Even from the depths of Hell his voice I hear,
> Within the unfathomd caverns of my Ear.
> Therefore I print; nor vain my types shall be:

Within these lines the words '… his voice I hear, … Therefore I print' stand out. They immediately bring to mind the words, themselves the product of a doubt akin to Blake's own, of the great French mathematician and philosopher René Descartes (1596–1650), who expressed the true means to discover knowledge, and thus self, in the following words – 'I think, therefore I am'. We may, with justice, believe that Blake's perception embraced, above all else, the notion 'I print, therefore I am' and that his books, despite the many challenges they present, therefore offer us the truest and most accessible path into his mind. RH

298 Songs of Innocence and of Experience
1789/1794/*c*.1825

'Shewing the Two Contrary States/of the/ Human Soul'
Songs Copy Y *c*.1825
54 relief etchings on 54 leaves
Printed in orange-brown ink, heightened with watercolour and shell gold, with hand-painted decorative borders 15.2 × 14 (6 × 5½)
Metropolitan Museum of Art, Rogers Fund, 1917
Lit: Lincoln 1991 (facsimile Copy W); Viscomi 1993, pp.299–301, 363–6

Songs of Innocence and of Experience is the best-known of Blake's works. The artist originally produced this small, richly illustrated collection of short lyric verses as two separate books: *Songs of Innocence*, begun in about 1784, was first published in 1789; the companion collection, *Songs of Experience*, was first published in 1794. Blake combined them in a single volume in 1794, and continued to print copies from the original relief-etched copper plates throughout his life. More copies of the *Songs* are known than any other of Blake's illuminated books, and each is unique, distinguished by the colouring, and, in some instances, by the reordering of the plates. Given the importance of this celebrated work, however, the total print-run seems surprisingly small: only twenty-four separate copies of *Innocence*, twenty-four of the combined work, and four of *Experience* alone are known.

The apparent simplicity of this minute, colourful volume explicitly addressed to children is deceptive. Although Blake adopts the format of a children's book, and writes at times with a disarming directness, the meanings of his poems are anything but straightforward or conventional. *Innocence* and *Experience* contrast opposite states of human existence, before and after the Fall. The poems in *Innocence* express themes of religious faith and acceptance and adopt a pastoral tone; those in *Experience*, by contrast, convey disillusionment and anger and employ a bardic voice. Published at the height of the Terror, the brutal events of the French Revolution left their mark on these verses.

Many poems in the two books bear the same or parallel titles. Each of the *Songs* contains 'The Chimney Sweeper', 'Nurses Song', 'The Divine Image', 'Holy Thursday', 'The Little Girl Lost', and 'Little Boy Lost'. 'Infant Joy' in *Innocence* is matched by 'Infant Sorrow' in *Experience*, as are 'The Lamb' by 'The Tyger', and 'The Blossom' by 'The Sick Rose'. Yet the pairings are less schematic than the titles suggest, and several similarly named poems treat unrelated themes. Moreover, the arrangement of the book itself remained unfixed; Blake transferred as many as six verses from *Innocence* to *Experience* in certain copies.

Generally, the plates of *Innocence* appear more finely detailed, characterised by elegantly curving lines, whereas the pages of *Experience* exhibit broader textural effects, distinguished by bolder outlines.

Blake prepared the *Songs* using the new method of relief etching with which he had experimented in 1788 in *All Religions are One* (no.109) and *There is No Natural Religion* (no.107), a technique he claimed to have learned from his deceased younger brother Robert Blake in a vision. This innovative method allowed Blake to control all aspects of the book's production: he composed the verses and prepared the designs, and transferred them onto the copper plate in stopping-out liquid; after biting the plates in an acid bath he printed them on the large rolling press in his home, and, with the assistance of his wife Catherine, then finished each sheet by hand in colours he had mixed himself, before finally stitching the leaves in paper wrappers. Blake saved the expense – and potential censorship – of a printer, and economised on copper by using plates of a small size (in certain instances, he even re-used the backs of *Innocence* plates for *Experience*).

This copy of *Songs of Innocence and of Experience* dates to the final years of the artist's life, and is one of the last he appears to have produced. Blake prepared it in about 1825 (the year for which several pages are watermarked) for the painter and printmaker Edward Calvert (1799–1883), whom he probably met at that time, perhaps introduced by their mutual friend and fellow-artist Samuel Palmer (1805–1881), or by Palmer's cousin, John Giles, who acted as Calvert's stockbroker.

Unique to this and one other copy that presumably dates to the same time (Copy W, King's College, Cambridge) are the elaborate scroll and foliate borders with which Blake decorated the sheets after printing. The designs recall the inner framing of Blake's *Job* engravings, which appeared in proofs from March 1825. The deep, saturated hues and distinctive ornamental borders of late copies, such as this one, contrast with the paler tones and lighter overall effect of editions prepared three decades earlier. Whereas earlier copies were printed on both sides of the sheet, the later books are printed only on one side, and are assembled in a slightly altered order, indicated by the page numbers added in red.

This volume remained in Calvert's family until the late nineteenth century. In 1917, it became the first work purchased for the Metropolitan Museum's new Department of Prints by its distinguished first curator, William M. Ivins Jr. EEB

Opposite: 'Songs of Innocence and of Experience' (no.298 pl. 25, detail)

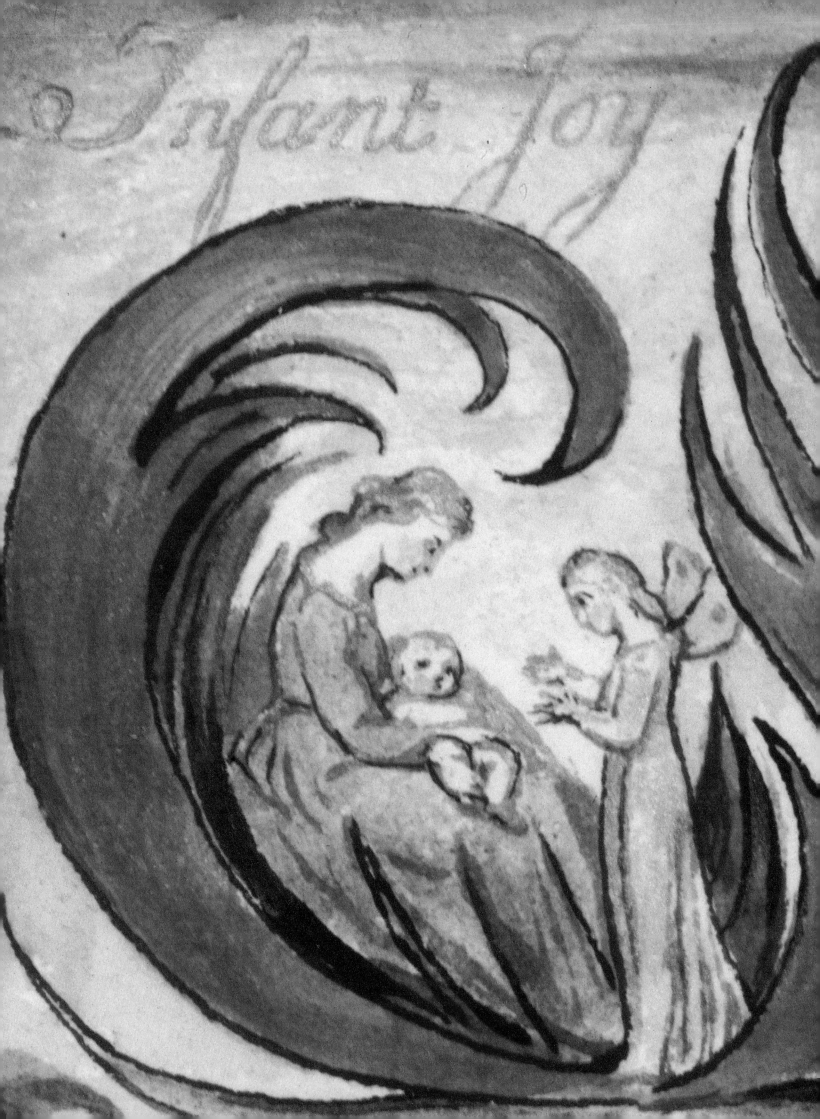

Plate 1 *Songs of Innocence and of Experience:* **Combined Title-Page**

The book's title sparkles in letters touched with gold: *Songs Of Innocence and Of Experience Shewing the Two Contrary States of the Human Soul*. Above, a bird soars into the lucid sky beyond *Innocence*; below, two human figures, identified as Adam and Eve by their abbreviated leaf garments, appear felled beneath *Experience*. Eve, shielded from the vivid flames by the protective gesture of her mate, looks back at him, and re-directs the reader to the title with her gaze. EEB

Plate 2 *Songs of Innocence:* **Frontispiece**

Blake establishes the pastoral voice of *Innocence* at the outset. In the Frontispiece, within a glittering woodland setting of idyllic forms, a shepherd in a close-fitting blue suit (his features not dissimilar to the artist's own) lifts a pipe from his lips, and pauses his song to face the child flying above him in a pink cloud. Just as Blake's friends must have encouraged him to publish the verses he is known to have sung at small social gatherings in the early 1780s, so here the cloud-borne infant, as related in the book's Introduction, instructs the piper to write his songs so that all may read them. EEB

Plate 3 *Songs of Innocence:* **Title-Page**

The piper's song is realized at the beginning of the text. The blue-suited poet appears as a minute figure leaning against the 'I' of *Innocence*. Beneath a tree heavy with oranges, presumably in reference to the biblical fruit of knowledge, a woman sits within a broad landscape, supporting on her lap a large book read by a standing boy and girl. Placed beneath the piper/author, these readers function both as the consumers for this, Blake's book the *Songs of Innocence*, and also as more general human types in search of knowledge. EEB

Plates 6–7 **'The Ecchoing Green'**

The design, like the verse, describes a clear pattern. The page is divided into upper and lower halves, and centres on the main motif at the top, a large tree ringed with seated adults who watch children playing with a shuttlecock. Just as the arboreal group acts as the fulcrum on which the centrifugal design appears to pivot, so the verse's sympathetic witnesses, who link past, present and future tenses within the poem, centre its sequence of 'ecchoing' images: sunrise, children at play, aged observers, children at rest, sunset.

In the following plate, boys entwined in vines distribute the fruit that encircles the text, a motif repeated in the tendrils of the hand-painted border. EEB

Plates 9–10 **'Little Black Boy'**

By addressing the evils of slavery in his poetry and his art, Blake acknowledged a topic of increasing concern among his contemporaries and fellow poets. By presenting an African child who achieves closeness to God without the aid of formal Christian instruction, however, Blake exceeded conventional liberal notions of the subject. For the 'Little Black Boy' of the poem, God's divine love blazes forth like the scorching beams of the African sun illustrated on the first page of the verse. On the second page, the sun forms a natural halo behind the seated Christ, who greets a black and white child together, beneath the gentle embrace of a bending tree. Blake embellished the top of the first plate with palm fronds executed with great refinement; he surrounded the second with a green vine touched with blue fruit or flowers. EEB

Plate 11 **'The Blossom'**

The simple rhythms of this enigmatic lyric – interpreted in this century in terms of sexual virility – are matched by the clean design, in which a winged woman and infants inhabit the flame-like, fiery-toned foliage of a large plant, embracing, dancing, and reading. The green leaves, sparrow, robin, and blossom of the verse are omitted from the illustration. EEB

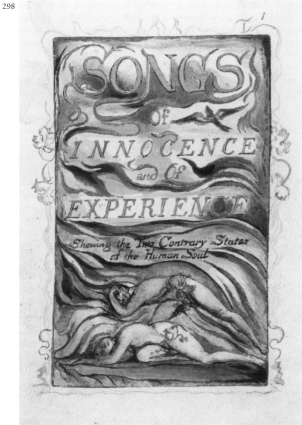

PLATE 1

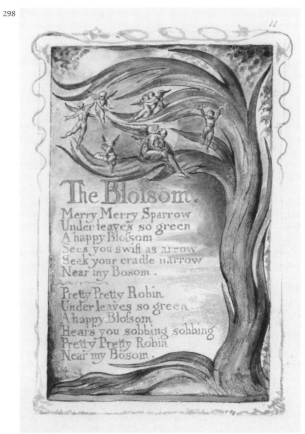

The Blossom.

Merry Merry Sparrow
Under leaves so green
A happy Blossom
Sees you swift as arrow
Seek your cradle narrow
Near my Bosom.

Pretty Pretty Robin
Under leaves so green
A happy Blossom
Hears you sobbing sobbing
Pretty Pretty Robin
Near my Bosom.

PLATE 11

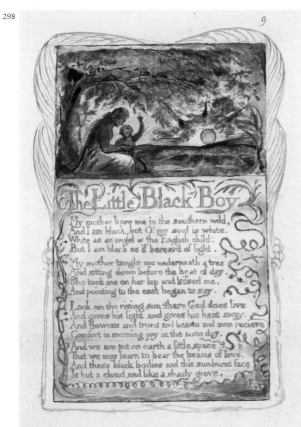

The Little Black Boy

My mother bore me in the southern wild,
And I am black, but O! my soul is white.
White as an angel is the English child:
But I am black as if bereav'd of light.

My mother taught me underneath a tree
And sitting down before the heat of day,
She took me on her lap and kissed me,
And pointing to the east began to say.

Look on the rising sun: there God does live
And gives his light, and gives his heat away.
And flowers and trees and beasts and men recieve
Comfort in morning joy in the noon day.

And we are put on earth a little space,
That we may learn to bear the beams of love.
And these black bodies and this sunburnt face
Is but a cloud, and like a shady grove.

PLATE 9

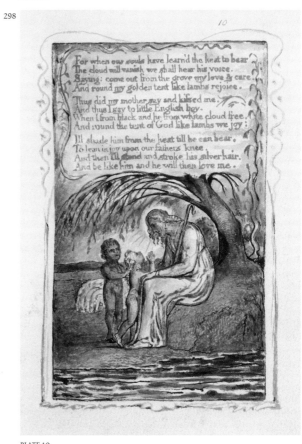

For when our souls have learn'd the heat to bear
The cloud will vanish we shall hear his voice.
Saying: come out from the grove my love & care,
And round my golden tent like lambs rejoice.

Thus did my mother say and kissed me,
And thus I say to little English boy.
When I from black and he from white cloud free,
And round the tent of God like lambs we joy:

Ill shade him from the heat till he can bear,
To lean in joy upon our fathers knee.
And then I'll stand and stroke his silver hair,
And be like him and he will then love me.

PLATE 10

Plate 15 'Laughing Song'

A youth, holding a feathered cap in his hand, raises his glass before a small group of men and women seated at a table out of doors. Presumably, he sings the lyric 'Come live & be merry and join with me', a line with which Blake transforms the intimate entreaty of Christopher Marlowe's celebrated 'Come live with me and be my love' into a chorus of shared celebration. Coiled, looping lines form the upper portion of the border, suggesting the buoyancy and effervescence of the party's laughter. EEB

Plate 18 'The Divine Image'

Broad, curling leaves inhabited by slender figures climb the sheet, encircling the text. At the base, in the lower right corner of the page, a haloed figure in a long robe raises a nude man as a woman reclines below – a vignette that recalls the Creation of Adam and Eve. Their presence underscores the message of the text, which seeks the human in the divine. The border repeats the exquisite curling tendrils that embellish the central forms. EEB

Plate 25 'Infant Joy'

Blake expresses the joy that accompanies the birth of a child in clean, bright verse, complemented by a simple, masterfully balanced design. A large flowering plant across the sheet, embracing figures and text alike within its curving forms. The large red and pink blossom at the top, supporting a woman draped in blue, her infant, and an angel who attends them, is matched by the closed bud, bending on its stem at the bottom of the sheet. The title appears in gold, and the clear forms of the flowers exhibit strong black outlines. EEB

Plate 27 'On Anothers Sorrow'

Tiny figures stand beneath and climb within the border of this page, filled with glittering text. Against an azure sky accented with yellows, pinks, and greens, the black outlines of the vines resemble stained glass, while the trellis that forms the internal border suggests a gothic arch. With this poem on the power of empathy and the promise of divine mercy, Blake concludes the *Songs of Innocence*. EEB

298

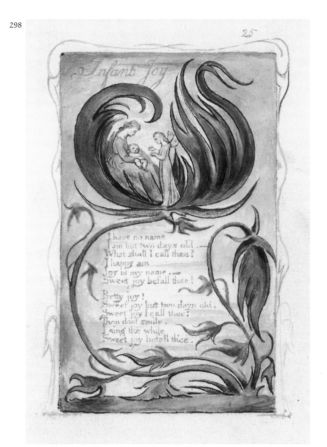

PLATE 25

298

PLATE 30

Plate 28 *Songs of Experience*: **Frontispiece**
A shepherd wearing an expression of wonder
and carrying a winged infant on his head strides
forward, towards the reader. The mottled pale
blue bark of a tree at the right restricts the
picture space, emphasising the monumentality
of the figure. The shepherd wears a rose-
coloured suit, as if, in capturing the flying child
in the Frontispiece to *Innocence*, he has also
claimed the infant's cloud of inspiration.

The refined, filigreed forms of the hand-
painted border create an architectural
framework for the natural scene. EEB

Plate 29 *Songs of Experience*: **Title-Page**
A boy and girl bend weeping across the bodies
of their deceased parents, laid out within a
sepulchral space open to the sky. Male and
female figures fly alongside the letters of the
title, like souls released from the corpses below.
The rigorous geometry of the design is matched
by the severe classicism of the lettering, and
further enhanced by the external border drawn
in lilac wash. Resembling a curtain gathered at
the top of the design, its folds cascade across the
sides of the plate, echoing the fabric that lines
the funeral bier. EEB

Plate 30 Introduction
Beneath the title, glimmering in gold, the
text inscribes the clouds of a deep blue sky
crowded with stars. The words fall towards a
nude female figure reclining on a yellow couch
at the base of the page. She is the lapsed Earth,
addressed by the Bard of the verse, who calls her
to arise and claim her destiny. The dawning sun
that rises behind her head suggests such an
awakening. EEB

Plate 31 'Earth's Answer'
Earth acknowledges the words of the Bard in
the preceding poem, confirming that verse's
expression of confinement, while suggesting
the possibility for hope. The sun has risen, and
shines its white-gold light in purple rays across
the head of a snake at the bottom of the plate,
presumably a reference to the biblical serpent
who tempted Eve to sin. The vines that wind
between the lines of text – repeated in stylized
leaves of the geometric frame – recall the
curving body of the serpent, and suggest growth
and life. EEB

Plates 34-35 'The Little Girl Lost'
Rounded forms and rich colours lend this page
a marked sensuality. Curving tendrils (inhabited
at the left by a snake) caress the text and green
leaves dropped from drooping branches fall
across its straight lines. At the lower right, a man
in blue and woman in yellow embrace within a
burst of purple, echoing the red and mauve
tones at the upper left of the sheet. The couple
may represent the parents of the lost girl
described in the poem; on the following page
Lyca herself appears, a young woman lying
alone within a muscular wood. EEB

Plates 35–36 'The Little Girl Found'
Where the narrative breaks, the page divides;
the second part of the verse begins on the lower
half of the same sheet. On the right, beneath the
branches of a bare tree, a jungle cat – one of
the leopards or tigers that play 'round her as
she lay' – mirrors the woman's pose. On the
following page, Lyca, stripped of her 'slender
dress', and accompanied by nude figures, lies
beside a yellow leopard and a golden lion.
A richly described tree, encrusted in leaves, rises,
twisting, along the right side of the sheet; from
its unseen top vines dangle at the left. EEB

Plate 42 'The Tyger'

'The Tyger', arguably Blake's most famous poem, describes a creature of brutal and terrifying strength. For Blake's earliest readers, his questioning of a God who could unleash such cruelty onto the world, would have evoked notions of the Apocalyptic and Sublime, and recalled the contemporary Revolutionary violence in France. The illustration's narrow cat with mottled fur hardly conveys such awesome power. Shown in profile beneath the pale blue bark of a tree trunk, the tiger of this copy is lightly colored, printed in orange-brown ink, touched with pinkish-red and blue-grey washes, and outlined in black. EEB

Plate 45 'The Little Vagabond'

In this poem, spoken by a poor child, Blake contrasts the indifference of churchgoers to the generosity of alehouse patrons. At the bottom of the page, a homeless family, the adults' bodies crushed and weary, cluster around a fire touched with gold. Above them is a heavenly vision of a soul embraced by God: a nude man (the pinks, purples, and blues of his flesh repeated in the nearby trees) kneels beside a bearded, white-haired man, whose divine rays emanate from his head like a red sunrise against the blue sky. EEB

Plate 46 'London'

Across a 'midnight street' of the poet's native city, its cobble stones flecked with gold, a small boy in green clothes leads a stooped and bearded man in blue, ragged robes. The elderly man bears the 'marks of weakness, marks of woe' described in the verse, and the door of the stone building they pass is closed to them. The structure may be a church; in this copy, Blake composed a border of medieval architecture: four pinnacled arches appear stacked along each side, joined at the top with a calligraphic flourish. Below them, alongside the text, a tiny figure kneels, and warms his hands before a flame. EEB

Plate 47 'The Human Abstract'

In 'The Human Abstract' the selfish motives of society contrast with the personal virtues celebrated in 'The Divine Image'. Cruelty, baiting a trap with the fruit of Deceit, appears caught in his own snare. Within a wild, jungle landscape, a fearsome man with a furrowed brow, his hair and beard touched in gold appears bound by thick ropes tethered to the edges of the design. The border, fence-like at the base and foliate at the top, strengthens the design. EEB

Plate 49 'A Poison Tree'

In this cold and powerful image, Blake presents a cruel counterpart to the fruit trees that have recurred throughout the book: a poison tree, sowed in wrath. A man lies pale and prone beneath the tree, luminous in the blue crepuscular light. The lowest branch seems to restrain the fallen figure, and its leaves repeat the pattern of his outspread hair. A jagged green border of thorny vines intensifies the energy of the scene. EEB

Plate 54 'The Voice of the Ancient Bard'

Once included in the *Songs of Innocence*, Blake moved this verse to conclude the *Songs of Experience* with a triumphant vision of dawn and renewed hope. As the colours of sunrise tint the cerulean sky, the bearded, white-robed Bard strokes his enormous harp, accompanied by the smaller figures of young men, women and children, who embrace and listen to his song. The hand-painted border is remarkable: supple, flame-like shapes flicker along the top of the design, and loop down the sides, before sharpening and stopping at the base. EEB

The Tyger.

Tyger Tyger, burning bright,
In the forests of the night;
What immortal hand or eye,
Could frame thy fearful symmetry?

In what distant deeps or skies,
Burnt the fire of thine eyes?
On what wings dare he aspire?
What the hand, dare seize the fire?

And what shoulder, & what art,
Could twist the sinews of thy heart?
And when thy heart began to beat,
What dread hand? & what dread feet?

What the hammer? what the chain,
In what furnace was thy brain?
What the anvil? what dread grasp,
Dare its deadly terrors clasp!

When the stars threw down their spears
And water'd heaven with their tears:
Did he smile his work to see?
Did he who made the Lamb make thee?

Tyger Tyger burning bright,
In the forests of the night:
What immortal hand or eye,
Dare frame thy fearful symmetry?

PLATE 42

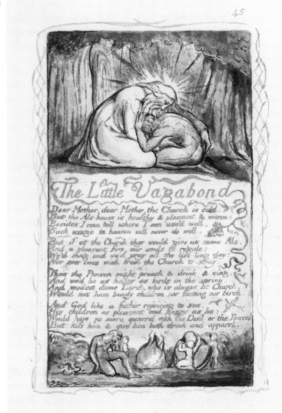

The Little Vagabond

Dear Mother, dear Mother, the Church is cold.
But the Ale-house is healthy & pleasant & warm;
Besides I can tell where I am us'd well,
Such usage in heaven will never do well.

But if at the Church they would give us some Ale.
And a pleasant fire, our souls to regale;
We'd sing and we'd pray, all the live-long day;
Nor ever once wish from the Church to stray,

Then the Parson might preach & drink & sing.
And we'd be as happy as birds in the spring;
And modest dame Lurch, who is always at Church,
Would not have bandy children nor fasting nor birch.

And God like a father rejoicing to see,
His children as pleasant and happy as he:
Would have no more quarrel with the Devil or the Barrel
But kiss him & give him both drink and apparel.

PLATE 45

The Human Abstract.

Pity would be no more,
If we did not make somebody Poor:
And Mercy no more could be,
If all were as happy as we;

And mutual fear brings peace;
Till the selfish loves increase.
Then Cruelty knits a snare,
And spreads his baits with care.

He sits down with holy fears,
And waters the ground with tears:
Then Humility takes its root
Underneath his foot.

Soon spreads the dismal shade
Of Mystery over his head;
And the Caterpiller and Fly,
Feed on the Mystery.

And it bears the fruit of Deceit,
Ruddy and sweet to eat;
And the Raven his nest has made
In its thickest shade.

The Gods of the earth and sea,
Sought thro' Nature to find this Tree
But their search was all in vain:
There grows one in the Human Brain

PLATE 47

The Voice of the Ancient Bard.

Youth of delight come hither,
And see the opening morn,
Image of truth new-born.
Doubt is fled & clouds of reason,
Dark disputes & artful teazing.
Folly is an endless maze,
Tangled roots perplex her ways.
How many have fallen there!
They stumble all night over bones of the dead:
And feel they know not what but care;
And wish to lead others when they should be led

PLATE 54

299 Europe a Prophecy 1794

'Lambeth/Printed by Will: Blake: 1794'
Copy B 1794
17 colour-printed relief etchings finished with
watercolour each on paper approx. 37.3 × 26.7
(14⅝ × 10½)
Special Collections Department, Glasgow
University Library

*Lit: Damon 1924, pp.342–51; Erdman 1954; Bindman
1977, pp.79–83; Butlin 1981, no.201; Viscomi 1993,
pp.276–9; Dörrbecker 1995 (facsimile Copy B),
pp.139–283*

Europe was the second of Blake's 'Prophecies',
following on from *America* (nos.115, 124) and
can be seen as pair to it: their themes link two
continents – with the revolution in the New
World of America contrasted with the deep-
rooted tyrannical Old Order and its eventual
overthrow in the French Revolution of the
European world; the text and designs of *Europe*
were etched on the backs of the copper plates
used for *America*; both books are about the same
length, and they were sometimes bound
together during Blake's lifetime. Unlike *America*
which first appeared uncoloured in 1793. Blake
colour printed the earliest copies of *Europe* in
1794. The result, as in Copy B of the book shown
here, is a work of extraordinary textural and
colouristic power in which Blake seems to be
challenging the Grand Style as exclusive to
academic history painting. Twelve copies of
Europe are known, though three of them were
printed after Blake's death. In 1818 the work
was priced at five guineas.

Europe is the more ambitious and complex
of the two historical allegories and as such is
open to many different interpretations. Blake's
own creation myth, with figures like Urizen,
Enitharmon (see nos.282–5) and Orc (see
nos.290–2), is interwoven with an account of
events from the time of the French Revolution.
Europe spans the period beginning with the birth
of Christ (pl.5(3), lines 1–4) and leading to a
Judgement Day or the Revolution – the climax
to the 'Eighteen hundred years' (pl.12(8), line 5)
of the Christian era.

The Frontispiece to *Europe* (pl.1) is perhaps
best known of all Blake's images – though as an
independent colour print *The Ancient of Days*
rather than as part of an illuminated book
(no.297). The figure is that of the Law-maker
Urizen (see nos.295–7). His presence at the
beginning of *Europe* complements the
Frontispiece to *America* (pl.1), which depicts
the ills of war, attributable to Urizen's rule and
colours the reader's view of the *Europe* text in

which Urizen, 'like a meteor' is present at the
opening of the Prophecy (pl.6(3)) and whose
'brazen Book' of unchangeable laws is copied by
'Kings and Priests' so they can enforce their rule
(pl.14(10)). The universal results of such old
order laws are illustrated in designs throughout
the text – the scaly figure of War or Death with
his sword in pl.8(5), famine in pl.9(6), plague in
pl.10(11), and mental and physical captivity in
pl.16(13). A real sense that such images were
inspired by events of the day, and so relevant to
Blake's attack on Church and State tyranny, can
be gained from a comparison between 'Famine'
(pl.9(6)) and Gillray's piercing commentary on
the massacres of prisoners, priests, women and
children by 'citizens' in the name of national
salvation, in Paris in September 1792 (see no.173).
David Erdman has identified in *Europe* more
specific commentaries by Blake on the political
events of his times, for example, the figure of
War – Rintrah 'furious … king of fire' (pl.11(7),
lines 8, 12) – can be seen as Prime Minister
William Pitt who took Britain into war against
Revolutionary France in early 1793 (see no.213).

The image of the serpent on the Title-Page
(pl.2) can be interpreted in at least two ways.
First as a symbol of materialism and therefore
the creation of Urizen's reasoning which is
shown at work as he sets out to 'bind the infinite'
in the Frontispiece. The restraining power of
materialism and reason is emphasized in the
way the serpent coils off the page and back again
as though pinning down the pages of the book.
Alternatively, looking back to *America* (pl.8, line
15), Orc (a symbol of the American Revolution,
see nos.290–2) says 'Empire is no more' and so
signals the impact of revolution in Europe: Orc
is described in *America* as 'serpent form'd' (pl.9,
line 3). The design here, then, might represent
Orc as Revolution, the counterpart to Urizen the
Law Maker.

In plate 18(15) *Europe* concludes with the
most powerfully energetic of all the designs in
the book, an idealised nude male rescuing a
woman and child from a destructive fire.
The last three lines of the poem, with their
reference to Los, implicate Blake himself as Los
(see nos.286–9) as a witness to the drama being
acted out – allying himself simultaneously with
Orc 'in the vineyards of red France', who has
ignited the fire of revolution. A response to
this is Blake's/Los's 'cry that shook all nature to
the utmost pole' (line 10) – the 'Prophecy' itself,
which is also an instrument for destroying the
forces of religious and state oppression. RH

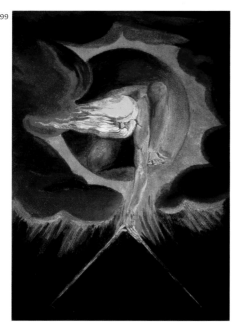

299

PLATE 1

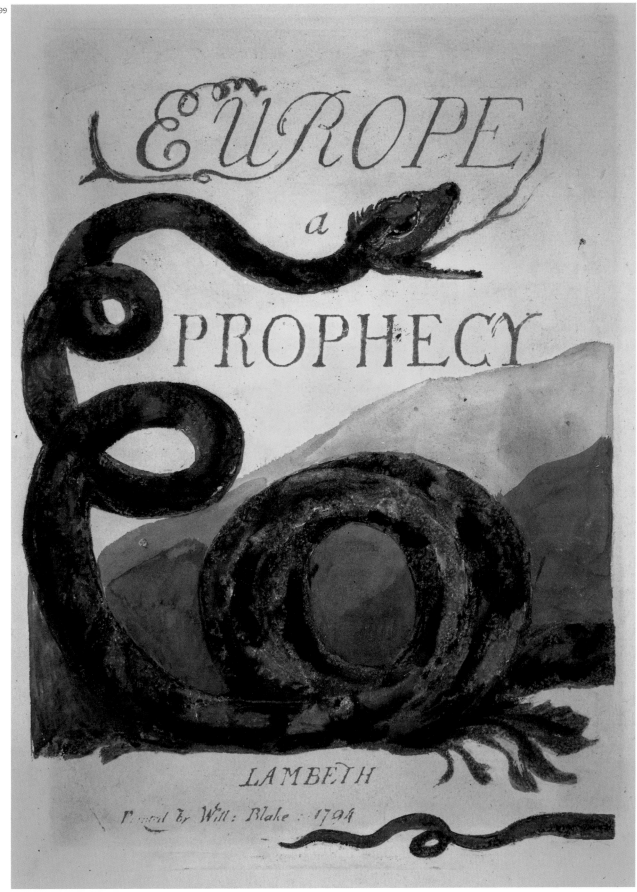

PLATE 2

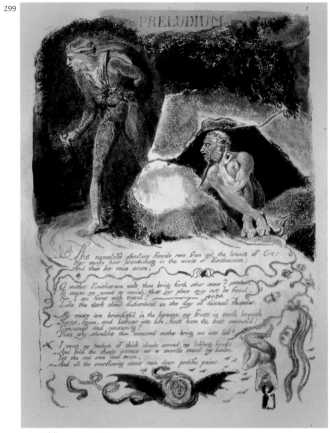

PLATE 4 (1)

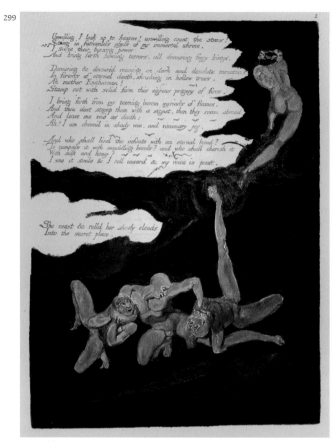

PLATE 5 (2)

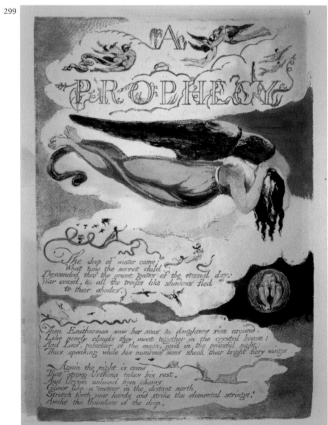

PLATE 6 (3)

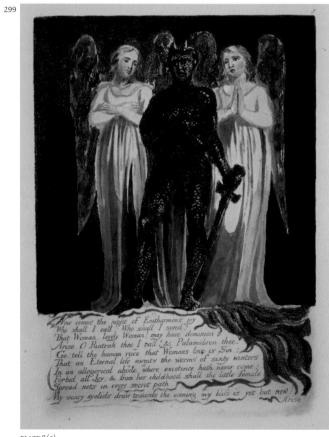

PLATE 8 (5)

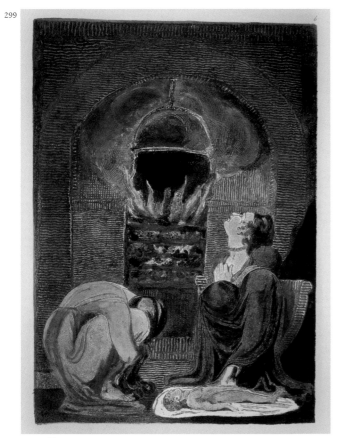

PLATE 9(6)

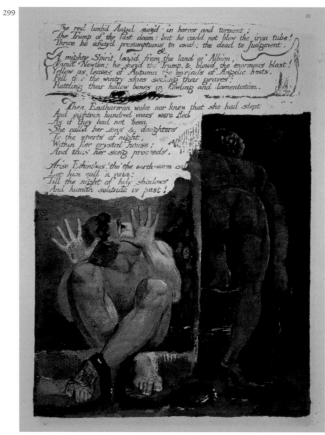

The red limbd Angel siezd in horror and torment:
The Trump of the last doom; but he could not blow the iron tube!
Thrice he assayd presumptuous to awake the dead to Judgment.

A mighty Spirit leap'd from the land of Albion,
Namd Newton; he siezd the Trump, & blow'd the enormous blast!
Yellow as leaves of Autumn the myriads of Angelic hosts,
Fell thro' the wintry skies seeking their graves;
Rattling their hollow bones in howling and lamentation.

Then Enitharmon woke nor knew that she had slept
And eighteen hundred years were fled
As if they had not been
She calld her sons & daughters
To the sports of night,
Within her crystal house;
And thus her song proceeds.

Arise Ethinthus! tho' the earth-worm call;
Let him call in vain;
Till the night of holy shadows
And human solitude is past!

PLATE 16(13)

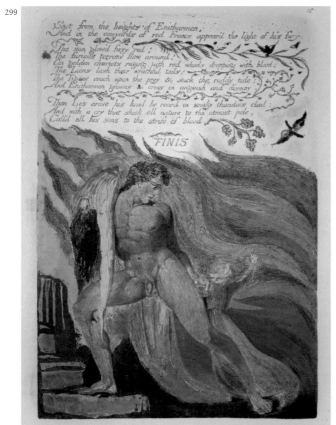

Shot from the heights of Enitharmon;
And in the vineyards of red France appear'd the light of his fury.

The sun glowd fiery red!
The furious terrors flew around!
On golden chariots raging, with red wheels dropping with blood;
The Lions lash their wrathful tails!
The Tigers couch upon the prey & suck the ruddy tide:
And Enitharmon groans & cries in anguish and dismay.

Then Los arose his head he reard in snaky thunders clad:
And with a cry that shook all nature to the utmost pole,
Calld all his sons to the strife of blood.

FINIS

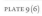

PLATE 18(15)

300 Vala, or The Death and Judgement of the Ancient Man, a Dream of Nine Nights 1797
'by William Blake 1797'
later **The Four Zoas, The torments of Love & Jealousy in The Death and Judgement of Albion the Ancient Man** *c.*1797–1807?
'by William Blake 1797'
Manuscript in pen and ink and pencil with marginal illustrations in pencil, pen and ink, chalk and watercolour on 70 folios approx.
42×32.5 (16½×12¾) with two smaller sheets and a fragment bound in a volume
Pages 1–3, photographs; open at pp.4–5
The British Library Board
Lit: Damon 1965; Bentley 1963 (*facsimile*); Grant 1973; Butlin 1981, no.337; E.300–407, 816–46, 948–67; Magno & Erdman 1987; Viscomi 1993, pp.316–19

After 1795 Blake's public role, so confidently announced in the 1793 *Prospectus*, (p.122) more or less withered away: a period of extraordinary creativity came to an end and a seven-year period began when no further copies of the illuminated books were printed from existing plates. From the early 1800s, Blake was relief etching the plates for *Jerusalem* (no.303) and *Milton* (no.272) but it was not until the first printing of copies of the latter in 1811 that we detect a return to the aspirations of the mid-1790s.

In this context, Blake's acceptance at the end of 1795 of a major commission to design and engrave illustrations to Young's *Night Thoughts* (nos.29–36), can be viewed as confirmation of his clear withdrawal as writer and publisher from the public sphere. It was a withdrawal that paralleled that made at the same time by many other radicals in the face of Prime Minister Pitt's November 1795 measures to stifle political unrest – a Royal Proclamation against seditious meetings and the passing of related parliamentary bills. A commission from John Flaxman at the end of the year to illustrate Gray's poems (nos.37–40) eased the pessimism but in one of these illustrations (no.39) we can see, in the image of the silent bard alone on a deserted shore, like *Joseph of Arimathea* (nos.2, 274), a true reflection of the artist's state of mind.

One powerful symbol of Blake's withdrawal was his embarking on his first epic poem *Vala* or *The Four Zoas*. Its division into nine 'Nights', its origin in 'a Dream', the surrounding of the text with wide margins for illustrations and, from the end of 'Night the Third', the inclusion of proof engravings related to the *Night Thoughts* commission, all show the influence of Young. The form in which he wished it ultimately to

appear is not clear. The use of an elegant copperplate script, used from the beginning but only maintained for the first forty-two pages of the manuscript, suggests a future for *Vala* divorced from the possibilities opened up by Blake's earlier printing innovations: perhaps a unique work intended for limited private circulation. On the other hand, it is possible to see Blake considering publishing it in conventional intaglio engraved form (as in *The Book of Los*, no.302), as a comparison between the copperplate hand of the Title-Page and the line-engraver's 'hand' in the inscription on *Edward & Elenor* suggests (no.123), or using the same combination of letterpress with engraved designs around them created for *Night Thoughts*.

Vala draws on Blake's earlier books and links them with the final great poems *Milton* and *Jerusalem*. It was to occupy Blake over many years and an indication of the extent of the revisions he made at different times, as well as the resultant great complexity of the narrative, can be seen in the book's change of title and in the erasures and additions obvious on the pages shown here. The whole manuscript is a singularly vivid illustration of the ferment of Blake's ceaseless creativity as writer and designer. In the marginal additions, taking over the spaces meant for designs, we see the urgency of that 'immediate Dictation twelve or sometimes twenty or thirty lines at a time, without Premeditation & even against my Will' which governed his writing (to Butts, 25 April 1803, E.729) – giving some idea of how those illuminated books which we know only in printed form might have evolved. Against this 'visionary' process we find a pragmatic process of borrowing second hand 'dictations' from earlier works going right back to words from *Tiriel* (nos.20–8) for inclusion in the first copperplate script section. The description of Los's growing jealousy of Orc from plate 20 (no.296) of *Urizen* is incorporated in Night 5 (p.60). In one instance, Blake pencils in a reminder between the ink lines to 'bring in' an episode from plates 15–16 (no.296) of *Urizen*. In doing this, Blake was, understandably, re-using, where appropriate, some of his most vivid lines, perhaps occasionally with the powerful designs which they inspired also in mind. Sometimes the marginal illustrations in *Vala* have their sources in earlier illuminated books, as in the 'Chaining of Orc' episode on p.62 that is very close to the design on plate 3 of *America* (no.124) or *Urizen* with his globe from plate 23 of Urizen on p.74. The process also went

the other way with quite a number of passages from *Vala* being re-used in the later illuminated books *Milton* and *Jerusalem*.

The subject of this 'immense number of verses on One Grand Theme', as Blake seems to describe *Vala* in 1803 (to Butts 25 April 1803; E.728) is the Fall of Man – a state in which his passiveness allows his Four Zoas (see *Milton*, no.272 pl.32) to fight among themselves for supremacy. Each Zoa has a female counterpart, or Emanation (no.280–1), representative of the feminine part of Man and these also become separated from each other. This disunity among those parts within Man which energise him is what Blake means by the Fall. It is a state applicable as much to the individual being as to society as a whole – for Blake specifically Britain (Albion).

Having first lived in Eden it is only when unity is restored among all these elements and Man is regenerated – the awakening, resurrection, and Last Judgement of the dead in the Ninth Night – that he can return to that eternal state.

The '*Vala*' of the original 1797 title (p.1) is the goddess who in *Jerusalem* is described as 'Nature Mother of all' (pl.34; E.176). She is the emanation of the male Luvah, one of the Four Zoas who in Eden or Eternity represents passion or love in Man. Luvah, in order to have power over the Eternal Man has Vala seduce him. In 'Night the First' (p.10f.; E.305) Vala and Luvah take the place of Urizen, the Zoa who stands for Reason, in Man's mind. Reason and Passion, which should be in harmony in Man, are thus set against each other and this contributes to his Fall.

The name 'Vala' is pronounced to rhyme with 'veil' since her veil is the materialism – for example, moral law or reason – which conceals the eternity from Man.

The 'Ancient Man' is Blake's 'Eternal' or 'Fallen Man' – an idea which Blake could have taken from Swedenborg's 'grand man' or the giant Adam Kadman of the Jewish mystical text, the cabbala. The later pencil addition of 'Albion' to the title points towards Blake's final realisation of this concept of the universal Man in the figure of the 'Giant Albion' of *Jerusalem* (pl.27, no.303).

Although used in the revised title, the name 'Zoas' – used by Blake for the group of Urizen, Luvah, Urthona and Tharmas, who are the four aspects of the Eternal Man (see also no.272 pl.32) – does not appear in *Vala*. 'Zoa' is the Greek word, found in the Bible, for 'beasts'. In Night IX

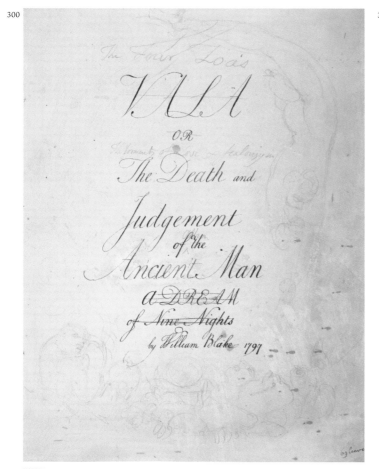

PAGE 1

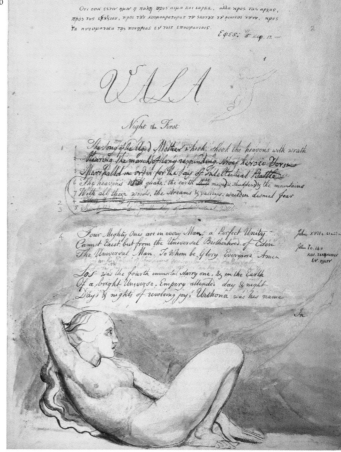

PAGE 3

(p.123, lines 34–40; E.393), inspired by verses in Revelation Chapter 4 which describe the unresting praise of God by the four watchful beasts around his throne, Blake writes of the 'Fourfold … Lifes in Eternity' – a linking of Man with the Almighty as well as defining the nature and centrality of the Four Zoas to his being. The design on this page, probably drawn at the time of the pencil changes to the poem's title, shows a Last Judgement scene with a falling figure blowing a trumpet and waking figures in the grave below. Among these it is possible to see the faces of a lion and an eagle, two of the four beasts of the Book of Revelation already mentioned as a likely source for the Four Zoas (and who can be seen in another context in *Beatrice Addressing Dante*, no.91) and thus here representative of aspects of Albion.

In the drawing on p.2, 'Rest before Labour', we recognize Blake's act of preparing himself for the task of writing his epic. The struggle 'against powers, against the rulers of the darkness of this world, against spiritual wickedness in high places' that is the subject of the passage from 'Ephesians' written in Greek at the top of the opposite page (p.3) is the author's own as well as the story of *Vala*. Out of the idea of 'Rest' comes a reminder of sleep, the night thoughts or 'Dreams' which accompany it, and out of which *Vala* grew. This continuous creative process is described by Blake in a line from *The Marriage of Heaven and Hell*: 'Think in the morning, Act in the noon, Eat in the evening, Sleep in the night' (pl.9, line 41; E.37). There is also a biblical dimension to Blake's words that further emphasises the scope and one of the roots of his epic – God's rest on the seventh day having created Man on the sixth, followed by the Fall of Man and his expulsion from Eden: the figure's cloven hoof alludes to Satan's part in this. The blindfold symbolises the spiritual and moral blindness that resulted. The broken chain symbolises the breaking free from this that is the Resurrection of 'Night the Ninth'.

The reclining female figure at the bottom of the opening page of the poem (p.3) shows the goddess Vala. The 'Aged Mother' of the opening line on page 3 is Eno. Her name is an anagram of Eon, the Greek word for Age so she can be seen as the personification of an 'aged' or unending period of time. Here she sings the epic that follows. She is also the speaker of *The Book of Los* (no.302). The 'Four Mighty Ones' who 'are in every Man' referred to in the line numbered '4' are the Four Zoas. One of these is Urthona, as he is known in Eden, a part of whom – when divided and fallen – is Los, 'the fourth immortal starry one' (the other part being Enitharmon). As his role of addressing 'the Auricular Nerves of human life' (that is the sense of hearing) implies, he is a poet and prophet and thus identifiable with Blake himself. The Fall of Los, who as one of the Zoas, is a part of the Universal Man, 'into Division & his Resurrection to Unity' is the main theme of 'Night the First' and 'Night the Ninth Being The Last Judgement'.

Tharmas, one of the Four Zoas who represents compassion is first mentioned on page 4 and his Emanation, the female Enion, in the following line. For Enion, Tharmas was once the 'loveliest son of heaven' (p.4, line 20; E.301) but now he is 'terrible' (line 21) though she still loves him despite having looked into his soul and found sin there: she is jealous because Tharmas has taken pity on Enitharmon. In the design at the foot of page 4 the conjunction of Cupid, the gentle disarmer in love, on a threatening phallus-like serpent illustrates another aspect of disunity in the world of the fallen Man. The Serpent reaches up towards lines (in pencil) at the top of the page that describe Tharmas's pained sexual yearning for Enion. The design at the foot of the page 5 shows Tharmas, like cupid also winged. In order to murder 'his Emanations [and] secret loves & Graces' (p.7, lines 1–2; E.304) Enion has bound him in a cocoon of 'Sinewy threads' (p.5, line 60) which make a 'filmy Woof' (line 14). The design at the foot of this page shows Tharmas 'sunk down into the sea a pale white corse' (line 13) as a result of this. This is the prelude to Enion drawing out Tharmas's Spectre 'from his feet in flames of fire' with whom she mates, to produce Los and Enitharmon. RH

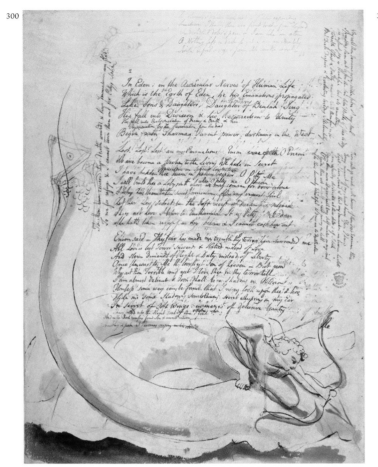

PAGE 4

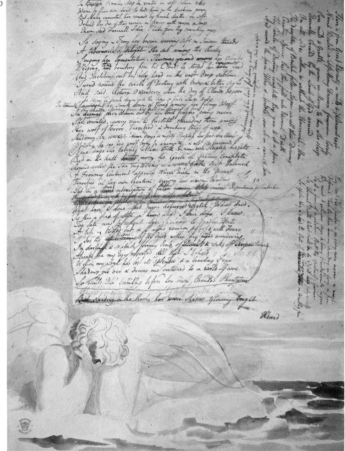

PAGE 5

301 The Song of Los 1795

'Lambeth Printed by W Blake 1795'
Copy B 1795
8 colour-printed relief-etched plates printed in grey-black ink finished with some pen and ink and watercolour approx. 23 × 14 (9 × 5½) on paper 32 × 24 (12⅝ × 9½)
Lessing J. Rosenwald Collection, Library of Congress
Lit: Keynes, Bibliography, 1921, pp.153–4; E.67–70, 804–5, 905–6; Bindman 1982, pp.108–9; Viscomi 1993, pp.287–8; Dörrbecker 1995, pp.287–354 (facsimile Copy A)

The character of Los represented a kind of alter ego for Blake, signifying the potential creativity of the unrestrained imagination (see pp.286–7). Los is also deeply infused with Blake's ambitions for his own poetry, the visionary nature of which most readily approximates to the prophetic incantations of the ancient bards, whose utterings were thought to have been accompanied by music. This relationship is firmly established in *The Song of Los*, both in its title, and its opening lines: 'I will sing you a song of Los, the Eternal Prophet: / He sung it to four harps at the tables of Eternity'. There is a definite biographical kinship here with accounts of Blake's unusual practice of singing, or declaiming his poems to his immediate audience (see also nos.39, 128 pl.54, 221, 298 pl.54).

The Song of Los is the last in the group of illustrated books known as the Continental Prophecies, which began with *America* in 1793 (nos.115, 124), followed in 1794 by *Europe* (no.299). These works were a direct and urgent response by Blake to the turbulent events of the American and French revolutions. In contrast, *The Song of Los* does not deal so explicitly with contemporary themes, and instead seeks to situate the drama of the earlier books in a longer historical framework. The text is much shorter than either of its predecessors and is made up of two smaller parts that recount the mythical histories of 'Africa' and 'Asia'. The first is effectively a prelude to the action of *America*, surveying the origins of the oppression of humanity, effected chiefly in the form of religion. In 'Asia', Blake brings his revolutionary chronicle to an apocalyptic climax, with the apparent overthrow of the order imposed by Urizen; in this *The Song of Los* seems to follow on from *The First Book of Urizen* (no.296).

Blake's experiments in colour printing in 1794–5, that included painting directly onto some of the copper plates (see pp.106–7), resulted in a much richer use of colours and textures than he had achieved in earlier illuminated books. In the years after his death, two of Blake's sincerest admirers, Dante Gabriel Rossetti and A.C. Swinburne, singled out *The Song of Los* for its particular splendour. Six copies of the book are known.

The sequence of eight plates for *The Song of Los* begins with a white haired, Urizenic figure kneeling below an extinguished, or darkened sun. This stooped, priestly figure is representative of organized religion, one of Blake's perennial targets. But the obscured sun above him also reflects Blake's distrust of the contemporary scientific speculations about unusual phenomena by astrologists, with their attempts to rationalize, and so limit, the natural order.

Another, or perhaps the same, old man appears on the facing title-page. His frail form dissolves into the earth, and his imminent fate is underlined by the skull on which he leans. His exact identity is unclear, but he gives form to the waning of humanity's greatness after the imposition of the Laws of Urizen, described in the following plate. The text of 'Africa' begins on plate 3, where a snake has insinuated itself within the title-word, bearing down from there on a shepherd sleeping amid his flock. Blake identifies the forces he associates with repression on plate 4: 'These were the Churches: Hospitals: Castles: Palaces:. / Like nets & gins & traps to catch the joys of Eternity'. The names of Sir Isaac Newton (see nos.248, 249) and John Locke (see no.108), more generally associated with the progressive ideas of the Enlightenment, are also invoked as agents of the constraining power of Urizen. Blake presents the impact of these ideas on the diminished figures of Har and Heva (see *Tiriel*, nos.19–28) as they flee their crazed companions. Blake ends this part of the text with the same words he had used at the beginning of *America*, thereby steering the reader back to the earlier prophetic book.

Plate 5 breaks the chronological sequence of the text with its representation of the tiny figures of a king and his female consort resting on lilies against a starry sky. This composition is based on a drawing by Blake's brother, Robert (see no.164), and was one that is also repeated, in reverse, as a separate watercolour, generally known as *Oberon and Titania* (Butlin 1981, no.245). In the context of *The Song of Los*, this strangely exotic image can be seen as an elaboration of the idea that all mankind, including its monarchs, was reduced from its original giant proportions as a direct consequence of Urizen's rule.

In the first plate of 'Asia' (pl.6), Blake resumes his narrative at the point at which he had left off at the end of *Europe*, with Los letting forth a 'cry that shook all nature to the utmost pale' (no.299 pl.18(15), line 10). This howl is heard in Asia by its spidery kings (they are perhaps to be associated with the diminutive form of the figure in plate 5). Blake characterizes Asia as dark and overgrown, but the letters of its title word in his illustration are beginning to be illuminated by the approach of the 'thick-flaming, thought-creating fires' of Blake's revolutionary Orc (see nos.290–2).

The last sections of the text are accompanied by a naked figure falling through a burning sky, evoking the cataclysmic resolution to which Blake, who was sympathetic to prevailing millennarian beliefs, looked forward as a means of overthrowing the tyranny of established regimes and systems. *The Song of Los* ends with a leavening of society, so that kings stand equal with the rest of mankind, and the hitherto 'sullen earth' reacts with a kind of rebirth that prompts the deposed Urizen to weep.

Outside these events, in the final image (pl.8), Los is seen looking down on the sun he has just forged with the hammer on which he rests. In spite of his triumph over Urizen, he is shown here by Blake with an expression of sadness – as vulnerable to error, perhaps, as the priest-Urizen, who faces away from us in the Frontispiece. IW

301

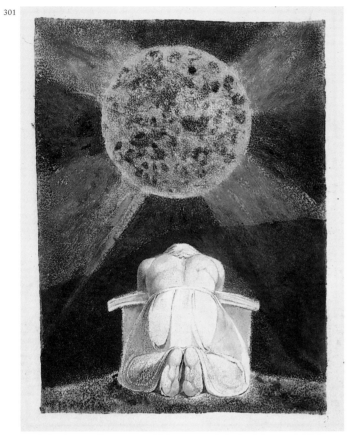

PLATE 1

301

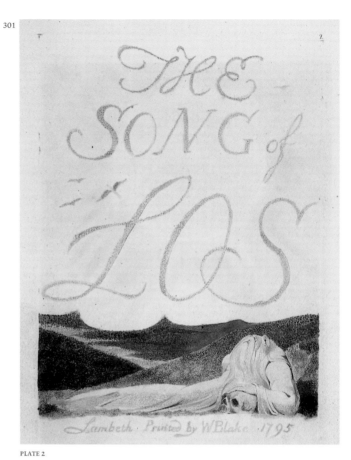

PLATE 2

301

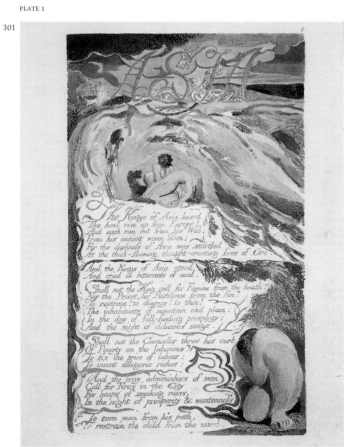

PLATE 6

302 The Book of Los 1795

'Lambeth/Printed by W Blake 1795'
Copy A
5 intaglio etched plates with some colour printing, approx.13.6×9.9 (5⅜×3⅞) on paper 24.8×29.4 (9¾×11⅝)
The British Museum, London
Lit: Viscomi 1993, pp.286–88; Worrall 1995, pp.195–224 (facsimile Copy A)

The Book of Los is a fragment of Blake's 'Bible of Hell', his alternative account of the beginnings of time, which was partly conceived as a means of questioning the authority of the earliest books of the Bible (known collectively as the Pentateuch). As well as *The Book of Los*, Blake's 'Bible of Hell' includes *The First Book of Urizen* (no.296) and *The Book of Ahania*, all of which were written and illustrated in 1794–5. Like other books of this period, it addresses the myths of human origins. The nature of Blake's satirical purpose is manifest not only in his use of the biblical word 'Book' in his titles, but also in the way the plates have their text set in two parallel columns, as would be found in most editions of the Bible. Blake, conscious of his bardic role (see nos.39, 128 pl.54, 221, 298 pl.54) was also interested in the idea of prophecy – very relevant at the time because of the competing visions offered by self-styled (and, for the government, politically subversive) prophets, such as Richard Brothers, Sarah Flaxmer and Joanna Southcott. Mirroring the divergence of views offered through such personal revelations, Blake's books of this period offer overlapping but differing accounts of Los and his origins.

There is a close association between *The Book of Los* and *The Book of Ahania*, both in terms of subject-matter and design, which has led some scholars to believe they were produced back-to-back on the same set of copper plates. Both volumes are among the rarest of Blake's printed books, with only one complete copy of each known.

The first plate is dominated by the squatting figure of Eno, and is the only plate in this volume to be entirely colour printed. Blake uses muted earthy tones, on either side of which he adds glimpses of a deep blue sky, where the light is evocative of the period just before dawn. Eno is a kind of cross between an earth-mother and an ancient druidic priestess, and the orator of the following text.

On the title-page, Blake's image of Los, hemmed in among rocks that threaten to crush him, is at first difficult to read, appearing almost abstract. But in a book with so few illustrations the reader cannot help but contrast the constricted form of Los here with his expansive gesture of release in the final plate. The moment depicted possibly recalls that at the beginning of Chapter II of *The Book of Los*, described on plate 4.

At the top of plate 3 Blake implants an image of Urizen inside the central letter of Los's name, thereby making manifest how the two characters are inextricably bound together as irreconcilable opposites, a juxtaposition which might also be seen at the beginning and end of *The Song of Los* (no.301). Scholars have seen the form of the elongated letter 'O' as an egg from which Urizenic controls (which are like nets) are hatched. Urizen sits at the centre of this letter holding tablets inscribed with text, resembling those in depictions of Moses after his descent from Mount Sinaii. The sinister nature of these dictates is made plain by the way a net fans out to ensnare two fallen figures.

The text describes a lost Golden Age in which humanity had not yet developed the sins that Mosaic Law specifically prohibits. As this ideal passes away, a frustrated Los is at first forced to watch as Urizen triumphs. In his rejection of the new order, Los erupts upwards until he is outside this realm. Having escaped from the controls of Urizen, Los inhabits a place where he stands 'frozen amidst / The vast rock of eternity' (lines 11–12), and though still 'bound', his senses are clear and untrammelled. During the following sequence Los falls through space in a passage that has obvious links with the fall of Lucifer in Milton's *Paradise Lost* (see nos.258–68). Until this point, Los existed as a kind of spirit, but the result of this descent is the creation and shaping of the essence of humanity. Initially, this is merely as a 'glutinous' mix of mind and lungs, floating without will on the tide.

The creation of light allows Los to see the form of Urizen with his 'vast spine', and this prompts Los to forge an immense orb of fire in an attempt to restrict his enemy's power. The text closes with the completion of a 'Form', 'A Human Illusion / In darkness and deep clouds involved'. In the final illustration Los appears floating above his creation, echoing the final image of *The Song of Los* (no.301). IW

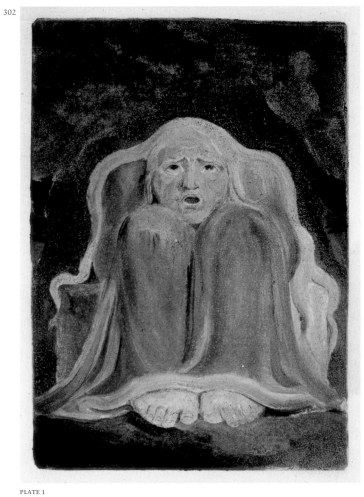

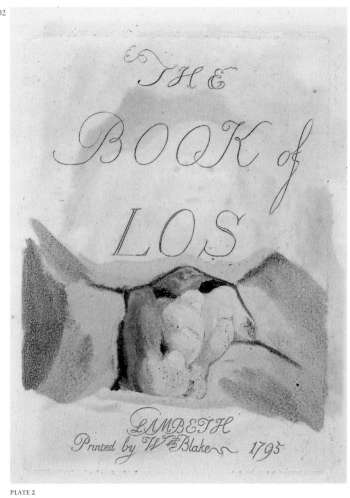

PLATE 1

PLATE 2

303 Jerusalem. The Emanation of the Giant Albion 1804–c.1820

'1804/Printed by W. Blake S^th Molton S^t'
Copy E 1821
100 relief-etched plates printed in orange-brown ink, finished with watercolour, pen and ink, and gold and silver, approx. 21.9 × 15.9 (8 ⅝ × 6 ¼) on paper 34.5 × 27 (13⅝ × 10⅝)
Paul Mellon Collection, Yale Center for British Art
Lit; Bindman, 1978, nos.480–579; Wicksteed 1954; Paley, 1991 (facsimile Copy E); Viscomi, 1993, pp.338–61

Jerusalem was the last of Blake's illuminated books, and his crowning achievement as a prophetic poet and artist. It draws together the characters and themes of his visionary universe in a drama of Redemption embracing the whole of mankind, and especially the British nation – on whose soil, as he had already promised in the famous lines from his earlier *Milton* (no.272 pl.2), Jerusalem must be built anew. Like *Milton* the work originated in his period of isolation at Felpham, 1800–3 – those 'three years slumber on the banks of the Ocean' as he described them in plate 3. In July 1803 he informed Thomas Butts of his intention

> to speak to future generations by a Sublime Allegory, which is now perfectly completed into a Grand Poem[.] I may praise it since I dare not pretend to be any other than the Secretary the Authors are in Eternity I consider it as the Grandest Poem that This World Contains.
>
> Allegory addressd to the Intellectual powers while it is altogether hidden from the Corporeal Understanding is My Definition of the Most Sublime Poetry … This Poem shall by Divine Assistance be progressively Printed & Ornamented with Prints & given to the Public.' (E.730)

In writing and illustrating the work, Blake felt the benefit of a fresh surge of inspiration – 'the light I enjoyed in my youth'. Felpham had brought a renewal of his visionary experience, and back in London he was able to put his often frustrating relationship with his Sussex host, William Hayley, into perspective while relishing his regained independence. Moreover his acquittal, in January 1804, in the sedition trial following his encounter with Private Scholfield (nos.208–11), removed a shadow of fear. By 1807, George Cumberland could report that Blake had 'engd. 60 Plates of a new Prophecy'; this, and the 'ancient history of Britain' to which Blake

himself referred in the *Descriptive Catalogue* of his 1809 exhibition (E.543), must be *Jerusalem*, and the inference must be a fairly concentrated spell of activity on the project around the middle of the decade. However, as a whole it was a product of many years, and the printing of the plates proceeded only slowly, no set of the complete hundred being printed before 1820 to judge from the watermarks on the leaves of five of the six copies printed by Blake himself.

Of the six surviving copies, five of them complete, and printed by Blake himself, Copy E, exhibited here, is the most lavish, richly decorated like a medieval illuminated manuscript. Uniquely, Blake also drew borders outside the design area on each page. While he found buyers for four monochrome copies, Blake was unable to sell the coloured copy, and it passed from Catherine Blake to her executor Frederick Tatham, together with the copper plates. Blake had estimated that printing *Jerusalem* in full 'will Cost my Time the amount of Twenty Guineas', and recognised that 'it is not likely I shall get a Customer for it' (to Cumberland, 12 April 1827; E.784). The issue of monochrome copies, probably not originally planned, may have been a response to the cost implications, and certainly it was one of these that was bought by Linnell, who was otherwise sponsoring Blake's Dante illustrations (see nos.68–96) and Job subjects (see no.218), and must have found the spectacular coloured version too expensive. Even so, Blake must have felt that the completion of this masterpiece of illuminated printing was a creative imperative.

The theme of *Jerusalem* is a grand one, bringing his Prophecies to a final resolution in the Redemption of Albion and his female emanation Jerusalem through realisation of the true meaning of Christ's sacrifice.

The poem offers nothing less than a spiritual history of mankind, progressing towards a glorious conclusion in which all contraries are reconciled and primal unities restored. The message is universal, but has particular resonance for the British nation, whose visionary prehistory and imperial destiny are linked in an inclusive historical continuum. From the Fall and division of Albion, the Original Man, the narrative passes through historical phases, from the monotheism of the Jews – associated by Blake with the Ancient British Druids – through the oppressive restrictions of modern Deism and Natural Religion to the final dawn of true Christianity. These phases are epitomised by the four

chapters, which after the first, firmly addressed 'To the Public', are directed 'To the Jews', 'To the Deists' and 'To the Christians'. There are one hundred plates in all. Each chapter has a full-page frontispiece, an address page, pictorial headpiece and endpiece. Throughout the text is ornamented with illustrations of different sizes, sometimes filling much of the page, sometimes restricted to marginal border decorations. Their relationship to the text is not always precise, and at times inscrutable, but overall their imagery reflects the change of mood from negative to positive that characterises the work as a whole.

Blake is not so literal or dogmatic as to show us Jerusalem complete as a rebuilt city. It is rather a state of mind, to be built by all of us at all times – ongoing work, contingent, provisional, and always under threat. Of his cast of mythic characters, Los now plays a leading role, his labours at forge and furnace, and struggles against temptations and obstructions to complete his 'Great Task' of building Golgonooza, the City of Art, representing Blake's own exertions at the poem itself and the aspirations of the human soul. Just as Albion must contend with Vala – Nature – in his progress to Redemption, so Los is pitted against Enitharmon, his own negative emanation, and the hostile sons and daughters of Albion. Moreover Los's transformation from his first appearance in the Frontispiece (pl.1) as a London nightwatchman, entering the grave like Christ to set the story on its way, to his final incarnation as a naked and Apollonian figure, parallels Albion's awakening. But at the end Los can still only pause from his work. It must continue through such noble activity as his – Blake's own, of course, and 'the best that the fallen imagination can do' (Damrosch 1980, pp.334–5).

Blake's Prophecies collectively amounted to a personal Bible, and biblical incidents and characters constantly recur while the author, as we have seen, claimed 'Divine Assistance' for his words and images. Among Blake's contemporaries the idea of a New Jerusalem was current among millenarians, who believed the world was on the verge of a new millennium brought to a state of grace by the second coming of Christ, and that an Apocalypse was on the way if it had not already begun. One of these, Richard Brothers, the self-styled Prince of the Hebrews and Nephew of the Almighty, applied himself literally to the planning of a New Jerusalem, publishing designs for it in 1801 and asking John Flaxman to be its architect; he hoped to lead the Jews back to the site where they would

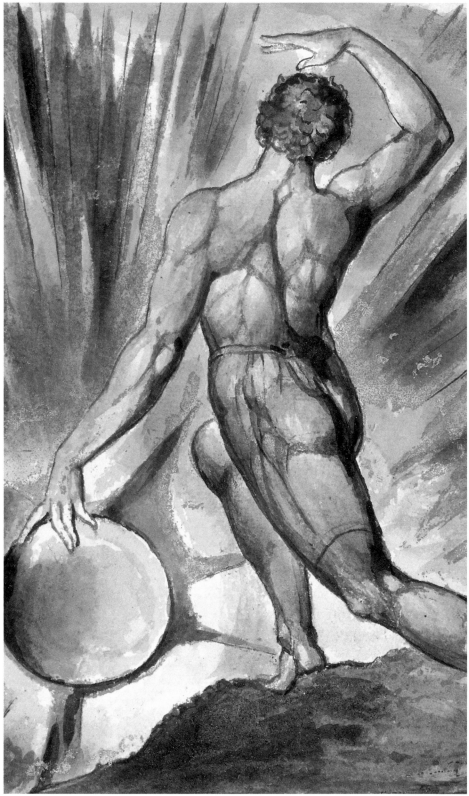

Jerusalem: plate 97 (detail)

undertake the work. Blake's vision was less material, but just as urgent.

Recent events had given the English millenarians a nationalist edge to their beliefs; they saw their nation as the Chosen People of the age, given special notice of the imminent Apocalypse by such tribulations as the current Revolutionary wars. At the same time, Blake was strongly influenced by antiquarian traditions that looked back to the prehistory of Britain and claimed, for example, that the Druids had arrived there during the time of Abraham, bringing with them the true patriarchal religion. In his mythology, it was they who had corrupted it by oppressive authoritarianism and human sacrifice, and Druidic trilithons and Stonehenge-like structures occur throughout the book as symbols of repression (see pl.70). Blake declared that *Jerusalem* described the 'ancient history of Britain, and the world of Satan and of Adam'(E.543), indicating the central place given to his own nation in its narrative sweep; the Fall and Redemption of mankind is especially that of Britain, and the poem constantly names and maps the country and, above all, the districts of its capital, at once the poet's home and source of inspiration and the modern Babylon that must be saved from itself. But from the perspective of a growing imperial power Blake was also able to draw in many references to Hindu and other non-European cultures and traditions, looking back to the supposed unity of prelapsarian times and forwards to the coming reconciliation.

While contemporary events, from the Napoleonic Wars to the Bourbon Restoration in France, resonate in the poem, Blake's own professional history also left its mark, literally so in plate 3, whose address 'To the Public' was, as noted below, altered to remove expressions of personal affection for his 'Reader' – following, presumably, the withdrawal of a likely purchaser or patron for the work. Other rebuffs and rejections in the course of its preparation provide the background to Los's creative struggles, and one of his chief antagonists, Hand, a Son of Albion – in fact the critic Robert Hunt, who attacked Blake's work in 1808 and 1809. In contrast to these reversals, the appreciative encouragement of John Linnell, from their meeting in 1818, must have encouraged Blake to make his final push to complete the work, and parallels, if it does not alone account for the positive and uplifting tone of its conclusion. DBB

Plate 1 (Frontispiece) 'Los as he Entered the Door of Death'

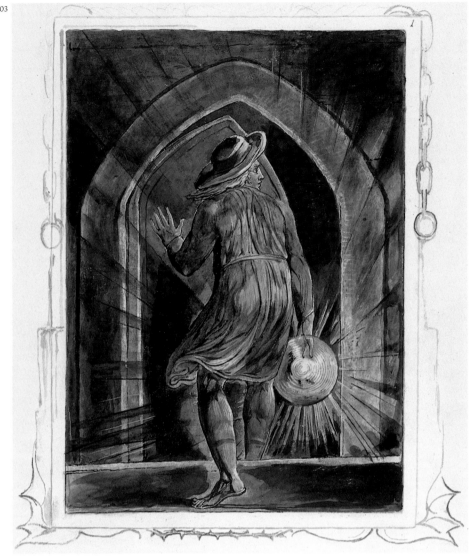

PLATE 1

Writing to Hayley, 23 October 1804, of his visit to the Truchsessian Gallery of pictures, Blake described his renewed inspiration; 'I was again enlightened with the light I enjoyed in my youth, and which has for exactly twenty years been closed from me as by a door and by window-shutters.' (E.756). The images of illumination and the door recur here, and the Gothic form of the latter may link more precisely to this revelatory experience since the Gallery contained 'primitive' northern pictures. Los, the artist-poet-architect, *alter ego* of Blake himself, in the guise of a London nightwatchman, crosses the threshold of a dark, grave-like place, his hair and garments blown back by a rush of wind. He raises one hand to salute what lies within; the other holds a brilliant sun to light his way. Plate 31 describes him:

> Los took his globe of fire to search the interiors of Albions
> Bosom. in all the terrors of friendship. entering the caves
> Of despair & death, to search the tempters out ... (lines 3–5)

Graffiti on the wall, partially erased here but legible in the proof impression (no.289), tells us he is entering 'a Void outside of Existence', a 'womb ... Albions Couch ... Albions lovely Land'. Uniquely in this coloured copy, a decorated border shows thorns beneath Los's feet and manacles at the sides, drawn outside ruled lines; these endow his entry into the grave with a Christ-like significance and hint at the suffering he will find within Albion in his Fallen state. The artist illuminates the darkness of the world by his visionary imagination, and the body passes through death to eternal life. DBB

Plate 2 (Title-Page) 'Jerusalem the Emanation of the Giant Albion'

303

Albion's female emanation Jerusalem sleeps, desolate, in a sort of cocoon, her human form wrapped in butterfly wings. She is flanked by her grieving Daughters, who have bat and bird wings. Since Albion is Fallen, they believe her dead. The fairy motifs of birds and insects draw our attention to the inscribed title and replay the Daughters' lamentation, implying that the drama of Fall and Redemption is experienced throughout Creation. Also directing us into the poem, before the word 'Giant', is the tiny figure of a man in Regency costume. This copy is unique in having a decorated border, this time showing clouds. DBB

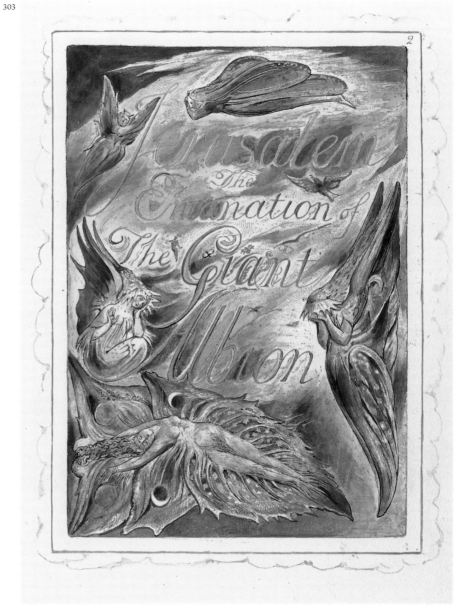

PLATE 2

Plate 3 (Address) 'To the Public'

> After my three years slumber on the
> banks of the Ocean, I again
> display my Giant forms to the Public …

Blake addresses his readers after his return from Felpham. He claims 'the highest reward possible' for his previous illuminated books – a considerable exaggeration, as noted by Paley (1991, p.10) – and hopes for a similar response. He speaks of his inspiration – his verses being 'dictated' – and of his renunciation of traditional blank verse for a more varied style. The plate shows substantial changes, presumably arising from a personal rebuff, to eliminate personal expressions of friendship and affection for his 'Reader' and to add the words 'SHEEP' and 'GOATS' to the upper corners, alluding to the separation of mankind at the Last Judgement. These turn this introduction and the following poem into a challenge to its readers; their response will decide where they should be placed. The border motifs around the central verses are of insect-like forms, rising and falling; that at the left is a reduction and reprise of the sleeping Jerusalem in the title page. DBB

Plate 4 ('Chap: 1', headpiece) 'Albion divided'

> Of the Sleep of Ulro! and of the passage
> through
> Eternal Death! And of the awaking to
> Eternal Life

The verses repeat the Saviour's call to mankind and contrast their promise with the isolation of earthbound Albion, building his laws of moral virtue whose insidious effects are suggested by the web-like patterns creeping down the right margin of the text. Above, the design encapsulates the Fallen state of despair in which the poem begins, and its redemptive message as a whole. A naked woman, an analogue of Jerusalem herself, attended by her Daughters, directs us to the title and to the Greek motto, *Movos o Iesous*, 'Jesus only', in a crescent moon and stars above it. Beneath, a hooded sibyl – ?Vala – divides two images of naked Albion, on the left rising, his hands clasped in prayer, on the right rooted to the white Cliffs of Dover. DBB

Plate 9 'Albion sleeping'

> Condens'd his Emanations into hard
> opake substances;
> And his infant thoughts & desires into
> cold, dark, cliffs of death.

A 'Body of Death' is forming around the Lamb of God to destroy Jerusalem, devour the body of Albion and 'win the labour of the husbandman' by 'war and stratagem'. It is being forged by Hand, imagined here as a blacksmith in a Satanic parody of Los who, labouring at his own anvil, sees 'Inspiration deny'd; Genius forbidden' by this Giant Son of Albion: a pointing hand was the editorial symbol of the brothers Robert and Leigh Hunt, the first of whom had published hostile reviews of Blake in *The Examiner*. The text is divided into three zones by horizontal pictorial bands linked by descending motifs in the right border. The topmost is a charming pastoral; a shepherd pipes and a woman feeds a cat while a sheepdog eats or sleeps. This paradise is inverted at the centre where the trailing roots of a tree metamorphose into a cunning serpent, taking food from a woman while her partner crouches, unaware or perhaps drugged. Connected with this by rocky formations, suggested by Los's use of precious stones for his forge, Albion lies sleeping, like a fallen warrior. Misguided and perverse, he has chosen the wrong direction, and attracts the lamentations of the daughters of Beulah. Above him, stars fall from the heavens. DBB

Plate 11 'Swan and Fish'

> To labours mighty, with vast strength,
> with his mighty chains.
> In pulsations of time, & extensions of
> space, like Urns of Beulah

Los's work has been productive; he weeps with joy at his achievement – expressing Blake's own satisfaction at the illuminated pages so far completed – but laments that there is still so much to do for Jerusalem's sake. The text is set across the centre of the page between two illustrations intended to be seen as one, showing water from above and below with the text as its surface in cross-section. Above, a beautiful but strange creature, half woman, half swan, dips its beak into the water. Bubbles rise, which in the watery domain below correspond to the jewelled bracelets and necklace of a fish-like woman. Among various inconclusive interpretations of these contrasted forms, Butlin (1978, p.128) sees them as respectively Sabrina, the naiad of the River Severn, and Ignoge, two of the Daughters of Albion mentioned in the text, while Erdman (1975, p.290) regards them as a projection of poetic genius, and the emergent Erin (Ireland), described as coming forth from Los's furnaces. DBB

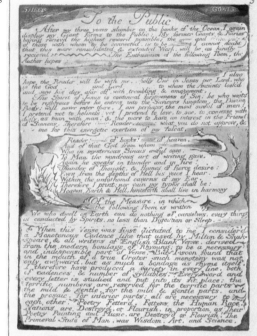

PLATE 3

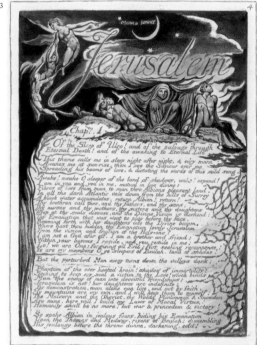

PLATE 4

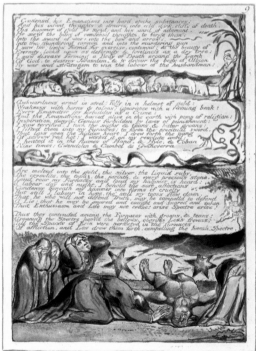

PLATE 9

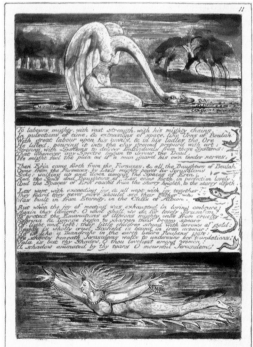

PLATE 11

Plate 12 'Vala and Newton'

> Why wilt thou give to her a Body whose
> life is but a Shade?
> Her joy and love, a shade: a shade of sweet
> repose:

Los feels himself dividing – 'Such thing was never known' – as is Albion. The poem moves on to describe the continuing construction of Golgonooza, the City of Art, and its attributes, linking it to the Bible and to modern London through references to Tyburn, Paddington and Lambeth, and setting its compass points. The decorations descending the right margin begin at the top with a finned or bat-winged woman apparently trying on a hat before a mirror; a Vanitas, she is Vala, the vain and worldly shadow of Jerusalem. Below a naked youth, presumably Isaac Newton (but also like Urizen with his compasses in the Frontispiece to *Europe*, no.299 pl.1), applies compasses to the globe, exercising the 'mathematic power' (line 12) and 'Demonstrative Science' that Blake thought so pernicious and whose malign effects have marked off the globe into regular squares of territory (a reference perhaps to the contemporary practice of Enclosure that was harming the English rural poor?). Beneath it a kneeling woman points upwards. DBB

Plate 26 (Frontispiece, Chapter 2) 'Hand and Jerusalem'

This richly coloured design prepares us for the preliminary address and title page of Chapter 2. Jerusalem recoils in horror from the apparition of Hand, revealed as a fiery Antichrist. His outstretched arms parody Christ on the Cross; the fires around his body rise to form a serpent-like grip on his arms and a flaming halo. However, in this coloured copy Blake removed the nails that, in the monochrome versions, are in his hands. Since this chapter will be addressed to the Jews, Blake is perhaps alluding to Old Testament monotheism as well as to the critic Robert Hunt. Jerusalem, here identified as Liberty, will in the ensuing pages enter Albion's consciousness as some counter to the enslavement of the wicked Sons of Albion, and contend with Vala. DBB

Plate 27 (Address) 'To the Jews'

> Jerusalem the Emanation of the Giant
> Albion! Can it be? Is it a
> Truth that the Learned have explored?
> Was Britain the Primitive Seat of
> the Patriarchal Religion?

In this prefatory address Blake asserts his belief in the historical continuum that will make Britain the seat of a spiritual regeneration – 'All things Begin & End in Albions Ancient Druid Rocky Shore'. The central portion of the page, divided into two columns by a flowering lily stem, is occupied by a poem in a simple rhyming metre; beginning in London, in places associated with Blake's childhood, it moves eastwards through the docks and Essex, 'across the Sea' to Europe and Asia; as suggested by Damon (1924, p.447) it charts progress from Innocence through Experience to Redemption. Wars and 'self-righteous pride' must be renounced and unity embraced. The page ends with a call to Israel to take up the cross and return to Jesus. DBB

Plate 28 ('Jerusalem. Chap: 2'; headpiece, 'Couple in a Waterlily'

> Every ornament of perfection, and every
> labour of love,
> In all the Garden of Eden, & in all the
> golden mountains
> Was become an envied horror, and a
> remembrance of jealousy

At the beginning of Chapter 2, the Fallen Albion becomes 'punisher & judge' of physical love by his imposition of Hebraic moral law. Above the text a couple embrace in a waterlily, exemplifying the 'unnatural consanguinities … horrid to think of' that Albion now proscribes as crimes. Blake had already placed Oberon and Titania in lily flowers in *The Song of Los* (no.301 pl.5). An earlier state of the *Jerusalem* plate (New York, Pierpont Morgan Library) shows that Blake intended the figures to be copulating, but here he has disengaged them. The right margin contains marine life, including a hermit crab. The plate may reflect the influence of Indian designs known to Blake. DBB

Plate 35 (31) 'The Descent of Christ'

> Then the Divine hand found the Two
> Limits, Satan and Adam,
> In Albions bosom: for in every Human
> bosom those Limits stand.

Christ descends to delimit Albion's Fall and calls him to rise again. He sweeps down from the top of the page, His feet and hands bearing the stigmata. Beneath the text Albion lies asleep, still unaware of Christ's sacrifice. He has not yet reached the ultimate depths of his despair, but his latent desire for Redemption is presaged here by the head that emerges from his body; shining and female, it already suggests the form of Jerusalem. This positive image of regenerative division – perhaps echoing the biblical creation of Eve – introduces a hopeful note.

Plate 36 (32) (headpiece) 'The Moon of Ulro'

> Reuben return'd to his place, in vain he
> sought beautiful Tirzah
> For his Eyelids were narrowd. & his
> Nostrils scented the ground

The text describes Los's building of the Moon of Ulro – much like Noah's building of the Ark, 'plank by plank & rib by rib'. Previous pages have already associated the moon with the Ark. The construction work also produces Reuben, the type of the ordinary man. The moon, when made, will light him over the sea, away from the despair of Ulro. At the top of the page Los's work is seen yet again as smithery. He is forging the moon – which looks more like a sun or is being manufactured out of the sun's rays – on an anvil, swinging his hammer. Connected to the moon by an umbilical thread is Reuben, who is sent forth afresh with each blow from the blacksmith's hammer. DBB

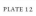

PLATE 12

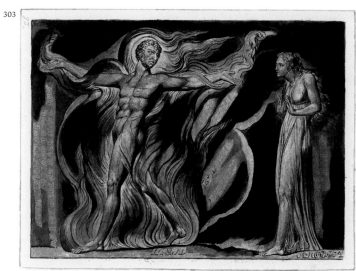

PLATE 26

Plate 51 (frontispiece, Chapter 3) 'Vala, Hyle and Skofeld'

Chapter 3 is addressed to the Deists, and in this full-page frontispiece picturing their three presiding gods, Blake takes a further opportunity to settle old scores. In the fiery depths of Ulro, Vala sits slumped on her throne, wearing a spiked crown and holding a sceptre topped with the fleur-de-lys. The whorish counterpart or shadow of Jerusalem, she commands the allegiance of nature rather than spirit and produces only misery. Her companions and chief courtiers are Hyle, based as ever on Hayley, Blake's 'corporeal' friend, and representing the absence of spirit, and Skofeld, his soldier-antagonist Scholfield, harbinger of war and destruction; the latter clanks chains – forged of course in his own mind – and has a shaven head like a convict or madman (see no.251). A preliminary drawing (Hamburg, Kunsthalle) shows that Blake had considered adding a fourth figure, presumably Hand. DBB

Plate 69 'Sacrificial Dance'

> Then all the Males combined into One
> Male & every one
> Became a ravening eating Cancer growing
> in the Female

The text explores deceitful and cruel perversions arising from relations between the Fallen sexes. The illustration below associates these with Druidic practices of human sacrifice. It is a scene of torture. Two female figures dance a frenzied dance around a manacled male victim; both flourish knives over his head, and the woman at left also a holds a flayed face, her accomplice at right a cup. In the right distance are groups of stones including a Druidic trilithon and a phallic pillar. The sky is filled with stars and a crescent moon, indicating nocturnal rites. Whip-like lines extend down the right margin of the text. DBB

Plate 70 'Trilithon'

> And this is the form of mighty Hand
> sitting on Albions cliffs
> Before the face of Albion: a mighty
> threatning Form.

Hand looms over Albion as a Satanic presence 'Plotting to devour Albions Body of Humanity and love'. Albion's twelve Sons mutate or combine into 'Three Forms, named Bacon, Newton & Locke' – rationalists who in Blake's world view had divided mind from spirit and helped initiate the Deism attacked in this Chapter. In a striking, if not extreme parallel, Blake associates the corrupting influence of Reason and Science with the Druids' perversion of patriarchal religion towards oppressive laws and human sacrifice. Thus in the central design the three figures of his archetypal scientists stand beneath the giant stones of a Druidic trilithon – brought into the foreground from the previous plate and given explicitly sinister associations. The structure also develops the 'strong Druid temples' seen in plate 6 of *Milton*. A striking example of Blake's antiquarian interests, this design has been compared to the reconstruction of Stonehenge illustrated in William Stukeley's *Stonehenge. A Temple restor'd to the British Druids*, 1740 (e.g. by Bindman, 1982–3, pp.165–6). Uniquely in this coloured copy, the moon is full; clouds form smoke-like trails across the sky. DBB

Plate 77 (address) 'To the Christians'

> I give you the end of a golden string,
> Only wind it into a ball:
> It will lead you in at Heavens gate,
> Built in Jerusalems wall.

The fourth and last chapter begins with an address intended to answer that directed to the Deists in Chapter 3. The touching verse that precedes it comments on Blake's own visionary and inspirational methods, while its naïve tone suggests we must return to a child-like state to receive his message. Beneath, the string extends across the page from the ball held by a girl beneath the Cliffs of Dover – Jerusalem's wall. It rises, then descends to link at the bottom of the page with vine-like forms entwining to frame and divide the concluding verses:

> England! awake! awake! awake!
> Jerusalem thy sister calls!
> Why wilt thou sleep the sleep of death?
> And close her from thy ancient walls.

The fourth and final stanza, proclaiming the Lamb of God 'In Englands green & pleasant bowers', reprises the famous lines in *Milton*. DBB

Plate 78 (headpiece) 'Man with Bird's Head'

> The Spectres of Albions Twelve Sons
> revolve mightily
> Over the Tomb & over the Body: ravning
> to devour
> The Sleeping Humanity …

The last Chapter opens with one of the most mysterious of all Blake's designs – made more so in this coloured copy where the Chapter title, seen in the monochrome versions to occupy a bright cloud over the sun, is blacked out, thus rather contradicting what must be assumed to be the message at this point of the narrative, that Redemption is nigh. The sombre and baleful colouring suggests sunset rather than sunrise, and the disk is seen from Albion's western shore – green or rocky, not the white Cliffs of Dover. The inference is rather that a dark age is finally passing, not, just yet, that the new day has dawned. The sun is watched by a naked giant with the head of a bird; the figure has been variously seen as Los, Hand, Osiris, or as some humanised natural form still belonging to the realm of Vala, while the head has been said to belong to a cock or a bird of prey. The 'g' in a word in the tenth line sprouts a vine which trails down the right margin, its tendrils splitting – in a further realisation of the divisions and dualities encountered throughout the work – to break the text in two, the gap being formed by two tiny birds whose wheeling flight suggests the freedom denied to the disconsolate giant. DBB

303

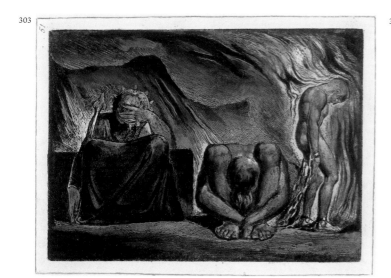

PLATE 51

303

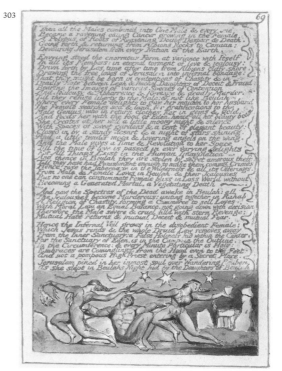

PLATE 69

303

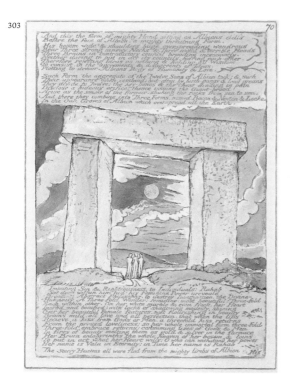

PLATE 70

303

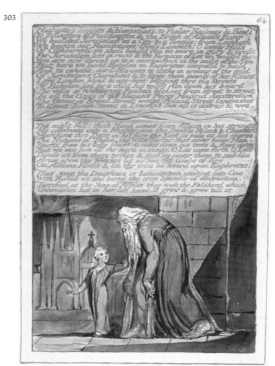

PLATE 84

Plate 84 'London; Old Man led by a Child'

> Highgates heights & Hampsteads,
> to Poplar Hackney & Bow:
> To Islington & Paddington & the Brook
> of Albions River
> We builded Jerusalem as a City
> & a Temple …

The text conflates and contrasts Babylon and London, yet Jerusalem was built in the city, from Blake's own home and studio – 'From Lambeth/We began our Foundations' – and it will be transformed again into a new Jerusalem. Below, in a conception related to the design for the poem *London* in *Songs of Experience* (see nos.129, 161c, 298 pl.46), the now-exhausted and decadent city is pictured as an old man

> blind & age-bent begging thro the Streets
> Of Babylon, led by a child. his tears run
> down his beard

Its eventual rebirth and Redemption will involve release from the confines of State religion – marked by the background dome of St Paul's – for the freedom of true faith – figured by the Gothic arches and towers of Westminster Abbey, over which (uniquely in this coloured copy) a golden sunrise is already aglow in the sky.

Plate 92 'Enitharmon's Lament'

> What do I see: The Briton Saxon Roman
> Norman amalgamating
> In my Furnaces into One Nation the
> English: and taking Refuge
> In the Loins of Albion …

With Los's vision of the beginning of Albion's awakening through a union of ethnicities in a global as well as a British sense – 'The Canaanite united with the fugitive/Hebrew' – his adverse emanation Enitharmon feels herself powerless and 'The Poets Song draws to its period'. Sometimes identified as Jerusalem on account of the background inscription, the female figure at the centre of the page, languishing in a gesture of surrender and grief, is, as noted by Bindman (1977, p.182), more probably Enitharmon, while Jerusalem is the city in the distance – represented by further trilithons – whose physical ruin awaits its spiritual regeneration. DBB

Plate 97 'Los with the Sun'

> Awake! Awake Jerusalem! O lovely
> Emanation of Albion
> Awake and overspread all Nations as in
> Ancient Time

Los calls to Jerusalem, 'For lo the Night of Death is past and the Eternal Day/Appears upon our Hills'. He appears below, transformed from his first appearance as night watchman in the frontispiece, an Apollonian figure, naked and in the motions of some enraptured dance, his left hand resting on a radiant sun whose rays banish the moon and stars from the night sky. The brilliant colouring is augmented by gold and silver leaf – the latter however now lost from the crescent moon. Compare with *Albion rose* (no.279). DBB

Plate 99 'The End of the Song of Jerusalem. The Union of Contraries'

> All Human Forms identified even Tree
> Metal Earth & Stone, all
> Human Forms identified. living giving
> forth & returning wearied
> Into the Planetary lives of Years Months
> Days & Hours reposing
> And the Awaking into his Bosom in the
> Life of Immortality.
> And I heard the Name of their
> Emanations. they are named Jerusalem

This ecstatic vision of reconciliation and Redemption concludes the poem. It is realised below in a pair of embracing figures whose ambiguous gender or identity proclaims its universality. In witnessing the union of Jerusalem with Christ, Albion is saved, but so too are all divisions and contraries healed, mental and physical, and – as the text and animal imagery of the previous plate showed – all living creatures are brought within the Divine purpose. This brings a positive interpretation of much that had formerly been seen negatively, including patriarchal authority, and thus the bearded figure could as easily be the stern Jehovah as Christ, while the androgynous figure who exults in his clasp could be Jerusalem herself, or a sort of prodigal son returning to his father. Blake does not expect us to identify the figures specifically, but rather to appreciate their union as a symbol of spiritual yearning and attainment in the broadest possible sense. DBB

Plate 100 'Los and the Serpent Temple'

This final, whole-page plate offers not so much a conclusion as a continuum, in which the processes of creation and regeneration, and the dialectics of true and false religion, are shown to be eternal. Los stands, still naked, his blacksmith's hammer and tongs in his hands; he has paused from his labour in building Jerusalem, but must soon return to his task for behind him a Druidic temple of false religion has already formed a full circle and is extending serpent-like to cover Britain. At his left (our right), Enitharmon, darkly shadowed, and surrounded by stars, winds fibres of life from a distaff, continuing her own work of Generation; they fall to a crescent moon and thence to the earth. On Los's other side a youth, perhaps the 'Spectre of Urthona' (E.379), carries the sun on its diurnal round. While positive in emphasis, this last image qualifies the finality and rapture of the preceding plate. Jerusalem is not shown complete or in its heavenly form, but in construction on earth through the most exalted forms of human activity and imagination. DBB

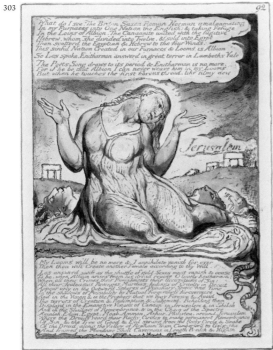

PLATE 92

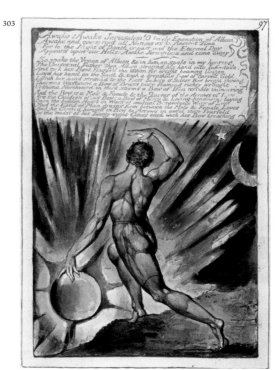

PLATE 97

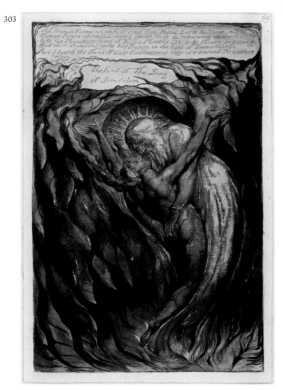

PLATE 99

Bibliography

The journal-of-record for Blake studies is *Blake. An Illustrated Quarterly*, published by the University of Rochester, New York.

A major hypermedia archive, *The William Blake Archive*, is at http://jefferson.village.virginia.edu/main./html

References in the text to Bentley 1969 and Erdman 1982 are abbreviated to BR and E respectively, followed by the page number.

ACKROYD 1995: *Blake*, London 1995

ALEXANDER 1998: David Alexander, *Richard Newton and English caricature in the 1970s*, Manchester 1998

BAIN 1977: Iain Bain, David Chambers and Andrew Wilton, *The Wood Engravings of William Blake for Thornton's 'Virgil'*, London 1977

BELLIN AND RUHL 1985: H. Bellin and D. Ruhl (eds.), *Blake and Swedenborg: Opposition is True Friendship*, New York 1985

BENTLEY 1963: G. E. Bentley Jr, *William Blake: 'Vala or the Four Zoas'. A facsimile of the manuscript*, Oxford 1963

BENTLEY 1967: G. E. Bentley Jr, *William Blake, 'Tiriel'. Facsimile and transcript of the Manuscript, Reproduction of the Drawings and a Commentary on the Poem*, Oxford 1967

BENTLEY 1969: G. E. Bentley Jr, *Blake Records*, Oxford 1969

BENTLEY 1977: G. E. Bentley Jr, *Blake Books. Annotated Catalogues of William Blake's Writings*, Oxford 1977

BENTLEY 1988: G. E. Bentley Jr, *Blake Records Supplement*, Oxford 1988

BENTLEY 1995: G. E. Bentley Jr, *Blake Books Supplement*, Oxford 1995

BINDMAN 1973: David Bindman, 'Blake's 'Gothicised Imagination' and the History of England' in M. Paley and M. Phillips (eds.), *William Blake: Essays in Honour of Sir Geoffrey Keynes*, Oxford 1973, pp.29–49

BINDMAN 1977: David Bindman, *Blake as an Artist*, London 1977

BINDMAN 1978: David Bindman and Deidre Toomey, *The Complete Graphic Works of William Blake*, London 1978

BINDMAN 1982: David Bindman, *William Blake. His Art and Times*, exh. cat., Yale Center for British Art 1982

BINDMAN 1983: David Bindman, 'An Afterword on "William Blake: His Art and Times"', *Blake. An Illustrated Quarterly*, Rochester, New York, vol.16, no.4 (Spring 1983), pp 224–5

BINDMAN 1987: David Bindman (ed.), *William Blake's Illustrations of the Book of Job*, London 1987

BOULTON 1968: Edmund Burke, *A Philosophical Enquiry into the Origin of our Ideas of the Sublime and Beautiful*, ed. with an Introduction and Notes by James T. Boulton, Notre Dame, Indiana 1968

BUTLIN 1978: Martin Butlin, *William Blake*, exhibition catalogue, Tate Gallery, London, March–May 1978

BUTLIN 1981: Martin Butlin, *The Paintings and Drawings of William Blake*, 2 vols., New Haven and London 1981

BUTLIN 1989: Martin Butlin, 'The Physicality of William Blake: The Large Color Prints of "1795", *Huntington Library Quarterly*, San Marino, vol.52, no.1, (Winter 1989), pp 1–17

BUTLIN 1990: Martin Butlin, *The Tate Gallery Collections, Volume Five: William Blake 1757–1827*, London 1990

BUTLIN AND GOTT 1989: Martin Butlin and Ted Gott, with an Introduction by Irena Zdanowicz, *William Blake in the Collection of the National Gallery of Victoria, Melbourne*, Melbourne 1989

CUNNINGHAM 1833/4: Allan Cunningham, *The Cabinet Gallery of Pictures*, 2 vols., London 1833, 1834

DAMON 1924: S. Foster Damon, *William Blake. His Philosophy and Symbols*, Boston and New York 1924

DAMON 1965: S. Foster Damon, *A Blake Dictionary. The Ideas and Symbols of William Blake*, Providence 1965; revised edition Hanover, New Hampshire and London 1988

DAMROSCH 1980: Leopold Damrosch, Jr, *Symbol and Truth in Blake's Myth*, Princeton 1980

DÖRRBECKER 1995: D.W. Dörrbecker, *William Blake. The Continental Prophecies: 'America', 'Europe', 'The Song of Los'*, London 1995 (vol. 4 in the William Blake Trust/Tate Gallery *The Illuminated Books of William Blake*, general editor David Bindman)

DUNBAR 1980: Pamela Dunbar, *William Blake's Illustrations to the Poetry of Milton*, Oxford 1980

EAVES 1992: Morris Eaves, *The Counter-Arts Conspiracy: Art and Industry in the Age of Blake*, Ithaca and London 1992

EAVES, ESSICK, VISCOMI 1993: M. Eaves, R. N. Essick and J. Viscomi (eds.), *William Blake. The Early Illuminated Books*, London 1993 (vol.3 in the William Blake Trust/Tate Gallery *The Illuminated Books of William Blake*, general editor David Bindman)

ERDMAN 1954: David V. Erdman, *Blake: Prophet Against Empire*, Princeton 1954

ERDMAN 1965: David V. Erdman, *The Illuminated Blake: William Blake's Complete Illuminated Works with a Plate-by-Plate Commentary*, London 1992; revised edition New York and London 1992

ERDMAN 1982: David V. Erdman, *The Complete Poetry and Prose of William Blake*, Berkeley and Los Angeles, 1982

ERDMAN AND GRANT 1980: David V. Erdman, John Grant, Edward Rose, Michael Tolley, *William Blake's Designs for Edward Young's Night Thoughts*, 2 vols, Oxford 1980

ERDMAN AND MOORE 1977: David V. Erdman and Donald K. Moore, *The Notebook of William Blake. A Photographic and Typographic Facsimile*, Chester, Vermont 1977

ESSICK 1980: Robert N. Essick, *William Blake Printmaker*, Princeton 1980

ESSICK 1983: Robert N. Essick, *The Separate Plates of William Blake. A Catalogue*, Princeton 1983

ESSICK 1991: Robert N. Essick, *William Blake's Commercial Book Illustrations*, Oxford 1991

ESSICK AND PALEY 1982: Robert N. Essick and Morton D. Paley, *Robert Blair's 'The Grave' illustrated by William Blake. A Study with Facsimile*, London 1982

ESSICK AND VISCOMI 1993: Robert N. Essick and J. Viscomi, *William Blake. Milton a Poem and the Final Illuminated Works*, London 1993 (vol.5 in the William Blake Trust/Tate Gallery, *The Illuminated Books of William Blake*, general editor David Bindman)

FULLER 1988: David Fuller, 'Blake and Dante', *Art History*, London, vol. XI (1988), pp.349–73

GILCHRIST 1863: Alexander Gilchrist, *The Life of William Blake*, 2 vols., London 1863

GITTINGS 1966: *Selected Poems and Letters of John Keats*, edited with an Introduction and Commentary by Robert Gittings, London 1966

GRANT 1972: John E. Grant, 'The Meaning of Mirth and Her Companions in Blake's Designs for *L'Allegro* and *Il Penseroso*', Part II: Of Some Remarks Made and Designs Discussed at the MLA, Seminar 12: 'Illuminated Books by William Blake,' 29 December 1970, *Blake Newsletter* Nineteen (Winter 1971–2) vol.5, no.3, pp.190–202

HAMLYN 1992: Robin Hamlyn, 'William Blake: The Apprentice Years', exh. broadsheet, Tate Gallery 1992

HAMLYN AND MOORE 1993: Robin Hamlyn and Andrew Moore, *William Blake. Chaucer's Canterbury Pilgrims*, exh. broadsheet, Castle Museum, Norwich, 2 October–28 November 1993

HAMLYN 1996: Robin Hamlyn, *William Blake: Illustrations to Edward Young's 'Night Thoughts'*, exh. broadsheet, Tate Gallery 1996

HAMLYN 1998: Robin Hamlyn, 'Introduction' to *Dante Alighieri*, trans. Henry Francis Cary, 'Inferno', London 1998

HEPPNER 1981: Christopher Heppner, 'Reading Blake's Designs: Pity and Hecate', *Bulletin of Research in the Humanities*, New York, vol.84, no.3 (Autumn 1981) pp.337–65

HEPPNER 1996: Christopher Heppner, *Reading Blake's Designs*, Cambridge 1996

KEYNES 1927: Geoffrey Keynes, *Pencil Drawings of William Blake*, London 1927

KEYNES 1960: Geoffrey Keynes, 'Blake's Visionary Heads & the Ghost of a Flea', *Bulletin of the New York Public Library*, vol.64, no.11 (Nov. 1960), pp.567–72

KEYNES 1971: Geoffrey Keynes, *Blake Studies: Essays on his life and work*, 2nd edn, Oxford 1971

KEYNES 1977: Geoffrey Keynes, *The Complete Portraiture of William and Catherine Blake*, London 1977

KEYNES 1980: Geoffrey Keynes (ed.) *The Letters of William Blake with Related Documents*, Oxford 1980

KLONSKY 1980: Milton Klonsky, *Blake's Dante. The Complete Illustrations to the 'Divine Comedy'*, London 1980

LINCOLN 1991: Andrew Lincoln, *William Blake. Songs of Innocence and of Experience*, London 1991 (vol.2 in the William Blake Trust/Tate Gallery *The Illuminated Books of William Blake*, general editor David Bindman)

LINDBERG 1973: Bo Lindberg, *William Blake's Illustrations to the Book of Job*, Abo, Finland 1973

LINDSAY 1989: David W. Lindsay, 'The Order of Blake's Large Color Prints', in *Huntington Library*, San Marino, vol.52, no.1, (Winter 1989), pp.19–41

MAGNO AND ERDMAN 1987: Cettina Tramontano Magno and David Erdman, *The Four Zoas by William Blake. A Photographic Facsimile with Commentary on the Illuminations*, London and Toronto 1987

MAHEUX 1984: Anne Maheux, 'An Analysis of the Watercolor Techniques and Materials of William Blake', *Blake. An Illustrated Quarterly*, Rochester, New York, vol.17, no.4 (Spring 1984), pp.294–311

MELLOR 1978: Ann K. Mellor, 'Physiognomy, Phrenology, and Blake's Visionary Heads' in *Blake and his Time*, ed. R. N. Essick and D. Pearce, Bloomington and London 1978

MUSES 1951: Charles A. Muses, *Illumination on Jacob Boehme. The Work of Dionysius Andreas Freher*, New York 1951

PALEY 1991; Morton D. Paley, *William Blake 'Jerusalem'*, London 1991 (vol.1 in the William Blake Trust/Tate Gallery *The Illuminated Books of William Blake*; general editor David Bindman)

PANOFSKY 1945: E. Panofsky, *Albrecht Dürer*, 2 vols., London 1945, vol.1, pp.156–71

PENNY AND NEWMAN 1986: N. Penny and J. Newman in Nicholas Penny (ed.), *Reynolds*, exh. cat., Royal Academy, London 1986, pp.251–4

POSTLE 1995: Martin Postle, *Sir Joshua Reynolds. The Subject Pictures*, Cambridge 1995

RAINE 1968: Kathleen Raine, *Blake and Tradition*, 2 vols, Princeton 1968

ROE 1953: Albert S. Roe, *Blake's Illustrations to the Divine Comedy*, Princeton 1953

SCHIFF 1973: Gert Schiff, *Johann Heinrich Füssli 1741–1825*, 2 vols., Zurich and Munich 1973

SCHIFF 1990: Gert Schiff with Martin Butlin, *William Blake*, exh. cat., The National Museum of Western Art, Tokyo, 1990, pp.137–8 (cat. no.31)

SCHUCHARD 1992: Marsha Keith Schuchard, 'The Secret Masonic History of Blake's Swedenborg Society', *Blake. An Illustrated Quarterly*, New York, vol.26, no.2 (Fall 1992), pp.40–51

SCHUCHARD 1999: Marsha Keith Schuchard, 'Why Mrs Blake Cried: Swedenborg, Blake, and the Sexual Basis of Spiritual Vision', *Esoterica: The Journal of Esoteric Studies*, online at http://www.esoteric.msu.edu/ (Autumn 1999 issue, pp.1–29)

SHANES 1990: Eric Shanes 'Dissent in Somerset House: Opposition to the Political Status-quo within the Royal Academy around 1800', *Turner Studies*, London, Winter 1990, vol.10, no.2, pp.40–6

SWINBURNE 1906: A.C. Swinburne, *William Blake. A Critical Essay*, London 1906 (a new edition of a work originally published in 1868)

TAYLER 1971: Irene Tayler, *Blake's Illustrations to the Poems of Gray*, Princeton 1971

THOMPSON 1962: Stanbury Thompson (ed.), *The Journal of John Gabriel Stedman 1744–1797 Soldier and Author*, London 1962

VISCOMI 1993: Joseph Viscomi, *Blake and the Idea of the Book*, Princeton 1993

WARK 1975: Sir Joshua Reynolds, *Discourses on Art*, ed. Robert Wark, New Haven and London 1975, p.242

WEINGLASS 1982: D. H. Weinglass (ed.), *The Collected English Letters of Henry Fuseli*, New York and London 1982

WEINGLASS 1994: D. H. Weinglass, *Prints and Engraved Illustrations By and After Henry Fuseli*, A Catalogue Raisonné, Aldershot 1994

WELLS AND JOHNSTON 1969: William Wells and Elizabeth Johnston, *William Blake's 'Heads of the Poets' for the Turret House, the Residence of William Hayley, Felpham*, Manchester City Art Gallery, Manchester 1969

WHITE 1997: Michael White, *Isaac Newton, the Last Sorcerer*, London 1997

WICKSTEED 1954: Joseph Wicksteed, *William Blake's 'Jerusalem'* (companion volume to facsimiles of copies C and E), The William Blake Trust, London 1954

WORRALL 1995: David Worrall, *William Blake. The Urizen Books*, London 1995 (vol.6 in The William Blake Trust/Tate Gallery *The Illuminated Books of William Blake*; general editor David Bindman)

WRIGHT 1972: Andrew Wright, *Blake's Job. A Commentary*, Oxford 1972

Lenders

Photographic credits

Private Collections

David Alexander 135, 136
Christopher Bacon, Bewick Studios 100a, 101a, 102a, 117a
Collection of E. B. Bentley & G. E. Bentley Jr 192b
Andrew Edmunds, London 121a, 121b, 207
Collection of Robert N. Essick 23, 192a, 278
The family of George Goyder, deceased 1997 45
Benjamin Lemer 171
Private Collection 26, 28, 257
Keynes Family Trust 25, 118b, 122, 147, 150, 152, 163, 198, 248, 286, 289
Michael Phillips 105, 142, 143, 160, 166, 167, 178,

Public Collections

Ashmolean Museum, Oxford 89, 94, 139
Birmingham Museums & Art Gallery 72, 74, 92
The Bodleian Library, Oxford 5, 7, 8, 9, 10, 11, 12, 13, 14, 15, 169, 191
The British Library, London 19, 69, 108, 145, 151a-c, 162, 168, 170, 174, 175, 177, 179, 180, 181, 182, 183, 184, 185, 197, 229, 232, 233, 234a, 234b, 300
The British Museum, London 22, 29, 30, 31, 32, 33, 34, 35, 36, 66, 68, 87, 90, 99a, 99b, 113, 114, 118c, 123, 124, 131, 134, 137, 138, 154, 159, 164, 165, 172, 173, 187, 196, 203, 206, 214, 215, 216a, 217c, 218d, 228, 236, 241a-c, 272, 276, 277, 283, 284, 287, 288, 291, 294, 296, 302
Brooklyn Museum of Art 56
Congregational Memorial Hall, London 146
East Sussex Record Office 208
Fitzwilliam Museum, Cambridge 2, 3, 4, 21, 27, 52, 60, 65, 67, 106, 120, 127, 186, 212, 217b, 218b, 219, 220, 223, 224, 225, 239, 273, 281, 289
Glasgow Museums 57, 58, 62
Glasgow University Library 299
Houghton Library, Harvard University 115, 117a, 125
The Huntington Library, Art Collections and Botanical Gardens 109a, 109b, 118a, 205, 259, 279
Library of Congress, Washington DC 112b, 119a, 144c, 301
London Borough of Lambeth Archives 98, 140a-f, 155
London Metropolitan Archives, Corporation of London 97, 148, 149, 153, 156, 157, 158
Manchester City Art Galleries 64, 254
Metropolitan Museum of Art, New York 41, 44, 46, 49, 214e, 298
Museum of Fine Arts, Boston 260, 261, 262, 263, 264, 265, 266, 267, 268
National Gallery of Art, Washington DC 43, 112a, 116, 176, 204, 218c, 275, 293
National Gallery of Canada, Ottawa 117c, 117d, 161c,
National Gallery of Victoria, Melbourne 70, 76, 77, 78, 79, 80, 81, 83, 85, 88, 93, 96, 290
National Portrait Gallery, London 1
The National Trust 59, 240
The New Art Gallery Walsall 47
Philadelphia Museum of Art 48, 235, 256
The Pierpont Morgan Library, New York 107, 218a, 226, 269, 270, 271
The Preston Blake Library, City of Westminster Archives Centre 17, 211, 217a
Public Record Office 188, 189, 190, 193, 195, 199, 200, 201, 202
The Science Museum, London 103
Tate 18, 42, 50, 51, 53, 54, 61, 63, 71, 73, 75, 82, 84, 86, 91, 95, 119b, 213, 218, 221, 222, 227, 237, 238, 241d, 242, 243, 244, 245, 247, 249, 250, 251, 252, 253, 274, 282, 292
Tate Gallery Library 16, 216b
The Victoria & Albert Museum, London 6, 24, 55, 104, 132, 133, 246, 255, 258, 280, 285
West Sussex Record Office 209, 210
The Whitworth Art Gallery, Manchester 297
Dr Williams's Library, London 230, 231
Yale Center for British Art, New Haven, Connecticut 20, 37, 38, 39, 40, 111e, 126, 128, 129, 130, 295, 303
Yale University Art Gallery Collection, New Haven, Connecticut 194

Ashmolean Museum, Oxford
E. B. Bentley & G. E. Bentley Jr
Birmingham Museums & Art Gallery
Bodleian Library, University of Oxford
Museum of Fine Arts, Boston
The British Library Board
The British Museum
Brooklyn Museum of Art
Geremy Butler
National Gallery of Canada, Ottawa
Christie's Images
Andrew Edmunds, London
Robert N. Essick
Fitzwilliam Museum, Cambridge
Glasgow Museums: The Stirling Maxwell Collection, Pollok House
Special Collections Department, Glasgow University Library
Guildhall Library, Corporation of London/Geremy Butler
Houghton Library, Harvard University
The Huntington Library, Art Collections and Botanical Gardens
Keynes Family Trust on loan to the Fitzwilliam Museum, Cambridge/ Fitzwilliam Museum, Cambridge
London Borough of Lambeth Archives/ Alan J. Robertson
London Metropolitan Archives, Corporation of London/Geremy Butler
Library of Congress
Manchester City Art Galleries
Metropolitan Museum of Art
National Portrait Gallery, London
National Trust Photographic Library
Philadelphia Museum of Art
Michael Phillips/Tate Photography/ Rod Tidnam
The Pierpont Morgan Library, New York
Public Record Office
Science & Society Picture Library, Science Museum
Sotheby's Picture Library, London
Tate Gallery Library/Tate Photography/ Rod Tidnam
Tate Photography
V&A Picture Library
National Gallery of Victoria, Melbourne, Australia
The New Art Gallery Walsall
National Gallery of Art, Washington
The Preston Blake Library, City of Westminster Archives Centre
Whitworth Art Gallery, University of Manchester
Trustees of Dr Williams's Library/Tate Photography/David Lambert
Yale Center for British Art

Index

Supporting Tate

Tate relies on a large number of supporters – individuals, foundations, companies and public sector sources – to enable it to deliver its programme of activities both on and off its gallery sites. This support is essential in order to acquire works of art for the Collection, present education, outreach and exhibition programmes, care for the Collection in storage and enable art to be displayed, both digitally and physically, inside and outside Tate. Your funding will make a real difference and enable others to enjoy Tate and its Collections, both now and in the future. There are a variety of ways in which you can help support Tate and also benefit as a UK or US taxpayer. Please contact us at:

The Development Office
Tate, Millbank, London SW1P 4RG
Telephone: 020 7887 8000
Facsimile: 020 7887 8738

American Fund for the Tate Gallery
1285 Avenue of the Americas (35th fl)
New York
NY 10019
Telephone: 001 212 713 8497
Facsimile: 001 212 713 8655

Donations

Donations, of whatever size, from individuals, companies and trusts are welcome, either to support particular areas of interest, or to contribute to general running costs.

Gift Aid

Through Gift Aid, you are able to provide significant additional revenue to Tate for gifts of any size, whether regular or one-off, since we can claim back the tax on your charitable donation. Higher rate tax payers are also able to claim additional personal tax relief. A Gift-Aid Donation form and explanatory leaflet can be sent to you if you require further information.

Legacies and Bequests

Bequests to Tate may take the form of either a specific cash sum, a residual proportion of your estate or a specific item of property such as a work of art. Tax advantages may be obtained by making a legacy in favour of Tate; in addition, if you own a work of art of national importance you may wish to leave it as a direct bequest or to the Government in lieu of tax. Please check with Tate when you draw up your will that it is able to accept your bequest.

American Fund for the Tate Gallery

The American Fund for the Tate Gallery was formed in 1986 to facilitate gifts of works of art, donations and bequests to Tate from United States residents. It receives full tax exempt status from the IRS.

Membership Programmes

Members and Fellows

Individual members join Tate to help provide support for acquisitions for the Collection and a variety of other activities, including education resources, capital initiatives and sponsorship of special exhibitions. Benefits vary according to level of membership. Membership costs start at £24 for the basic package with benefits varying according to level of membership. There are special packages for supporters of Tate Liverpool and Tate St Ives.

Patrons

Patrons are people who share a keen interest in art and are committed to giving significant financial support to Tate on an annual basis, specifically to support acquisitions. There are four levels of Patron: Associate Patron (£250), Patrons of New Art (£500), Patrons of British Art (£500) and Patrons Circle (£1000). Patrons enjoy opportunities to sit on acquisition committees, special access to the Collection and entry with a family member to all Tate exhibitions.

Tate American Patrons

Residents of the United States who wish to support Tate on an annual basis can join the American Patrons and enjoy membership benefits and events in the United States and United Kingdom. Single membership costs $1000 and double membership $1500. Please contact the American Fund for the Tate Gallery for further details.

Corporate Membership

Corporate Membership at Tate Liverpool and Tate Britain, and support for the Business Circle at Tate St Ives, offers companies opportunities for exclusive corporate entertaining and the chance for a wide variety of employee benefits. These include special private views, free admission to paying exhibitions, out-of-hours visits and tours, invitations to VIP events and talks at the workplace. Tate Britain is only available for entertaining by companies who are either Corporate members or current Gallery sponsors.

Founding Corporate Partners

Until the end of March 2003, companies are also able to join the special Founding Corporate Partners Scheme which offers unique access to corporate entertaining and benefits at Tate Modern and Tate Britain in London. Further details are available on request.

Corporate Investment

Tate has developed a range of imaginative partnerships with the corporate sector, ranging from international interpretation and exhibition programmes to local outreach and staff development programmes. We are particularly known for high-profile business to business marketing initiatives and employee benefit packages. Please contact the Corporate Fundraising team for futher details.

Charity Details

Tate is an exempt charity; the Museums & Galleries Act 1992 added the Tate Gallery to the list of exempt charities defined in the 1960 Charities Act. The Friends of the Tate Gallery is a registered charity (number 313021). The Tate Gallery Foundation is a registered charity (number 295549).

Tate Britain Corporate Members

PARTNER LEVEL

BP

Merrill Lynch Investment Managers

Prudential plc

ASSOCIATE LEVEL

Alliance & Leicester plc

Cantor Fitzgerald

Credit Suisse First Boston

Drivers Jonas

Freshfields Bruckhaus Deringer

Global Asset Management

Honda (UK)

Hugo Boss

Lazard

Linklaters

Manpower plc

Morgan Stanley Dean Witter

Nomura International plc

Publicis Ltd

Robert Fleming Holdings Ltd

Schroders

Simmons & Simmons

The EMI Group

UBS AG

Founding Corporate Partners

AMP

AVAYA UK

BNP Paribas

CGNU plc

Clifford Chance

Energis Communications

Freshfields Bruckhaus Deringer

GLG Partners

Goldman Sachs International

Lazard

Lehman Brothers

London & Cambridge Properties Limited

London Electricity, EDF Group

PaineWebber

Pearson plc

Prudential plc

Reuters

Rolls-Royce plc

Railtrack PLC

Schroders

UBS Warburg

Wasserstein Perella & Co.

Whitehead Mann GKR

Tate Collection Sponsor

Carillion plc

Paintings Conservation (1995–2000)

Tate Britain Founding Sponsors

BP

Campaign for the Creation of Tate Britain (1998–2000)

New Displays (1990–2000)

Tate Britain Launch (2000)

Ernst & Young

Cézanne (1996)

Bonnard (1998)

Tate Britain Benefactor Sponsors

Channel 4

The Turner Prize (1991–2000)

Prudential plc

Grand Tour (1996)

The Age of Rossetti, Burne-Jones and Watts: Symbolism in Britain 1860–1910 (1997)

The Art of Bloomsbury (1999)

Tate Britain Major Sponsors

Aon Risk Services Ltd in association with ITT London & Edinburgh

In Celebration: The Art of the Country House (1998)

Glaxo Wellcome plc

Turner on the Seine (1999)

William Blake (2000)

Magnox Electric

Turner and the Scientists (1998)

Morgan Stanley Dean Witter

Constructing Identities (1998)

John Singer Sargent (1998)

Visual Paths: Teaching Literacy in the Gallery (1999)

Sun Life and Provincial Holdings plc

Ruskin, Turner & the Pre-Raphaelites (2000)

Tate & Lyle PLC

Tate Friends (1991–2000)

Tate Britain Sponsors

AT&T

Piet Mondrian (1997)

British Telecommunications plc

Tate Britain Launch (2000)

The Guardian/The Observer

Jackson Pollock (1999)

Media Sponsor for the Tate 2000 launch (2000)

Hiscox plc

Tate Britain Members' Room (1995–2000)

Tate Britain: Donors to the Centenary Development Capital Campaign

FOUNDER

The Heritage Lottery Fund

FOUNDING BENEFACTORS

Sir Harry and Lady Djanogly

The Kresge Foundation

Sir Edwin and Lady Manton

Lord and Lady Sainsbury of Preston Candover

The Wolfson Foundation

MAJOR DONORS

The Annenberg Foundation

Ron Beller and Jennifer Moses

Alex and Angela Bernstein

Ivor Braka

The Clore Foundation

Maurice and Janet Dwek

Bob and Kate Gavron

Sir Paul Getty KBE

Mr and Mrs Karpidas

Peter and Maria Kellner

Catherine and Pierre Lagrange

Ruth and Stuart Lipton

William A. Palmer

John and Jill Ritblat

Barrie and Emmanuel Roman

Charlotte Stevenson

Tate Gallery Centenary Gala

The Trusthouse Charitable Foundation

David and Emma Verey

Clodagh and Leslie Waddington

Sam Whitbread

DONORS

The Asprey Family Charitable Foundation

The Charlotte Bonham Carter Charitable Trust

Giles and Sonia Coode-Adams

Thomas Dane

The D'Oyly Carte Charitable Trust

The Dulverton Trust

Friends of the Tate Gallery

Alan Gibbs

Mr and Mrs Edward Gilhuly

Helyn and Ralph Goldenberg

Pehr and Christina Gyllenhammar

Jay Jopling

Howard and Linda Karshan

Anders and Ulla Ljungh

Lloyds TSB Foundation for England and Wales

David and Pauline Mann-Vogelpoel

Sir Peter and Lady Osborne

Mr Frederick Paulsen

The Pet Shop Boys

The P F Charitable Trust

The Polizzi Charitable Trust

Mrs Coral Samuel CBE

David and Sophie Shalit

Mr and Mrs Sven Skarendahl

Pauline Denyer-Smith and Paul Smith

Mr and Mrs Nicholas Stanley

The Jack Steinberg Charitable Trust

Carter and Mary Thacher

Dinah Verey

Gordon D. Watson

The Duke of Westminster OBE TD DL

Mr and Mrs Stephen Wilberding

Michael S. Wilson

and those donors who wish to remain anonymous

Tate Collection

FOUNDERS

Sir Henry Tate

Sir Joseph Duveen

Lord Duveen

The Clore Foundation

BENEFACTORS

American Fund for the Tate Gallery

Gilbert and Janet de Botton

The Friends of the Tate Gallery

The Heritage Lottery Fund

National Art Collections Fund

National Heritage Memorial Fund

The Patrons of British Art

The Patrons of New Art

MAJOR DONOR

Robert Lehman Foundation, Inc.

DONORS

Howard and Roberta Ahmanson

Lord and Lady Attenborough

Mr Tom Bendhem

Robert Borgerhoff Mulder

The British Council

Neville and Marlene Burston

Mrs John Chandris

The Clothworkers Foundation

Edwin C Cohen

The Daiwa Anglo-Japanese Foundation

Judith and Kenneth Dayton Foundation for Sport and the Arts

Mr Christopher Foley

The Gapper Charitable Trust

The Gertz Foundation

Great Britain Sasakawa Foundation

HSBC Artscard

Sir Joseph Hotung

Mr and Mrs Michael Hue-Williams

The Idlewild Trust

The Japan Foundation

The Kessler Family Re-Union

Mr Patrick Koerfer

The Henry Moore Foundation

The Leverhulme Trust

Peter and Eileen Norton, The Peter Norton Foundation

Mr David Posnett

The Radcliffe Trust

The Rayne Foundation

Mr Simon Robertson

Lord and Lady Rothschild

Mrs Jean Sainsbury

Scouloudi Foundation

Stanley Foundation Limited

Mr and Mrs A Alfred Taubman

The Vandervell Foundation

Mr and Mrs Leslie Waddington

and those donors who wish to remain anonymous

Tate Britain Donors

MAJOR DONORS

Bowland Charitable Trust

Mr and Mrs James Brice

Robert Lehman Foundation, Inc.

The Henry Luce Foundation

The Henry Moore Foundation

DONORS

David and Janice Blackburn

Cadogan Charity

Ricki and Robert Conway

The Elephant Trust

The Hedley Foundation

Hereford Salon

John Lyons Charity

Kiers Foundation

The Kirby Laing Foundation

Leche Trust

London Arts Board

The Paul Mellon Centre

Sally and Anthony Salz

and those donors who wish to remain anonymous